The
Color Photo Book

by Andreas Feininger

Prentice-Hall, Inc., Englewood Cliffs, New Jersey

Books by ANDREAS FEININGER

THE COLOR PHOTO BOOK by Andreas Feininger

Library of Congress Catalog Card Number: 69–12820

Printed in the United States of America T

Prentice-Hall International, Inc., London
Prentice-Hall of Australia, Pty. Ltd., Sydney
Prentice-Hall of Canada, Ltd., Toronto
Prentice-Hall of India Private Ltd., New Delhi
Prentice-Hall of Japan, Inc., Tokyo

Sixth Printing...........March. 1976

Contents

Facts about This Book

This book represents a complete home-study course in color photography. Its purpose is to teach you how to make good color photographs even if you have little or no experience in this field, and also how to get still better pictures if you are already a more accomplished worker. It contains all the necessary directions from the most elementary information about cameras and films to suggestions for making, and color illustrations exemplifying, the most sophisticated kinds of color photographs.

It is devoted solely to color photography and contains the gist of my thirty-year occupation with color photography and twenty-year experience of working as a staff photographer for *Life*. It combines the essence of my previous phototechnical texts * but omits information applying only to black-and-white photography. It was written to replace my book *Successful Color Photography*, which, now fifteen years old and despite a number of revisions, is no longer adequate. However, the enthusiastic acceptance of this book by photographers all over the world (it also appeared in German, Italian, Swedish, and Finnish editions) prompted me to retain the most successful of its features in the present book. Brought up to date, rewritten wherever necessary, expanded and amplified by a wealth of new material, and complemented by ambitious illustration, they form the nucleus of a book which, I trust, will be a standard text for many years to come.

It progresses from the general to the specific, a principle followed by all good textbooks. But there is a difference: most photographic textbooks start immediately with elementary discussions on cameras, films, etc., without mentioning the vitally important subject of photographer motivation. Why does anybody take up photography? What does photography mean to him? What are his specific goals?

* In particular: *Successful Color photography* (1954), *The Creative Photographer* (1955), *Total Picture Control* (1961), and *The Complete Photographer* (1965); going far beyond these texts, however, *The Color Photo Book* is a completely integrated, self-contained dissertation on the principles, techniques, and creative aspects of color photography.

It seems to me these questions have to be discussed and, as far as possible, answered, before the student photographer can be guided in a direction that will assure his successful development and growth. Therefore a special chapter addressed to the reader precedes the more technical text.

It deals with many aspects of color photography which, although vitally important, are either completely neglected in ordinary texts or treated only in the most rudimentary fashion. For example: What are the qualities which make a photograph "good"? What is "photographic seeing"? What are the symbols of photography? What are the controls which a photographer has at his disposal, how can he master them, how can he use them to improve the technical quality and strengthen the emotional impact of his pictures? Without giving consideration to such basic aspects of photography, not even the technically most adept photographer can produce "good" photographs.

It is designed to remain up-to-date for many years because no information of merely temporary value has been included. For example, brand names of cameras, exposure meters, films, etc., are normally not mentioned, nor are instructions given for the use of specific products. Because progress in the photo-technological field is so rapid, information of this kind does not belong in a book where its inclusion would doubtlessly be of little relevance by the time it is published. Furthermore, specific, authoritative, and up-to-date instructions for use are provided by virtually all manufacturers to accompany their products, no matter whether cameras, exposure meters, or films, etc. Other readily available sources of currently valid information are the Kodak Data booklets and, of course, the photo-magazines whose special province is "photographic news."

It is thoroughly practical because information is restricted to the immediately useful. Erudite theorizing has no place in a popular guide, nor has highly specific information pertaining to, for example, the constituents of color films, exposure systems requiring involved calculations, or principles of optics and lens design. Subjects like these are the province of specialists but have no immediate value to the working photographer, whose pictures will not be improved by one iota if he knows that, for instance, his lens has seven elementary aberrations called astigmatism, coma, and so forth. Twenty years of practical experience as a *Life* staff photographer has taught me what is important and what is not. It is now my pleasure to share this knowledge with the reader. I trust it will help him to derive additional satisfaction from his work.

1

Dear Reader...

I assume you reach for this book because you wish to improve the quality of your color photographs in regard to technical proficiency and pictorial effect; and you, of course, assume that I will be able to guide you toward this goal. Whether or not we both will be happy—I, with your progress as a student of photography, and you, with the effect of this book upon your work—depends to a great extent upon mutual understanding right from the start of our common venture. Let me clarify: You are entitled to expect from me an authoritative, technically sound, and completely up-to-date guide to color photography, giving you the benefit of my twenty-year experience as a *Life* staff photographer and thirty-year preoccupation with photography and the needs of photographers. However, I realize that I have strong convictions and definite ideas on many aspects of photography. I therefore feel it is only fair to warn you that you may be in for surprises. My approach to the subject is often different from that of the average textbook. If all you want is a conventional introduction to color photography, you may be disappointed. But if you are open-minded and willing to try new ways, I believe you will find the following discussions both stimulating and profitable.

On the other hand, I expect that you have faith in my ability as a teacher. And since teaching implies learning, I also expect a certain effort on your part. Even if, as far as you are concerned, photography is merely a hobby; to make it successful and rewarding, you must memorize a few technical terms and familiarize yourself with certain principles and rules. However, do not worry; what at first may seem strange and difficult because it is new, will soon become familiar to you.

WHY DO YOU WISH TO PHOTOGRAPH?

An honest answer to this question is vitally important to your development as a photographer, whether amateur or professional. Why? Because there are different fields of photography, each requiring a different approach, personality, and state of mind, each presenting different problems, each offering its own rewards. In this respect, four main categories of photography must be distinguished:

3

Photography as a hobby

This is the province of the amateur photographer, the man or woman who photographs for pleasure and relaxation. An amateur is a person who does something for the love of doing it (in contrast to a professional, who does more or less the same thing for gain). But more than love is needed if you are to derive satisfaction from your hobby: success. And the only way to succeed as an amateur photographer—to derive a feeling of accomplishment, self-respect, and satisfaction—is to do original work.

Being an amateur gives you a priceless advantage over most professionals: you are your own boss. No editor to satisfy, no client to worry about, no art director to look over your shoulder and tell you what to do. You are completely free.

Being on your own may give you a marvelous feeling of freedom; on the other hand, it may also put you in a state of insecurity. In the first case, you are on the right track and nothing short of disaster can prevent you from succeeding. In the second case, you are in danger of falling into the same old trap that has cut short the development of countless other amateurs: imitation.

It is an unfortunate fact that very few amateurs realize their unique position as free agents and take advantage of it. Most are indecisive, lacking in both purpose and goal. To compensate for this lack of direction they look desperately for guidance. This inevitably leads them into imitation of the work of others under the illusion that what worked well for others will work well for them. Once a photographer competes on this level, he will quite likely end by being part of that society for mutual admiration, the photo-club. If this happens, he gives up the chances of becoming a photographer with something of value to say.

To avoid the trap of imitation, don't concentrate your attention on what some other photographer does, whether he is your friend or a stranger whose work you respect. People are different, and another's approach or interest may be totally wrong for you. You are YOU—so be yourself, and be proud of it. Listen to criticism, but analyze it carefully and accept only that advice which you are convinced applies to you—*your* kind of interest and work, *your* temperament and personality, *your* goals.

Photography as a means of self-expression

The difference between photography as a hobby and photography as a means of self-expression is not one of kind but one of degree. Whether or not you will

reach this higher and more satisfactory level depends on whether you possess the necessary prerequisites: talent, imagination, and creativity. Creative photographers are found among both amateurs and professionals. As a matter of fact, many of the most successful professional photographers began as amateurs, switching because their talent enabled them to combine the best of two worlds: to do full time what they best liked to do, and get paid for doing it. And by taking the step from amateur to professional they gained access to many means and opportunities normally denied nonprofessionals which in turn enabled them to broaden further the scope of their work and derive additional satisfaction from an activity that started as a hobby.

Creative photographers are artists in the true sense of the word. They stand in the forefront of photography. They are often stubborn and opinionated. Their work is always stimulating, often controversial, and occasionally shocking, particularly to those who are conservative in their thinking. They follow no "rules" and respect no "taboos." Driven by the compulsion common to all creative people, they must find expression for their feelings and views. It is they who first explored the potentialities of such "revolutionary" methods and techniques as the bird's-eye and worm's-eye views, candid photographs taken by "available light," blur as an indicator of motion, multiple exposures and photograms, and the processes of controlled solarization, reticulation, and bas-relief. These techniques, once derided as "faults" and "fads," are today part of the vocabulary of any visually articulate photographer.

The born photographer—the artist—works by intuition, unconsciously doing the right thing at the right time; if you are one of these fortunate people, you do not need this book. However, scanning its pages, you may find, here and there, something to clarify a conclusion you may have reached intuitively, or some useful technical advice.

Photography as a career

To be successful as a professional in a field that is already overcrowded and fiercely competitive, you need exceptional drive, persistence and—luck. To be happy and satisfied, you must find the kind of activity that goes with your interests. For example, if you have a feeling for people, consider news reporting or portraiture; if you like to travel, try working toward a career as a photo-journalist on a big picture magazine; if your interests are predominantly technical, you might consider industrial photography or becoming a plant photographer; and so on.

The highest financial rewards are, of course, to be gained in the fields of commercial and advertising photography, but competition at the top is savage, the pace murderous, overhead fantastically high, and worries and frustrations are likely to soon make you a member of the ulcer brigade.

Personally, I feel that the price of success and fame can be too high. Even if your imaginative and creative faculties qualify you as a top contender, think twice before you take the plunge and consider whether, perhaps, daily satisfaction with one's work is more important than being in a higher income-tax bracket. The happiest professional photographers are those who made a successful adjustment between work load and income. Freedom from excessive worry and frustration enables them to fully enjoy what they most love to do.

Photography as a supplement to other work

Today, photography is used in virtually every field of human endeavor: science, industry, medicine, teaching, publishing, banking, law enforcement, and so forth. In these instances, photography plays the role of handmaiden to some other profession, science, or business. Its main function is to record, and those who produce this kind of picture are usually not professional photographers, but scientists, researchers, laboratory and X-ray technicians, engineers, police officers, insurance adjusters, etc., who use photography to complement their written records or notes. Their interest in photography is neither commercial, artistic, nor that of a hobbyist, but strictly practical. The degree of clarity and objectivity determines the success of their pictures, creative imagination being a handicap rather than an asset in this field of strictly utilitarian photography. But a high degree of technical competence may be required in order to solve the sometimes considerable technical problems involved in the making of this type of picture and to utilize to fullest advantage the often rather complex instruments needed for this purpose. Qualifications for success in this kind of photography are patience and deliberation, orderliness, mechanical ability, and a feeling for quality and precision.

YOUR ATTITUDE TOWARD PHOTOGRAPHY

If there is one single factor which decides whether your efforts will end in mediocrity or be rewarded by success, it is your attitude toward photography. This attitude is particularly critical in regard to three different aspects of picture-making:

Motivation
Equipment
Technique

Motivation

Photography is a form of communication. Rarely does anyone take pictures merely to please himself. Normally, we want our photographs to be seen by others. We wish—or are compelled—to share an experience, to entertain, record, inform or reform, or simply to be admired by our peers. In any event, we make pictures to show them to other people. We want to communicate because we feel we have something to say, we want to be understood and, not being writers but photographers, to get our message across, we use pictures instead of words.

Now, no intelligent person would ever put words on paper unless he felt he had something to communicate that is of interest to a reader. Unfortunately, among photographers, and particularly among amateurs, this attitude is often the exception rather than the rule, a fact which is borne out by the enormous mass of photographs that are devoid of interest to anyone, including the photographer himself, who usually made such pictures only because he had seen similar ones reproduced in magazines or hung in a show. But the mere event of a photograph having been published or exhibited does not prove that it is meaningful or good.

A photograph which cannot arouse interest in anyone has missed its purpose and is valueless, no matter how technically well it may be executed. Therefore, the best advice which I can give you for improving the quality of your work is to *stop looking for subjects that have been "done" successfully by other photographers and to concentrate instead on those that are of interest to YOU.*

Interest on the part of a photographer in the subject of his picture is the first prerequisite for success. It is the energizing factor which is the basis of every form of creative activity. Unless a photographer is motivated by interest in what he photographs, he cannot instill that element of excitement into his work which alone can stir the imagination of the viewer and arouse *his* interest, and the entire process of picture-making sinks to the uninspired level of mechanical routine.

A photograph is interesting if it has something to say. Not all people, of course, are interested in all subjects, and a picture that says something to one may be of no interest to another. But nobody is so unique that he cannot find others to share his interests. Therefore, it stands to reason that anything that interests YOU is worth photographing because it will also have meaning to those who share your interests. If this is your attitude toward photography, it does not matter *what* you photograph nor *how* you photograph it, provided that you express in your own terms those attributes of your subject which caught your interest. If this comes out in your photographs—interest, feeling, opinion, a personal way of seeing things—

although people may still disagree with you, no one can question your integrity as a photographer and your pictures will be valid.

Equipment

Cameras, lenses, exposure meters, and so forth, are tools. They are instruments designed to perform specific functions, the combined result of which is the photograph, the picture with purpose and meaning. They are the means which we need to accomplish our ends.

Unfortunately, they are more to certain photographers who see in them what almost amounts to objects of worship. I don't think I go too far when I say that these photographers are in love with their equipment. Their attitude toward a fine camera is very similar to that of the car buff who is in love with his automobile—the man who gets his satisfaction out of tending to all its mechanical needs, polishing it until it shines, embellishing it with an endless line of gadgets and accessories instead of using it for its intended purpose: as a means of transportation which makes it possible for him to move around freely, to travel and see places and things, meet people, and generally enrich his life by widening his horizons both physically and intellectually.

Photographers in love with their equipment never get around to serious picture-making because their main interest is focused on the means instead of the end. They are experts in the field of gadgetry, know all about the different models of cameras, endlessly "test" their equipment, and are the proud possessors of the sharpest "hand-picked" lenses. They constantly "trade" their equipment to "keep it up-to-date," spend countless hours discussing with one another the merits of their respective cameras, are familiar with all the fine points that distinguish this model from that, and they never make a worthwhile photograph.

Therefore, if you truly wish to grow as a photographer, the second piece of advice which I must give you is to *treat your camera the way a writer treats his typewriter:* NOT with "love," but with ordinary workmanlike respect. Don't baby it, don't shine it up, don't see in it a symbol that can enhance your status as a photographer or a citizen. So what if the finish is scratched—this does not affect the quality of your work. So what if the leather is scuffed—this is no reason for trading an otherwise satisfactory camera for a newer one. No—what counts in photography is NOT the looks of the equipment, nor the brand name of the camera or lens, nor the price you paid for it, BUT its suitability for the job at hand, its mechanical condition, and the skill with which you use it.

8

In itself, a camera is no more creative than a lump of clay. But like a lump of clay, in inspired hands it becomes a means for creative expression. "Prize-winning cameras" and "systems that can do everything" exist only in the imagination of the copywriters who compose the ads. There are only prize-winning photographers. Meaningful pictures can be made with any type or brand of camera. As a matter of fact, I know a world-famous photographer who carries only two 35-mm cameras for his work; but I also know an amateur who owns some $4,000 worth of equipment yet never made a worthwhile photograph.

Now you may rightfully ask why professionals, photographers who make the kind of important pictures you admire in *Life* or *Look,* invariably work with expensive equipment while the "little guys" who make those dreadful snapshots of Aunt Mimi and cousin Al, of babies, cats, and dogs, generally use cheaper cameras. Isn't this the reason why their pictures are so tiresome? The answer, of course, is a categorical NO. Their photographs are bad because they themselves are bad photographers—give them the tools of a *Life* photographer and their pictures would still be awful. On the other hand, give a good photographer an inexpensive camera and he will still come up with work that makes you goggle.

Although it is perfectly true that many more *good* photographs are taken with expensive than with cheap cameras, it is equally true that these pictures are good *not* because they were made with good cameras, but because they were made by *good photographers.* In most of these cases, the same picture could have been made just as well with a camera costing half as much or less—the difference, which would have been one of technical (*not* pictorial!) quality, noticeable only to the sharpest professional eye or, if such pictures were reproduced in magazines or books, not noticeable at all. Why, then, do good photographers use expensive cameras if cheaper ones work just as well? For two reasons: Firstly, because expensive cameras generally, through a long list of accessories, are adaptable to a wider range of uses than inexpensive cameras, which are more limited in their scope, a fact which, however, is usually of little importance to the amateur, who rarely encounters the difficult problems which professionals must be prepared to solve. Secondly, and this is the main reason, because expensive cameras are better designed and engineered than cheap ones, they are built of better material to closer tolerances, they stand up better under hard use; their alignment, focusing mechanism, shutter assembly, etc., will stay accurate longer, they are more dependable. Good photographers—professionals as well as amateurs—buy expensive cameras because they cannot afford to miss a picture as a result of equipment failure. The extra dollars they spend on their outfits pay for peace of mind.

I hope I made it abundantly clear that restriction to the use of inexpensive photographic equipment is no excuse for uninspired work. Photographers who believe that their pictures would improve if only they had a Hasselblad, a Leica, a Linhof, or a Nikon, fool nobody but themselves. Unless special circumstances require special tools—as in extreme tele, close-up, or wide-angle photography—anyone who cannot produce interesting pictures with an inexpensive camera would do no better if he were given the costly instrument of his dreams. If your pictures are dull, don't blame your camera; blame yourself. And while this may sound brutal, there is a consolation: although you may not be able to afford your dream camera, you can always afford to improve yourself—your photo-eye, your taste, your skill—by studying the work of more accomplished photographers published in magazines and books, by reading photographic texts, through practice and experimentation. As long as you have the will to progress you'll be surprised how fast you'll get ahead, and how little the cost.

Technique

Photography, like any form of expression or communication, involves two different levels:

> The level of creation
> The level of execution

Creation—the "why" and "what" of a photograph—begins with a flash of inspiration or a train of thought, with an idea and a plan. It is intimately linked to inventiveness and imagination, feeling, sensitivity. These are talents which are inherent in the artist, no matter through which medium he may express himself, whether he is a painter, sculptor, writer, composer, or photographer. Talent is elusive—hard to define. Different people are talented to different degrees—they either do, or do not, possess creative faculties; such talents cannot be taught.

In contrast, the execution of any creative work—the "how" of a photograph—is based upon concrete techniques involving means and devices. Anyone who is willing to make the effort can learn to master them.

A comparison with music might be useful. A good composer is an artist who, from the individuality of his imagination, creates new forms in sound. However, to communicate what he has composed, someone must play it. Instruments—mechanical devices—must be used by technically trained performers. A composer must not necessarily be a good technician, nor does he have to play his music himself.

Conversely, a musical performer must not necessarily have a creative mind; he does not have to write his own music. But only if creative and technical abilities are brought together can a work of art take concrete form and its meaning be communicated to others.

A duality of creativity and technical ability is also found in photography. I know personally several unusually creative photographers who have only the most rudimentary understanding of photographic techniques and who would not think of developing films or making prints. And I have met quite a few extraordinarily skilled phototechnicians who lacked a creative mind.

What I wish to arrive at is this: if you study the following pages you can with work become an expert photo-technician but not necessarily an artist. Whether or not you can do original work depends entirely upon your inherent qualifications. However, talent is often dormant until stirred by some outside influence. This book might conceivably provide that influence. With this in mind I have included information and pictures of a kind not found in ordinary photographic texts in the hope that they will stimulate you and induce you to strike out on your own. Once started in the right direction, the satisfaction you experience from doing original work will carry you to the limit of your ability.

Now, the fact that "technique" is a necessary ingredient of any photograph must not mislead you to overrate its importance. Unfortunately, not only photographers, but people in general commonly make the mistake of judging a photograph primarily on the basis of its technical excellence: a picture that is crisp, sharp, and correctly exposed is likely to rate higher than one that is deficient in phototechnical respect—more fuzzy, grainy, or off-color—*even though the first may be totally devoid of subject interest while the second depicts an important, interesting, or moving event.* Honestly, if you had to choose between a photograph that shows something you are interested in but presents its subject badly, and a picture that leaves you cold subjectwise although it is "technically" unassailable, which one would you prefer? Personally, I don't see how anyone could even hesitate to choose the photograph which at least provides stimulation if not esthetic satisfaction, whereas contemplating a meaningless picture seems to me a total waste of time.

A *good* photograph, of course, is one that combines interesting subject matter with photo-technically suitable rendition. This is the ideal for which any photographer must strive. But when a choice between subject matter and photo-technical presentation—a choice between content and form—is inevitable, content takes

precedence over form. A picture that says something is at least stimulating, even though we may deplore its lack of technical accomplishment; a picture that says nothing—no matter how accomplished in photo-technical respects—is visual drivel.

I give so much prominence to what I feel is the *relative* importance of photo-technique because excessive preoccupation with this aspect of photography on the part of photo-magazine and textbook writers has made it seem that the entire growth and development of the student photographer should be oriented toward technical proficiency. This, I believe, is wrong. By itself—that is, unless backed by interesting subject matter—not even the slickest, most accomplished technique can make a photograph "good." As a matter of fact, excessive preoccupation with technique often inhibits creation. Photographers who waste too much time taking light readings, calculating exposures, and adjusting their camera settings in an effort to produce technically perfect photographs frequently miss out entirely; by the time they are ready to shoot, the crucial moment is past, the animated expression gone, the situation dull. On other occasions, technical perfectionists may worry so much whether or not a contemplated shot will "come off" that they pass up the chance of making an interesting picture; this happens especially when confronted with backlight, extreme contrast, or rapid subject motion—admittedly difficult shooting conditions which, however, often lead to the most interesting pictures. Many times have I seen photographs that were effective precisely because they were unorthodox—the kind of picture that perfectionists call "failures" because they include flare, halation, blur, or graininess, qualities which, although normally faults, in particular cases give the pictures extra punch and immediacy and strengthened the expressiveness of the subject. Timid photographers, who are too much concerned about "technique" and too little about "seeing," will never produce great photographs.

Now, please don't misunderstand: it is not my intention to recommend unorthodox or "bad" techniques as panaceas for producing interesting photographs although, occasionally, if used in the right place by a discriminating and accomplished p. 231
p. 111 photographer, picture qualities normally considered "faults"—halation, blur, or graininess, etc.—can doubtlessly enhance the effectiveness of the presentation. Basically, however, I believe that mastery of photo-technique should mean to a photographer what mastery of grammar and spelling means to a writer: an indispensible requirement for the production of pictures or prose which should be taken for granted; a faculty which, once acquired, should become so much second nature that it does not ever have to be mentioned again, least of all with pride.

And here is another thing: in the following picture sections, no "technical data" will be given as supplement to the photographic illustrations. Although found in every photo-magazine, such data—camera make, f-stop, exposure time, etc.—is valueless and misleading. I simply don't see why it should make a difference whether a picture was made with, say, a Leica instead of a Nikon, a Rolleiflex instead of a Rolleicord; or how it can help a photographer to know that the published picture of a subject in which he is interested had been made with, say, 1/60 sec. at f-11, as long as he is not told how bright the light was, or what kind of illumination prevailed. But this kind of information is rarely, if ever, included in the "data" that is supposed to tell the reader how he too can make a similar shot; nor is information pertaining to film type and emulsion speed, auxiliary or fill-in illumination, filtration, mode of processing, or corrective measures that might have played an important role in making the picture what it is. No—only familiarity with his equipment and material, experience, and the data furnished right on the spot by a reliable exposure meter can assure a photographer that a contemplated shot will turn out successfully in regard to "technique." Data pertaining to other people's pictures, even if they were honest and complete, and most of them are not, are worthless.

WHAT MAKES A PHOTOGRAPH "GOOD"?

Every ambitious photographer's goal is to make good photographs. It is with this purpose in mind that he studies textbooks and reads photo-magazines, enrolls at a photo-school, practices and experiments, analyzes his work and compares it critically with that of photographers who have arrived. All this is, of course, highly commendable, but is it effective? Not unless the photographer first establishes his aim in more specific terms: what, actually, are the particular photographic qualities he is aiming at, the qualities which make a photograph "good"?

Obviously, specific photographs have different meanings to different people, and it is not only possible but dead certain that a picture that won the highest award at a pictorialist's convention would be termed a "reactionary cliché" by an *avant-garde* photographer whose own work in turn would be scornfully rejected as "incompetent" by any academically oriented competition-judge. Because of the absence of a uniform standard it is, of course, impossible to specify unequivocally those qualities which make a photograph "good." And when in the following I make the attempt, it can only be with the understanding that I do it within the frame of my own experience in an effort to provide the reader with at least some kind of basis from which to proceed.

But before I continue I must insert a word of caution: To my mind, it is unfair to judge a photograph *except* in the context of the intentions of its maker. In other words, only if we know what a photographer was after, what he tried to express with his work, what he wanted to communicate, can we draw valid conclusions with regard to the merits of the picture: Was he able to realize his intentions? Did he succeed in expressing what he felt? Did he capture some aspect of his subject and present it in a convincing form?

The importance of this approach was brought home to me some years ago when I saw in an exhibition a print of a Cape Cod landscape that seemed to violate all "accepted" photographic standards: it was very gray and very grainy, the horizon divided the picture in two equal parts, and it contained virtually no subject matter except an enormous expanse of dunes sparsely covered with marsh grass and an evenly overcast sky. The combined effect was one of unbelievable dullness and monotony.

And then, just as I was ready to turn my back on it, wondering why in the world anybody would want to exhibit such a dull picture, it struck me: but this is exactly what the photographer had in mind! He *wanted* to express "dullness"—the abject loneliness of these wide stretches of sand on a rainy March day, the clammy feeling and the damp chill under a harsh northeastern wind, the mood of desolation and monotony when everything is gray, a gray diffused by veils of drifting fog and driving scud—*and he had succeeded magnificently!* Suddenly I felt I was there—I felt cold, I felt lonely, I almost thought I could hear the forlorn cry of a sea gull tacking with flapping wings against the stiffening breeze. I don't believe I'll ever forget this "unbelievably dull" photograph. . . .

Analyzing photographs which I had instinctively accepted as "good" I found that these pictures possessed, without a single exception, although to various degrees, four specific qualities:

> **Stopping power**
> **Purpose and meaning**
> **Emotional impact**
> **Graphic quality**

On the other hand, photographs which left me cold invariably lacked one or more of these qualities, and the greater their deficiency in this respect, the less I liked the picture. I therefore believe it is these qualities which a photographer must strive to instill in his work if he expects to make "good" photographs.

Stopping power

To produce any kind of an effect, a photograph must first of all be noticed. Unfortunately, today, people are so satiated with photographs that a picture must have some rather unusual qualities to receive attention. To command it, a photograph must have stopping power.

Stopping power is that quality which makes a photograph *visually* unusual—"outstanding" insofar as it stands out among other pictures. Its essence is surprise or shock effect—but how many subjects possess these qualities? Most photographs depict ordinary people or everyday events, subjects which are all too familiar to the viewer. Without additional stopping power, photographs of such subjects easily go unnoticed—and an unnoticed photograph is a wasted statement.

Stopping power can be achieved in three different ways: by photographing only unusual subjects; by applying an unusual treatment to ordinary subject matter and thereby enhancing its visual appeal; by combining these two approaches. In other words, what a photographer must look for and work toward is the unexpected, unusual, new, imaginative, or bold; anything that is intriguing and, very likely, anything that makes other photographers exclaim: Why didn't I think of that!

This, of course, does not mean that a picture must be vulgar or loud to attract attention. As a matter of fact, in our present society, subtlety, because it is rare, is often especially effective. The use of pastel shades, for example, often commands greater attention than color that is garish and loud.

Here is a listing of some of the devices which, properly used, can give a picture stopping power: color photographs that contain mostly white (or black) and very little color; unusually saturated and strong or unusually pale and subtle color; deliberately "distorted" and "unnatural" color, provided its use is meaningful and contributes to the characterization of the subject or mood; exceptionally low and exceptionally high contrast; use of extreme telephoto or wide-angle lenses instead of lenses of standard focal length; close-ups and macrophotographic views; cylindrical and spherical ("fish-eye") perspectives; exceptionally shallow depth of field ("selective focus"); unusual light effects, perhaps utilizing glare, flare, and halation; shooting under unusual atmospheric or light conditons; creative use of film grain, camera motion, multiple exposure, distortion, filtration; extreme simplicity or semiabstract rendition; unusual and daring cropping (masking if transparency or slide).

p. 315
p. 314
pp. 88, 86
p. 343
p. 231

15

However, before a photographer goes all-out in his search for stopping power let me inject a note of warning: if an effect is used merely for its own sake and not as an integral component of the picture, if it is out of context with the essence of the subject or the character of the mood, although it may at first attract attention, it will subsequently cause the picture to be rejected as "cheap" and phony and thereby defeat its purpose. Meaningless distortions, vulgar color (the picture-postcard effect), indiscriminate use of gelatins and colored light, shooting pictures through such trick devices as prisms, diffraction gratings, or exposure-meter grids, are examples of this.

Purpose and meaning

To make a photograph good, more is needed than stopping power which, in essence, is merely the equivalent of a blinker light—a device to attract attention. Having caught the observer's eye, a photograph must have something to hold his interest. It must say something, give something, make the viewer think and somehow enrich his experience. It must have purpose and meaning.

Although the terms "purpose" and "meaning" are often used interchangeably, their connotations are subtly different, and I feel that this fine distinction can be of help to the student photographer. As I see it, in photography, *purpose* is equivalent to the intent of the photographer—the "why" of the photograph; *meaning* is equivalent to the content of the picture—the "what" of the photograph.

Although there are symbolic photographs whose meaning might be obscure though the intent of the photographer is not, the meaning of most photographs is obvious; rarely does a viewer have to ask: What is this? What does it mean? But meaning alone is insufficient to make a photograph "good"—it must be guided by purpose.

Purpose is the most important of the four basic qualities which any good photograph must possess; it is also the most diversified. The purpose of a photograph may constitute an appeal to the conscience of the viewer (as in the case of Lewis W. Hine's famous photographs of sweatshops and child-labor practices in New York around the turn of the century, or certain types of civil-rights photographs)—a deliberate attempt by a socially aware photographer to inform the public of intolerable conditions in order to force a change. It may be intent to educate, entertain, record, or sell something. It may be sex appeal. Or it may simply be an attempt at arresting time by fixing in picture form happy moments of family life, as in the case of most snapshots.

Let me use this last example as a point of departure for further clarification of the

difference between, and the importance of, purpose and meaning: Beginners usually start their photographic careers with snapshots of their children, wives, sweethearts, homes, etc. Although, as a rule, such pictures have neither "artistic merit" (or, for that matter, pretentions) nor interest to outsiders, they have both purpose and meaning since they provide lasting records of family and friends, happy hours, and important events.

But sooner or later there comes a point where the former beginner arrives at that state in his development as a photographer where he can call himself an amateur—a person in whose life photography plays a significant role, a nonprofessional photographer who has mastered the elements of his craft to such a degree that he is able to produce photo-technically competent pictures. Unfortunately, this is often also the moment when his outlook in regard to the purpose and meaning of a photograph changes radically. No longer is he satisfied with making pictures of his family, or records of his vacation time; now he feels compelled to make photographs of a higher order—pictures that have "class." Motivated by pride in his technical accomplishments and aware of his new "status," he must become "creative" and produce, if not "art for art's sake," so at least "photographs for photography's sake." And so he goes and starts making those same tiresome pictures one sees year after year in photographic annuals and photo-club exhibitions—the coils of rope lying on a wharf; oily nudes contorted in an effort to casually conceal their face or unphotographable parts of their anatomy; old men with beards; old women clutching crucifixes in gnarled hands; spectacles resting on an open book or Bible, preferably with a burning candle standing by; fake monks dressed in burlap; apple-eating freckled boys; and still lifes composed of spun-aluminum plates and vases—the pictures without interest, the aimless photographic clichés.

True—there is some kind of misguided purpose: the desire to create "works of art"; true, there is some obscure meaning: a coil of rope can make an attractive design. BUT WHO CARES? If a photographer is motivated by pretentiousness and his work lacks interest, his statements are worthless.

I have asked photographers why they make this sorry kind of picture. What they replied was in essence: Why not? Others take such pictures and do very well, thank you. They get them reproduced in photographic publications and hung in photographic "salons." Why shouldn't I?

This seems to me a hopelessly futile approach to photography, the attitude representing on a smaller scale the lack of individual thinking that exists in our time. People get their opinions readymade from newspaper columnists and radio com-

mentators who edit and "digest" the news, slant it to fit particular interests, and serve it authoritatively to the reader or listener who, convinced of his own inferiority, does not dare to have an opinion of his own, accepts it as true, and repeats another's view until he believes it to be the result of his own thinking.

With the whole wide world beckoning, with interesting subject matter everywhere, it seems to me that amateurs would find better ways of using their time and energy than to repeat themselves *ad nauseam*. Again I must come back to my contention that *personal interest* is the most important ingredient in the making of a picture. Honestly—are you really interested in the subjects that constitute the above-mentioned photographic clichés? Do you really prefer spun-aluminum plates or coils of rope to people? Or phony setups to real life?

Amateurs who love photography but are undecided what to photograph are advised to look where their interests lie. Ask yourself: What do I like to do? Travel? Hunt? Fish? Ski? Sail? Or are you perhaps interested in automobiles, classic or new? Gardening and flowers? Stamp collecting? Dogs? Or perhaps in people, their activities, the way they live, work, worship, play? And by *interested* I mean *genuinely*, with understanding and sympathy and not "because people are good subject matter" and "character studies" are always accepted by photographic salons. And *if* you are interested in people you should go out and photograph them—*not* in a sadistic vein seeking to make them appear "funny," but with a wish to show how people live. And the more you put into your photographs—of your feelings, your point of view, of yourself—the more purposively you approach your subject and the more meaningful you make your pictures, the better will be your photographs.

Emotional impact

In a similar way that a photograph's purpose and meaning are aimed at the viewer's intellectual faculties, a picture's emotional impact is directed toward his heart.

Emotional impact is a quality that is difficult to define although its presence or absence in a specific picture· is easy to ascertain: If your photograph makes the viewer ponder; if it makes him experience something beyond the immediate effect of the depicted subject; if it makes him feel good or proud, happy or ashamed, angry or sad; if it stirs his feelings, makes him laugh or want to cry—then you can be sure it has emotional impact. And if the reaction of the viewer is compatible with that which you intended to evoke, you can also be sure that your photograph

has merit although it may still be deficient in some other respect, for example, in composition, technical execution, or form of presentation.

In order to create pictures with emotional impact it is essential that the photographer himself feels the emotions which he wishes to convey to others through his work. It is for this reason that I consider genuine interest in a subject the first condition for making good photographs. Unless a photographer is able to respond emotionally to his subject he obviously cannot produce pictures which contain emotional qualities and, just as obviously, photographs lacking such qualities cannot evoke emotions in those who see them.

The emotional reaction of a photographer toward his subject may be compassion for children who have nowhere to play beyond the garbage-littered backlots of big cities; the awe-inspiring, almost mystical serenity felt in the redwood forests of California; or a sensitive appreciation of the exquisite structure of a seashell. The response may stem from admiration for the talent of an artist, the sex appeal of a girl, disgust with a demagogic politician, or hatred of war. What matters, and what usually makes the difference between pictures with and without emotional impact, is whether the photographer reacts emotionally to his subject or whether he is indifferent and simply shoots the picture as part of his job. In the first case he may succeed in transferring to his work something of what he felt in the presence of his subject. In the second he will merely produce a picture which, for all its worth, might just as well not have been made.

As it is impossible to establish rules for the creation of any work of art, so it is impossible to come up with a formula that will guarantee the production of photographs that have emotional impact. Personally, I believe that the work of photographers like W. Eugene Smith, Leonard McCombe, Gordon Parks, or Ed van der Elsken is emotionally stirring, *not* because these photographers follow certain rules, but because they represent that rare kind of photographer who is equally at home on both levels of his craft: the level of creation and the level of execution. Being sensitive artists, they photograph only subjects to which they react emotionally, and their responses are strong and true. And being past masters in regard to handling their medium, they are able to translate intangible feelings into the tangible forms of expression of their craft: light and shadow, color, contrast, form.

However, trying to reach more helpful conclusions, I analyzed a number of photographs which, as far as I am concerned, have emotional impact. And I found that *all these photographs had one quality in common: they were honest statements.* By this I mean that there was about them nothing phony, nothing contrived, faked,

or posed. To me, then, honesty is a prime requirement for the creation of emotional impact.

And in the course of this analysis I came across a curious thing: some of the emotionally most stirring photographs were technically imperfect—grainy, unsharp, or blurred. But far from distracting, these imperfections actually heightened the impression of honesty and realism in the picture and thus became, in fact, means of creative expression. Particularly in photographs concerned with violence or squalor—war, demonstrations, riots, slum conditions and underprivileged people—they achieved a sense of immediacy which was lacking in otherwise similar but technically slicker pictures. Their imperfections gave them a vital sense of immediacy, a feeling of excitement which emphasized the rush of the event and the difficulty or danger of the situation. In a sense, these technically deficient photographs reminded me of handmade objects with their interesting individual irregularities—objects which precisely because of their flaws are more expressive, and hence more appreciated and sought after, than their machine-made, technically perfect but impersonal counterparts. The fact that a (in the traditional sense) technically deficient photograph can have greater emotional impact than a technically flawless picture probably comes as a shock to those who are naïve enough to believe that technical excellence alone is a measure of the value of a photograph.

Graphic quality

In order to communicate, a photographer must express his intent with graphic means—the lines, forms, colors, and other marks which form the picture, the instruments of visual representation indispensable to expressing ideas, concepts, and images through the medium of photography which in combination give a photograph its graphic quality.

Now, even the cheapest camera pointed by some nitwit at a subject will yield some kind of picture which, of course, also has "graphic quality"—in essence the same but in degree, *i.e.,* in regard to beauty and effectiveness, vastly inferior to the graphic quality that distinguishes the work of sensitive and technically accomplished photographers. To a considerable extent, it is this disparity in the degree of graphic quality which divides good photographs from bad ones. Mastery of photo-technique—proficiency in the use of the means necessary to translate ideas and impressions into the lines, forms, colors, and other marks which form the picture—is therefore a vitally important prerequisite for the making of good photographs.

It is for this reason that a photographer who does not know how to translate his

feelings and ideas into a graphically satisfactory form is bound to produce in-effective photographs, *no matter how idealistic, compassionate, sensitive, or imag-inative he may be.* For in order to be considered *good,* a photograph must not only say something worthwhile, it must also say it *well.*

A picture can be meaningful, interesting subjectwise, or emotionally stirring, yet unless its subject is also presented, not only in a suitable, but also in a esthetically pleasing form—unless it has a high degree of *graphic quality*—it cannot achieve its full potential as a means of expression and communication. This is a fact—an outgrowth of human nature—which an ambitious photographer cannot realize soon enough: if different things serve the same purpose and function equally well—no matter whether automobiles, homes, wristwatches, or color photographs—people invariably prefer the one that appeals most strongly to their sense of beauty. Among a number of photographs depicting the same subject, the one that has the strongest esthetic appeal—the one that is most satisfying as far as form of expression is concerned, the one that rates highest in regard to graphic quality—will normally score highest, out-rating, perhaps, even photographs that are more meaningful but graphically inferior.

Graphic quality is the combined result of such components as sharpness, unsharp-ness, blur, contrast, color, scale, perspective, graininess, etc.—in short, of all the visual manifestations of applied photo-techniques. Since many of these techniques can be modified to a greater or lesser extent, by making the appropriate de-cision, a knowledgeable photographer can exert a considerable amount of control over the graphic quality of his pictures. p. 219

To better understand the considerations which must precede such photo-technical decisions, it is advisable to distinguish between two different levels of photo-technique: a lower level encompassing what might be called the *basic techniques,* and a higher level comprising the more sophisticated *selective techniques.* Let me explain this by means of specific examples:

In order to produce photographs that are sharp, a photographer must focus his lens correctly and hold the camera perfectly still while making the exposure. Since this applies to *all* instances in which sharpness of rendition is required—no matter what kind of subject is photographed or what kind of camera, lens, filter, film, etc., are used—focusing and methods of preventing camera movement are *basic techniques.* In other words, *if* a photographer wants his picture to be sharp—no matter what the circumstances—he *must* focus his lens correctly and he *must* hold his camera still during the moment of exposure; he has no choice. p. 121
p. 119

However, as far as the achievement of certain other graphic qualities is concerned, *a photographer has a choice.* For example, to control the scale of rendition, he

p. 215
has the choice of photographing his subject from a greater or lesser distance, or
p. 72
with a lens of shorter or longer focal length. He can change the perspective of
p. 86
his picture by choosing a lens with a different angle of view; he can influence
p. 35
color rendition with the aid of a properly selected filter, or indicate subject motion by choosing a shutter speed which will produce in the photograph just the
p. 357
right degree of blur; and so on. In each example, he can *precisely* achieve the desired result with the aid of a *selective technique*—a technique which offers him the choice of several possibilities, each resulting in a different effect, each producing a different graphic quality.

This freedom of choice is more extensive than most photographers realize. "Automatic" cameras, for example—cameras equipped with a built-in exposure meter which, in accordance with the prevailing light, automatically sets the appropriate controls for a correct exposure—automatically produce correctly exposed nega-

p. 129
tives or color transparencies. However, a "perfect" exposure can always be achieved in many different ways since, basically, a relatively *small* diaphragm opening in conjunction with a relatively *slow* shutter speed produces, as far as "exposure" (*i.e.,* the density of the negative or the color rendition of the transparency) is concerned, the same result as a relatively *large* diaphragm opening in conjunction with a relatively *high* shutter speed. But although, as far as color rendition is concerned, each combination of diaphragm opening and shutter speed would produce a correctly exposed color transparency (or negative), in other graphic respects the two pictures would be quite different. In the first case, sharpness in depth would be rather extensive but a subject in motion might be rendered blurred; in the second, sharpness in depth would be rather limited but a subject in motion would probably be rendered sharp. Thus even in the seemingly "hopeless" case of an automatic camera, the photographer still has a choice. And if he makes the right decision, the resulting graphic effect will enhance the effect of his picture whereas, if he is wrong, it will diminish it.

The principles and mechanics of both the basic and the selective photo-techniques
pp. 117-153
will be discussed later. What is important at this point is that the student photographer realizes the complex interrelationship of certain factors involved in the making of good photographs: photo-technical proficiency, graphic picture quality, and ability to make the right decision on the part of the photographer, who, if he is to make good photographs, must have the qualities of both the artist and the artisan.

22

SUMMARY

In some respects, photography is getting simpler and easier all the time. Cameras are becoming increasingly sophisticated, automated, and electronically controlled; films are getting faster, and the services of competent commercial processing laboratories are available, if necessary by mail, to anyone who likes to take color photographs but wants no part of darkroom work. More and more, pointer readings taken from the dial of a meter, and guide numbers provided by the manufacturers of films and lighting equipment, are replacing the need for skill and experience previously required for the making of technically perfect photographs. And with Polaroid Land cameras, finished color prints can now be produced within p. 61 one minute from the moment the shot was made. As a result of these and other advances in the field of photo-technology, without training or experience, and simply by following the instructions that accompany his camera and film, anyone of average intelligence can now make technically satisfactory color photographs.

In other respects, however, photography is steadily becoming more difficult and demanding. Precisely because of photo-technical advances, the technical quality of the average photographer's work is often excellent, competition among photographers is extremely stiff, possibilities for outstanding work are unlimited and the public's expectations correspondingly high, and the standards by which one's pictures are judged are more severe than ever. Furthermore, a photograph's merits are no longer evaluated solely on technical grounds, but primarily on the basis of its content and the stimulation it affords. As a result, the student photographer must give highest priority to the purpose, meaning, and emotional impact of his pictures, never forgetting that the camera is merely a tool, being to a photographer what a typewriter or ballpoint pen is to a writer: a means to accomplish an end. And just as a writer's literary output will not improve in value merely because it is typed on an electric typewriter instead of being written by hand with a pen, so a photographer's work will not automatically rise in quality merely because it is produced with the latest kind of equipment. For while it is a fact that every medium of expression—whether painting, creative writing, sculpture, music, or photography —requires the use of mechanical aids to express in tangible form intangible concepts—ideas, thoughts, sounds, or images—it is also a fact that, no matter what the medium, it is still the creative mind which conceives the idea, selects the subject, chooses the approach, decides upon the final form of presentation, and guides the hand and the tool.

The making of any photograph presents a problem that must be solved in two

23

respects: in terms of the picture (conceptually), and in terms of the camera (mechanically). For practical purposes, it is helpful to divide the process of making a photograph into five consecutive stages:

The first stage: The conception of the future picture. Stimulated by interest in a specific subject or theme, thoughts, ideas, and images take shape in the photographer's mind. This is the actual moment of creation, decisive for purpose, meaning, and value of the future photograph.

The second stage: Rough shaping of the future picture. Having decided upon a specific subject, the photographer then takes a closer look at it. He tries to learn more about it and to understand its essence so that he may give emphasis to its typical characteristics and play down or eliminate entirely nonessential or distracting details. Without this kind of critical analysis, meaningful photographs cannot be made.

The third stage: Evaluation of the subject. Knowledge and understanding of the subject provide the basis for a personal response and a point of view. This in turn leads to ideas concerning the rendition of the subject in terms of camera position and angle of view, type of illumination, cropping, composition, and so on. When a valid personal opinion is combined with an individual way of seeing and creative ability, the result is bound to be a photograph which shows the subject in a form that provides insight and stimulation.

The fourth stage: Terms of nature into terms of photography. Several of a subject's most outstanding qualities—life, movement, depth, sound, tactile sensations, smell and, in black-and-white photography, color, to name only the most obvious ones—cannot be rendered directly in a photograph but must be conveyed by means of symbols. How this can be done will be shown later. Unless such "unphotographable" subject qualities are symbolized with understanding and skill, the photograph will fail because, as many a disappointed photographer has found out, the picture of a beautiful girl is not necessarily a beautiful picture.

p. 207

The fifth stage: Technical execution of the picture. Once a photographer has made up his mind what to say and how to say it, all that is left to do is to assemble the means required to achieve this end—camera, lens, filter, lights, film, etc.—and to use them in accordance with established practices of photo-technique. As a result of advances in modern photo-technology and the high degree of standardization of its methods, focusing, exposing, developing, and printing can now be reduced to a science in which dial readings have largely replaced the need

24

for laboriously acquiring the technical skill previously needed. In this age of fool-proof automated cameras, photoelectrically controlled exposures, and time-and-temperature controlled development, anyone who can read, follow simple instructions, and has an exposure meter, a thermometer, and a timer, can produce technically perfect color transparencies and prints.

CONCLUSIONS

Each of the five stages described above is equally important. Unfortunately, few photographers are aware of the significance of the first four, many do not even know that they exist. At first glance, creation of a photograph might seem to take place at the instant of exposure. The *real* process of creation, however, takes place during the first four stages. Only during these preparatory stages does a photographer have the power to work out his picture in accordance with his plan. Only *before* he takes the irrevocable step of making the exposure does he have the choice of selection and rejection, the opportunity for condensation, stylization, and dramatization in accordance with the requirements of the specific case. Only during these stages is he at liberty to select the ways, means, tools, and techniques most suitable for the execution of his ideas. Once the exposure is made, the die is cast, for better or worse. The main qualities of the future photograph are un-alterably fixed, and what remains to be done can be done by any skillful technician.

Regrettably, however, to the neglect of all the others, stage five—the technical execution of the picture—is that upon which the average photographer spends all his effort. This, of course, explains why the majority of photographs are meaning-less and dull. As mentioned, it is the photographer's attitude toward his medium, revealed in his approach to his subject, which decides whether he will fail or suc-ceed. For know-how is of no use unless guided by "know-what."

Whether you who read these pages will fail or succeed is entirely up to you—what you want to do; how far you want to go; how much you expect from your pictures; how much of your time, money, and energy, how much of yourself, you wish to put into your color photographs.

YOU are the factor which decides what kind of pictures you will get.

What is it that makes the difference between your color pictures and those of nationally famous photographers?

p. 29 **The equipment?** No—because successful photographers use exactly the same makes of camera and lens as the amateur uses: Leica, Nikon, and Pentax for 35-mm work; Linhof and view cameras for large-size films; and Hasselblad, Mamiya-flex, Rolleiflex, etc., for the rest.

p. 102 **The color film?** Certainly not—for we all buy the same brands and types of film.

p. 176 **The processing?** No—that is, if you have your color films developed by a first-class commercial color lab or the Eastman Kodak Company—which, incidentally, is such a sound practice that most top professionals subscribe to it.

The choice of subject matter? Obviously not—since some of the most beautiful and stimulating color photographs taken by professionals depict subjects that are accessible to everyone—people, landscapes, scenes from daily life, etc.

Where, then, is the difference?

It is the difference between you and those nationally famous photographers—between your personality and theirs, your skill and creativity and theirs—which alone accounts for the difference between your pictures and their pictures. To use an analogy from music: tyros use only one finger to play a tune; professionals (and experienced amateurs) use all ten. The tune and the piano may be the same—the subject and the camera may be the same—but the effect is different.

"That's just it," you may say, "they're professionals. How can I possibly compete against them?"

My reply to that is: Remember, they were not born professionals. They also started as "amateurs" or ignorant beginners, and in comparing their own attempts with the finished work of the "masters" they too were often ready to give up. *But instead they stuck to it!* They made their mistakes and profited from them by learning how NOT to do certain things. They persevered. They improved their techniques, their color eye, their feeling for color harmonies, their taste and skill. And gradually they succeeded to become the experts of today.

And YOU can do the same!

2

Equipment and Material

Acquisition of the right kind of equipment and material—*right* as far as YOU are concerned—is a vitally important prerequisite for your future success as a photographer. Confronted with the almost unbelievable number of cameras, accessories, lenses, speedlights, films, etc., displayed in any major photo store—apparently so similar and yet so different—beginners (and also experienced photographers who ought to know better) often make the mistake of selecting *their* camera, lens, etc., primarily on the basis of prestige, popularity, or advertising pressure, buying the most expensive camera and fastest lens they can afford, or one publicized by a famous photographer, heedless of whether or not their purchase suits their own personality and type of work. This is a sure way to get off to a bad start.

To avoid handicapping yourself from the beginning, listen to one who has made every mistake in the book and, during a lifetime in photography, finally learned that the only way to acquire the *right* kind of equipment is to select it on the basis of two qualities:

Suitability
Simplicity

Suitability

People sometimes ask me: "Which is the best type of camera?"—a question as pointless as asking, "Which is the best type of automobile?" Is a sedan "better" than a station wagon, or a convertible "better" than a Jeep? What good is a sedan to a person who needs the space of a station wagon? Or a four-wheel-drive vehicle to someone who never gets off the paved road? Are oranges "better" than apples, or cigarettes "better" than cigars?

No—the only criterion whether or not a camera or lens is "good" is *suitability*: Is it suited to *your* needs, the kind of work *you* intend to do? If the answer is yes, the camera or lens is "good" as far as you are concerned; if it is no, it isn't.

Suitability has nothing to do with brand name or price. For example, as far as an architectural photographer is concerned, a used forty-dollar 4 x 5-inch view camera equipped with a "slow" f/6.3 pre-World War II lens, is infinitely "better" than the latest model of the finest 35-mm single-lens reflex camera fitted with a high-speed lens, an outfit costing perhaps ten times as much. Why? Because it is in the nature of architectural photography that the picture must contain an abundance of fine detail, which makes it necessary that a relatively large film size must be used; that perspective must be controlled and distortion avoided, which means that the camera must be equipped with individually adjustable front and back movements which 35-mm cameras lack; that sharpness in depth must be extensive, which requires that the picture is made with a small diaphragm aperture—so why pay the much higher price of a large-aperture or high-speed lens?

p. 105

p. 52

p. 125

p. 85

pp. 50-71

In addition to the mechanical and design features of cameras, which I'll discuss later, there are intangible qualities which make a camera more or less *suited to you*. It is almost like falling in love—why with this girl or woman instead of that? What is it that makes this particular camera more desirable than that (and here I am not speaking of differences in quality or cost which would be understandable, but thinking of cameras that are similar in regard to design, workmanship, and price). This is what I mean—the way a camera "feels" in your hands, whether your fingers do or do not fall naturally on the various controls, whether the shape of the camera body does or does not fit your grip, how well you like its viewfinder (this is particularly important if you wear glasses—some finders permit bespectacled photographers to see the entire area of the future picture, others don't); whether you prefer a lighter or heavier model, much chrome trim or little, or perhaps an all-black job; whether you do or don't mind bulkiness.

These too are things that count—the pleasure that comes from handling a camera that fits one in every respect—or the constant annoyance over little things that are not quite right, like a grip that feels uncomfortable, an awkward film transport lever or rewind handle, numerals that are too small to be read easily, or an annoying viewfinder eyepiece. It is to make sure that your future camera *suits you in every respect* that I suggest you handle a number of *potentially suitable* cameras in the photo store before you decide, and NOT order by mail the camera you fell in love with because it is "famous." Never mind what other photographers do who might be very different from you, or just plain foolish. Buy what suits YOU—SUIT YOURSELF!

Simplicity

One of the most valuable *practical* lessons that twenty years of work as a staff photographer for *Life* taught me, was to keep my equipment simple. The simpler the equipment, the faster it is ready for use; the fewer pieces one carries, the less one has to worry about, particularly while traveling. Photographers who load themselves down with equipment rarely bring home good photographs. Notwithstanding the well-filled photo stores, only a few pieces of equipment are truly indispensable for making good color pictures; certain kinds of additional equipment can help you to broaden the scope of your work; still other equipment is of very limited usefulness. The following survey should clarify this.

INDISPENSABLE EQUIPMENT

Camera
Lens shade
Exposure meter
Flash attachment
Color conversion filters
Gadget bag
Color film

Camera. The different camera designs from which you can choose are discussed on pp. 59-63; the principles according to which you should select your camera on pp. 69-71. The authoritative instruction manual that accompanies every new camera tells you everything you need to know about its operation—there simply are too many different camera designs on the market to go into this subject here, and besides, because of constant design changes, information of this kind would largely be outdated by the time this book appears in print.

Lens shade. Ideally, only light reflected by the subject or emitted by a source within the field of view of the lens should fall upon the lens. All other light is potentially dangerous as a source of lens flare and fog and should be prevented from striking the lens by a lens shade. p. 231

To be effective, a lens shade must be long enough to shield the lens from unwanted light (most lens shades are too short for this purpose); on the other hand, it must not be so long that it cuts off part of the picture. To be practical, it must permit

p. 35 the use of a filter or polarizer. Some lenses, particularly the more expensive tele-photo lenses, have built-in lens shades. But as a rule, a photographer must supply his own lens shade. A good shade will protect the lens not only from unwanted light but also from raindrops, snowflakes, and accidental fingerprints.

Exposure meter. This little instrument measures the intensity of the light and tells you how to set your camera's diaphragm aperture and shutter speed. It is the one truly indispensable accessory. The accompanying instructions tell you precisely how to use your new exposure meter to best advantage. Nowadays, many cameras have built-in exposure meters which are coupled, semi- or fully automatically, to the exposure controls; see your camera's instruction booklet. If this is the case, you may not need a separate exposure meter but should consider the limitations char-acteristic of all built-in exposure meters, which are discussed on p. 138.

Self-contained exposure meters come in two basically different types:

Reflected-light meters measure the light reflected by the subject; to take a read-ing, point the meter from the camera position at the subject.

Incident-light meters measure the light that falls upon the subject; to take a read-ing, point the meter from the subject position at the camera.

Each type has certain advantages and drawbacks, which is the reason most mod-ern exposure meters permit, either with or without the aid of a small accessory, to alternatingly measure reflected and incident light, combining the advantages of both methods of exposure determination.

Reflected-light meters permit the photographer to take separate readings of specific subject areas to establish contrast range, but may give misleading results p. 141 if incorrectly used (most common mistake: pointing the meter to include too much sky with the result that the reading will be too high and the picture underexposed, *i.e.,* appear too dark).

p. 146 **Incident-light meters** are perhaps somewhat easier to use because they auto-matically integrate all the light that falls upon the subject, an advantage most appreciated in indoor and studio photography where two or more sources of light are used. On the other hand, they do not permit a photographer to take individual readings of specific subject areas and therefore cannot be used to establish con-trast range. For example, light readings taken off the face of a girl (very light tone) and her dark green sweater (very dark tone), if illuminated identically, would be identical.

Types of photocells. Photoelectric exposure meters may be powered by either one of two different types of light-sensitive cells, each having specific advantages and drawbacks:

Selenium cells

Cadmium sulfide cells

The selenium cell generates its own electric current proportional to the brightness of the light that falls upon it (and therefore needs no batteries which are a potential source of trouble and also have to be replaced periodically). This current is fed into a galvanometer which moves a pointer in accord with the current generated. The advantages of a meter powered by a selenium cell are that it lasts virtually indefinitely, is extremely reliable and accurate, and that its spectral (color) response is very similar to that of the color film. Disadvantages are relatively large size (because light sensitivity is proportional to the active surface of the cell), failure to respond to very dim light, and high sensitivity to shock, which easily damages the delicate galvanometer mechanism.

The cadmium sulfide cell operates in conjunction with a tiny battery (which must be replaced about once a year). Under the influence of light falling upon the CdS cell, its electrical resistance changes in inverse proportion to the intensity of the incident light: the brighter the light, the lower the resistance of the cell, the greater the amount of current permitted to pass from the battery through the CdS cell to the galvanometer, the higher the "reading." The advantages of a meter powered by a CdS cell are small size (small enough to be built into a 35-mm camera body without increasing its size), comparative ruggedness with following insensitivity to shock, and extraordinary light sensitivity (permitting a photographer to take readings by moonlight). Disadvantages are uneven spectral response (high green and yellow but low red and blue sensitivity); time lag, *i.e.*, to respond properly, the meter must be exposed to light for a certain amount of time which, if the light is dim, may be as long as fifteen seconds and more before the needle comes to rest in its final position; dependence upon a battery; and, worst of all, the fact that the CdS cell, like the human eye, only more so, gets "blinded" temporarily when exposed to strong light and needs time to recover before it will again produce accurate readings. If, for example, the cell has been exposed accidentally to direct sunlight, it may take half a day and longer before it will again respond correctly to dim light.

Flash attachment. Flash at the camera is used on two occasions: As auxiliary illumination for outdoor close-ups (particularly portraits) taken in bright light in

p. 253 order to reduce overall contrast through lightening ("filling-in") the deep shadows cast by the sun, and thereby improving the rendition of color and detail within the shadow zones; and if the light is dim (particularly indoors), to provide sufficient light for satisfactory color rendition at shutter speeds high enough to avoid unwanted blur due to camera movement during the exposure, and for "freezing" motion and action. More specific information on pp. 324-326.

Two sources of flash illumination are available, each with its own merits and faults:

Flashbulbs
Electronic flash

Flashbulbs consist of a glass envelope similar to that of a lightbulb containing a loose mass of fine aluminum wire, foil, or a blob of primer paste in an atmosphere of oxygen; they can be used only once. For use, they are battery-ignited in synchronization with the shutter so that they go off at the exact moment of exposure, give an intense light for a fraction of a second, and burn out. Flashbulbs come in a number of different types and sizes, and it is absolutely essential that flashbulb and shutter type of the camera are compatible. For color photographs on daylight-type film, only blue-lacquered flashbulbs should be used. More information on p. 41.

Electronic flash (or EF or speedlight) utilizes the light generated by the instantaneous electric discharge of a capacitor across two electrodes within a gas-filled "flash tube" and has these advantages over conventional flashbulbs: repeating-type flash tube good for thousands of flashes before it needs to be replaced; extremely short flash duration which permits a photographer to make critically sharp pictures of subjects in rapid motion (he can "freeze" fast action); a relatively soft light, which is particularly suitable for portraiture and color photography; low operating cost per shot. Drawbacks are weight and relatively high initial cost; comparatively low light output; high and potentially dangerous voltage, which in larger units is sufficient to cause lethal shocks; impossibility to synchronize at high shutter speeds if the camera is equipped with a focal plane shutter. More information on pp. 42-47.

p. 106 **Color-conversion filters.** As will be explained later, natural-appearing color rendition can be expected only if color film is used in conjunction with the kind of light for which it is "balanced." Occasionally, however, it may become unavoidable to make on the same roll of color film photographs by different kinds of light, or use a color film balanced for one type of light in conjunction with an-

other type of light. Under such circumstances, satisfactory color rendition can still be achieved if the shot is made through the appropriate color-conversion filter. The following Kodak Wratten Color Conversion Filters must be used:

80A if a daylight-type color film is exposed by 3200 K tungsten lamps
80B if a daylight-type color film is exposed by 3400 K photoflood lamps
80C if a daylight-type color film is exposed by clear flashbulbs
85 if a Type A (3400 K) color film is exposed by sunlight
85B if a Type B (3200 K) color film is exposed by sunlight

Notice, however, that all these filters reduce the effective speed of color films; instead of basing your exposure upon the listed ASA speed of the respective film, you now must calculate it in accordance with the new reduced speed, see the film or filter manufacturer's instructions.

p. 108

Gadget bag. To carry your photographic equipment conveniently and safely, you need a gadget bag. Choice of type, size, material, etc., is, of course, dependent on your taste and needs, whether you wish to carry much equipment or little, the size of your camera, and so forth. However, for the beginner, I wish to add these suggestions: Don't buy a gadget bag that is too small; invariably, as time goes by, you will acquire more pieces of equipment, another lens or two, a set of extension tubes, or what have you. By all means get a bag with one or two outside pockets to hold your exposure meter and film; this will eliminate the need for constant "digging" in the main compartment of the bag. Adjustable partitions are a valuable aid in keeping things orderly within the bag; excellent also are loose pieces cut from a sheet of foam rubber that can be used in many ways to separate the various items and prevent them from scratching one another, and to provide cushioning against shock.

Color film. A fairly large selection of different color films with different characteristics made by different manufacturers is available. Distinguish between two main groups, the second one of which consists of three subgroups:

Color negative films which yield color prints on paper, and

Reversal color films which yield positive color transparencies or "slides."

Daylight-type color films balanced for use with sunlight;
Type A color films balanced for use with 3400 K photoflood lamps;
Type B color films balanced for use with 3200 K tungsten lamps.

Complete information on color films will be given on pp. 102-116.

EQUIPMENT TO WIDEN THE SCOPE OF YOUR WORK

Additional camera for a different purpose
Additional interchangeable lenses
Extension tubes or auxiliary bellows
Reflex housing for 35-mm RF camera
Additional filters, or a polarizer
Additional lighting equipment
Tripod, or "gun stock," for telephotography

Additional camera. No "universal" camera exists that is equally suitable to every kind of photographic work. Therefore, if a photographer is interested in two or more different fields of photography, it may become necessary for him to acquire a second camera. For example, for candid photography of people, the 35-mm rangefinder or single-lens reflex cameras are unsurpassed; however, although they will also take pictures of buildings, they are basically unsuited to architectural photography because their film size is too small to render fine detail with satisfactory precision, and they lack the required adjustments for perspective control: in most pictures of buildings taken with 35-mm cameras, the vertical lines converge, creating the impression of houses about to collapse. Hence, if a photographer seriously intends to photograph *both* people *and* architectural subjects, for satisfactory results in both fields, he would need two different cameras: a 35-mm rangefinder or single-lens reflex camera, and a 4 x 5-inch view camera. The eight basic camera designs from which a photographer can choose are described on pp. 59-63.

Additional lenses. No lens exists that is equally suitable to all photographic tasks. It is for this reason that so many cameras feature interchangeability of lenses: if the regular or "standard" lens is unable to do a particular job, perhaps a "wide-angle" lens, one that includes a larger angle of view, will be able to do it; or a "telephoto" lens, a lens which, from the same camera position, renders the subject in larger scale than a standard lens; or a "high-speed" lens, a lens which is "faster" than a standard lens ·and therefore permits a photographer to get a picture even in light that is too dim for his "normal" lens; and so on. Acquisition of one or more lenses with specific characteristics therefore enables a photographer to broaden the scope of his work by branching out into heretofore inaccessible fields. The twelve basic lens types from which a photographer can choose are described on pp. 85-102.

p. 85
p. 86
p. 88
p. 85

34

Extension tubes and auxiliary bellows. Design and mechanical restrictions limit the focusing range—the maximum distance between lens and film—of any camera, thereby limiting a photographer's approach to his subject. For it is one of the laws of optics that the shorter the distance between lens and subject is, the longer the distance between lens and film must be if the picture is to be sharp. Now, if the subject is very small, for example, a flower or an insect, photographing it from the shortest distance which the focusing range of the camera permits would result in an impossibly small rendition. To overcome this handicap, most cameras with interchangeable lenses can be fitted with special extension tubes or auxiliary bellows which increase their focusing range and enable a photographer to approach small subjects much more closely than would have been possible without the aid of these devices, permitting him to produce pictures in sufficiently large scale. If you are interested in close-up photography, make sure that the camera of your choice permits the use of extension tubes or auxiliary bellows.

Reflex housing. This accessory in effect converts a 35-mm rangefinder camera into a single-lens reflex camera. In comparison to an SLR camera, the focusing range of an RF camera is even more limited since most rangefinders cease to function at subject distances shorter than approximately 3 feet, and do not work at all in conjuncton with telephoto lenses whose focal length exceeds approximately 6 inches. Insertion of a reflex housing between camera body and lens eliminates both these shortcomings of the RF design and widens the scope of this camera type's potential to include both close-up and extreme telephotography.

Additional filters and a polarizer. In color photography, five types of filters are commonly used:

Color-conversion filters
Light-balancing filters
Color-compensating filters
Ultraviolet filters
Polarizer

They serve the following purposes:

Color-conversion filters enable a photographer to use a specific type of color film in conjunction with a type of light which, for faithful color rendition, would normally require the use of a different type of color film. For example, if a color film intended for use with photoflood illumination must be used for taking pictures

in sunlight, its color response must be altered with the aid of a suitable filter if it is expected to yield a natural-appearing color rendition. Filters suitable for conversion of one type of color film into another type are the Kodak Wratten Color Conversion Fliters already mentioned.

Light-balancing filters enable a photographer to change the color (spectral composition) of "off-color light" and make it conform with the type of light for which the color film is balanced. Daylight, for example, can have many colors: it is yellowish in the early morning and late afternoon, reddish at sunset, bluish in the shade if the sky is clear, and so on. Daylight-type color film, however, is balanced to give natural-appearing color rendition only in one specific kind of daylight: *a combination of direct sunlight and light reflected from a clear blue sky with a few white clouds during the hours when the sun is more than 20 degrees above the horizon.* If outdoor pictures are taken on daylight color film in "daylight" that does not conform to these specifications, the resulting colors, no matter how closely they may correspond to reality, will fail to appear "natural." Under such conditions, to insure a natural-appearing color rendition, the picture must be taken through the appropriate light-balancing filter.

Two kinds of light-balancing filters are available: the Kodak Wratten Filters No. 81, which are red, come in eight different densities, and must be used if the daylight contains too much blue; and the Kodak Wratten Filters No. 82, which are blue, come in four different densities, and must be used if the daylight contains too much yellow or red. The correct use of these filters is explained on pp. 226-228.

Color-compensating filters enable a photographer to deliberately change the overall color balance of the transparency. Such changes may be necessary for the following reasons: to compensate for reciprocity failure caused by abnormally short (electronic flash) or abnormally long exposure times; to compensate for deviations from normal color balance of a specific color-film emulsion which, if uncorrected, would give the transparency an overall color cast; to correct deficiences in the illumination caused, for example, by a greenish spotlight condenser lens; or to purposely change the overall color balance of a transparency to achieve a specific effect.

Kodak Color Compensating Filters, designed as Series CC filters, are available in the colors yellow (Y), magenta (M), cyan (C), red (R), green (G), and blue (B), most in six and some in seven different densities. The correct use of these filters is explained on pp. 294-298.

p. 32

pp. 242-244

p. 149

Ultraviolet (haze) filters. All photographic emulsions are sensitive to ultraviolet radiation, which is invisible. Ultraviolet radiation increases with altitude and contributes to the bluish haze that veils distant views when the day is clear (this haze must not be confused with mist and fog, which are white). In color photography, the effect of ultraviolet radiation manifests itself in distant views that appear abnormally blue. This effect can be mitigated or eliminated through use of filters which absorb ultraviolet radiation, among others the Kodak Wratten Filters Nos. 1A and 2B.

Polarizer. The purpose of this kind of filter is to mitigate or eliminate glare and reflections. It is also the only means by which a pale blue sky can be darkened in a color photograph. Maximum effect is evident in that part of the sky which is at right angles to the rays of the sun.

The reader is probably familiar with Polaroid sunglasses and the way they reduce glare. Polarizers work in the same way. Through their use, unwanted glare and reflections can be partly or completely eliminated in a photograph, the degree of rendition depending on the angle of the reflected light. At angles of approximately 30 degrees, glare reduction is more or less complete; at 90 degrees, glare is not affected at all; at intermediate angles, glare is partly eliminated.

The correct use of a polarizer is explained on pp. 266-268.

Additional lighting equipment. The kind of flash attachment previously described, which forms part of the "indispensable equipment" of a color photographer, is rather restricted in its usefulness and confined mainly to making unpretentious portraits and groups shots. Anyone wishing to go beyond this elementary kind of photography by artificial light will need additional lighting equipment of a more sophisticated type. In this respect, he has the choice of the following:

Lamps producing continuous light:
 Floodlamps
 Reflector floods and spots
 Quartz-iodine or halogen lamps
 Spotlights
 Fluorescent lamps

Lamps producing discontinuous light:
 Flashbulbs
 Electronic flash

Lamps producing continuous light have the great advantage over lamps producing discontinuous light in that the photographer can see exactly what he is doing: he can avoid overlighted areas; he can use a reflected-light exposure meter to check the contrast range of his subject and thereby produce well-balanced color transparencies and slides; he can see which part of the subject will catch the light and which will be in shade; and he can control the form and position of shadows. The disadvantages of this type of light are its relatively low intensity, which prohibits the use of action-stopping high shutter speeds, and the large amount of heat generated by floodlamps and spotlights which, if placed too close, can scorch paper and wood and blister paint.

p. 141

Floodlamps have high light output and relatively short life (approximately three to six hours depending on type). If used at the rated voltage, they provide an excellent source of illumination for color photography with Type A and Type B color films. They produce continuous and rather evenly distributed light, are equally suitable as main lights and fill-in lights, and are available in different sizes with different light output and in three different types:

pp. 252-253

3200 K professional tungsten lamps
3400 K photoflood lamps
4800 K blue photoflood lamps

The meaning of the terms "3200 K," "3400 K," etc., which refer to the color of the light given off by the respective lamp, is explained on pp. 224-226.

Professional tungsten lamps (3200 K) look like photofloods but, since they are less overloaded, produce a slightly more yellow light and their light output is somewhat more constant in color and brightness throughout the lamp's life, which is longer then that of a photoflood. They must be used in suitable metal reflectors and are designed for use with Type B color films.

p. 107

Photoflood lamps (3400 K) look like ordinary frosted household bulbs, but they produce considerably more light per watt. Because they are overloaded, they burn out in a few hours. They are the least expensive source of high-intensity photo-illumination. For maximum efficiency, they must be used in suitable metal reflectors. They are designed for use with Type A color films.

p. 106

Blue photoflood lamps (4800 K) are ordinary photoflood lamps which have blue instead of colorless glass bulbs. They are intended mainly as fill-in and supplementary lamps for use with daylight color films in daylight color shots of interiors in which the main illumination is provided by daylght coming through windows.

They must be used in metal reflectors. If they provide the sole source of illumination, because their light is slightly more yellow than standard daylight, photographs taken with blue photofloods on daylight color film have warmer, more yellow tones than photographs taken in standard daylight, an effect which can be very pleasing.

Reflector floods and reflector spots. Lamps of this type have their own reflector built into the bulb. This, of course, makes them very convenient when one is traveling because it reduces the amount of equipment to be carried. They are available in several different makes and models that give a photographer a choice of floodlight and spotlight effects, and larger and smaller lamps with higher or lower light output. Lamps of this type have color temperatures of either 3400 K or 3200 K for use with Type A and Type B color film, respectively.

pp. 106-107

Tungsten-Halogen lamps (formerly called quartz-iodine lamps) have a tungsten filament mounted inside a Vycor or quartz tube filled with iodine or bromine gas. Ordinary lamps employing a tungsten filament glowing at high temperature in an atmosphere of nitrogen gas evaporate a continuous stream of microscopic particles which are deposited on the inside of the glass bulb, darkening it with age. Iodine gas prevents this darkening and the light output of the lamp remains constant during its twenty-five- to thirty-hour life. Tungsten-halogen lamps produce an intensely bright light. They are powered either by A.C. house current or by a battery pack, which makes it possible to use such lamps outdoors as fill-in lights. Tungsten-halogen lamps come in two types: those that produce light of 3400 K for use with Type A color film, and those that burn at 3200 K for use with Type B color films.

pp. 106-107

Spotlights, because they concentrate the light of a projection-type filament lamp by means of a spherical mirror behind, and a condenser or Fresnel lens in front of, the bulb, give a sharper and more intense illumination than floodlamps and throw harsher and more sharply defined shadows. All better spotlights can be focused, *i.e.,* by adjusting the lamp and reflector in relation to the condenser, the light can be varied from a narrow beam to a broad cone. Spotlights are excellent as main lights and accent lights but cannot be used as shadow fill-in lights. Most spotlights are suitable for color photography with Type B films if they are equipped with a 3200 K lamp. A spotlight with a greenish condenser lens may cause a slightly greenish color cast; this can be prevented if a suitable CC filter is used. The correct filter must be determined by test. Spotlights come in many sizes from tiny baby spots of 150 watts for tabletop photography to the huge 5000-watt lights used in commercial studios for lighting entire sets.

pp. 252-253
p. 107
p. 36

Fluorescent lamps emit light that differs from daylight and tungsten light in that it has a line spectrum superimposed upon a continuous spectrum. Although this is of no consequence in black-and-white photography, it makes fluorescent lamps basically unsuited to color photography because the same colors seen in daylight and in fluorescent light may appear identical to the eye, but differences in the spectral compostion of these two types of light would make these colors appear different if photographed on color film.

On the other hand, since fluorescent light is more and more widely used, taking color photographs in fluorescent light is often unavoidable. Recognizing this, Kodak has suggested the following light and filter combinations and accompanying exposure increases for use with Kodak color films which, however, are only intended as a starting point for test series to be made by the photographer. In mixed daylight and fluorescent-light illumination, suitable filtration is very difficult and may even be impossible to achieve.

Kodak color film type	Daylight	Type of fluorescent lamp		
		White	Warm white	Cool white
Daylight Type	20M + 20Y + ⅔ stop	Not recommended	Not recommended	Not recommended
Type B and Type L	85B + 30M + 30Y + 1 stop	20M + 20Y + ⅔ stop	20M + 20Y + ⅔ stop	40M + 50Y + 1⅔ stop
Type A	Not recommended	30M + 10Y + 1 stop	30M + 1 stop	30M + 40Y + 1⅓ stop
Type S and Kodacolor	Not recommended	20M + 10Y + ⅔ stop	20M + 10Y + ⅔ stop	30M + 20Y + 1 stop

NOTE: This table does not apply to deluxe fluorescent lamps.

Lamps producing discontinuous light have, of course, the great advantage that they enable a photographer to render motion sharp. In this respect, although electronic flash is superior for stopping action, flashbulbs have the edge over speedlights in that they are much more efficient when high-intensity illumination is needed: flashbulbs provide it at a fraction of the cost, weight, and bulk that an equally effective speedlight setup would entail. On the other hand, a speedlight has the advantage of being a repetitive light source—no time is wasted as it is in changing flashbulbs. The main disadvantage of all lamps that produce discontinuous light is, of course, that the photographer cannot know precisely how light and shadow will be distributed in the picture (although some electronic flash

lamps contain small incandescent modeling lights to facilitate setting up the lights correctly), nor can he measure the subject's contrast range.

Flashbulbs, despite certain advantages over speedlights mentioned above, are all but obsolete today, at least as far as the serious amateur is concerned. However, there are exceptions: snapshooters and weekend photographers still consume large quantities of Flashcubes and FlipFlash bars which, in conjunction with inexpensive cameras, are very practical for making unpretentious color photographs. And professional photographers use flashbulbs as an inexpensive and practical means for illuminating large industrial and other interiors, often in conjunction with so-called slave units which permit firing a flashbulb away from the camera by remote control, without the nuisance of trailing wires.

Flashbulbs are available in different sizes, types, and colors. Specifically:

Size and light-output are directly related: the larger the bulb, the brighter the light. Light-output ranges from about half a million to five million lumens, as a result of which there is a flashbulb for just about any kind of job.

In regard to type, distinguish between two types of flashbulb: ordinary bulbs suitable for use in conjunction with cameras featuring between-the-lens shutters; and special Class FP

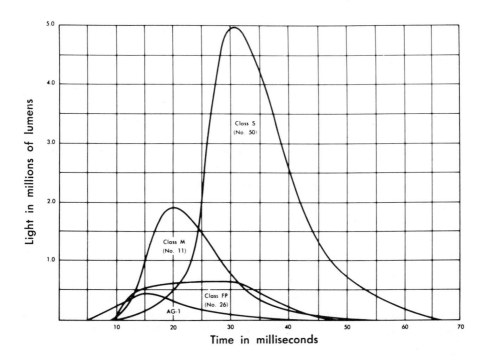

Time in milliseconds

flashbulbs which are the only ones that will work satisfactorily if the camera is equipped with a focal-plane shutter.

In regard to color, distinguish between clear-glass flashbulbs intended for use with black-and-white films, and blue-coated flashbulbs designed for use with daylight color films.

Time to peak is the length of time a flashbulb requires to reach its full intensity from the moment of ignition. It varies with different classes of flashbulbs and must be considered in the interest of satisfactory synchronization between peak brightness and the moment the shutter is wide open.

Exposure with flashbulbs is determined on the basis of guide numbers furnished by the manufacturer. These, like all other pertinent data, are listed in the data sheets which are available at photo stores at no extra cost. Explicit instructions for exposure determination with flashbulbs are given on p. 249.

Electronic flash or speedlight has over incandescent or fluorescent light two great advantages: It eliminates worry in regard to unsharpness caused by subject motion or accidental camera movement during the exposure; since flash duration is measured in thousands of a second, all normally encountered motion, no matter how fast, will be "frozen" and, provided the lens was focused correctly, the picture will be razor sharp. And, because its light-output is constant and predictable in regard to brightness and color, provided the exposure is made on daylight color film either automatically or in accordance with the flash unit's true guide number (see below), color rendition should be excellent. Because of these characteristics, day in and day out, hordes of photographers all over the world who know nothing about photography except how to load a camera with film and where to press the button, crank out millions of pictures of surprisingly high technical quality. But electronic flash is not only the snapshooter's best friend, but also an indispensable tool of the pro who makes his living in photography: today, there is hardly a professional studio in which main reliance isn't on electronic flash. Not to mention wedding photographers, ships' photographers, passport and ID photographers, photographers of babies and children, in-plant photographers, police photographers, and so on, none of which would know how to stay in business were it not for electronic flash. And although flash at the camera is not likely ever to produce great photographs, it has one advantage which endears it to millions: it works.

Before I go any further, I want to clear up a common misunderstanding: popularly, speedlights or electronic flash (which is the same) are often referred to as "strobes." This is technically incorrect. To use an analogy: a speedlight can be compared to a single-shot rifle, a strobelight to a machine gun. The first yields individual flashes, whereas the second

produces a continuous series of flashes spaced at certain adjustable, but usually very short intervals. In other words, all the popular electronic flash units are speedlights, not "strobes."

All speedlights consist of five main parts: a power supply (batteries or AC house current), a condenser (capacitor) in which a high-voltage electric charge is stored until it is needed, circuitry for triggering the flash at the moment the camera's shutter is open, a flash tube filled with pressurized gas which lights up while under the influence of a surge of high-voltage current, and a reflector which directs and concentrates the light on the subject.

Speedlights are available in a wide variety of models that differ in size and weight, light-output, constructions, refinements, and price. They range all the way from bantam-sized units light enough to be mounted on top of a 35mm camera to large professional models costing thousands of dollars and powerful enough to light up entire convention halls. But regardless of such differences, all speedlights share the following characteristics:

1. A flash duration short enough to "freeze" on the film any normally encountered subject motion. As a result, the photographer can stop worrying about pictures that are blurred due to movement of either the subject or the camera during the exposure.

2. Uniformity of light-output. As long as the unit is given enough time to fully charge its capacitor, each flash will be as powerful as the previous one or the next, a fact which enables a photographer to calculate his exposure precisely on the basis of the guide number that applies to his unit—unless, of course, the unit is automatic and times its own exposures.

3. Speedlight illumination approximates in color that of standard daylight. As a result, color photographs taken on daylight color film exposed by speedlight illumination usually show excellent color.

4. Synchronization of film exposure and flash is possible at any shutter speed if the camera is equipped with a between-the-lens shutter. However, if the camera features a focal-plane shutter, synchronization is possible only at relatively low speeds (usually 1/30 sec.) because, at higher speeds, the shutter curtains don't open fully with the result that only part of the film would be exposed.

5. Inability on the part of the photographer to evaluate the illumination precisely in terms of light and shadow. With big studio speedlights, however, this problem is solved (after a fashion) thanks to small incandescent guide or modeling lights built into the flashlamp heads.

6. Impossibility to measure the light intensity at the subject plane with ordinary light meters (or the light meter built into the camera). As a result, unless the speedlight unit is of the automatic kind, the photographer must either use an electronic flash meter (at a cost of up to $250.00) or calculate his exposure on the basis of guide numbers (see below).

7. High initial cost, but relatively low cost of operation.

Mode of operation. Speedlights are powered either by batteries (all amateur units) or by AC house current (all large professional models). Many, however, can be operated alternatively with either form of current.

Battery-operated speedlights have the great advantage of freeing the photographer from dependence on a fixed power source and can therefore be used anywhere. They come in two types: units powered by high-voltage batteries, and units powered by low-voltage batteries. Each has advantages and shortcomings. Speedlights powered by high-voltage batteries are more compact, their circuitry simpler, they are more dependable and, most important, their recycle time—the time required to get the capacitor fully charged and ready for the next flash—is shorter than that of battery-operated units. This, of course, is an often decisive advantage, especially to news and documentary photographers specializing in fast-breaking events. A disadvantage of this kind of speedlight is that high-voltage batteries are rather expensive, deteriorate with age faster than low-voltage batteries even when not in use (they have a shorter shelf-life) and, unlike certain low-voltage batteries, cannot be recharged.

For low-voltage powered speedlights, the choice is between two types of battery, each having a specific advantage not shared by the other: *Nickel-cadmium cells* are dependable, powerful for their size, and, when exhausted, can be recharged, recharging time varying with the type of battery from one to twenty-four hours. This, of course, means that, unless the photographer has a spare battery handy, he is grounded until his battery is ready again, a serious problem for anybody taking a large number of flash pictures at one time. In that case, a speedlight powered by ordinary *flashlight batteries* would probably be more advantageous. Although such batteries cannot be recharged and must be discarded when spent, they are relatively inexpensive, available everywhere, a good supply can easily be carried on a job, and exchanging batteries takes virtually no time.

Light-output and exposure calculation. The light-output of a speedlight unit, knowledge of which is indispensable for reliable exposure calculation, can be measured in different ways. Unfortunately, this is a field characterized by confusion since the respective methods are incompatible with one another, sometimes produce data which are useless as far as the working photographer is concerned, and are seldom accurate. The following should clarify the situation.

Originally, the light-output of a speedlight was measured in watt-seconds, one watt-second delivering approximately 40 lumen-seconds. Unfortunately, the watt-second figure was not based on measurements of the actual light-output of the respective speedlight unit, but was established simply by calculating the charge held by its capacitor. In other words, it was merely an estimate of raw electric power with no consideration of the fact that this available power could be spent efficiently or wastefully, depending on the circuitry of the unit and the design of the flash tube and reflector. In consequence, speedlights of identical watt-second ratings but different construction often delivered flashes that considerably differed in brightness.

A better formula for rating the light-output of speedlights is based upon BCPS (beam-candle-power-seconds) and ECPS (effective-candle-power-seconds) units. Its advantage is that rating is directly related to exposure insofar as doubling the rating, say, from 800 to 1600, is equivalent to an exposure difference of one f-stop. For example, if a speedlight unit rated at 800 BCPS required at a specific subject distance an exposure at f/8, a unit rated at 1600 BCPS would, under otherwise identical conditions, permit the lens to be stopped down to f/11.

At the present time, most amateur speedlights are rated by their manufacturers on the basis of a system which uses guide numbers that relate to the speed of Kodachrome II daylight film in accordance with the following formula:

Guide number divided by subject-to-flash distance
equals f-stop number.

This would be perfectly adequate provided the ratings are accurate and the photographer works with Kodachrome II film. Unfortunately, however, such ratings are sometimes inflated and, if films other than Kodachrome II Day are used, the then applying guide number must be established by recalculation or conversion in accordance with the ASA speed of the respective film.

In view of all these uncertainties and complications this author suggests that the reader establish *by test* the guide number which precisely applies to his own speedlight in conjunction with his favorite film. This is easily done. Simply take a series of exposures with different f-stops bracketed at half-stop intervals around a value that ought to be correct on the basis of a calculation which uses the speedlight manufacturer's "official" guide number, modified, if necessary, in accordance with the speed of the film you use (if it is either faster or, less likely, slower than Kodachrome II). To simplify the subsequent calculation, place your model exactly ten feet from the flash-equipped camera and make notes on the f-stop with which each shot of the series was made. The best way to do this is to write each f-stop number on a card which the model holds up to the camera so that it appears on the film and thereby becomes a permanent part of the record. Subsequently, the developed trans-

parencies should be examined carefully and the best exposure picked out. Since the f-stop number with which it was made is known, the *accurate* guide number for the speedlight used in conjunction with this particular film can easily be calculated on the basis of the following formula:

$$Guide\ number = f\text{-}stop\ number\ multiplied\ by\ subject\text{-}to\text{-}flash$$
$$distance\ in\ feet.$$

p. 249

For example, if the manufacturer's guide number for the speedlight was 56 and the subject-to-flash distance ten feet, the best exposure should be the one made at f/5.6. However, let's assume that, on the basis of this test, the best exposure was the one made at f/4.5 (half-way between f/4 and f/5.6. In that case, the light-output or "speed" of the unit was obviously overstated by the manufacturer because its actual or effective guide number is not 56, but 45.

Exposure calculation or automation. Each time a photographer varies the distance between subject and flash, he has to recalculate the required f-stop. This, of course, is not only a nuisance but also a potential source of failure because misjudging the subject-to-flash distance by only two feet—say, guessing at 5 instead of 7 feet—already makes a difference of one f-stop. Furthermore, guide numbers are based on "average" shooting conditions, which means indoors in rooms with light (but not white) walls and white ceiling, and if a shot has to be made outdoors at night with no reflecting surfaces nearby, an exposure based upon the same guide number would obviously be way off and the film underexposed. And this despite the fact that in both cases the photographer conscientiously calculated his exposure in accordance with the guide number established as "correct."

To avoid such possibilities, free the photographer from tiresome and not always reliable calculations, and improve the reliability of their products in regard to correctness of exposure under any conditions, speedlight designers invented the automatic flash exposure by making use of the principle of feedback: light reflected from the flash-illuminated subject falls upon a photo-conductive cell which, via a special electronic circuit, the moment the required exposure has been reached, shunts the surplus of the charge released by the capacitor into a "black" (non-light emitting) tube where it is dissipated. Alternatively, other, still more sophisticated speedlights simply stop the flow of power as soon as the required exposure level has been reached without wasting any current at all. As a result, of course, their batteries last longer. There even are speedlights on the market which permit automatic exposure with bounce-light. As a matter of fact, developments in the field of speedlight design are in such a flux that it would be pointless to go into more detail here since today's marvel may already be superseded by a still more fantastic innovation tomorrow. All I can do here is to present a summary of what is available today, then

let the informed reader decide what he needs. The final selection should then be made at the photo shop on the basis of an actual demonstration.

Tripods. Almost without exception, other factors being equal, photographs taken with the camera mounted on a good tripod or steadied by another rigid support will be sharper than others that were made with the camera hand-held, no matter how high the shutter speed. In many cases the difference will be so slight as to be practically negligible and probably not worth the trouble of mounting the camera on a tripod, always provided that the nature of the subject and the circumstances surrounding the shot permit this. Still—*if* a tripod can be used, *i.e.,* if the subject is sufficiently static and the extra time available, I strongly urge the reader to make his pictures with the camera mounted on a tripod instead of shooting them "hand-held," even if he works with a 35-mm camera. The reward will be transparencies that are uncompromisingly crisp and slides that can be projected wall-size without getting fuzzy around the edges.

In other instances, a tripod is a prerequisite for getting useable pictures at all. To mention only the most important examples: time exposures at night; close-ups in which differences measured in fractions of an inch in the distance between the subject and the lens make the difference between a sharp and an unsharp picture; interior shots made in relatively dim light with small diaphragm stops (for sufficient depth) and correspondingly long exposure time; architectural photographs in which perspective is controlled with the aid of camera "swings," telephotographs with extreme long-focus lenses that demand an especially firm support; pp. 329-334 copy work of any kind—all these require a tripod.

The best tripod is the strongest, most rigid tripod; unfortunately, it is also the heaviest and the most expensive. Unless the tripod is used only in the studio or at home, weight is a problem. Consideration should also be given to the height to which a tripod can be extended. Height in a tripod is normally proportional to its weight and bulk. I like a center post (elevator) which can be raised or lowered either manually or by a crank. It makes precise adjustments in height much easier, which is particularly appreciated in close-up photography or when the tripod is set up on uneven or slanting ground. In addition, a center post extends a tripod's useful height. However, care must be taken not to extend the center post unnecessarily high because this, by promoting instability, negates the purpose of a tripod. Occasionally one sees photographers who are too lazy to extend the three tripod legs at all and instead mount their camera on the fully extended center post, where it sways like a topheavy flower at the end of a thin long stalk.

Most tripods have what I consider a serious defect: they provide no means for levelling the camera laterally; this must be done by adjusting the tripod legs. For levelling relatively light cameras, a heavy-duty universal joint can be mounted on the tripod. But for large and heavy cameras, only a special levelling adjustment which is part of the tripod will do, like the lateral tilt of the *Tilt-all* tripod.

A versatile support for cameras up to 2.1/4 x 2.1/4-inch size are certain rugged tabletop tripods which, when equipped with a ball-and-socket head, can be set up on any hard, reasonably level surface, or pressed tightly against any rigid surface, vertical or slanting—a wall, a tree trunk, a telephone pole, a rock. They can also be held against the chest, making hand-held exposures with extreme long-focus lenses or relatively slow shutter speeds more likely to succeed without dangerously moving the camera.

EQUIPMENT OF RELATIVELY LIMITED USEFULNESS

The feeling of utter confusion that the beginner often experiences upon entering a large photo store is primarily due to the fact that most of the equipment he is interested in is available in a profusion of different models which, nevertheless, seem more or less alike. For example, there may be a dozen 35-mm single-lens reflex cameras in his price class, and a recent survey of interchangeable lenses designed for use with 35-mm SLR cameras listed, among others, 97 different tele-photo lenses of 135-mm focal length. Facts like these, of course, make it obvious that selecting the right kind of equipment is a matter not to be taken lightly. On the other hand, if a selection is made on the basis of suggestions voiced in this book and test reports that appeared in recent issues of photo-magazines, it shouldn't be too difficult either, and the photographer who knows what he needs and then proceeds to get it, systematically weighing advantages against draw-backs, can hardly go wrong.

But he can go very wrong indeed if he acquires certain kinds of photographic equipment which, according to my experience, are of relatively limited usefulness. Foremost in this category are the so-called subminiature cameras, many of them beautifully made little precision objects equipped with all imaginable refinements. They are virtually irresistible to gadget-minded photographers who take great pride in being able to coax from them pictures that, in regard to technical quality, are "virtually indistinguishable" from those made with larger cameras. In my opinion, subminiature cameras are invaluable in cases in which smallness and lightness are of the essence (for instance, if you are a spy), and otherwise useless.

Only slightly more practical are the so-called single-frame 35-mm cameras which produce negatives half as large (18 x 24-mm) as the standard (24 x 36-mm or double-frame) 35-mm negative. If you need a camera that fits into your hip pocket, if you are looking for a "photographic sketchbook" that accompanies you wherever you go without being obvious, and if you are satisfied with slides or color prints that, in photo-technical respects, are not quite as good as they could have been, by all means, go to it and get one. You probably will be satisfied, although it would not surprise me if, sooner or later, you exchanged it in favor of a standard (double-frame) 35-mm camera.

A gadget that few color photographers have seen, although most have heard of it, is the color-temperature meter. Its purpose is to measure the color temperature— p. 224 color to you—of the incident light to find out whether it does, or does not, conform to that of the light for which a specific color film is balanced, of which more will be heard later. However, only incandescent bodies such as the sun or the p. 106 glowing filament of a tungsten lamp have color temperatures in the strict sense of the word, and therefore can be measured accurately with the aid of a color temperature meter; ordinary daylight (which is a combination of direct sunlight and light reflected from clouds and the clear blue sky), light in the shade, light on an overcast day, or light emitted by fluorescent lamps, cannot. All attempts at measuring the "color temperature" of these types of light can at best yield only approximations which are practically valueless; more likely, they will produce data that is downright misleading. Besides, the "color temperature" of standard daylight is well known and therefore does not need to be measured, as are the color temperatures of 3200 K and 3400 K photo lamps as long as they are operated at the specified voltage (as far as tungsten light is concerned, a voltmeter or voltage-control equipment is far more helpful than a color-temperature meter). For these reasons, as far as the average color photographer's needs are concerned, I regard a color-temperature meter as useless.

And finally, there is that pet gripe of mine, the wobbly tripod. If you need a tripod (and I think most photographers do), buy a good one—one that is rigid and strong. Many photographers carry a tripod only "in case . . ." and therefore feel that a light and flimsy one will suffice; they don't want to weigh themselves down more than necessary. In my opinion, this kind of thinking is fallacious—if you need a tripod at all, you need one that will give your camera the rigid support that is required to prevent unsharpness due to inadvertent camera movement even during long time exposures or when using a long, vibration-prone telephoto lens. A wobbly tripod is a total waste because, sooner or later, you will get rid of it.

Now that you know what's available and, to some extent, what you need, the time has come for a closer look at the three most important devices of picture-making:

> **Camera**
> **Lens**
> **Film**

THE CAMERA

Regardless of design, size, make, or price, a camera—any camera—is basically nothing but a light-tight box or sleeve connecting two vitally important components:

> **The lens** that produces the picture, and
> **The film** that retains it.

Most of its other components are merely auxiliary devices that control the three operations by which the picture is made:

> **Viewing**
> **Focusing**
> **Exposing**

The fact that despite their fundamental similarities cameras come in such a profusion of different models is due to three factors: design, size, and quality. Each of the various control devices can be designed in different ways, each type having advantages which make them particularly suited to certain photographic purposes as well as drawbacks which make them less suitable to others. Each camera design can be executed in different sizes depending on the film size which it must accommodate, different film sizes in turn having specific advantages and drawbacks. And finally, cameras identical in design and size can be of low, medium, or high quality —quality, of course, being a decisive factor in manufacturing cost and retail price.

pp. 104-106

No wonder that the number of possible combinations of design, size, and quality is so great and our photo stores filled with such an abundance of different camera models. To be able to find his way through this profusion, a photographer must be familiar with the advantages and drawbacks of the various camera designs described in the following, and he must know what he needs, which depends on the kind of work he intends to do.

Viewing controls

What gun sights are to the marksman, viewfinders are to a photographer: devices to pinpoint a target. Without an accurate viewing device, no photographer can accurately compose his subject, nor can he isolate it effectively from its surroundings and be sure that the picture will be a self-contained unit. A viewfinder enables him to do this.

Distinguish between the following types of viewfinders:

 Off-the-lens viewfinders
 Combination viewfinder - rangefinder
 Frame finders
 Nonfocusing optical finders
 Through-the-lens viewfinders
 Groundglass panel
 Reflex finder
 Prism-reflex finder
 Twin-lens reflex finder
 and
 Eye-level viewfinders
 Waist-level viewfinders

Off-the-lens viewfinders, in comparison to through-the-lens viewfinders, have two fundamental drawbacks: 1. They are subject to parallax, *i.e.,* they show the subject from an angle which is different from that at which it is "seen" by the lens. The consequence, of course, is a discrepancy between the picture as seen by the eye in the finder and the picture as it will appear on the film. While this difference is negligible as long as subject distances are greater than approximately ten feet, it becomes increasingly serious with decreasing subject distance, making cameras equipped with off-the-lens viewfinders that don't feature parallax compensation unfit for close-up photography unless they are also equipped with a groundglass panel or permit the use of a reflex housing.

2. They do not permit a photographer to check visually the extent of the sharply covered zone in depth, *i.e.,* he is unable to see the effect of his stopping down p. 75 the lens upon the depth of field of his future picture.

Off-the-lens viewfinders come in two types: viewfinders which have the great advantage that they DO, and others which have the drawback that they do NOT,

measure the distance between subject and camera and therefore can, or cannot, be used in focusing the picture. Exponents of the first type are the familiar combination viewfinder-rangefinders—nowadays always coupled directly to the focusing mechanism of the lens—employed in 35-mm RF (rangefinder) and large-format press-type cameras. Nonmeasuring viewfinders come in two different designs: frame finders (also called sports finders because they are particularly "fast" in use and therefore especially well suited to fast-changing action photography) which consist of a metal frame attached to the front and a peep sight attached to the back of the camera; and simple optical nonfocusing viewfinders of various designs used mainly on simple inexpensive cameras and also as accessory finders for use in conjunction with extreme wide-angle lenses.

Through-the-lens viewfinders make use of a groundglass screen onto which the lens-produced image is projected; this screen serves simultaneously for viewing and focusing. Since the image which the eye sees is produced by the same lens that makes the picture (exception: twin-lens reflex cameras), there is no parallax. The image seen in the viewfinder and the picture will coincide, and cameras equipped with through-the-lens viewfinders are fundamentally suited to every kind of photography, including close-ups, and come in four designs:

Groundglass panel. This is the familiar "old-fashioned" focusing screen attached in the film plane to the back of a press-type or view camera. Particular advantages are: The image appears in the full size of the future negative or transparency; direct, visible indication of the extent of the sharply covered zone in depth, the so-called depth of field; unlimited range of operation with any type of lens at any subject distance. In addition, a groundglass panel is the only type of viewfinder which permits the installation and use of independent front and back camera adjustments—the tilts, slides, and swings indispensable for perspective control, which is essential in architectural, industrial, commercial, and interior photography

pp. 329-336 and, under certain conditions, for extending the sharply covered zone in depth without the necessity for resorting to undesirably small diaphragm stops.

Disadvantages: the image appears upside-down and reversed; insertion of the film holder blocks out the groundglass image—a serious drawback which makes groundglass-panel-equipped cameras, unless they possess a second viewfinder like the combination rangefinder-viewfinder used on all press cameras, unfit for photographing dynamic subjects: since they turn "blind" the moment the film holder is inserted, they cannot be hand-held but must be used on a tripod. Typical representatives: all view cameras.

A reflex finder consists of a mirror mounted inside the camera body behind the lens at an angle of 45 degrees which intercepts the image produced by the lens, reflects it upward, and projects it onto a horizontal groundglass panel, where it is viewed from above with the camera normally held at waist-level. Immediately before the exposure, the spring-loaded mirror flips up (or slides down) to get out of the way of the light coming from the lens. Following the exposure, the mirror either returns automatically to its 45-degree position (the so-called instant-return mirrors employed in all modern 35-mm single-lens reflex cameras), or it is returned to its position manually by the photographer.

This is the viewfinder employed by all large, medium-sized, and a few now obsolete 35-mm single-lens reflex cameras. It combines most of the advantages of the groundglass-panel viewfinder (exception: extreme wide-angle lenses of non-retrofocus design cannot be used in SLR cameras because they would get in the way of the upswinging mirror) with the added advantage that it makes the so-equipped camera eminently suitable to hand-held operation. Minor drawbacks are that the image, although right-side up, is reversed left and right; that certain individual adjustments for perspective control cannot be incorporated into a reflex-finder-equipped camera; and that the finder image is not visible during the moment of exposure. A more serious disadvantage is that, unless the camera has a revolving or reversible back, vertical pictures can be taken only by turning one's self 90 degrees from the subject, turning the camera on its side, and looking into it sideways—a position which makes fast and accurate shooting impossible. Single-lens reflex cameras, which produce square pictures, do not involve this problem, which is why most modern, medium-size SLR cameras are designed to produce square pictures. Typical representative: Hasselblad.

A prism-reflex finder consists of an ordinary reflex finder with a so-called pentaprism mounted on top. It is the most popular and successful viewing and focusing device for general photography available today and, in comparison to the reflex finder, has the following advantages: The image appears right-side up and is NOT reversed; the camera is held at eye level, which makes for faster operation and, in many cases, a more natural-appearing perspective in the photograph; and vertical pictures can be made simply by turning the camera into a vertical position. Its main drawback is that it precludes the use of individual camera-back adjustments for perspective control which, therefore, are never found on cameras equipped with prism-reflex finders. Typical representative: Leicaflex.

Twin-lens reflex finder. The image-viewing and picture-taking parts of the camera are separated, each equipped with a lens of identical focal length, with the image-viewing part designed in the form of a reflex-finder. This is the principle of the twin-lens reflex camera, which has the following advantages and drawbacks: The image appears right-side up but reversed. It is *continuously* visible —before, during, and after the exposure—since the viewing system employs a *stationary* mirror, which does not cause "mirror blackout." Normally, the image is viewed from above with the camera held at waist-level. However, if so desired, the camera can also be held in an upside-down position above the head and the image viewed from below in cases in which it is desirable to shoot from a higher angle, for instance, when trying to take pictures over the heads of a crowd that otherwise would block the view. Typical representative: Rolleiflex.

Eye-level viewfinders—rangefinder-viewfinders, frame finders, many nonfocusing optical viewfinders, groundglass panels, and prism-reflex finders—make it necessary to hold the camera at eye-level when taking the picture. Although normally the most natural position for making photographs, it is not always desirable. For example, when working very close to the ground, an eye-level viewfinder can be inconvenient because it would force the photographer to work in an uncomfortable position.

Waist-level viewfinders—reflex finders, twin-lens reflex finders, and some nonfocusing optical viewfinders—make it necessary to hold the camera at waist-level or lower when taking the picture which, depending on the work to be done, may or may not be an advantage. Addition of a right-angle finder to the eyepiece of a prism-reflex finder converts a camera from eye-level to waist-level operation.

Combinations. Because no viewing system is equally satisfactory for every kind of work, many cameras are equipped either with more than one viewfinder (most press cameras, for example, have three: a rangefinder-viewfinder, a frame [sports] finder, and a groundglass panel), or so designed that certain changes in their viewing systems can be made, for instance, the addition of a pentaprism to a reflex finder, which converts a camera from waist-level to eye-level operation. Any photographer whose work requires different types of viewfinders should make sure that the camera of his choice offers this convenience.

Focusing controls

To yield sharp pictures, a camera must be properly focused, *i.e.*, the distance between lens and film must be adjusted in accordance with the distance between subject and lens. This is done with the aid of two devices:

p. 121

A *mechanical device* (in most small cameras, a helical lens mount; in most larger cameras, a rack and pinion drive in conjunction with a bellows) that makes it possible to vary the distance between lens and film.

An *optical control,* which tells the photographer when the distance between lens and film is correctly adjusted. Distinguish between three designs, each with specific advantages and drawbacks:

Lens-coupled rangefinder. Two partly superimposed images of the subject appear in the finder window and move relative to one another when the lens is moved back and forth during focusing; when the two images are in register, the subject is in focus and the lens at the proper distance from the film to produce a sharp picture. Rangefinders come in several designs and, in good light and provided the subject contains sharply defined edges or lines, are the fastest and easiest means of focusing a camera precisely.

Lens-coupled rangefinders have several characteristics which may make a so-equipped camera unsuitable for certain types of work. The image which they present is usually quite small, making it difficult to check details of composition. They cannot be used at distances shorter than approximately three feet or in conjunction with the more extreme types of telephoto lenses. Although they are able to pinpoint the plane on which the lens is focused, they do not indicate the extent in depth of the sharply covered zone. They are difficult or impossible to use if the subject does not contain sharply defined edges or lines or if the light is dim. And synchronization between rangefinder and lens may fail without the photographer noticing it in time, resulting in unsharp pictures.

Reflex systems. Since the image is produced by the lens that makes the picture, the photographer perceives the subject in the form in which it will subsequently appear on film. As a result, he not only can check sharpness of focus but the extent of sharpness in depth, since the effect of stopping down the diaphragm is visible in the groundglass image. Additional advantages of reflex focus-control systems over lens-coupled rangefinders are: the larger size of the image (identical with that of the future negative or transparency), which facilitates evaluation in regard to optical quality and composition; complete freedom from parallax; and p. 51 the fact that this type of focus-control can be used in conjunction with almost any lens (exception: some wide-angle lenses) at any subject distance.

Unfortunately, there are also drawbacks: Determination of the moment when critical sharpness is achieved is somewhat more difficult and time-consuming, and sometimes more uncertain, with a reflex-system than with a lens-coupled range-

finder. The image appears progressively darker the more the lens is stopped down and "blacks out" completely during the exposure. And in comparison to range-finder-equipped cameras, reflex cameras are mechanically more complex and therefore more prone to breakdowns, noisier since the sound of the upflipping mirror is added to that of the shutter, and heavier and larger. Finally, there is the danger of "mirror shock"—inadvertent camera movement during the exposure caused by the upflip of the mirror, which might impair the sharpness of the picture.

To mitigate or eliminate these drawbacks, the basic reflex design has been improved in several ways. To facilitate critical focusing, all kinds of aids have been incorporated into the focusing screen, like a Fresnel lens (appearing as fine concentric circles) which improves the evenness of the illumination by brightening the corners of the groundglass image; in addition, a circular split-image rangefinder may be built into the center of the screen, or a focusing grid consisting of a multitude of microprisms which fracture the image but snap into clarity when proper focus is achieved (although very helpful in conjunction with lenses of more or less standard focal lengths, both devices work badly, or entirely fail to work, when used with telephoto lenses). Automatic diaphragms permit the photographer to focus with the lens wide open (bright finder image), automatically close down to a predetermined aperture (dark finder image) shortly before the shutter is released, and open up again (bright image) once the exposure is made. An instant-return mirror shortens the moment of "image blackout," and a Pellicle mirror, which does not move at all, eliminates it entirely together with the danger of "mirror shock." Another design prevents mirror shock with the aid of a mirror which locks in "up" position—an advantage of interest primarily to photographers who work with extreme telephoto lenses or telescopes which are particularly sensitive to vibration. Likewise, image blackout and mirror shock are eliminated by the twin-lens reflex design which, however, as we will see later, has a few drawbacks of its own.

Groundglass panel. This simplest of all focusing controls would rank at or near the top of the list were it not for the fact that, as previously explained, a ground-glass-equipped camera which has no other viewfinder (for example, a view camera) can only be used mounted on a tripod. However, in all cases in which circumstances and the nature of the subject permit to make the photograph with the camera mounted on a tripod, a groundglass-equipped camera is unsurpassed because it offers the following advantages: It presents a large and easily "readable" image in the full size of the negative or transparency, which is completely free from parallax, clearly shows the extent of the sharply covered zone in depth,

p. 60

p. 51

and can be used in conjunction with any type of lens of any focal length. In addition, only groundglass-panel-equipped cameras can be fitted with the back adjustments, the so-called "swings" indispensable for complete perspective control. p. 329

A fixed-focus camera has no focusing controls because it does not need them: its lens is permanently focused at a subject distance of approximately twelve feet which, in conjunction with its relatively short focal length and small diaphragm aperture (which is also usually nonadjustable), results in pictures that are evenly though only moderately sharp from about six feet to infinity. Because of these design limitations and the fact that only very simple lenses are used, the "sharpness" of pictures made with fixed-focus cameras, although sufficient for small formats and modest demands, is always inferior to that of photographs made with more sophisticated equipment.

Exposure controls

Exposing is admitting the amount of light to the film that is required to produce a negative of correct density or a transparency of satisfactory color. The combined use of two devices enables a photographer to achieve this:

The diaphragm, a variable aperture built into the lens, controls *the amount of light* which is admitted to the film. Depending on the camera design, it is operated either manually or semi- or fully automatically.

The shutter, in conjunction with a built-in timing mechanism, controls *the length of time* light is admitted to the film. Distinguish between two main types of shutters with different characteristics which must be considered when selecting a camera:

Between-the-lens shutters are built into the lens (primarily those designed for use in larger-size cameras). In comparison to focal-plane shutters they are, as a rule, more reliable and have the further advantage that they can be synchronized for ordinary as well as electronic flash at *any* shutter speed. However, in 35-mm and rollfilm cameras that feature interchangeability of lenses, their use involves technical complications that are sometimes avoided by a leaf-type or rotary-type "behind-the-lens" shutter.

Focal-plane shutters are built into the camera body and used mostly in 35-mm cameras. In comparison to between-the-lens shutters, they allow for shorter exposures and considerably simplify the construction of 35-mm and rollfilm cameras that feature interchangeability of lenses. On the other hand, they are less reliable, subject to uneven exposure or "wedging" (exposing one side of the film progressively more than the other), require a special type of flashbulb (Class FP), p. 42

and can be synchronized for electronic flash only at relatively slow shutter speeds.

Adjusting the diaphragm and shutter speed is done either manually on the basis of data furnished by an exposure meter, or with the aid of an exposure meter built right into the camera itself which usually is coupled to, and forms an integral part of, the exposure control system.

p. 138 **Built-in exposure meters,** which in most modern 35-mm cameras are powered by a CdS cell in conjunction with a tiny battery, measure the light reflected by the subject after it has passed through the lens. They come in two types—spot meters and integrating meters—each in a variety of different designs. Spot meters measure the light of a small area (usually in the center of the focusing screen) and can be used to establish the contrast range of the subject; integrating meters measure the light over the entire picture area and give an average reading. Location of the CdS cell varies widely with meter design; but although each manufacturer claims specific advantages for his own design and derides those of competitors, experience has shown that all work equally well provided they are used by a knowledgeable photographer in accordance with the instructions that accompany his camera.

The different camera designs

Selection of the most suitable camera becomes relatively simple if the different designs are arranged in groups in accordance with the following scheme and the final choice is made under consideration of the suggestions given on pp. 69-71. Photographers who engage in more than one type of work may need more than one camera for best results.

Cameras designed for general photography
Cameras equipped with a lens-coupled rangefinder
Single-lens and twin-lens reflex cameras

Semispecialized cameras
View cameras
Polaroid Land cameras
Simple rollfilm and box-type cameras

Highly specialized cameras
Super wide-angle cameras
Panoramic cameras
Aerial cameras

Cameras designed for general photography

All cameras belonging to this group are designed for hand-held operation although they can, of course, also be used with a tripod. Most feature interchangeability of lenses, and a good selection of wide-angle and telephoto lenses is usually available. In addition, the fastest lenses made commercially today as well as super telephoto lenses with focal lengths of up to 1000-mm (approximately 40 inches) and more, are available for use with many of the 35-mm cameras belonging to this group.

Rangefinder (RF) cameras represent the "fastest" design, the one best suited to photographing dynamic subjects, people, and action. Advantages and drawbacks of the rangefinder-viewfinder system have been previously mentioned. In 35-mm size, the RF camera is the favorite of some of the world's most famous and successful photojournalists; in larger sizes, it is used by large numbers of press photographers and others who require the use of a large-format all-purpose camera.

p. 55

In addition to general photography, the RF design lends itself well to wide-angle and moderate telephotography but does not permit the use of zoom lenses and is unsuitable to close-up photography and extreme telephotography unless the lens can be focused either by means of an accessory reflex-housing (35-mm camera), or with the aid of a groundglass panel (press-type camera); in the latter case, the shot cannot be made hand-held but only with the camera set on a tripod. Some press-type RF cameras are equipped with individually adjustable front and back movements for perspective control and therefore well suited to any kind of architectural, commercial, and industrial photography.

p. 99

p. 329

Single-lens reflex (SLR) cameras, although in operation perhaps not quite as "fast" as RF cameras, represent the most universally useful camera design available today and the only one permitting the use of zoom-lenses. Advantages and drawbacks of the reflex viewing and focusing systems have been mentioned earlier. In 35-mm size, the SLR is at present the most popular of all cameras.

p. 99
p. 55

In addition to general photography, particularly of dynamic subjects, the SLR design is especially well suited to close-up and telephotography. It is less well suited to wide-angle photography since extreme wide-angle lenses either cannot be used at all, or only if they are of retrofocus design; such lenses are always unproportionally large, heavy, and expensive. Because individual back adjustments cannot be used at all, and front adjustments are available only in a few

p. 329 very expensive models, the SLR design is unfit for any kind of photographic work that requires perspective control. On the other hand, the 2.1/4 x 2.1/4-inch SLR is the "workhorse" of many top-flight advertising, commercial, and industrial photographers who feel that the many advantages of this design by far outweigh its few drawbacks.

Twin-lens reflex (TLR) cameras, in comparison to SLR cameras, have four advantages: the viewfinder image is continuously visible, even *during* the exposure; it stays bright no matter how far the taking-lens is stopped down; camera operation is quiet and vibration-free since this design involves a stationary instead of a movable mirror and a between-the-lens instead of a focal-plane shutter; and, due to the fact that a between-the-lens shutter is employed, TLR's can be used in p. 42 conjunction with regular flashbulbs (instead of special Class FP bulbs) and syn- p. 45 chronized at *any* shutter speed, *even with electronic flash.*

On the other hand, the TLR design has the following drawbacks: cameras are larger and heavier than SLR's of the same film size; visual observation of the extent of the sharply rendered zone in depth is normally not possible; the usefulness of all models for close-up photography is severely restricted either because of limited focusing range (although special close-up lenses can mitigate this) or because of parallax problems. And finally, at least at the time of this writing, only one make allows for interchangeability of lenses.

Nevertheless, for general photography, provided that the restrictions listed are not objected to, this is, although perhaps not the most versatile, one of the most practical of all camera designs and, in my opinion, the one most suited to the needs of the serious beginner.

Semispecialized cameras

Cameras included in this group are particularly suitable for specific types of photographic work, but have certain limitations which will be pointed out in the following survey. *They are not suitable for general photography,* and to avoid disappointment anyone considering the acquisition of one should be aware of its uses and limitations.

View cameras, *because they cannot be hand-held but must be used on a tripod,* represent a design that is eminently suitable for photographing static but totally p. 64 unfit for photographing dynamic subjects. A view camera—theoretically, the larger the better, although practical considerations make the 4 x 5-inch format the most common size—should therefore be the first choice of anyone wishing to spe-

cialize in architectural, commercial, industrial, or interior photography. Likewise, view cameras are unsurpassed for copywork and the reproduction of objects of any kind, including works of art, for catalogue work, and for technical and many phases of scientific photography.

All view cameras are equipped with a groundglass viewing and focusing panel. All permit interchangeability of lenses. The most sophisticated models are constructed in accordance with the module or building-block principle: their basic components—tracks, bellows, lens support, back, etc.—are detachable and interchangeable with other parts of similar function but different construction or dimensions. As a result, a photographer can "custom-build" his own camera from standardized parts in accordance with the special requirements of his work. And should the nature of his work change, or should he wish to branch out into other photographic fields, as long as he started out with a modular design and restricts himself to static subjects, he will always be able to adapt his view camera to the new demands, including a change from a smaller to a larger film size.

Polaroid Land cameras *cannot be used with standard brands of film available anywhere, but only with Polaroid Land film.* Furthermore, Polaroid Land color film, at least at the time of writing, does not produce a usable negative, and *duplicate prints can only be made by copying the original.*

Polaroid Land cameras are designed primarily for photographing dynamic subjects—people, children, family events. They come in a number of different models that vary from simple to elaborate, although none offers interchangeability of lenses. Because they yield finished color prints on paper in only 60 seconds after the exposure has been made (and black-and-white prints in 15), they are ideally suited for anyone wishing or needing to see results in a hurry—no matter whether an amateur shooting color at his daughter's graduation, a professional trying to show his appreciation to someone who helped him in his work by presenting him on the spot with courtesy pictures, or a scientist who needs to see the result of an experiment in a hurry.

Although originally designed for amateurs and hobbyists, Polaroid Land cameras— and to an even higher degree accessory Polaroid Land camera backs which, like ordinary sheet-film holders, can be used in conjunction with most 4 x 5-inch cameras—are highly prized by many professional photographers as invaluable aids in making instant tests for a last-minute check of everything from the distribution of light and shadow to the correctness of the contemplated exposure before taking a difficult picture. p. 91

61

Simple rollfilm and box-type cameras are semispecialized tools in the sense that they are designed to serve only a very limited purpose: to fill the needs of people who wish to make acceptable "snapshots" of family and friends with the least expenditure of money, effort, and technical know-how.

Highly specialized cameras

Cameras belonging to this group are designed with one specific purpose in mind; they are perfectly suited to one narrowly defined type of work and useless for anything else. These are the "additional" cameras which ambitious and versatile photographers acquire to broaden the scope of their work and get the edge over their less imaginative or resourceful competitors.

Super wide-angle cameras are equipped with noninterchangeable lenses which cover unusually large angles of view that may range from 90-plus to a full 180 degrees (for comparison: standard lenses encompass angles of view in the neighborhood of 45 degrees). Lenses that cover angles up to 130 degrees (Goerz Hypergon) are designed to produce renditions in which perspective is rectilinear; those that cover a full 180 degrees, the so-called "fish-eye lenses," produce renditions in which perspective is spherical.

p. 329

p. 343

Super wide-angle cameras are used for one of two purposes: to include the largest possible angle of view in a photograph; to deliberately show the subject in an exaggerated or "distorted" form for the purpose of greater emphasis or to provide the picture with stopping-power. In either case, only a knowledgeable photographer who combines imagination with restraint will be able to come up with effective pictures since wide-angle lenses are notoriously "tricky." More will be said about this later.

p. 15

pp. 86-87

Panoramic cameras are a special type of super wide-angle camera whose lens swings in an arc during the exposure, scanning the film through a slit-like aperture. They encompass an angle of view of 140 degrees and produce renditions in which perspective is cylindrical: straight lines running parallel to the plane of the arc are not rendered straight, but in the form of curves. This form of rendition, of course, can be rather objectionable and may restrict the use of panoramic cameras to photographing subjects without straight lines—particularly landscapes —or those in which such curving would not be too pronounced and hence less objectionable, for example, overall views of ball parks or interiors of convention halls.

p. 343

62

Aerial cameras are of rigid, bellowless construction and their lenses are permanently focused at infinity. As a result, they cannot be used for anything except taking photographs from the air. Frequently, "surplus" aerial cameras are advertised in photo-magazines at fantastic "savings." But they are bargains only to photographers who need an aerial camera or lens since it is virtually impossible to convert them to any other use.

How to select your camera

I gave so much space to a discussion of the different camera components and designs because it has been my experience that *selection of the right kind of camera is the first condition for success in photography.* To give an analogy: nobody in his right mind who needs a saw would go into a hardware store and simply ask to buy "a saw" without specifying type and size. Because there are so many kinds of saws—ripsaws, crosscut saws, bucksaws, buzz saws, jigsaws, butcher's saws, big saws, little saws, handsaws, powersaws, saws designed to cut wood, or metal, or plastic, or foam rubber. . . . And the same is true in photography: there are so many kinds of cameras because each was designed for a slightly different purpose. And only if your purpose and the purpose for which your camera was designed coincide will you be able to realize your full potential as a photographer.

Selection of one's camera should be made with consideration of the following factors:

> The type of subject which is to be photographed
> The viewing and focusing system of the camera
> The film size for which the camera is built
> The personality and purpose of the photographer
> The price the photographer is willing to pay

All these factors are, of course, intimately interrelated, each influencing the others. It may even happen that two factors are mutually exclusive. For example, a photographer specializing in landscapes who is a fiend in regard to sharpness and detail of rendition may need a camera to take on a mountain-climbing expedition. The nature of his subject and his own personality would clearly prescribe a camera that takes a large film size, but the circumstances under which the work will be done just as clearly make selection of a small and light camera mandatory. In such a case, either the photographer or the photographs will suffer—the photographer, because he must either burden himself with a large and heavy camera, or accept unsatisfactory pictures; the photographs, because they were

63

made with an unsuitable camera as a result of which they are not as sharp, detailed, and grainless as they might have been. A compromise—use of a medium-size camera—is hardly any better because, in that event, both the photographer *and* the photographs are bound to suffer although, perhaps, to a somewhat lesser degree.

The type of subject which is to be photographed determines the viewing and focusing system of the camera. In this respect, distinguish between two types of subject:

> *Dynamic subjects*—subjects characterized by movement—require a "fast," i.e., relatively small and light camera which possesses a viewing and focusing system that permits hand-held operation.

> *Static subjects*—primarily inanimate subjects which do not move —can be photographed with any kind of camera although, as a rule, a large format will generally produce better results than a small one.

The viewing and focusing system. As far as speed of operation is concerned, the fastest system is one that incorporates a lens-coupled combination viewfinder-rangefinder, closely followed by the single-lens and twin-lens reflex systems (especially if the first is augmented by an automatic exposure-meter-controlled diaphragm). All three are ideally suited for hand-held operation. The slowest viewing and focusing system (which, however, has other advantages) is that based upon a groundglass panel. Unless they also possess a second finder, groundglass-equipped cameras cannot be hand-held but must be used with a tripod. Other factors which must be considered are:

p. 55
pp. 53-54
p. 52

The size of the finder image—the larger the better, because large ones show more clearly the desirable as well as the undesirable features of the contemplated picture and thereby facilitate composition. Reflex systems and groundglass panels provide large finder images, rangefinder systems small ones.

pp. 55, 52

Control of sharpness in depth: single-lens reflex systems and groundglass panels show the extent of the sharply rendered zone in depth (SLR's with automatic diaphragms must be equipped with a depth-preview button for manual diaphragm control); twin-lens reflex systems and viewfinder-rangefinders do not.

pp. 54, 55

The problem of parallax: single-lens reflex systems and groundglass panels are free from parallax; twin-lens reflex systems and rangefinder viewing systems are basically subject to parallax, which makes the so-equipped camera less suitable

pp. 52-55

64

for close-up photography. However, different kinds of parallax-compensating devices are often built into such cameras which somewhat ameliorate this disadvantage without completely eliminating it.

Compatibility with different lenses: a groundglass panel is the *only* viewing and focusing device which enables a photographer to use the so-equipped camera in conjunction with *any* lens regardless of type and make. Single-lens reflex systems can theoretically be used with any type and make of lens with the exception of some of the more extreme wide-angles; in practice, however, if the camera is equipped with an automatic diaphragm, only lenses which are compatible with the respective system can be used unless the photographer is prepared to relinquish this feature. Cameras equipped with a lens-coupled rangefinder and twin-lens reflex cameras that provide for interchangeability of lenses accept only lenses that are compatible with the respective make, a fact which may limit the number of available lenses severely.

p. 52

p. 53

pp. 55, 54

Visibility: the viewfinder image is continuously visible and bright at all times in cameras equipped with a viewfinder-rangefinder or a twin-lens reflex system. It is always bright but disappears momentarily during the exposure in single-lens reflex cameras equipped with instant-return mirrors and automatic diaphragms (exception: the Canon Pellix, the finder image of which is continuously visible; this camera, however, has certain other shortcomings). It turns increasingly darker the more the lens is stopped down, and disappears entirely during and following the exposure, in single-lens reflex cameras equipped with manually operated mirrors and diaphragms.

pp. 55, 54

p. 53

Finder-image visibility is further affected by the construction of the finder eyepiece. Spectacle-wearers in particular should consider that the eyepieces of certain makes of rangefinders and prism-reflex viewing systems may cut off part of the image since eyeglasses may make it impossible to bring the eye close enough to the eyepiece. Other makes, which provide for more eye-relief, do not have this fault.

Operational position: cameras equipped with a viewfinder-rangefinder or a prism-reflex system are held at eye-level during shooting; SLR's without a prism finder and twin-lens reflex cameras are held at waist-level during shooting. Groundglass-panel-equipped cameras require eye-level operation.

p. 54

The film size for which the camera is built. For our purpose, it is sufficient to distinguish between three sizes: small (35-mm), medium (no. 120 rollfilm), large (4 x 5-inch). Each has specific advantages and drawbacks:

Small (35-mm) film is least expensive per shot and 35-mm cameras have the most capacious film magazines, factors which make 35-mm cameras particularly suited to action and documentary photography where fluent situations make rapid shooting of large numbers of pictures a necessity. High-resolution Kodachrome II, of which more will be said later, is available only in 35-mm size, which also is the most popular and practical size for slides intended for projection. Working with 35-mm film makes it possible to use super-fast and zoom lenses which are available *only* for 35-mm cameras. Six rolls of 35-mm film—material for over 200 shots—take about the same space as two sheets of 4 x 5-inch film in a holder.

p. 111

p. 99

A serious drawback of 35-mm film is that the sales appeal of the small color slides is very much lower than that of larger transparencies. As a matter of fact, the majority of potential buyers of color photographs—magazine editors (exceptions: *Life, Look, Paris Match,* and a few others), book publishers, advertising art directors, calendar and picture-postcard manufacturers, etc.—still refuse even to look at 35-mm color slides, their minimum acceptable size usually being 2.1/4 x 2.1/4-inch, with 4 x 5-inch transparencies preferred. This prejudice, of course, does not apply to users of 35-mm color slides intended for projection—lecturers, supervisors of training programs, teachers, hobbyists, etc. Photographers who hope to make some money from their hobby, and particularly those who intend to make photography their career, should take notice of this.

Large (4 x 5-inch) film is quite expensive per shot, and 4 x 5-inch cameras are comparatively large, heavy, and slow in operation. Furthermore, there is no 4 x 5-inch rollfilm (although holders which take no. 120, no. 220, or perforated 70-mm rollfilm, respectively, are available for use with most 4 x 5-inch cameras); the only kind of color film made in this size is sheet film, and sheet film must be loaded into (and unloaded from) holders piece by piece in a darkroom (or at least a dark room). Sheet-film holders are bulky and heavy—half a dozen holders with material for only twelve shots, one-third of the number contained in a single roll of 35-mm film—take almost as much space as an entire 4 x 5-inch camera.

On the positive side, if made by a knowledgeable photographer, 4 x 5-inch color transparencies by far surpass those of smaller size in every respect—sharpness, richness of color, smoothness of tone, and precision and wealth of detail—qualities which give 4 x 5-inch color transparencies a very high degree of sales appeal. As a matter of fact, I have noticed again and again that a relatively poor 4 x 5-inch transparency was preferred to a much better 35-mm slide or 2.1/4 x 2.1/4-inch shot, bought by an editor, and printed full-page in a magazine or book. It

is primarily for this reason that, in my opinion, as far as color photographs are concerned, the "best" camera is usually the *largest* one that is still practicable under the respective circumstances.

Medium-size film is available in the form of both rollfilm and sheet film, with no. 120 rollfilm, 70-mm perforated rollfilm, and 2.1/4 x 3.1/4-inch sheet film the most popular sizes for serious work. As far as advantages and drawbacks are concerned, these intermediate sizes stand about halfway between 35-mm and 4 x 5-inch films, making them particularly suitable to photographers with a wide spectrum of photographic interests. However, medium-sized cameras have one unique advantage: in conjunction with Kodacolor film, they are the ones most suited for making inexpensive color prints on paper.

The personality and purpose of the photographer. Photographers differ widely in several respects. Some are casual, others disciplined. Some are adventurous and compelled to "see the world," others prefer to work near their homes. Furthermore, there are differences of purpose. Some people are satisfied recording the highlights of their lives—children, family, special events. Others find in photography a stimulating hobby that permits them to express themselves and, through their pictures, communicate with other people. Still others make their living by photography. Such differences in personality and purpose are, of course, reflected in a photographer's attitude toward his craft and the kind of photographs he intends to take, requiring different means for their realization.

For example, a high-strung and restless photographer who is more interested in capturing the essence of people, action, and "life" in his photographs than producing pictures that are first of all unassailable in regard to photo-technical quality, will only be satisfied—and able to express himself—with a fast and responsive 35-mm camera. Conversely, a slow and deliberate worker with a highly developed sense for technical quality—precision of rendition, beauty of color and tone—will need a relatively large camera to realize his photographic aims (and probably be glad to pay the price in the form of greater weight and bulk and a reduction in operational speed). Also, a camera perfectly suited to the needs of a family man whose purpose is limited to photographing his children on Sundays and taking occasional vacation shots will probably be insufficient in scope for a serious amateur; and one that satisfies an amateur may be too limited or delicate for a professional who shoots fifty times as many pictures. All these factors must, of course, be considered when selecting one's camera because, unless personality, purpose, and photographic means are in harmony, the photographer will be dissatisfied and his pictures fail.

Considerations of this kind may seem obvious, yet I was present when a friend of mine, a master of the 8 x 10-inch view camera, a photographer who is world-famous for his outstanding large-camera work, a superlative craftsman who makes a fetish of precision and tonal quality, fell in love with a 35-mm camera and bought it along with a full line of lenses and accessories. He worked with it for several months, captivated by its precision workmanship, in vain trying to reconcile the exquisite quality of the tool with the technically poor quality of its products. And it took him a surprisingly long time to accept emotionally what intellectually he must have known all the time: that a camera infinitely more complex and precise than his familiar instruments—big 4 x 5's, 5 x 7's, and 8 x 10's—should produce photographs that are inferior in every technical respect to those which his comparatively primitive means enabled him to create with such apparent ease.

The lesson is clear, and every photographer should heed it: there are "fast" and "nervous" cameras—the quick and always ready 35's; there are "average" cameras for "average" temperaments—the no. 120 rollfilm and medium-size sheet-film kind; and there are "slow" and "phlegmatic" cameras—view cameras, 4 x 5's, 5 x 7's, 8 x 10's. And each type is designed not only for a different purpose, but also for a different type of personality, a different kind of photographer. Don't let yourself be sidetracked by the choice of others whose work you respect, or seduced into buying a camera that is not suited to your personality or type of work by glamour and fame. Here, as in all creative work, complete honesty with oneself—knowledge of one's strengths and limitations—is indispensable for success.

The price a photographer is willing to pay. Many photographers believe that, where photographic equipment is concerned, the more they pay, the more they get. Although this may be true under certain circumstances, at other times it is not. Actually, it is possible that a very expensive camera can be totally unsuitable for a particular type of work whereas one designed specifically for the respective task may be relatively cheap. However, what should a photographer do when the best-suited camera is also the most expensive?

I suggest he buy a used camera instead of a new one. I know, this practice is commonly frowned upon, but I have followed it many times and never regretted it. Because advances in photo-technology are so rapid nowadays, photo-stores are full of "like new" used equipment that sells at considerably reduced prices. Provided one buys at a reputable photo-store where the used merchandise is guaranteed, chances are excellent that a knowledgeable buyer gets himself "a deal." Most photo-stores agree to a three-day or more trial period with a "money-back"

guarantee should the equipment prove to be defective. Utilizing such offers is the smart man's way of acquiring a fine camera, lens, or other kind of equipment at a relatively low price. For people who wish to test their own equipment, there is an excellent guide written by my friend Herbert Keppler (publisher of *Modern Photography*), *You Can Test Cameras, Lenses, and Equipment,* published by Amphoto, New York.

Summary relating camera design and purpose

The first of the two following summaries lists the most important camera qualities numbered from one to fifteen together with the designs in which they are most strongly pronounced; the second lists twenty different fields of photography, each followed by a series of numbers, each number referring to the respective quality listed in the first summary. By correlating these two summaries and evaluating their contents in the light of the facts given in the preceding chapters, anyone should be able to find the camera best suited to his personality, purpose, and photographic interests.

1. *Fastest lenses*—super-fast lenses with speeds of f/2 and higher are available only for 35-mm cameras. p. 85

2. *Flash synchronization*—between-the-lens shutters are most suitable for synchronization with conventional flashbulbs and electronic flash; focal plane shutters require special Class FP flashbulbs and synchronize with electronic flash only at relatively slow shutter speeds. p. 57

3. *Highest shutter speed*—focal plane shutters are potentially faster than between-the-lens shutters.

4. *Longest telephoto lenses*—the most extreme telephoto lenses with focal lengths of 1000-mm (approximately 40 inches) and more are available only for 35-mm and some 2.1/4 x 2.1/4-inch cameras, all of which must be of the single-lens reflex type (35-mm RF cameras by means of reflex housings).

5. *Parallax*—SLR's and groundglass panel equipped cameras are free of parallax; RF's and TLR's are not but usually feature limited parallax compensation devices; a reflex housing transforms a 35-mm RF camera into a parallax-free SLR. p. 51 p. 35

6. *Perspective control*—swing-equipped view cameras permit most complete perspective control, closely followed by swing-equipped press-type cameras. p. 60

7. Portability and weight—considerable differences in weight and bulkiness exist between cameras of similar design that take the same size of film. In 35-mm size, most RF cameras are smaller and lighter than SLR's. SLR's are smaller and lighter than most TLR's of the same film size.

p. 57 **8. Quietness**—between-the-lens shutters are quieter than focal-plane shutters; TLR's are quieter than SLR's; in the 35-mm size, most RF cameras are quieter than most SLR's.

9. Sequence shooting—a few cameras either have built-in battery- or spring-driven motors, or can be used in conjunction with accessory motors.

10. Sharpness of rendition—potentially, 4 x 5-inch and larger cameras are capable of producing the sharpest pictures; next in order are 35-mm cameras in conjunction with high-resolution Kodachrome II film.

11. Speed of operation—fastest design is that of a 35-mm SLR with built-in exposure meter and fully automatic, meter-coupled diaphragm; lacking a built-in diaphragm-coupled exposure meter, RF's are usually somewhat faster than SLR's and TLR's.

12. Suitability for close-ups—indispensable requirements are freedom from parallax, long extension and, in larger cameras, rear focusing. Suitable camera designs: SLR's and 35-mm RF's with reflex housings in conjunction with extension tubes or auxiliary bellows; for static subjects, groundglass-panel-equipped cameras.

13. Suitability for telephotography—SLR's and reflex-housing equipped 35-mm RF's are best suited; groundglass-panel-equipped cameras if subjects are static.

14. Suitability for wide-angle photography—special wide-angle cameras; SLR's in conjunction with retrofocus wide-angle lenses; 35-mm RF cameras; view cameras equipped with special wide-angle bellows; press-type cameras with drop-bed and recessed lens board.

15. Widest wide-angle lenses—180-degree fish-eye lenses for 35-mm cameras; accessory fish-eye lenses which convert most standard lenses of most cameras into 180-degree wide-angle lenses. Goerz Hypergon 130-degree lenses which, however, can only be used in special boxlike 5 x 7- and 8 x 10-inch view cameras; because of their very slow speeds, they are suitable only for photographing static subjects.

70

List of twenty different fields of photographic activity and kinds of subjects arranged in alphabetical order. The numbers, which refer to the camera qualities listed in the preceding summary, are not necessarily in order of importance.

Animals: 2, 7, 8, 11, 12, 13.
Architecture: 6, 10, 14.
Close-ups: 5, 12.
Copywork and reproductions: 5, 6, 10, 12.
Fashion: 1, 2, 5, 7, 11.
Food: 5, 6, 10, 12.
General photography: 2, 11, 13, 14.
Glamour and figure photography: 1, 2, 5, 7, 11.
Industrial and technical photography: 2, 5, 6, 10, 11, 12, 14, 15.
Interiors: 2, 5, 6, 10, 14, 15.
Landscapes: 6, 10.
Nature (general): 2, 3, 4, 5, 7, 8, 9, 11, 12, 13.
News and documentary photography: 1, 2, 3, 4, 7, 8, 9, 11.
Objects and works of art: 5, 6, 10, 12.
People (general): 1, 2, 7, 8, 9, 11.
Portraiture: 2, 5, 11.
Sports photography: 1, 2, 3, 7, 9, 11, 13.
Theater and stage photography: 1, 2, 8, 11.
Travel photography: 2, 7, 8, 11.
Wildlife photography: 2, 4, 7, 8, 9, 11, 13.

THE LENS

A recently published survey of interchangeable lenses currently available in the United States for 35-mm and 2.1/4 x 2.1/4-inch cameras, *i.e.*, exclusive of lenses designed to cover films of larger sizes, lists close to 700 entries. No wonder a photographer can get confused when confronted with the problem of selecting the right kind of lens for his camera or choosing an additional interchangeable lens. Fortunately, however, the task of selecting a suitable lens is not as formidable as it seems because all lenses, regardless of type or make, have certain common characteristics and obey the same optical laws. Furthermore, to make an intelligent choice, a photographer does NOT have to know how a lens produces an

image or what such frequently used terms as "node of emission," "chromatic aberration," "coma," etc., mean because, for practical purposes, it is sufficient to evaluate a lens on the basis of three factors:

> **Lens characteristics**—focal length, speed, etc.
> **Lens performance**—sharpness, color correction, etc.
> **Lens type**—standard, wide-angle, telephoto, etc.

Lens characteristics

Any lens, no matter whether wide-angle, telephoto, or what have you, has three fundamental characteristics with which a photographer must familiarize himself because they describe what the lens can and cannot do:

> **Focal length**
> **Relative aperture or "speed"**
> **Covering power**

Focal length. *The focal length of a lens determines the size of the image on the film.* Other factors like subject distance and camera position being equal, a lens with a relatively long focal length will render the subject in larger scale than a lens with a shorter focal length. Focal length and image size are directly proportional: a lens with twice the focal length of another produces an image that is twice as high and wide as that produced by a lens of half its focal length. Therefore, if a photographer wishes to increase the scale of rendition without shortening the distance between subject and camera, he must make the picture with a lens of longer focal length.

The focal length of a lens, normally engraved on the lens mount, is measured in inches, centimeters, or millimeters. It is the distance from approximately the center* of the lens to the film at which the lens produces a sharp image of an object that is infinitely far away, for example, a star. It is also the shortest distance between lens and film at which the respective lens can produce a sharp image.

Focal length has nothing to do with film size. A lens with a focal length of, say, 6 inches, will render a given subject at a given distance, for example a person 12 feet from the camera, in the same scale no matter whether the lens is used on

* More precisely, from the node of emission (which normally lies slightly behind the center of the lens) to the film, when the lens is focused at infinity. In telephoto and retrofocus wide-angle lenses, the node of emission lies outside the lens.

72

a 35-mm RF camera, a 2.1/4 x 2.1/4-inch SLR, or an 8 x 10-inch view camera. Naturally, if the lens is used in conjunction with a small film size, only part of the subject might appear in the picture; conversely, if used in conjunction with a very large film size, the lens, unable to cover the entire size, would produce a circular picture in the center of which the image of the subject would appear. But—and this is the important point—no matter whether the subject is shown in its entirety or only in part, whatever is shown would appear in exactly the same scale and, if the various transparencies were superimposed one upon another, their images would register.

According to their focal lengths, lenses are frequently referred to as standard, short focus, or long focus. Such a classification, however, is relative. A lens that has a *relatively* short focal length when used with one film size has a *relatively* long focal length when used with a *smaller* film size, although its *actual* focal length remains unchanged.

For example, a wide-angle lens that covers an 8 x 10-inch negative may have a focal length of 6 inches (which, obviously, is rather short *relative* to the size of the film). If used on a 4 x 5-inch camera, the same lens, however, would *behave* like a standard lens (because the normal focal length of a standard lens for 4 x 5-inch film is 6 inches), thus making it *in effect* a lens of standard focal length. And if used with a 2.1/4 x 2.1/4-inch SLR camera, the same 6-inch lens that was designed (and still is) as a wide-angle lens, would now *behave* like a long-focus or telephoto lens since the focal length of a standard lens designed for use with 2.1/4 x 2.1/4-inch film is 3 inches. A *standard lens* is customarily defined as a lens with a focal length equal to (or *slightly* shorter or longer than) the diagonal of the film size with which it is to be used. p. 86
p. 72
p. 85

Although the focal length of single lenses is invariable, lens systems—combinations of several lenses—can have almost any desired focal length. And if the system is variable, its focal length, of course, will be variable too. For photographic purposes, the following variable lens systems are of interest:

Supplementary lenses are positive or negative auxiliary lenses which, attached to the front of a standard lens, decrease or increase, respectively, its focal length. In this way, simple lens systems can be created inexpensively which have the properties of moderate wide-angle or telephoto lenses, respectively. p. 100

Convertible lenses make use of the fact that the front and the rear element, of which most lenses consist, each has its own focal length. By individually correcting p. 99

these elements so that, used by itself, each will produce a useable image, a lens designer in effect incorporates several focal lengths into one lens: used in combination, the two elements produce a lens with one specific focal length; used alone by itself, each element becomes a lens in its own right with a focal length approximately twice as long as that of the complete lens. If the focal lengths of the two elements are different, the convertible lens in fact offers a photographer a choice of three different focal lengths.

pp. 88, 97 **Mirror and prism telescopes,** in combination with eyepieces of various degrees of magnification, become in effect telephoto lenses with variable focal lengths. Such systems, most of which are designed for use with 35-mm cameras, are practical only when very long focal lengths (from 750- to 3,000-mm and up) are required. Its best known representatives are the Questar and the Bushnell Spacemaster.

p. 99 **Zoom lenses** are complex lens-systems containing groups of lenses which can be moved relative to one another, thereby varying the focal length of the entire system. Depending upon the respective design, the maximum focal length of the system is from two to four times as long as its minimum focal length. It offers the unique advantage of an infinite number of focal lengths since, through appropriate adjustment of its internal components, *any* focal length between minimum and maximum can be achieved.

Relative aperture or "speed." *The relative aperture indicates the maximum light transmission or "speed" of a lens.* It is expressed in the form of a ratio usually engraved on the lens mount: focal length (f) divided by effective lens diameter (which explains why the term includes the word "relative": by themselves, neither focal length nor effective lens diameter can give an indication of the light transmission or "speed" of a lens; only when one is evaluated relative to the other does the result become meaningful). For example, if a lens with a focal length of 6 inches has an effective diameter of 3/4 inch, its relative aperture would be 6 : 3/4 = 8 and expressed in the familiar form of f/8. However, if a lens of 6-inch focal length has a *larger* effective diameter, say, 2 inches instead of 3/4 inch (*i.e.,* a higher degree of light transmission), its relative aperture would be 6 : 2 = 3 and expressed as f/3, which, as every photographer knows, designates a much "faster" lens.

To understand how the "speed" of a lens is computed is important because it explains something which often confuses the beginner: the fact that the speed of an f/3 lens is *higher* than that of an f/8 lens although its f-number is *lower.* If

74

two lenses have equal focal lengths but different effective diameters, the f-number of the *"faster"* lens is always *lower* than that of the "slower" lens because the focal length of the "faster" lens, as shown in the following drawing, can be divided by its (relatively large) effective diameter *fewer* times than the focal length of the "slower" lens can be divided by its (relatively small) effective diameter.

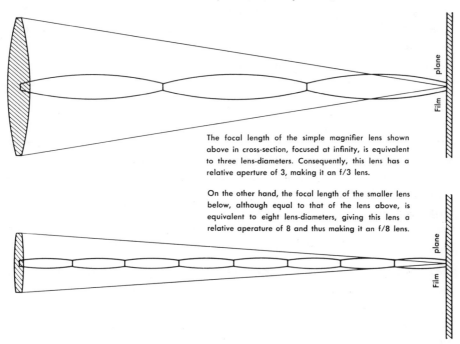

The focal length of the simple magnifier lens shown above in cross-section, focused at infinity, is equivalent to three lens-diameters. Consequently, this lens has a relative aperture of 3, making it an f/3 lens.

On the other hand, the focal length of the smaller lens below, although equal to that of the lens above, is equivalent to eight lens-diameters, giving this lens a relative aperature of 8 and thus making it an f/8 lens.

Other factors being equal, a fast lens has over a slower one the advantage that it permits a photographer to take the picture at a higher shutter speed. When light conditions are marginal or rapid motion requires an unusually high shutter speed to avoid blur, lens speed can make the difference between a possible and an impossible situation, between a picture "in the bag" and a picture missed. On the other hand, in comparison with slower lenses of equal focal length, fast lenses have certain disadvantages, which will be discussed later.

p. 85

The concept of f-stops. In practice, for reasons that will be discussed later, a lens is seldom used at its maximum aperture or "speed." Usually, its effective diameter is reduced to a greater or lesser extent with the aid of a variable aperture called *the diaphragm* which is built into the lens. Reducing the effective lens diameter by reducing the diaphragm opening is called *stopping down the lens (or the dia-*

pp. 125-127

phragm). To enable a photographer to know precisely how far his lens is stopped down (a vital necessity for computing the exposure), the diaphragm is calibrated in f-numbers (usually called *stops*) which are computed by dividing the focal length of the lens by the diameter of the respective diaphragm opening. These f-numbers or stops are figured in such a way that each consecutive f-number requires *twice the exposure of the preceding smaller f-number* (which, of course, represents a *larger* diaphragm opening). In other words, each time the lens is stopped down from one f-number to the next, the film must be exposed twice as long if the result in terms of density and color of the transparency is to remain constant.

F-numbers are indicators of the brightness of the image on the groundglass or film. The same f-number, say f/8, indicates *for most practical purposes* (because there may be slight but normally negligible differences due to manufacturing tolerances or differences in the construction of different lenses) the same degree of image brightness, no matter whether the image is produced by an f/8 lens at maximum aperture ("wide open"), or by an f/1.4 lens stopped down to f/8. Nor does it make any practical difference whether the lens is a tiny wide-angle or a huge telephoto lens. As long as each has a relative aperture of f/8 or, if it is a faster lens, is stopped down to f/8, there is no practical difference as far as image brightness and consequently exposure are concerned.

Covering power. *The covering power of a lens determines whether it can or cannot be used with a specific film size.* The greater the covering power of a lens, the relatively larger (relative in comparison to the focal length of the lens) the film size it will cover satisfactorily in regard to uniformity of sharpness and brightness.

Most lenses produce a circular image whose quality in regard to sharpness and brightness is not uniform: it is sharpest and brightest near the center, becoming progressively less sharp and bright toward the rim of the circle. This image deterioration is primarily due to three factors: The effects of residual lens aberrations become progressively more pronounced toward the edges of the image. When viewed obliquely, the circular aperture of the diaphragm appears as an ellipse, as a result of which the edges of the film receive less light than the center. And finally, the marginal areas of the film are farther away from the center of the lens than the central area and, in accordance with the inverse-square law, receive proportionally less light.

For photographic purposes, of course, only the inner, relatively sharp and bright part of the circular image produced by the lens should be used. Consequently,

the film size must always fit within the useful inner part of the circle, the diameter of which must never be smaller than the diagonal of the negative or transparency.

Although most long-focus lenses have greater covering power than short-focus lenses and therefore will cover larger film sizes, this is not always true. For example, the covering power of most 135-mm telephoto lenses designed for use with 35-mm cameras is sufficient only to cover satisfactorily the tiny 1 x 1½-inch area of 35-mm film, whereas several 90-mm wide-angle lenses exist that cover the much larger size of 4 x 5 inches. The ultimate in covering power is the 75-mm Goerz Hypergon wide-angle lens which will cover the relatively enormous film size of 8 x 10 inches.

The covering power of most lenses is barely sufficient to cover satisfactorily the film size for which they are designed. While this is acceptable as long as such lenses are used in cameras without independent front and back adjustments (the swings, slides, and tilts necessary for complete perspective control), lenses that are to be used in cameras that have such adjustments must have greater-than-average covering power. Otherwise, use of these adjustments may cause part of the film to be outside the sharply covered circle with the result that this part will be rendered unsharp in addition to being underexposed or even blank. To avoid this, experienced photographers, instead of using a standard lens designed for the respective film size, *use a wide-angle lens of equal focal length designed to cover the next-larger film size.* For example, with a 4 x 5-inch view camera, instead of using the regular 6-inch standard lens, they use a 6-inch wide-angle lens designed to cover 5 x 7-inch film—the next-larger size. The focal length of both lenses would be identical—producing images of identical scale—but the additional covering power of the 6-inch wide-angle lens would enable the photographer to make fullest use of the swings, slides, and tilts of his view camera without inviting trouble.

The covering power of a lens is not an unalterable factor. *It increases in direct proportion to increases in the distance between lens and film.* This phenomenon can advantageously be utilized in the making of close-up photographs in near-natural, natural, and more-than-natural size. Should the available focusing range of a camera be insufficient to allow the necessary lens-to-film distance required for such close-ups with a lens of standard focal length, the problem may be solved by using a lens with a shorter focal length. With a 4 x 5-inch camera, lenses of 2 to 5 inches in focal length are particularly useful for close-up photography. As a matter of fact, a lens with a focal length of only one inch, originally

designed to cover nothing larger than a 16-mm motion-picture frame, will sharply cover a 4 x 5-inch film at a distance of 10 inches from the film and, under these conditions, produce an image nine times natural size.

The covering power of many lenses increases somewhat as the diaphragm is stopped down. In a few lenses (for example, the Goerz Dagor), this increase is so great that the fully stopped down lens will cover a film one size larger than the size it covers at full aperture, making such lenses particularly suitable for use with swing-equipped view cameras.

p. 60

Lens performance

Any ordinary magnifying glass or positive spectacle lens will produce an image and could be used to make a photograph, but the quality of the rendition would be extremely poor: it would be fuzzy, distorted, and infested with color fringes. Only a properly corrected photographic lens can produce pictures that are sharp, undistorted, and free from color fringes.

Correcting a lens means reducing, as far as practicable, the seven basic faults inherent in any lens (the so-called aberrations: spherical and chromatic aberration, astigmatism, coma, curvature of field, distortion, diffraction). To achieve this, lens designers use combinations of individual lens-elements consisting of different types of glass with different refractive indices and different curvatures, which may be either cemented together or separated from one another by air spaces, to form an optical system—the lens—which combines a maximum of desirable qualities such as sharpness, high degree of color correction, "speed," wide angle of view, etc., with a price tag which is still within the mean of a large number of photographers.

Lens performance is directly related to lens design. Unfortunately, it is impossible to design a "perfect" lens, a lens that is completely free from aberrations. Likewise, it is, although perhaps not impossible but at least impracticable, to design a lens which combines *all* the desirable qualities to the highet practicable degree; this is the reason why, at least for the present, a high-speed lens at maximum aperture is never as sharp as a good lens of somewhat lower "speed," nor a wide-angle lens as free from distortion as a standard lens which includes a lesser angle of view, and so on. Nevertheless, lenses of remarkably high performance belonging to any one of the different categories (of which we will hear more later) exist today; but the cost is fantastic complexity, extraordinarily high manufacturing standards, and, as any photographer knows, a whopping price.

pp. 85-102

For practical purposes, the performance of any lens is determined by five factors:

The degree of sharpness
The degree of color correction
The degree of flare and fog
The evenness of light distribution
The degree of distortion

Sharpness. A lens is the sharper, the more its designer was able to reduce the five aberrations which combine to cause unsharpness: spherical and chromatic aberration, curvature of field, astigmatism, and coma. Each of these faults manifests itself in a specific type of unsharpness, and since each has to be corrected separately—sometimes more and sometimes less successfully than other aberrations—different lenses may produce pictures not only with different *degrees* but with different *kinds* of sharpness (or rather, unsharpness, because, if examined under sufficient magnification, not even the sharpest negative or color transparency will be found to be equally sharp over its entire area).

Furthermore, lenses designed for use with different film sizes are computed in accordance with different standards for the obvious reason that small negatives and transparencies, because they must be able to stand higher degrees of magnification, have to be sharper than large ones. As a result, lenses intended for use with 35-mm cameras have, on the average, twice the resolving power of lenses intended for use with larger cameras, a fact which explains why, normally, it is undesirable to use large-camera lenses for small-film photography.

To pick a sharp lens, a photographer does not have to know why certain aberrations cause certain types of unsharpness; all he has to know is the following:

It is more difficult to bring the light rays that pass through the peripheral areas of a lens into sharp focus than those that pass through areas closer to the optical axis. This has several practical consequences:

High-speed lenses (which, relative to their focal lengths, have large diameters and therefore make use of a large proportion of peripheral rays for the production of the image), if used at maximum aperture, yield pictures that are less sharp than those made by lenses of lower speed (which, relative to their focal lengths, have smaller diameters and therefore use mainly rays that pass closer to the optical axis for the production of the image). Photographers who are primarily interested in sharpness should therefore stay away from high-speed lenses and select instead a good lens of somewhat lower speed.

Stopping down a lens cuts off the peripheral rays that are the main spoilers of sharpness. As a result, the same lens, stopped down two to four stops beyond its maximum aperture, will as a rule (there are exceptions, see the following) produce sharper pictures than if used at a larger aperture. However, excessive stopping down will again cause deterioration of image sharpness, this time partly for reasons of lens design and partly because of diffraction, as light rays bend at the edges of the diaphragm aperture.

p. 87 **The sharpest lenses** (the so-called process lenses used in copywork and photo-engraving) are always relatively slow because, in the interest of maximum sharpness (as well as smaller size, weight reduction, and lower cost), their peripheral areas have, so to speak, already been removed during designing with the result that the finished lens consists only of a "central area" (equivalent to the area that would remain active had a faster lens of equal focal length been stopped down to the relative aperture of the process lens). Such lenses yield maximum sharpness already at maximum apertures. In other words, stopping down will not increase the sharpness of the image although, if three-dimensional subjects are photographed, it will increase the extent of the sharply covered zone in depth.

Curvature of field is the most common cause of unsharpness in modern lenses. It p. 85 is particularly prevalent in most high-speed lenses and manifests itself in the form of an image that is not flat (like the plane of the film), but concave—three-dimensionally curved like the inside of a saucer. Lenses suffering from this fault do not p. 87 have what is called a "flat field" (in contrast, process lenses, which are designed especially to photograph flat subjects, do have a flat field). In practice, curvature of field is most noticeable in photographs of flat subjects (for example, a lens test chart or a brick wall) but—and this is important—it is much less obvious, and may even be entirely unnoticeable, in pictures of subjects that have depth. Photographers not familiar with this fact frequently reject otherwise fine lenses because they perform poorly when subjected to the traditional test: a photograph of a brick wall or a page of newsprint. The *practical* value of such lenses, however, is determined by the degree of sharpness in the center of the image at full lens aperture (the sharper the better), the amount of stopping down (the less the better) needed to produce even distribution of sharpness, and the degree of sharpness of the image made by the lens moderately stopped down.

Different types of lenses may reach their maximum sharpness at different subject distances. Lenses intended for general photography, for example, are computed to yield maximum sharpness at "average" distances of 10 to 50 feet. Lenses for

80

aerial cameras are corrected for maximum sharpness when focused at infinity. p. 98
Process lenses—lenses specifically designed for near-distance reproduction work p. 87
and photo-engraving—are computed to produce maximum sharpness at distances
of a few feet. And special close-up lenses—the true macro-lenses like the Carl
Zeiss Luminars and others—are corrected to give their best performances at sub-
ject distances measured in inches.

Color correction. Light of different color is not uniformly refracted by glass. As
a result, a simple lens, for example, a positive spectacle lens or a magnifier, would
produce pictures that look like badly printed four-color reproductions that are
out of register: each line and contour of the subject would be surrounded by color
fringes due to the fact that *different* colors located at the *same* distance in front
of the lens are brought into focus at *different* distances behind the lens. As a re-
sult, those colors that are out of focus would *not* appear, say in the form of
sharply outlined dots and lines, but as fuzzy disks and bands, and the parts of the
subject that are white (which is a mixture of all colors) would be edged by color-
ful fringes.

Adequate color correction is therefore one of the prime requisites for any lens
intended for use in color photography. Nowadays, all except some simple box
camera lenses are color-corrected to some extent, the degree varying with the
design of the lens and its price. Basically, however, as far as color correction is
concerned, two types of lenses must be distinguished:

Achromatic lenses, the group to which the majority of modern lenses belongs,
are corrected to bring *two* colors (usually blue and green) into sharp focus and
perform satisfactorily for all average purposes of color photography.

Apochromatic lenses are corrected to bring *three* colors (blue, green, red) into
sharp focus and therefore superior to achromats as far as color rendition is con-
cerned. They are designed specifically for the most critical color work—top-quality
color photography for high-grade reproduction, the making of color enlargements
from color negatives, color separations, and photo-engraving—but are available
only in a limited number of makes and focal lengths, most of which are designed
for use with relatively large cameras.

Flare and fog. Not all the incident light that strikes a lens reaches the film in
the form of an image. Some of it is reflected by the surfaces of the lens elements,
the inside of the lens mount, or internal parts of the camera, bounced back and
forth and reflected again until it falls upon the film in the form of flare and fog.

Flare manifests itself as light spots in the transparency which can have almost any form and size but are most often circular, fan- or crescentlike, or repeating the shape of the diaphragm aperture.

Fog is flare that has been scattered so thoroughly that it arrives at the film plane in the form of an overall haze. Its effect upon the color transparency is that of an overall degradation of color combined with a reduction in contrast, similar to that caused by overexposure.

p. 29 Although lens coating has considerably reduced the incidence of flare and fog, and use of an efficient lens shade can further reduce the likelihood of their appearance, these faults still prevail to various degrees in modern high-speed (and other types of) lenses and may be particularly annoying when shooting high-contrast subjects or taking pictures against the light. Lenses with a more-than-average number of glass-to-air surfaces are particularly prone to flare and fog, but only tests can reveal which one of several lenses similar in regard to speed and focal length but different in construction is least affected by this annoyance.

Evenness of light distribution. Uneven exposure—color transparencies that are lighter in the center than around the edges—can be due to one of two factors:

Because the edges and corners of the film are farther away from the lens than the center, in accordance with the inverse square law, the marginal areas of the film receive less light than the central parts and consequently appear darker. This kind of illumination fall-off, which is inherent in any lens but normally insignificant in lenses with standard or longer focal lengths, is a common fault of many wide-angle lenses although some possess it to a more pronounced degree than others. Only a test can reveal the seriousness of this affliction which generally is the more pronounced, the wider the angle encompassed by the lens. Illumination fall-off reaches a high point in the Goerz Hypergon wide-angle lenses which cover angles of view of up to 140 degrees, where this unevenness is so pronounced that these lenses had to be equipped with a star-shaped spinner driven by an air pump. Mounted over the center of the lens, the function of this spinner is to keep the light off the center of the film during part of the exposure to give the edges sufficient exposure without overexposing the center.

The second cause of uneven light distribution in a transparency is vignetting, which is usually caused by a badly designed lens mount that prevents the corners of the film from receiving their full share of light. Vignetting is most often found in lenses with long and narrow, tubelike mounts, particularly telephoto and cer-

tain kinds of old-fashioned lenses, but can also occur if a lens is used in conjunction with a camera for which it was not designed.

Whereas unevenness of light distribution is usually only a minor annoyance to a black-and-white photographer, who can correct this fault by dodging his prints during enlarging, it should be a matter of concern to the color photographer, who works with reversal-type color films; having no recourse to corrective methods like dodging, he usually is better off leaving lenses with pronounced illumination fall-off alone.

Distortion. Distinguish between four types of distortion, none of which has anything to do with any of the others:

Barrel and pincushion distortion are the only forms of distortion that result from inherent faults of the lens. They manifest themselves by rendering actually straight lines as curves, an effect that becomes more pronounced with increasing distance of the image of the straight line from the center of the picture (where straight lines are rendered straight). If barrel distortion is present, a lens will render a square as if its sides were bulging; if pincushion distortion, as if they were curving inward; see the following illustration.

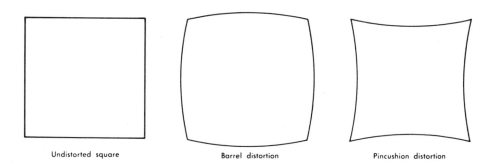

Undistorted square Barrel distortion Pincushion distortion

Barrel and pincushion distortion are faults most often found in wide-angle and zoom lenses. If requirements are high, they make the so-afflicted lenses unsuitable to architectural, interior, and commercial photography, where straight lines must be rendered straight, but not to general photography because, in the absence of straight lines, the distortion effect is usually unnoticeable.

p. 86
p. 99

Perspective distortion. Familiar examples are noses that appear unproportionally big in portraits, or hands that seem too large in pictures that show a person

reaching toward the camera. This kind of distortion—more precisely: exaggerated perspective—is not caused by any fault of the lens, but is the fault of the photographer, who took his picture with the wrong type of lens from a subject distance which, under the circumstances, was too short to produce a natural-appearing impression. In nearly all such instances it will be found that the picture had been

p. 86

made with a lens of relatively short focal length—most commonly a wide-angle lens—a fact which has led to the erroneous conclusion that "all wide-angle lenses distort." What actually happened was that the photographer, in an attempt to compensate for the relatively small scale of the image produced by the short-focus lens, went too close to his subject. Had he instead made the same shot with a lens of longer focal length from a correspondingly greater distance, he would have gotten more or less the same view in the same scale but in a natural-appear-

pp. 86, 340

ing perspective. More will be said about this later.

Unnatural elongation of actually spherical or cylindrical objects that appear near the edge of the picture in shots taken with extreme wide-angle lenses, although a form of "distortion," is not the result of any "lens fault," but is the natural consequence of projecting a three-dimensional object obliquely into a flat surface, the film; see the following illustration.

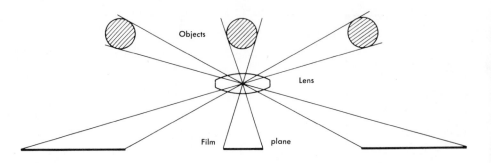

Again, a wrongly used wide-angle lens is blamed for a phenomenon that is not due to a lens fault but occurred as the consequence of bad judgment on the part of the photographer, who should have arranged his subject differently, taken the picture from a different point of view, or used a lens with a longer focal length.

The curving of actually straight lines, which is typical of spherical and cylindri-

pp. 342-346

cal perspective (of which more will be said later), is likewise not caused by a lens fault since the responsible lenses or optical systems were deliberately designed to produce this kind of perspective.

84

Lens type

As in camera selection, the most important quality of a lens is *suitability*. Neither "speed" nor appearance, brand name nor price, is of the slightest value if a lens is unsuited to the type of work it has to do. The following survey, which classifies lenses in regard to purpose, shows the reader what different types of lenses can do and should help him in making up his mind as to what he needs.

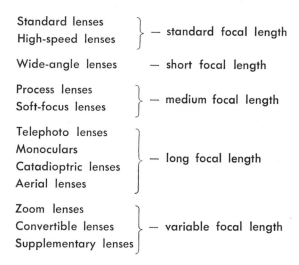

Standard lenses
High-speed lenses
} — standard focal length

Wide-angle lenses — short focal length

Process lenses
Soft-focus lenses
} — medium focal length

Telephoto lenses
Monoculars
Catadioptric lenses
Aerial lenses
} — long focal length

Zoom lenses
Convertible lenses
Supplementary lenses
} — variable focal length

Standard lenses have a focal length more or less equal to the diagonal of the film size for which they are designed, fairly high speeds ranging from f/2 and f/2.8 (35-mm and 2.1/4 x 2.1/4-inch cameras, respectively) to f/5.6 and lower (4 x 5-inch cameras and larger), and moderate covering power encompassing angles from approximately 45 to 60 degrees. They represent the best practicable compromise between sharpness, speed, and covering power and produce pictures that in regard to angle of view and perspective approximate most closely the impression received by the eye at the moment of exposure. p. 72 p. 74 p. 76

A standard lens is the first lens which a photographer who buys a camera which features lens interchangeability should acquire because it is the lens most suitable to the greatest number of different tasks.

High-speed lenses are superior to standard lenses in regard to speed, similar in focal length, but often inferior in regard to sharpness and covering power; they pp. 79, 76

p. 231 are also bigger, heavier, more expensive, and more prone to flare and fog. True high-speed lenses are commercially available only for 35-mm cameras and have relative apertures that range from f/0.95 to f/1.8.

Whereas standard lenses represent a compromise in order to combine in one design as many desirable qualities as possible, high-speed lenses are designed with only one objective in mind: speed. To attain this goal, other useful lens qualities had to be sacrificed to a higher or lesser degree, as a result of which high-speed lenses are not suited to general photography. On the other hand, their two outstanding qualities—unsurpassed speed and extremely shallow depth of field at maximum apertures—make them valuable tools in the hands of creative photographers when light conditions are marginal or it is desirable to keep the sharply covered zone in depth very shallow.

Wide-angle lenses have more covering power than standard lenses but usually less speed (although a number of relatively fast wide-angle lenses is now available for use with 35-mm cameras). Furthermore, many wide-angle lenses are sub-p. 83 ject to distortion, and all suffer to a greater or lesser degree from illumination p. 82 fall-off toward the edges of the picture (uneven light distribution at the film plane). Like high-speed lenses, they are designed with one prime objective in mind, this time covering power, with angles of view ranging from approximately 60 to 100 degrees. The ultimate are the Zeiss Ikon 35-mm Ultrawide camera equipped with a 15-mm f/8 Hologon lens covering an angle of 110 degrees, and the Goerz Hypergon lenses for 5 x 7 and 8 x 10 inch view cameras covering 130 degrees.

Distinguish between two types of wide-angle lenses: ordinary wide-angles which p. 329 produce pictures in which perspective is rectilinear, *i.e.*, actually straight lines are rendered straight (not counting any curving due to possible distortion); and "fisheye lenses"—super wide-angle lenses covering an angle of view of 180 degrees— p. 343 which produce pictures in which perspective is spherical, *i.e.*, actually straight lines are rendered in the form of curves.

In my opinion, wide-angle lenses are more difficult to use than any other lens type and, unless special considerations prevail, I would make a wide-angle lens the third in order of acquisition for use with a camera that features lens interchangeability, the other two being a telephoto and a high-speed lens. Nevertheless, it nowadays is common practice among documentary photographers to shoot the majority of candid pictures of people with a moderate wide-angle instead of a standard lens. They reason that, equality of f-stops provided, a wide-angle lens produces more sharpness in depth than a lens of standard focal length. However,

this is true only as long as the two comparison pictures are made at the same subject distance. In that event, of course, the wide-angle, because of its shorter focal length, produces an image in smaller scale than the standard lens. In other words, a gain on one side—additional sharpness in depth—is offset by a loss on the other side—smaller image size—a loss for which the photographer usually tries to compensate by approaching his subject more closely. Unfortunately, this practice, although it will increase the image size, invariably also causes the subject to be rendered in more or less distorted form—the inevitable price that has to be paid whenever the distance between the subject and a lens with a wider-than-average angle of view becomes too short. To avoid such unsightly effects, I recommend that wide-angle lenses be used for only two reasons: when circumstances make it impossible to include in the picture a sufficiently large angle of view with a standard lens; or when the typical "wide-angle distortion effect" is deliberately desired for extra emphasis.

Process lenses are designed with only one goal in mind: sharpness. They are usually apochromats computed for near-distance photography and are characterized by the possession of a particularly flat field resulting in uniform distribution of sharpness at full aperture over the entire film area; less than average covering power and therefore longer than average focal lengths; and lower than average speeds with maximum relative apertures of f/9.

p. 81
p. 80

p. 76

True process lenses (but not apochromats) are available only for 4 x 5-inch and larger cameras. They are unsurpassed for making reproductions of two-dimensional objects and, if slow speed is no objection, superbly suited to commercial photography, particularly in color and, if cameras with sufficient bellows extension are used, to close-up photography.

Soft-focus lenses are highly specialized lenses of very limited usefulness. They produce pictures which are neither sharp nor unsharp in the ordinary sense of the word—subject detail seems to consist of a fairly sharp nucleus surrounded by a halo of unsharpness. This effect increases with increasing subject contrast and is particularly pronounced (and can be very beautiful) in backlighted shots.

This is an "old-fashioned" type of lens which, however, still ranks high with certain pictorialists and portrait photographers of women. Only a few of this type are still being produced. However, similar effects can be achieved with the aid of supplementary soft-focus lenses and disks which, used in front of a standard lens, temporarily convert it into a soft-focus lens. Used on low-contrast subjects and in the hand of a tyro, soft-focus lenses and devices are an invitation to disaster.

Telephoto lenses, used from the same camera position, produce images in larger scale than standard lenses designed for the same film size, but include, of course, correspondingly smaller angles of view. They are long-focus lenses of unique design which, unlike ordinary long-focus lenses, when focused at infinity, require

p. 72

less extension between lens and film than their focal lengths indicate. For example, an ordinary lens of, say 32 cm focal length, when focused at infinity, requires a camera extension of approximately 32 cm whereas a telephoto lens of the same focal length, say a Zeiss Tele-Tessar with a focal length of 32 cm, when focused at infinity, requires an extension of only 20 cm. This compactness, of course, gives telephoto lenses a valuable practical advantage over ordinary lenses of comparable focal lengths (which, from the same camera position, would produce images in the same scale).

Telephoto lenses are used when distances between subject and camera are so great that a standard lens would render the subject too small, or when the special

p. 341

effect of the characteristic telephoto perspective is desired. Moderate telephoto lenses are particularly well suited to portrait photography. Extreme telephoto lenses are difficult to use successfully because atmospheric haze (which turns colorful subjects into blue monochromes) and thermal disturbances (the heat waves that turn static subjects into wobbly apparitions) limit conditions under which sharp pictures can be obtained at the great distances at which these lenses are commonly used.

Binoculars, monoculars, and prism scopes can be used in conjunction with almost any 35-mm or 2.1/4 x 2.1/4-inch SLR and TLR camera, including those with leaf-type shutters and nonremovable lenses, to produce pictures in greatly and even enormously enlarged scale. Although some monoculars and scopes screw directly into the front thread of the standard lens of an SLR 35-mm camera or attach to the camera's lens mount, most instruments have to be connected to the respective camera with the aid of special adapters or mounts. Distinguish between two methods of use:

Monophotography. The photograph is taken using only the monocular or scope. Since this necessitates removal of the camera lens and focusing through the monocular or scope, only focal-plane shutter-equipped single-lens reflex cameras featuring lens interchangeability can be used. The image is focused directly on the groundglass of the SLR (a split-image viewfinder or microprism focusing screen cannot be used since, because of the high focal length values involved, they would black out. A clear center spot with cross-hairs is best). In comparison to binophotography (see p. 97), monophotography has the following advantages:

Color films made by different manufacturers, as well as different types of color film made by the same manufacturer, differ from one another in regard to color rendition, exposure latitude, graininess and, unfortunately, uniformity. To get accurate data on these differences, *Modern Photography*, through the courtesy of which these pictures are reproduced here, made tests by exposing different brands of film under identical conditions with the results shown on this page; the left column was exposed in direct sunlight, the right one in the shade.

Note how some films render color "warmer," more toward yellow, than others which produce "colder," more bluish tones. The deep magenta cast is typical of very old, outdated film which furthermore had been underexposed because it was slower than its listed ASA speed.

The first step on the road to good color photography is to select a color film with qualities that appeal to one, then test it thoroughly and stick to it. Vacillating from one brand to another is disastrous because the photographer never has a chance to become truly familiar with any film.

More on pp. 107–116

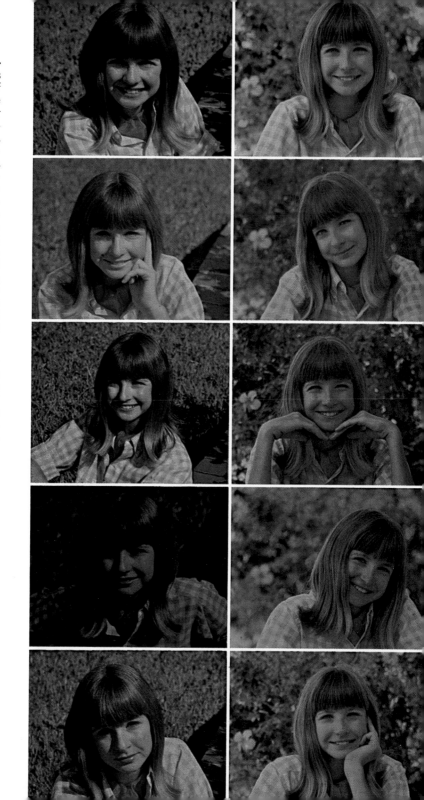

Color film test. Prerequisites for a successful film test are standardization of illumination, shutter speed, subject distance, and development. Write all pertinent data—film type, emulsion number, filter (if any), etc.—on cards; include these in setup for permanent identification.

Test object should consist of a model (for skin tones), some strongly colored objects, a Kodak Neutral Gray Test Card, and a patch of white. Perform three tests:

Speed test (this page). Start with a shot exposed according to exposure meter (here marked "no filter"); make additional shots bracketed at half-stop intervals (here marked $\frac{1}{2}+$, $1+$, $\frac{1}{2}-$, $1-$; see also pp. 114, 150).

Color test (this page). Photograph your test object through different color filters (05 Y, 10 Y, 05 R, 10 R, etc.; see pp. 36, 226).

Polaroid comparison test (picture at left). Establish the relationship between the exposure for your specific color film and Polaroid black-and-white film. In this case, identical exposures produced perfect pictures if the Polaroid shot was made through a 0.20 Neutral Density Filter. Once this relationship has been established, an instant, highly accurate exposure test for color shots can be made with Polaroid Film.

Only tests like these can answer precisely questions about actual speed, exposure latitude, and color response of a specific film.

Exposure meters "think average."

Exposure meters are designed, and their calculators adjusted, in such a way that a reading taken off any color, no matter whether light, medium, or dark, leads to an exposure which renders the respective color as a *medium-bright* shade.

For example, take the test object shown at the left. The numbers indicate the respective brightness of its four parts under uniform illumination. An exposure based upon a meter reading taken off the Kodak Neutral Test Card or the red patch (both *objects of medium or average brightness*, here 6.5) produced a color transparency (center) in which the white, gray, black, and red appeared as they appeared to the eye. However, if we were to base our exposure upon readings taken off the white or the black, respectively, we would find that these "colors" too would be rendered as medium shades—because exposure meters are designed to "think average."

In a photograph exposed in accordance with a meter reading taken off the white area of the test object (top), for example, the white would be rendered in the same shade of medium gray as the Kodak Neutral Test Card exposed in accordance with a reading taken off the gray card itself (center). Similarly, in a photograph exposed in accordance with a reading taken off the black area, the black would appear as a medium gray tone while the lighter colors of the subject would, of course, be catastrophically overexposed (bottom). This characteristic of exposure meters to "think average" can complicate exposure determination with the aid of spot-meters and makes integrating exposure meters more suitable for beginners.

More on pp. 135–136

Excessive color contrast.

The exposure latitude of color film is relatively narrow. As a result, if subject contrast is abnormally high, it may become impossible to achieve satisfactory rendition of the lightest and darkest colors in the same transparency.

For example, take the test object shown at the right. A meter reading taken off the Kodak Neutral Test Card near its center resulted in an exposure which rendered the gray card and the colors of medium brightness as they appeared to the eye (center).

However, the lightest color, the beige at the right in the picture, appears too light and the darkest color, the brown at the left, appears too dark. These colors, the brightness span of which exceeds the contrast range (and hence exposure latitude) of the color film, can be rendered accurately only if the photographer makes an appropriate adjustment in his exposure. The picture at the top, which received less exposure than the one at the center, shows the beige fabric as it appeared to the eye, but all the other colors are rendered too dark. On the other hand, the picture at the bottom, which received more exposure than the one at the center, shows the brown fabric as it appeared to the eye, but all the other colors are rendered too light.

Rarely can excessive subject contrast be reduced by illuminating the dark colors more strongly than the light ones. Ordinarily, the only alternatives are to favor either the lighter or the darker colors. Of the two, favoring the light colors and letting the dark ones go too dark in the transparency normally produces the more pleasing results.

More on pp. 142–144

Testing and experimenting is the key to successful color photography.

At the left is part of a test strip which I made to determine the best exposure for neon lights. Once these data are known, it is easy to time one's shooting to coincide with the brief period during which the evening sky requires the same exposure—the time when the sky can be rendered as a rich deep blue without over-exposing the neon lights.

Above are two frames of a test strip which I made to find the best exposure for photographing reflections of neon lights on rain-wet pavement at night.

More on p. 150

Color control through exposure. *If subject contrast is relatively low,* photographers, by slightly decreasing or increasing the exposure in regard to normal, can produce transparencies with darker or lighter colors, respectively.

Above, note how the shorter exposed, darker version of a marsh in Maryland produces an entirely different impression from the longer exposed lighter view, presenting it in a different mood.

At the right, a graduated strip shows how relatively short exposures produce more saturated colors than longer exposures, which produce more diluted, pastel color shades.

More on pp. 149–150

How to find your own flash guide number. Place the subject at a distance of 10 feet from the flash-equipped camera (flashbulb or electronic flash). Shoot a number of pictures with different diaphragm stops under otherwise identical conditions. Multiply the f-stop number of the best by 10—this is your flash guide number. *More on pp. 249–250*

The setup is simpler, more rigid, less cumbersome, and faster to assemble and take down. Since the monocular or scope is directly connected to the camera body via an adapter tube, no special adjustment for accurate alignment is necessary. The optical quality of the pictures is better and vignetting not likely to occur, not even with the most extreme focal lengths. p. 82

Binophotography. The photograph is taken using both the regular camera lens and a binocular, monocular, or scope. This method permits the use of a much wider variety of equipment, including twin-lens reflex cameras and cameras with nonremovable lenses but, in comparison to monophotography, has the following disadvantages:

Picture quality is inferior in regard to sharpness and shows increased illumination fall-off toward the edges of the film; generally, a high degree of vignetting occurs, which may result in almost circular images, considerably reducing the available film area; relatively clumsy adapter mounts are required to connect camera and instrument, which furthermore must be carefully aligned each time before the setup can be used.

Although any binocular, monocular, or prism scope is adaptable to this kind of telephotography, best results are always achieved if instruments specifically designed for photographic purposes are used. But even then, quality of the pictures in regard to sharpness and uniformity of illumination will generally be found to be inferior to that of photographs taken with true telephoto lenses of equal focal lengths. The best that can be said for these instruments is that they permit a photographer to enjoy the practice of telephotography with relative ease at reasonable cost and produce pictures in 15 to 60 times larger scale than those made by his standard lens.

Catadioptric lenses, a relatively new type of telephoto lens, are mixed lens-mirror systems built according to the principle of the reflecting telescope and employ a parabolic mirror as the main component of their design. "Cat" systems, as they are also called, are practicable only in focal lengths of 500 mm and longer, a range in which they have over true telephoto lenses of comparable focal lengths the advantages that they are very much more compact, weigh only a fraction as much, and are almost completely color corrected. Unfortunately, these advantages are partly offset by some serious drawbacks, the main one being that cat systems preclude the use of a diaphragm. As a result, catadioptric lenses cannot be stopped down but must always be used at full aperture. The consequences, of course, are that the sharply covered zone in depth is always very

97

shallow and exposures can be regulated only by changing the shutter speed; in cases in which the fastest available shutter speed is still too slow for a correct exposure, the light transmission of the system can be reduced by several stops with the aid of appropriate neutral density filters supplied by the manufacturer. A further disadvantage is that out-of-focus images of dots of light—sun-glittering water or street lights at night—will be rendered not as is usual in the form of disks or stars, but in the form of bright rings that look like miniature doughnuts, an effect that can be rather disconcerting.

The main advantages of cat systems are lightness and portability plus the fact that, in conjunction with magnifying eyepieces, enormous degrees of magnification can be achieved. (For example, the Questar, probably the best known of all catadioptric systems, has a focal length of 7 feet compressed by optical folding into a tube only 8 inches long, yet weighs less than 7 pounds. In conjunction with 80x eyepiece projection, magnification equivalent to a focal length of 31 feet (!) can be achieved; on this scale, the moon would be 2 feet in diameter). Whether or not the advantages of cat systems over true telephoto lenses outweigh their drawbacks is, of course, something each photographer must decide for himself.

Aerial lenses. Although photographs from the air can be made with any good standard and many wide-angle lenses, special aerial cameras are usually equipped with special aerial lenses, both of which, of course, should be the choice of the aerial photographer. However, surplus aerial lenses are constantly advertised in amateur photo-magazines, and a frequently asked question is whether such lenses, which are usually offered at bargain prices, can be used for portrait, close-up, and other types of nonaerial photography.

p. 57

In my opinion, the answer is a qualified no. Although a few aerial lenses with relatively short focal lengths have been adapted successfully to portrait photography with large cameras, most aerial lenses have drawbacks which make them unsuitable to general photography. Most of them are too heavy to be truly "portable" and too big to fit into conventional leaf-type shutters (and can therefore be used only in focal-plane shutter equipped cameras). They are computed for maximum sharpness at infinity and usually perform badly at near-distances. Many suffer from severe chromatic aberration and are therefore useless for color photography. And most are designed for use in conjunction with a deep red filter and corrected accordingly, which means that without such a filter they are not very sharp.

98

Zoom lenses are complex optical systems with variable focal lengths which, within the limits of their minimum and maximum focal lengths, provide an infinite number of intermediary focal lengths. Depending on the design, the longest available focal length is 2, 3, and, exceptionally, even 4 times as long as the shortest. Changing focal length—zooming—is done either by sliding or rotating a collar that forms part of the lens mount, an operation during which the image should stay in focus no matter what the focal length. Unfortunately, however, this is not necessarily the case with all zoom lenses, a few of which require a certain amount of focus adjustment after the focal length has been set. Advantages of zoom lenses are that they provide within *one* unit the equivalent of *several* lenses, thus saving the photographer both space, weight, money, and the time required to switch from one lens to another; they also enable him to study his subject from the same camera position in many different scales and forms of cropping simply by sliding a collar or turning a ring. However, there are drawbacks: zoom lenses can be used only on single-lens reflex cameras and, at the time of writing, are available only for 35-mm SLR's. They are rather heavy, clumsy, and long, which means that p. 59 even if a photographer wishes to use a standard focal-length effect, he must make the picture with a lens as big and heavy as a medium-size telephoto lens. In addition, zoom lenses are generally not quite as sharp as standard and true telephoto lenses of equal focal length, and most of them are, at least at certain settings, subject to distortion, *i.e.*, actually straight lines that appear near the p. 83 margins of the picture will be rendered slightly curved.

Convertible lenses represent an "old-fashioned" lens type which, depending on the design, combines within one unit two or three different focal lengths. This has been achieved by separately correcting each of the two lens elements: if the convertible lens is of symmetrical design (*i.e.*, if front and rear elements are identical), its front and rear elements each have twice the focal length and one-quarter the speed of the complete system. If the two elements are asymmetrical, they have different focal lengths as well as speeds, as a result of which such a lens combines three different focal lengths within one unit.

Disadvantages of convertible lenses are that they can be used only in conjunction with groundglass-panel-equipped or single-lens reflex cameras; that, in order pp. 60, 59 to produce acceptably sharp pictures, they require a considerable amount of stopping down; and that the "speed" of the individual elements is always very slow. They are designed for use with 4 x 5-inch and larger cameras and, by modern standards, are obsolete.

Supplementary lenses are designed for use in conjuncton with regular lenses, primarily for the purpose of changing their focal lengths (and, incidentally, also speeds) and have the following attractive features: at only a fraction of the cost of an additional and different lens, a photographer can acquire what in effect (and in many respects) amounts to a second lens with different characteristics; p. 60 users of cameras with fixed lenses (including TLR's) can, to a certain extent, enjoy the advantages which cameras that feature lens interchangeability provide; in addition to being money-savers, they also save space and weight. But they also have disadvantages: in comparison to regular lenses, supplementary lenses pro- p. 82 duce pictures that are generally less sharp and subject to illumination fall-off toward the edges; in addition, supplementary lenses that *increase the focal length* of the reglar lens also *reduce its speed* (at any diaphragm setting) in accordance with the inverse-square law. On the other hand, supplementary lenses that reduce the focal length of the regular lens simultaneously increase its speed; however, in the case of close-ups (the most common purpose to which positive supplementary lenses are put), such gains can be neglected in computing the exposure be- p. 148 cause they are offset by an equal loss due to the distance factor, by which the exposure-meter-derived exposure must be increased. Distinguish between the following types of supplementary lenses:

Supplementary lenses designed to be used in front of the regular lens (preferably a lens of standard focal length). Their purpose is to alter the focal length of the lens: a positive supplementary lens shortens, and a negative one increases, the focal length of the regular lens. Whereas positive supplementary lenses can be used in conjunction with any camera, negative supplementary lenses can only be used with cameras that have sufficiently long extensions or permit the p. 35 use of extension tubes or auxiliary bellows. For twin-lens reflex cameras, matched sets of positive supplementary lenses are available for close-ups which provide p. 51 for parallax compensation by means of a wedge built into the supplementary lens intended for the camera's finder lens. Positive supplementary lenses enable a photographer to adapt any camera to close-up photography within certain limits; negative supplementary lenses, in conjunction with sufficient lens-to-film extension, to telephotography. Instructions for use, including exposure calculation, commonly accompany each supplementary lens.

Focal length extenders (or tele converters) are negative supplementary lenses that fit between the camera body and the regular lens, increasing its focal length by a factor which, depending on the extender, ranges from 1.85 to 3. Unlike the negative supplementary lenses that attach to the front of the regular lens,

tele converters don't require additional extension and can therefore be used in conjunction with any 35-mm single-lens reflex camera (but not others) that provides for lens interchangeability. Simultaneously with any increase in focal length, of course, a corresponding decrease in lens speed (at any diaphragm stop) takes place. For example, a 135-mm telephoto lens in conjunction with a 2x converter acquires an effective focal length of 135 x 2 = 270 mm; unfortunately, its f-number must also be multiplied by the converter factor and, if it is an f/5.6 lens, would in effect turn into an 5.6 x 2 = f/11.2 lens, *i.e.*, a lens of only one-quarter of its former speed.

Tele converters come in a variety of qualities that range from poor to remarkably good although, even under the best conditions, the combination of regular lens and tele converter produces pictures which in regard to photo-technical quality are never quite as good as those made with a good telephoto lens of equal focal p. 88 length. They work best in conjunction with lenses of 135-mm focal length and over, except in certain instances of portrait photography where the increased softness and sharpness fall-off toward the edges of the picture, which seems to occur whenever tele converters are combined with lenses of standard focal lengths, might occasionally enhance the effect of the picture. Tele converters are also available for use in conjunction with lenses equipped with an automatic diaphragm, permitting a photographer to retain use of this valuable feature when working with this type of supplementary lens.

If extreme focal lengths are required, two tele extenders can be used simultaneously in tandem arrangement. But image quality will deteriorate even further while exposure times increase by leaps and bounds. For example, if two 2x extenders are used together, to arrive at the correct exposure the photographer must divide the ASA number of his film by (2x2) x (2x2) or 16; if a 2x and a 3x extender are used simultaneously, by (2x2) x (3x3) or 36; and if two 3x extenders are used in combination, by (3x3) x (3x3) or 81. However, such losses may well be worth his while, for the attainable degrees of magnification are staggering: in conjunction with two 2x extenders, a 200-mm telephoto lens acquires an effective focal length of 800 mm; if one 2x and one 3x extender are used, it becomes the equivalent of a 1200-mm lens and, with two 3x extenders, 1800-mm. Whether the resulting picture quality makes such magnification practicable depends on several factors: the quality of the regular lens; the quality of the tele extenders; how well lens and extenders work in combination (some extenders work well with certain lenses, perform poorly with others); how still the camera

is held during exposure; and finally, how good "seeing" conditions are, *i.e.,* whether or not thermal disturbances make it impossible to achieve sharp pictures no matter how favorable all other conditions may be.

Supplementary fish-eye lenses are now available for use in conjunction with all standard lenses to which they can be fitted, including those of 4 x 5-inch and larger cameras. They convert the so-equipped regular lens into a fish-eye lens, which covers an angle of view of 180 degrees and produces pictures in which perspective is spherical.

p. 343

Soft-focus supplementary lenses, disks, or devices convert a regular lens temporarily into a soft-focus lens without altering its focal length or speed. They must be fitted to the front of the regular lens and are available in several different designs for slightly different effects. The limitations and dangers of soft-focus renditions have already been discussed.

p. 87

THE COLOR FILM

In color photography, the problems of selecting the most suitable film are different from those that confront a photographer who works in black-and-white. There, graininess, speed, and contrast range are foremost considerations; here, the big questions are:

> Positive or negative color film?
> Small film size or larger film size?
> Daylight-type, Type A, or Type B film?

Positive or negative color film?

Two basically different types of color film exist: positive or reversal films, and negative or nonreversal films. Kodak facilitates distinction between the two groups by ending the brand name with a codelike suffix: the suffix "chrome" designates a *positive* color film (Koda*chrome*, Ekta*chrome*); the suffix "color" designates a *negative* color film (Koda*color*, Ekta*color*). As far as the amateur is concerned, if his primary interest is slides for projection, he must use a positive color film; if color paper prints for album or wall display, a negative color film.

Positive or reversal color film ("reversal," because the image produced by the exposure is a color negative which during development is "reversed" into a posi-

tive) yields positive color transparencies primarily intended for viewing or projection by transmitted light, and for reproduction by photo-mechanical methods. Although color prints and enlargements on paper can also be made from positive color transparencies, negative color films are preferable for this purpose. Compared to negative color films, positive color films have the following advantages:

Because the developed film represents the final, finished, salable product and no further time, money, or effort has to be spent on printing, cost per picture is relatively low. For the same reason, positive color films are usually preferable in cases in which time is of the essence as, for instance, in news reporting and many fields of magazine and commercial photography: the minimum time between shooting a picture and seeing the final result is much less than if a negative color film had been used. Furthermore, positive color transparencies can be edited, and final selection be made, without the need for contact prints or proofs, another saving in cost and time. Finally, in comparison with prints and enlargements made from negative color films, positive color transparencies are sharper, their colors more brilliant, and their contrast range considerably greater, factors which tend to make color transparencies more effective and give them greater sales appeal than color paper prints.

The main disadvantage of all positive color films is that, once the exposure has been made it is virtually impossible to correct a mistake; unless the type of light in which the shot was made corresponded precisely to that for which the respective color film was balanced or, if the light was "off," the correct light-balancing filter had been used, and unless the exposure was perfect, the result will be disappointing and often useless. Furthermore, each color transparency is an original and therefore unique and, if damaged or lost, not replaceable (unless, of course, it had been duplicated before). But color duplication is a time-consuming and expensive process which, unless done by a first-class color lab, yields transparencies that in regard to photo-technical quality are inferior to the original.

p. 36

Negative or nonreversal color film ("nonreversal" because the light-induced image does not have to be reversed into a positive during developing) yields color negatives in the complementary colors and tone values of the subject. Like ordinary black-and-white film, such film must be printed before it yields finished positive prints. In comparison with positive color film, negative color film has the following advantages:

p. 282

Because printmaking includes the intermediary step of the negative, a color photographer has just as much control over the final appearance of his color prints

as a photographer who works in black-and-white. Not only can a very considerable degree of overexposure and, to a lesser extent, underexposure of the color negative be corrected during the printing process, but far-reaching color changes can also be made in the overall tone and even within specific areas of the print. This fact alone is of the highest practical value because it virtually eliminates the need for time- and film-consuming "bracketing" (making a series of pictures of the same subject from the same point of view with different diaphragm settings or shutter speeds and, if desirable, different light-balancing filters to insure that at least one shot will turn out to be perfect), an advantage that is particularly appreciated by photographers involved in fast-breaking action photography, which leaves no time to make a second, let alone a third or fourth, exposure with different camera settings. Other advantages of negative color films are that cropping and sectional enlarging of the negative is possible; that irreplaceable negatives can be kept by the photographer who only sends out relatively expendable prints; that any number of identical prints can be made from the same color negative and sent out simultaneously to different places (which in effect means the end of the annoying "holding" of valuable transparencies by a client who thus monopolizes a color shot that in the meantime might have been submitted elsewhere); and that small-format cameras can be used to make large-size color prints.

p. 164

p. 150

Disadvantages of negative color film are that it is impossible to edit from color negatives (which means that time and money has to be spent on the making of proof prints); that good color prints, particularly in the larger sizes, are very expensive; and that even the best color print is still inferior to a positive transparency in regard to sharpness, brilliance of color, and contrast range, which adversely affects its sales appeal, although this may be partly offset by larger size.

Small film size or large?

Since different film sizes have specific advantages and drawbacks, for those photographers who are still undecided whether to buy a small, medium, or large camera the following summary may be of aid in making a choice:

In a nutshell: Photographers primarily interested in making slides for projection, no matter whether amateurs, travelers, lecturers, or professionals out to produce color slides for sale, unless special considerations make it necessary to use a larger format, should use 35-mm color film. Likewise, photographers with quick temperaments, action people, fast and impulsive workers, reporters photographing fast-breaking news, anyone interested more in life than in photo-technical quality, and all who wish to travel light, should make 35-mm color film their choice.

Photographers primarily interested in static subjects—landscapes, architecture, objects, art—no matter whether amateur or professional, as well as those who are perfectionists at heart—the slow and deliberate workers who insist on highest photo-technical quality and are obsessed by sharpness, texture, precisions of detail—will only be satisfied and able to do their best if they use a larger film size, 4 x 5-inch and up.

And finally, photographers who prefer the inexpensive type of color paper prints to color slides; those who are equally interested in static and dynamic subjects, in people as well as in things; professionals working in the fields of fashion and advertising photography who specialize in photographing models and action; and, strange as it may sound, inexperienced beginners will probably be most satisfied if they work with a medium-size film: 2.1/4 x 2.1/4-, 2.1/4 x 2.3/4-, or 2.1/4 x 3.1/4-inch.

More specifically, different film sizes have the following good and less desirable qualities and consequences which must be considered:

A small film size—35-mm—has the following advantages over larger sizes: Lower cost per exposure, a factor which insures more complete coverage of the subject, reduces the danger of missing important shots, and is conducive to bracketing. p. 150 Minimum weight and bulk of the film supply—35-mm film for over a hundred exposures takes less space than a pack of cigarettes. And 35-mm cameras are smaller, lighter, faster in operation, and less conspicuous than those that take larger film. Lenses of much higher speeds are available for 35-mm cameras than for any other size, and Kodachrome II, the color film with the highest resolution of any type or make, is, except for movie films, available only in 35-mm size.

Against these advantages, the following drawbacks must be weighed: Pictures are generally less sharp, detailed, and more grainy than those made on larger film sizes (exception: shots made on 35-mm Kodachrome II, which, when projected or enlarged, are potentially at least as sharp, and often sharper and less grainy, than similar shots made on no. 120-size film and, because of the general superior sharpness of 35-mm lenses, may hold their own even in comparison with 4 x 5-inch color transparencies). The sales appeal of 35-mm color slides (unless *slides* are specifically requested) is generally much lower than that of larger transparencies, and many buyers of color photographs don't even look at 35-mm films.

A large film size—4 x 5-inches and over—has the following advantages over smaller sizes: Higher photo-technical quality, primarily in regard to sharpness, rendition of fine detail, and smoothness of color and tone. Compositional advan-

tages—large cameras have large groundglass panels which make it easier to visualize the final picture than do small finder images, compose the subject, detect distracting influences before it is too late, accurately check the depth of the sharply covered zone, and critically evaluate the distribution of light and shadow. In addition, only groundglass-panel-equipped cameras can be fitted with individual front and back adjustments—the slides, swings, and tilts that are indispensable for perspective control. Finally, the sales appeal of large color transparencies is far superior to that of small ones.

A medium film size—2.1/4 x 2.1/4-, 2.1/4 x 2.3/4-, and 2.1/4 x 3.1/4-inch—combines, to a proportionally lesser degree, most of the advantages and drawbacks of both smaller and larger sizes.

Daylight-type, Type A, or Type B film?

Unlike different types of black-and-white film, all of which can be used in any kind of light, color films are made in the form of three specific types, each designed for use in one specific kind of light. If used in a different kind of light, the colors of the transparency will not correspond to those of the subject.

Daylight-type color films are designed for use with "standard daylight," which is defined as *a combination of direct sunlight and light reflected from a clear blue sky with a few white clouds during the hours when the sun is more than 20 degrees above the horizon,* and are also suitable to shooting pictures with electronic flash or *blue* flashbulb illumination. If a daylight-type is to be used in a different kind of light, the correct color-conversion filter must be used if a natural-appearing color rendition is expected. Without appropriate filtration, color transparencies shot on daylight-type film by photoflood, tungsten lamp, or clear flashbulb illumination will appear too yellow.

p. 45
p. 43
p. 32

Incidentally, the *negative color film Kodacolor-X* is designed primarily for daylight illumination but can also be used with 3200 K professional tungsten-lamp illumination if a Kodak Filter No. 80A is used, and with 3400 K amateur photoflood lamps if a Kodak Filter No. 80B is used. In the first case, its original ASA speed of 80 is reduced to 20, in the second case to 25. The exposure, of course, must be adjusted accordingly.

p. 108

Type A color films are designed for use with 3400 K amateur photoflood lamps. If used in daylight, color transparencies shot on Type A color film will appear too blue unless a Kodak Filter No. 85 is used and the meter-indicated exposure multiplied by the filter factor.

p. 38

106

Type B color films are designed for use with 3200 K professional tungsten lamps. p. 38 If used in daylight, color transparencies shot on Type B color film will appear too blue unless a Kodak Filter No. 85B is used and the meter-indicated exposure multiplied by the filter factor.

Only after a photographer has decided whether to use a positive or a negative color film; a small, medium, or large film size; and familiarized himself with the differences between daylight-type, Type A, and Type B color films, should he go on and consider the following factors, all of which play an important although perhaps less critical role in the outcome of his color pictures:

Make of film
ASA speed rating
Sharpness
Graininess
The variables
Testing
Mode of processing

Make of film

No color film exists as yet which, even under ideal conditions, yields transparencies which in every respect match the colors of the subject. Furthermore, if the same subject is photographed under identical conditions on different makes of color film, the colors of the resulting transparencies will differ. Part of this difference may be due to certain variables which I'll discuss later; the main reason, p. 111 however, is that color films made by different manufacturers have inherent differences which may cause them to respond somewhat differently to a given color. Some brands, for example, are known for their brilliant colors, which at times may even appear "exaggerated"; others again will render color muted and "soft." Certain brands of color films produce renditions that are generally "warmer" (more toward yellow and red) than others, which respond with tones that are "colder" (more toward blue and purplish shades). But differences in the reaction to specific colors are common too: one brand of color film may be famous for its particularly pleasant rendition of skin-tones and therefore preferred for close-ups of people; another for its ability to render clear blue skies or green foliage in more natural shades than other films, which reproduce these colors too harshly, evoking viewer responses that range from "artificial-looking" to "poisonous." Still others may be weak in the reds, which come out looking like stale tomato sauce, or

the greens, which have overtones of brown. And so on. Comparative illustrated surveys of the different brands of color films are periodically published in photo-magazines in up-to-date form and should be studied by any serious color photographer. To discuss here the characteristics of specific brands would be futile because film manufacturers, constantly striving to improve the quality of their product, may alter the color response of an emulsion without changing the designation of the film. A better way to learn something about the characteristics of a color film is to make test shots of a flatly lighted chart consisting of swatches of differently colored matte papers, *black, white, and a Kodak Neutral Test Card of 18% reflectance (or a Kodak Gray Scale) to represent gray*—the toughest test for any color film. If black comes out as jet-black, white a *clean* white and gray a *neutral* gray without overtones of color, you hardly have to look any further—you can be sure to have found a good color film.

Other factors that make one brand of color film preferable to another are contrast range and exposure latitude. As a rule, the more contrasty a film, *i.e.*, the narrower its contrast range and the more brilliant its colors, the narrower also its exposure latitude, *i.e.*, the more limited its ability to absorb a certain amount of over- or underexposure and still produce acceptable results. In this respect, some color films will still yield acceptable (although never first-class) transparencies if overexposed up to two and one-half and underexposed one and one-half f-stops; others will hardly tolerate over- or underexposure by half a stop. The more contrasty the subject is and the less experienced the photographer, the greater the exposure latitude of the film should be. Negative color films, as mentioned earlier, have considerably more exposure latitude than positive color films.

ASA speed rating

To make accurate exposure calculations possible, the United States of America Standards Institute (formerly American Standard Association or ASA) has assigned specific "ASA speed numbers" (the designation ASA will be retained) to all films as a basis for setting the dial of the exposure meter. These speed numbers reflect the respective film's sensitivity to light: the more sensitive the film (the "faster" it is or the higher its "speed"), the higher the number. To give an idea: an ASA number of 100 characterizes at present a color film of "average" speed; outdoors in sunlight, if the subject is of average brightness and contrast, such a film requires an exposure of 1/100 sec. at f/14. Since speed number and exposure are directly proportional, other factors being equal, a film rated at twice the speed of another (in our example, ASA 200 instead of ASA 100) can be exposed *either* at twice the shutter speed (1/200 sec. instead of 1/100 sec.) or with the dia-

Margin notes:

Margin cross-references (left margin):

p. 89

p. 114

p. 103

phragm opening reduced by one stop (f/20 instead of f/14). At present, the slowest color films have ASA speed ratings of 25, the fastest of 500. The ASA rating for any color film can be found printed on the protective box or in the instruction sheet that accompanies the film.

Now it may seem as if the fastest film were also the most desirable one because, the faster the film, the shorter the exposure and, consequently, the less danger of blur due to subject or camera movement; or a smaller diaphragm stop can be used and the extent of the sharply covered zone in depth extended accordingly. However, in comparison to fast color films, slow ones have certain advantages: almost without exception, the resolution of a slow film is higher and its grain structure finer than those of faster films, as a result of which slow films are able to reproduce fine detail more satisfactorily than fast ones. For this reason, the "best" color film is frequently *the slowest film* that is still fast enough to do a perfect job.

A word of caution: Film speed ratings are not absolute but intended primarily as guides which may have to be modified in accordance with a photographer's preferences and needs. For example, color transparencies intended for photomechanical reproduction should normally be a shade darker than those intended for viewing, making it advisable to rate a color film just a trifle higher than its "official" speed. On the other hand, for specific reasons, a "high-key" effect may be desirable, making it necessary slightly to overexpose the film, *i.e.,* rate it at a somewhat lower speed. Furthermore, some shutters are consistently either too fast or too slow, and some flash reflectors are more efficient than others—all factors which might make it advisable to rate a film slightly higher or lower than its ASA-assigned speed. Photographers who consistently overexpose should rate their film at a higher than its listed speed; those who underexpose, lower.

Sharpness

The sharper a transparency is, the more detail can be distinguished in the picture. This, of course, makes sharpness a very desirable quality. Now, whether or not a photograph is sharp depends on several factors, primarily the quality of the lens, the accuracy of focusing, the diaphragm stop, and the steadiness of the camera during exposure. But it also depends in part on the sharpness of the film, for some films are sharper than others.

In color photography, film sharpness presents a problem only to photographers who work with 35-mm or no. 120 films—small sizes which later, during projection or printing, must be able to stand considerable degrees of magnification without "falling apart." Provided other factors that influence sharpness are favorable,

4 x 5-inch and larger color transparencies are usually sufficiently sharp for all normal purposes, regardless of the brand of color film that was used.

When speaking of "sharpness," we must distinguish between *the sensation* people experience when looking at a transparency or print and *the quality of the film,* which in part at least is responsible for it. For the sensation of sharpness is influenced by several factors that have nothing to do with the "sharpness" of the film itself, such as subject matter and form of rendition, picture contrast, and the grain structure of the film. As a matter of fact, a high-contrast subject generally *appears* sharper than a low-contrast subject, and under certain circumstances, a coarse-grained transparency may *appear* sharper than a fine-grained one which *actually is sharper* insofar as the color film it was made with had the greater resolving power, *i.e.,* was able to render sharply and separate satisfactorily from one another a larger number of lines per millimeter in a test. For example, a transparency in which the subject is rendered in *very slightly* blurred form (*i.e.,* not yet *obviously* unsharp) and contrast is low, made with a coarse-grained color film of low resolution power, may actually *appear sharper* than an otherwise identical shot (made, for example, as part of a film comparison test) on a high-resolution fine-grain color film. The explanation of this apparent paradox is that the high-resolution film appeared *uniformly blurred* since subject rendition was indistinct and the film grain too small to become apparent at the respective magnification. On the other hand, the coarser grain of the low-resolution film, which required less magnification to become visible, was sufficiently enlarged during projection (or printing or by the magnifier of the photographer who made the test) that it became apparent to the eye and, being "sharp," created the erroneous impression that the less-sharp film had produced the sharper image.

There are several ways of measuring the "actual" sharpness of a film which can be expressed in terms of resolving power (or resolution), acutance, or in the form of the more recent concepts of modulation-transfer function, spread function, and SMT acutance. For practical purposes, however, it is sufficient to know that, generally, "slow" fine-grain color films are somewhat sharper than "fast" films with coarser grain patterns, although, as mentioned, a transparency made with a faster film of coarser grain structure may *appear* sharper. And, in the end, isn't that what counts?

At present, the sharpest color films are Kodachrome II closely followed by Kodachrome-X, both of which, however, are available only in 35-mm (and movie-film) size. Least sharp are high-speed color films.

Graininess

"Film grain" is almost a dirty word among photographers, who have a tendency to shy away from "grainy" films. To me, this attitude seems to be much more justified in black-and-white than in color photography, where other factors like quality of color reproduction and exposure latitude should have priority when it comes to selecting a film. However, for those who take their film grain seriously, Kodachrome II closely followed by Kodachrome-X are the color films with the finest grain, high-speed color films those with the coarsest. But, as explained above, it is not necessarily the transparency with the finest grain that appears sharpest.

The variables

Color film is a highly complex and perishable commodity easily affected by outside influences. Already during manufacture, despite elaborate controls, minor variations in speed, contrast, and color balance among color films of the same type are unavoidable. Kodak manufacturing tolerances hold these disparities to within plus or minus one-half stop in speed while color balance is not allowed to vary in any direction by more than the equivalent of a 10 CC filter. In addition to these unavoidable variables, other avoidable and usually more serious deviations from standard may be caused by unsuitable storage conditions before or after exposure, and by variations in the processing of color films. Together, these variables may cause greater changes in color rendition than those caused by relatively large fluctuations in the quality of the light for which the film is balanced. This fact, of course, would make the use of corrective filters illusory unless the photographer (1) eliminates the avoidable variables by correctly storing, handling, and processing his film, and (2) precisely establishes by test the extent of the unavoidable variables so that he can correct them by suitable means.

p. 36

p. 114

Variations due to manufacture. These are generally greater among emulsions from different batches than among films with the same emulsion number. Film emulsion numbers are stamped on film boxes and embossed on the margin of sheet films. Whenever a series of related pictures must be taken, to minimize variations in color rendition it is strongly recommended to shoot all photographs on film carrying the same emulsion number.

The only way to find out if color film conforms to standard and, if not, the extent to which it deviates, is by means of actual tests as will be described later. A valuable aid in this are the supplementary data sheets packed by the manu-

p. 114

facturer with color sheet film which contain specific information pertaining to the particular film emulsion. However, it has been my experience that this information, valuable as it is as a guide, is not infallible, most likely because of subsequent changes in the emulsion due to adverse conditions during shipping and storing. Reliance on such data is therefore no substitute for actual tests.

To guard against variations in color rendition, whenever possible I make it a practice to buy color film in quantity, making sure that all the rolls or packages carry the same emulsion number. However, before I take home my supply, I have the dealer put it aside while I take out one roll or package of sheet film for testing. If the test is satisfactory, I collect the rest and store it in my freezer. If unsatisfactory, I try film with a different emulsion number. Photographers who don't use enough film to justify buying in bulk might do well to get together with others and do their buying and testing collectively.

Variations subsequent to manufacture. More easily than black-and-white film, color film is damaged by heat, humidity, moisture, and certain vapors and gases, notably the fumes given off by ammonia, formaldehyde, carbon tetrachloride and other solvents, and internal combustion engines. These agents, by affecting the three emulsion layers differently, upset the color balance of the film and may also cause overall changes in contrast and speed. To minimize these and other dangers, photographers should observe the following:

Watch the expiration date. Color film ages, deteriorates, and eventually becomes useless, no matter how suitable storage conditions may be. Consequently, the longer the time between manufacture and developing, the greater the danger of changes in the characteristics of the film. For this reason, manufacturers stamp an expiration date on every film box, indicating the date beyond which the film should not be used. Check this date when buying your film and refuse film that is either outdated, or unreasonably close to the expiration date. However, it has been my experience that color film that was very "fresh" when bought (i.e., with a long period ahead of it before expiration) and stored continuously in a freezer until it was used, kept its characteristics at least a full year beyond the manufacturer's expiration date, still producing beautiful results.

Heat protection. The destructive influence of heat upon color film emulsions is best illustrated by Kodak's comments regarding the storage of Kodachrome and Kodacolor films; these will keep for two months at temperatures up to 75°F, for six months at temperatures up to 60°F, and for twelve months at temperatures up to 50°F.

The best way to keep color film fresh for any length of time is to store it in a freezer at temperatures between 0 and $-10°F$. However, a difference must be made between factory-sealed and opened packages of color film. Factory-sealed film is packed in airtight, moisture-proof wrapping and thus protected from humidity (but not from heat); opened packages are not. Therefore, once the moisture-proof barrier has been broken, film that is to be refrozen, must first be desiccated by placing it together with an adequate supply of a desiccating agent like silica gel in a vapor-proof container for anywhere from two days to a week, the exact time depending on the amount of drying agent used and the relative humidity of the air to which the film had been exposed. Subsequently, the dried film is packed in a waterproof container or wrapping material, sealed with waterproof surgical tape, and refrozen.

Film that had been frozen must be given several hours to thaw and warm up to air temperature before the moisture barrier is broken. Otherwise, moisture from the air would condense on the cold surface of the film and penetrate the emulsion, causing streaks and spots. Frozen film is also extremely brittle, and particularly 35-mm film might tear or break if used in ice-cold condition.

Color film that cannot be stored in a freezer (or at least a refrigerator) must be kept in the coolest practicable place. In particular, *places to avoid* are attics or lofts (which get too hot) and basements (which get too damp), the glove compartment and rear decks of automobiles, shelves near radiators or hot water or steam pipes, and all places exposed even temporarily to the sun. Kodak advises traveling photographers to carry their film supply in a suitcase tightly packed with dry clothes, which provides good heat insulation and absorbs humidity before it gets to the film. That equipment cases and containers with film should never be left standing in the sun almost goes without saying: likewise, that a portable icebox makes an excellent storage place for color film on automobile trips in hot countries; that a heat-reflecting aluminum equipment case is better than a nonmetallic one, and that the worst possible color for a film storage container is black.

Moisture protection. Factory-sealed film is adequately protected against dampness by its moisture-proof wrapping. Exposed film, however, unless it can be developed without much delay, may have to be desiccated with the aid of a silica gel and subsequently kept in a moisture-proof sealed container if more or less serious deterioration is to be avoided. Excellent containers for desiccating 35-mm and rollfilm are stainless-steel developing tanks with tight lids sealed with waterproof surgical tape.

X-ray protection. In hospitals, doctor's offices, laboratories and other places where X-ray equipment or radioactive material is used, damage from radiation must be considered. If film must be stored in or near such localities, it is advisable first to test the safety of the contemplated storage place: at the selected spot, leave for several days one of the safety badges containing a piece of photographic film which X-ray personnel carry pinned to their clothing, then develop it. If the film is unaffected, the place ought to be safe for storing color film.

General precautions. Do not break the moisture-proof seal of film packages until the film is needed. Do not leave sheet film in holders longer than absolutely necessary. As far as possible, protect your film holders and film carrying case from the sun and bright light in general. Do not expose 35-mm or rollfilm cameras loaded with color film to the sun longer than absolutely necessary, keep them in the shade between shots (if there is no shade, use the shade cast by your body). Have your exposed color film developed as soon as possible. When traveling, ship exposed color film home by air as soon as you can instead of carrying it with you for the rest of the trip.

How to test color film. Before any photographer who takes his color seriously spends money on film and effort on shooting pictures, he will demand accurate information in regard to two vitally important factors: the *precise* way in which his particular color film emulsion reproduces color, and its *actual* speed. For no matter what manufacturers of color film may say in their advertisements, it is a fact that (1) a "perfect" color film does not exist: (2) different brands of color film vary widely in their response to color; (3) even within the same brand and type of color film, considerable fluctuations in regard to color rendition and film speed may occur. For these reasons, the only way to get at the facts is to conduct a test each time you buy a new batch of film.

pp. 90-91 To have any value at all, a color film test must be performed under strictly standardized conditions. In particular, this means that the test object, the light, the camera, the lens, the respective diaphragm stops and shutter speeds used, and the distance between test object and camera as well as between test object and photolamps, must be the same in every test because, otherwise, the resulting data would be useless and valid comparisons between the results of different tests impossible. And one more thing: *before* a photographer makes his first test, I suggest that he have a competent camera repairman check his shutter in regard to accuracy at all speeds and consistency at each setting. He probably will learn that few, if any, of his shutter speeds are what they are supposed to be—a common

occurrence that is not serious as long as deviations from the listed speed are not too great and the photographer knows the *actual* value of each speed (the repairman will prepare a little shutter-speed card for him). What is unacceptable are shutter speeds that vary from one shot to the next, usually as the result of accumulations of dirt and gummed oil within the mechanism. Such shutters must be cleaned before they can be adjusted and used.

Each type of color film must be tested in the light for which it is balanced, *i.e.*, daylight-type color film in "standard daylight," Type A film in 3400 K photoflood-lamp illumination, and Type B film in 3200 K tungsten-lamp illumination. The following tells you how to conduct a valid test:

pp. 243, 38

Prepare a setup consisting of swatches of differently colored matte papers plus a good-sized swatch of dead-black material, ditto one that is pure white, and a Kodak Neutral Test Card of 18 percent reflectance (or a large Kodak Gray Scale) to represent gray, and a live model (to represent skin tones). Evenly illuminate this setup with the appropriate type of light and make a series of test shots around the exposure indicated as correct by your exposure meter, using the same shutter speed for all the pictures but varying the diaphragm aperture by one-half f-stop between exposures. In this way, make a sequence of five or seven photographs ranging from severe underexposure through correct exposure to severe overexposure. For permanent foolproof identification of each shot (without which the entire test would be a waste), write the following data on a piece of paper which you include in your setup: brand name and type of color film; emulsion number; date of test; type of illumination; identification of camera and lens. Also, prepare a set of smaller cards on which you write the pertinent data for each shot: f-stop number, shutter speed and, if necessary, type and density of the color correction filter used. Place these cards so that they appear prominently in the pictures (don't forget to change them after each shot). Conspicuously mark the card which contains the data that according to exposure meter ought to be correct. If this particular test shot turns out to be the one with the best exposure, the *actual* speed of the tested emulsion is the same as its *listed* speed; if not, you know right away whether this particular film is slow or fast.

Use a tripod to insure that all shots are made at the same distance and to avoid accidental camera movement, which might blur the rendition just enough to make reading the data cards impossible. To minimize the danger of color distortion due to processing variations, have the test film developed by the same color lab that does your regular work.

A test of this kind provides priceless information in three respects: film speed, exposure latitude, and color rendition. Evaluation in regard to speed and exposure latitude is obvious. Evaluation of color rendition should mainly be based upon rendition of the gray and white areas of the test chart: the "cleaner" and more neutral the steps of gray, and the "whiter" the white (i.e., the less degraded by overtones of color—a greenish, bluish, or pinkish tinge), the better the color balance of the film.

p. 225

p. 36

For accurate evalution of the test, the individual transparencies should be masked, mounted side by side in a black cardboard frame, and viewed in a dim room on a light-box or a light-table illuminated by light with a color temperature of 4000 to 4500 K and a brightness of at least 100 (better 150) candles per square foot. If the grays have a color cast, view the test shots through a Kodak Color Compensating Filter in the complementary color until you find a filter through which the gray appears neutral. Then run another test, using a filter in the same color but of *half the density* as the viewing filter. A second test is necessary because eye and color film often react differently, and a visual match does not necessarily guarantee a similar result on film.

Mode of processing. Distinguish in this respect between three classes of color film: those that can be processed by either the user, the manufacturer, or a commercial color lab; those that *cannot* be processed by the user but *must* be processed by *either* the manufacturer *or* a commercial color lab; and those that *can* be processed by the user or a commercial color lab but are *not* processed by the manufacturer. Informaton of this kind is of interest to photographers who either wish to have their color films processed by the manufacturer because, normally, this is the best guarantee for top-quality service, or to those who wish to do their own processing. If necessary, ask your dealer to which one of these three groups the film you would like to use belongs.

Color-film development is a highly critical process. Unless done precisely in conformance with the manufacturer's specifications, the result will be unsatisfactory. Normally, the more highly standardized the procedure and the more fully automated the processing equipment, the better the result. For this reason, selection of a reliable color lab is as important to a color photographer as selection of the right type of film. As a matter of fact, carefully controlled tests have shown that color variations due to variations in processing (by different color labs) are usually greater than variations resulting from all other causes together—a reminder to any photographer to choose his color processor with care.

116

3

How To Take a Picture

PHOTOGRAPHY AT THE BASIC LEVEL

Photography can be pursued on many different levels. Without any previous experience, simply by following the instructions that accompany every new camera, exposure meter, or roll of film, anyone can snap pictures that are technically adequate and pleasing to look at. This is photography on the basic level, the level at which to start, the level at which all of us began. You will be able to compete successfully at this level if you observe the following twelve "basic rules":

1. Read—and study—your camera's instruction manual. Familiarize yourself with the different controls and how they work, make a few "dry runs" involving the whole sequence of operations from loading the camera to rewinding the film before you make your first shot.

2. Load the camera with the right type of film—for slides (transparencies) or for color prints, for daylight or for photoflood illumination. Be sure to keep camera and film out of the sun during this operation or extraneous light might fog and ruin your film. If there is no shade, turn away from the sun and load the camera in the shadow of your body. p. 102

3. Photograph only subjects in which you are genuinely interested. p. 7

4. Avoid unusually contrasty subjects with which neither the color film nor the automatic exposure controls of your camera can cope. For the same reason, make sure that your subject is either *completely* in the sun, or *completely* in the shade. Until you are more experienced, avoid photographing a light subject against a very dark background, and a dark subject against something very light. p. 319

5. Watch the direction of the light relative to your subject. Until you have p. 222

117

more experience, it is best to have the light-source more or less behind your back as you face the subject.

6. Don't pose people so that they have to face the sun while having their portraits taken. This would make them squint and mar their faces with harsh and ugly shadows. Instead, place your model so that the sun shines on her back or side, set your exposure controls for bright sunlight, then take the picture either with a blue flashbulb or with electronic flash. The only thing you have to watch out for is that no direct sunlight falls upon your lens. A good lens shade, or the shadow cast by another person placed accordingly, will prevent this.

pp. 43, 45

7. Move in on your subject—whatever it may be—until it fills the entire viewfinder frame. One of the most common mistakes made by beginners is to take pictures from too far away. Such pictures contain too much, and too diversified, subject matter, and everything shown is rendered too small to be effective.

p. 200

8. Watch the background behind your subject. Make sure it is not too cluttered and distracting. Often, taking a few steps in either direction, by changing the relationship between subject and background, can improve a picture enormously.

p. 135

9. Set the diaphragm and shutter speed according to the exposure table in the instruction sheet that accompanies your film; or, use your camera's built-in exposure meter, or a separate exposure meter, in accordance with the instructions that accompany it.

p. 121

10. Focus the lens sharply on your subject (consult your camera's instruction manual).

11. When making the exposure, *hold the camera level* and *perfectly still.* Spread your feet apart, brace yourself, press the camera firmly against your face and your elbows against your ribs, hold your breath, and *slowly* press the shutter release button without jerking the camera. Otherwise, your picture will be blurred.

12. Immediately following the exposure, wind the film. If the film transport and shutter cocking mechanisms are coupled, this makes you ready for the next shot more quickly; if they are separately operated, you will avoid possible double-exposure.

118

How to steady a camera during exposure

The number one picture spoiler, particularly among beginners, is unsharpness or blur due to inadvertent camera motion during exposure. To avoid, do two things: shoot at the highest practicable shutter speed, and hold the camera as still as possible. Normally, 1/60 second is about the slowest shutter speed that most people can hand-hold without incurring blur; anything slower requires mounting the camera on a tripod and releasing the shutter by means of a flexible cable release, or pressing the camera firmly against a solid object—a wall, fence, chairback, tree, telephone pole, etc. These precautions become increasingly important, the longer the focal length of the lens since telephoto lenses, while magnifying the subject, also magnify the effects of camera movement.

To avoid accidental camera movement while making a hand-held exposure, observe the following precautions: Take a steady stance, feet slightly apart, elbows pressed against the ribs. Get a comfortable grip on the camera and press camera and hands firmly against your forehead, nose, and cheek for additonal steadiness. Take a deep breath, let it out halfway, hold it for a second and during this moment make the exposure by slowly "squeezing" the release button until the shutter goes off. If possible, brace yourself by resting part of your body against a firm support, like leaning your back or shoulder against a wall, a tree, a car or other rigid object. Keep in mind that unsharpness due to inadvertent camera motion during exposure is most commonly caused by an insecure stance and a jerky, sudden jab at the shutter release button.

PHOTOGRAPHY AT THE SECOND LEVEL

Photographers who wish to progress beyond the basic level must not only know *what* to do, but also *why* to do it. For example, in bright sunlight, Kodachrome II film will yield correctly exposed transparencies if the lens is stopped down to f/8 and the shutter set at 1/100 sec. However, the exposure would also have been correct if, instead of using the above data, a photographer had made the picture with a diaphragm opening of f/2.5 and 1/1,000 sec., or f/16 and 1/25 sec. Giving him this information is telling him *what* to do. But in order to select the particular combination of f-stop and shutter speed which is most suitable for a specific occasion—the combination which would give him *the most effective picture* —he must know *why* he is doing what he does. It is this difference between knowing *what* and knowing *why* which makes the difference between photographing at the basic and the second level.

A photographer who works at the second level brings home pictures that are superior to those made by one who is unable to go beyond the basic level. Why? Because there is always the problem of *choice*—any subject can be rendered in an almost limitless number of different ways. But only a photographer familiar with the "Why?" will be able to make an intelligent selection among the many possible ways of rendition.

This brings us to a common misconception: the idea that photography is "easy." It is—and yet it isn't. In this respect, photography is somewhat like reading and writing: any normal person can learn to read and write without much difficulty; but having learned how to read and write does not necessarily make him a good writer. Likewise, in photography, camera and film manufacturers have made it very easy to make rather pleasing snapshots without any knowledge except the limited information given in the instruction sheets or booklets which they provide. But following these instructions doesn't necessarily make one a great photographer. Unfortunately, many beginners encouraged by initial success, are loath to go beyond this "easy" stage and dig deeper into what seems like a complex and difficult subject. They want results without "going back to school." They may remember periods of learning which required hard work and entailed frustration. If photography is their hobby, they want to encounter nothing of that sort. They think a hobby should provide fun and relaxation. But it is neither amusing nor relaxing if inadequate photo-technique makes pictures disappointing. To avoid this, students of photography must start with fundamentals and systematically learn the elements of their craft. These are presented in the following sections.

The technically perfect color transparency, in addition to being absolutely clean—free from spots, streaks, scratches, and fingermarks—combines sharpness (or a deliberately chosen degree of unsharpness or blur) with proper color balance, contrast, and the right degree of lightness or darkness. To make it a perfect *picture,* it must be well composed. The four operations which bring on these desirable results are

<div align="center">

Viewing
Focusing
Exposing
Processing

</div>

How these operations, their controls, and the results they produce, are interrelated, is shown in the following diagram.

120

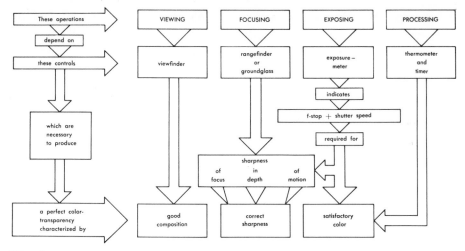

Viewing

At the basic level, viewing is equivalent to aiming, and aiming a camera is very much like aiming a gun: the photographer lines up his subject squarely in his "sights"—the viewfinder—and "shoots," satisfied if he gets his victims on the film without cutting off their heads.

At the second level, however, viewing is what the term implies: a deliberate contemplation and examination of the subject within the confinements of the viewfinder with the objective in mind, not only to "get it on the film," but also to get it on the film in a form that shows it to best advantage and will make the future picture a graphically satisfactory, self-contained unit. In other words an operation which, at the basic level, amounted to nothing more than mechanically pointing the lens at the subject now becomes *composing*. Since this is a large and important topic, I have devoted an entire chapter to its discussion. p. 368

Focusing

Focusing means adjusting the distance between lens and film in accordance with the distance between lens and subject *to produce a sharp image*. The *nearer* the subject, the *greater* the distance between lens and film, and vice versa. If the subject is very far away, or at "infinity," the distance between lens and film, except for telephoto and retrofocus wide-angle lenses, is approximately equal to the focal length of the respective lens; this is the shortest distance between p. 72 lens and film at which a lens can still produce a sharp picture. Visual controls—a lens-coupled rangefinder or the groundglass of a reflex or view camera—show pp. 55, 56

the photographer whether the image is out-of-focus and unsharp, or in focus and sharp.

Three kinds of sharpness. The observant reader will have noticed that three kinds of sharpness were listed in the diagram on p. 121. This is how they differ:

Sharpness of focus is essentially two-dimensional sharpness theoretically limited to the plane on which the lens is focused. It is a function of focusing.

Sharpness in depth is three-dimensional sharpness which, in the photograph, extends the zone of sharpness in two directions at right angles from the plane of focus: toward and away from the camera. It is the combined result of focusing (which places the plane of focus at the desired distance from the camera) and stopping down the lens (which extends the depth of the sharply rendered zone from the plane of focus both toward and away from the camera). It is a function of the diaphragm.

p. 125

Sharpness of motion means that a subject in motion has been rendered sharp instead of blurred. This is done by accurately focusing—by placing the plane of focus at the distance from the camera where the moving subject is located—and using a shutter speed high enough, or electronic flash, to "freeze" or "stop" the subject's motion in the rendition. Sharpness of motion is a function of the exposure time.

Sharpness is a psychophysiological phenomenon. Actually, one should only speak of "apparent sharpness" because sharpness is always relative. If a transparency or print *appears* sharp it *is* sharp as far as the observer is concerned, even though when further enlarged it would eventually become "unsharp." For if sufficiently magnified, even the sharpest negative, transparency, or print becomes unsharp. "Absolute" sharpness does not exist.

Theoretically, sharpness is when a point-source of light (for example, a star) is rendered in the transparency as a point. Practically, of course, this is impossible because even the most perfect image of a star is not a point (which has a diameter of zero) but a circle. Similarly, the image of a subject is not composed of an infinite number of points, but of tiny, overlapping circles called "circles of confusion." The smaller these circles of confusion are, the sharper the image appears.

For practical purposes, the definition of "sharpness" has been related to negative size for the simple reason that small negatives must be sharper than large negatives because they must be able to stand higher degrees of magnification during enlarging. Generally, depth-of-field scales and tables (that give the extension of

122

the sharply covered zone in depth at different diaphragm stops in conjunction with different subject-to-camera distances for lenses of different focal lengths) are computed on the basis that negatives 2.1/4 x 2.1/4 inches and larger are "sharp" if the diameter of the circle of confusion is no more than 1/1000 of the focal length of a standard lens for the respective film size. And a 35-mm negative or trans- p. 85 parency is considered "sharp" if the diameter of the circle of confusion is not more than 1/1500 of the focal length of the standard lens, which corresponds to a diameter of 1/750 inch.

Causes of unsharpness. Whether or not this degree of sharpness is achieved depends upon the following factors:

The sharpness of the lens, see p. 79.

The sharpness of the film, see p. 109.

Camera movement during exposure. I already mentioned that inadvertent p. 119 camera movement is the most common cause of unsharp pictures and recommended certain precautions. I'd like to add the following: The lighter and smaller a camera, the more difficult to hold it still during exposure. To overcome this disadvantage, some professional photographers attach a quarter-inch lead plate to the bottom of their 35-mm camera to increase its weight without objectionably increasing its volume; others leave a small electronic flash unit attached all the time, even when they don't intend to use it. A good way of steadying any camera is to wrap the strap around one's hand or wrist and tense it against the shoulder or neck so that its other end pulls against the camera, which in turn is pressed firmly against the face or, if a waist-level finder is used, the chest. When preparing to push the shutter release button, rest your finger on the collar that encircles it, then roll your fingertip onto the button itself; this method results in a softer release than a straight downward jab with a finger. If you add a release-extension button to your 35-mm or 2.1/4 x 2.1/4-inch camera—a small device that looks like an oversized thumbtack, screws into the release button, and considerably enlarges its surface—you will have still greater control over the exact moment of release. And unless other considerations prevail, use the highest possible shutter speed. Even though your lens may perform better at a smaller stop, such a gain in sharpness is likely to be more than offset by a loss of sharpness due to inadvertent camera motion caused by the then-required slower shutter speed.

Subject movement. When a subject in motion is photographed, its image moves across the film during the exposure with the result that it will be rendered more or less blurred. To reduce this unavoidable blur to a degree where it becomes un-

123

noticeable, the picture must be taken with a shutter speed high enough so that, during the time the shutter is open, the image of the moving subject moves only an imperceptibly small distance across the film. Whether or not a shutter speed is high enough to avoid blur depends on the motion of the subject relative to the film: a higher shutter speed is needed to "stop" a fast-moving subject than one that moves slowly; or a subject that moves across the field of view than one that moves toward or away from the camera; or a subject that moves close to the camera than one that is farther away. For specific information, consult the table on p. 357.

Rangefinder out of synchronization. To check, make this test: Take a printed page from a magazine. At approximately the center of the page, draw a black line above, another line below, the same line of print. Tape this page to a wall so that its lines run *vertically* and use it as a test object. Mount your camera on a tripod, the lens axis horizontal and its height that of the center of the page. Place your tripod to one side of the magazine page 3 to 4 feet from it *at an angle of approximately 45 degrees* (this is not critical). Sharply focus on the type between the two lines you drew and take a picture with the lens wide open. Examine the processed transparency with a good magnifier or project it. If the type between the lines is sharpest and the rest more or less fuzzy, the rangefinder and the lens are correctly synchronized. But if a line of type other than the one you had focused on—the one between the black lines—seems sharpest, the rangefinder and the lens are out of "sync" and they must be synchronized by a competent repairman before the camera can produce sharp pictures.

Dirty lens. Fingermarks on the glass, or a filmy deposit of grease and dust particles, act as diffusers and produce overall softness of the image. To clean a dirty lens correctly, use a soft camel's-hair brush to remove all traces of dust and grit from both surfaces; breathe on the glass and, with a piece of lens-cleaning tissue, gently wipe it clean. To avoid scratching the antireflection coating, don't press too hard. Make it a habit never to touch the glass with your fingers—the ever-present acid sweat might leave indelible marks.

A dirty filter has the same effect as a dirty lens.

Unsuitable filters. Acetate filters, because of their optically poor quality, are unsuitable for taking photographs although perfectly adequate for balancing the light of an enlarger used for making color prints (as long as they are used between light-source and film and NOT between the enlarging lens and the paper) or changing the overall color of a photo lamp.

124

Focus shift of the lens. Some high-speed lenses shift the plane of focus with a p. 85 change in f-stop. If such a lens is focused with the diaphragm wide open (as is the case in many 35-mm cameras with automatic diaphragm and built-in exposure meter) and then stopped down to shooting aperture *without refocusing,* the transparency will be slightly unsharp. To produce sharp pictures, such a lens must be focused with the same diaphragm stop with which the photograph will be made.

Turbulent air. This phenomenon can easily be seen when sighting across the steel top of an automobile that has been standing for a while in the sun: the heat rising from the hot metal in waves causes the background to wobble and appear now sharp, now blurred. Normally, this effect is too small to cause unsharpness. But it can become serious under certain conditions: if pictures are taken out of a window set in a sun-heated wall, waves of hot air rising past the window may blur the picture, and the same effect will often be observed when a shot is made across a hot radiator, chimney, or roof. And the magnifying power of long-focus and telephoto lenses will also magnify the effects of heat waves and turbulent air until it may become impossible to get sharp photographs. Turbulence strong enough to cause unsharpness is visible on the groundglass of an SLR, TLR, or view camera: parts of the image wobble, or the image appears partly or uniformly unsharp, only to snap suddenly (and temporarily) into sharp focus; this is the moment to release the shutter quickly before the mad dance starts again.

Buckling film. Film does not always stay flat in a camera or film holder. Under humid conditions, film, which is very hygroscopic, absorbs moisture and may buckle out of the plane of focus, the tendency to buckle increasing with film size. To minimize the danger of partial unsharpness, particularly when working with 8 x 10-inch film and a long-focus lens, it is advisable to stop down the diaphragm an additional stop or two to create a "safety zone" of extended depth of focus.

How to create sharpness in depth. Most photographic subjects are three-dimensional: in addition to height and width they have depth. This fact immediately raises two questions: Which depth zone of the subject shall I focus on? and: How can sharpness be extended beyond the *plane* of focus to cover a subject *in depth?*

The most instructive way of finding the answers to these questions is to mount an SLR or groundglass-equipped camera on a tripod and focus it obliquely on a subject that has great extension in depth, for example, a picket fence.

Step 1: With the diaphragm wide open, focus on a pale 3 to 4 feet from the camera. Notice that the pale on which you focused appears perfectly sharp; that

the pale in front of it and two or three behind it appear reasonably sharp, and that all others are unsharp, increasingly so, the farther they are from the plane of focus, *i.e.,* the pale you focused on.

Step 2: With the diaphragm wide open, focus on a pale about 30 feet from the camera. Notice that now a larger number of pales than in your first experiment, both in front and behind the one you focused on, appear sharp.

Step 3: Focus on a pale about 15 feet from the camera and, while gradually stopping down the diaphragm, watch the image on the groundglass. Notice that, as the diaphragm aperture is decreased (and the image darkens), more and more pales are brought into sharp focus.

Evaluation of this test reveals the "secret" of creating sharpness in depth:

1. A certain amount of sharpness in depth is inherent in any lens. It is the greater the slower the respective lens and the farther the plane of focus from the camera.

2. Normally, the "inherent depth" of a lens is insufficient to cover the entire depth of the subject. It then becomes necessary to increase the zone of sharpness in depth. The means for this is the diaphragm.

3. The more the diaphragm is stopped down, the more extensive the zone of sharpness in depth. Also, the darker the image and consequently the longer the exposure.

4. Stopping down the diaphragm creates a zone of sharpness in depth in front of and behind the plane of focus. Therefore, it is wasteful to focus on either the beginning or the end of the depth zone that must be rendered sharply and then stop down the lens accordingly. For example, focusing on infinity and stopping down the lens is wasteful because depth beyond infinity is useless.

5. Stopping down the diaphragm creates proportionally *more sharpness in depth behind the plane of focus* than in front of the plane of focus. This being the case, the best way to cover a three-dimensional subject in depth is to

> focus the lens on a plane situated approximately one-third within the subject's depth

and stop down the diaphragm until the entire subject is covered sharply.

How much to stop down. Selecting the most advantageous diaphragm stop usually amounts to making a compromise between two conflicting interests:

Large diaphragm apertures have the advantage that they permit a photographer to use the relatively high shutter speeds which are required to minimize the chances of getting unsharp pictures due to inadvertent camera movement and to "stop" subject motion. They have the disadvantage that the sharply covered zone in depth is relatively small.

Small diaphragm apertures have the advantage that they create a relatively extensive zone of sharpness in depth. They have the disadvantage that they require proportionally long exposure times which may result in unsharpness due to inadvertent camera movement, necessitate the use of a tripod or other firm camera support, and may be insufficient to "stop" subject motion, causing the picture to be blurred.

To determine the diaphragm stop necessary to cover a given zone in depth, observe the image on the groundglass or use the camera's depth-of-field indicator: first, focus on the nearest, then on the farthest part of the subject which must be rendered sharply, to determine their distances from the camera. Note each distance as registered on the foot scale. Refocus the lens until identical diaphragm stop numbers appear on the depth-of-field indicator scale opposite the foot numbers that correspond to the beginning and end of the zone that must be sharply covered. Leave the lens as focused and stop down the diaphragm to the f-number that appears opposite the foot-numbers that correspond to the distances at the beginning and the end of the subject-depth. In this way a maximum of sharpness in depth is created with a minimum of stopping-down.

The hyperfocal distance. When a lens is focused on infinity, sharpness in depth extends from infinity to a certain distance toward the camera. Precisely at which distance from the camera sharpness begins depends on the focal length of the lens, the diaphragm aperture, and the diameter of the circle of confusion: p. 122 the shorter the focal length, the smaller the diaphragm aperture, and the larger the diameter of the circle of confusion, the nearer the camera the beginning of the sharply covered zone. The distance from the camera to the beginning of this sharply covered zone is called the *hyperfocal distance*.

> If a lens is focused on the hyperfocal distance, sharpness in the picture extends from half the hyperfocal distance to infinity.

A photographer can easily determine the hyperfocal distance for any of his lenses

at any diaphragm stop with the aid of the following formula (this could be a worthwhile job for a rainy afternoon):

$$\text{Hyperfocal distance equals } \frac{F^2}{f \times d} \text{ inches}$$

p. 122
In this formula, F is the focal length of the lens in inches; f is the diaphragm-stop number; d is the accepted diameter of the circle of confusion in fractions of an inch.

For example, a landscape photographer wishes to make a picture with his 4 x 5-inch view camera in which sharpness in depth should extend from infinity to as close to the camera as possible, using a lens with a focal length of 5 inches stopped down to f/22. Sharpness of the transparency should be governed by the require-
p. 123
ments stated previously according to which the diameter of the circle of confusion must not exceed 1/1000 of the focal length of the lens. In this case it would be 5/1000, or 1/200 of an inch. To produce the maximum extent of sharpness with a minimum of stopping down, the lens must be focused at hyperfocal distance. Then everything from half that distance to infinity will be sharp in the picture. The hyperfocal distance can be found by the formula given above which leads to the following equation:

$$\frac{F^2}{f \times d} = \frac{5^2}{22 \times 1/200} = \frac{25}{22} \times 200 = 227 \text{ inches} = \text{about 19 feet.}$$

Accordingly, by focusing his lens at 19 feet and stopping it down to f/22, the photographer can create a sharply rendered zone which begins at 9½ feet from his camera (half the hyperfocal distance) and extends to infinity.

And here is another useful formula:

If you want to find the f-stop that is required to create a sharply covered depth-zone that begins at a given distance from the camera and extends to infinity, the following formula will provide the answer:

$$\text{f-stop number equals } \frac{F^2}{H \times d}$$

p. 122
In this formula, F is the focal length of the lens in inches; H is the hyperfocal length in inches; d is the diameter of the permissible circle of confusion in fractions of an inch.

For example, you wish to shoot a picture with your 35-mm camera in which sharpness extends from infinity to 10 feet from the camera. You use a 2-inch lens and accept a circle of confusion with a diameter of 1/1500 of the focal length of the

lens, or 1/750 inch. You know by now that to get a maximum of depth with a minimum of stopping down you must focus your lens at twice the distance at which sharpness in the picture should begin or, in this case, at 20 feet (240 inches) from the camera. But how far do you have to stop down the diaphragm to create a zone of sharpness in depth sufficient to cover the distance from 10 feet to infinity? Here is your answer:

$$f = \frac{F^2}{H \times d} = \frac{2^2}{240 \times 1/750} = \frac{4}{240} \times 750 = \frac{750}{60} = 12.5$$

Accordingly, by focusing your lens at a distance of 20 feet and stopping down to f/12.5, you can create a sharply covered depth-zone which begins at 10 feet (half the hyperfocal distance) and extends to infinity.

Depth of field. The sharply covered depth-zone in a photograph is called the *depth of field.* Its extent depends upon the two following factors:

The distance between subject and lens. The farther away the subject, the greater the extent of the sharply covered zone in depth created by any given diaphragm stop. For this reason, close-ups require smaller diaphragm stops than long shots; at short subject distances, stopping down is "less effective."

The focal length of the lens. At equal subject-to-lens distances, short-focus (wide-angle) lenses have greater depth of field than long-focus (telephoto) lenses, all other factors being equal. However, if the size of the image on the film (the scale of rendition) and the f-stop are the same, the depth of field will also be the same *regardless of the focal length of the lens.* For example, if a portrait is taken with a lens of 50-mm focal length from a distance of 3 feet, and another shot is made with a lens of 200-mm focal length from a distance of 12 feet, the scale of both images will, of course, be the same. And if both pictures are made with identical diaphragm stops, depth of field will also be the same in both, although one was made with a short-focus and the other with a long-focus lens. However, as we will see later, the perspective of the two pictures would be different. pp. 339-340

Exposing

Exposing means admitting to the film the exact amount of light necessary to produce transparencies in colors that match those of the subject. Basically, if the light is dim, a longer exposure is required than if the light is bright; likewise, other factors being equal, a slow film requires a longer exposure than a faster film. Precisely how long a certain type of color film must be exposed under certain con-

ditions is determined with the aid of the exposure table in the instruction sheet that accompanies every roll or box of color film or, better still, with the aid of an exposure meter. If positive (reversal) color film is incorrectly exposed, this is what happens:

p. 135

Overexposure (exposure too long—shutter speed too slow or diaphragm aperture too large, too much light admitted to the film) produces transparencies that are too light. They seem too "thin," their colors are diluted or completely washed out, and shadow areas appear unnaturally transparent and detailed.

Underexposure (exposure too short—shutter speed too high or diaphragm aperture too small, too little light admitted to the film) produces transparencies that are too dark. Light colors appear darker than they were in reality, dark colors may be rendered as black.

Exposure controls. The two devices which control the exposure are the diaphragm and the shutter, each of which has two functions:

The diaphram controls	the amount of light admitted to the film
	the extension of sharpness in depth
The shutter controls	the time light is admitted to the film
	the sharpness of subjects in motion

For the moment, let's disregard the second functions of these two devices which, as we will see later, influence the exposure only indirectly. We are then left with what amounts to a *light control* (the variable diaphragm aperture) and a *time control* (the variable shutter speed). Through appropriate adjustment of these controls, the desired result—a correctly exposed transparency—can be achieved in many different ways.

pp. 75-76 As explained earlier, the diaphragm is calibrated in f-stops, which are numbered in such a way that reducing the diaphragm aperture from one f-stop to the next (for example, from f/5.6 to f/8) reduces by one-half the amount of light that can reach the film. Conversely, increasing the diaphragm aperture by one stop (for example, from f/8 to f/5.6) doubles the amount of light that can reach the film. Now, since the shutter is calibrated in such a way that doubling its speed (for example, from 1/100 sec. to 1/200 sec.) cuts down the amount of light admitted to the film by one-half—or halving its speed (for example, from 1/200 sec. to 1/100 sec.) doubles the amount of light admitted to the film—it is easy to see that the same result, a correct exposure, can be achieved in many different ways. For example, *as far as the color rendition in the transparency is concerned*, an

130

exposure of, say, 1/100 sec. at f/8, will produce exactly the same result as an exposure of 1/200 sec. at f/5.6. However, as far as the extent of sharpness in depth and rendition of subjects in motion are concerned, *the results would be very different* indeed—the reason it is important to know not only *what* a photographer should do but also, as already mentioned, *why* he should do it.

p. 119

Since, *as far as the exposure is concerned,* the *same* result can be achieved by *different* combinations of diaphragm aperture and shutter speed, the idea suggests itself to *indicate by a single number* each group of combinations that produce the same exposure. This is the basis of the Exposure Value Scale, also known as the EV or LVS (for Light Value Scale) system. It has been adopted by several camera manufacturers and works as follows:

The EV system consists of the numbers 1 to 18. Each number represents one specific group of different diaphragm and shutter-speed combinations, each group producing a specific exposure. Calibration is such that each EV number represents an exposure that admits exactly twice the amount of light to the film as the next higher number. For example, EV 10 represents twice the exposure of EV 11, which in turn represents twice the exposure of EV 12, and so on.

The appropriate EV number is found by taking a brightness reading of the subject with an exposure meter (or by consulting an exposure guide) and setting the camera's EV dial or ring accordingly. The EV number is then locked in place by engaging the cross-coupling mechanism, which connects the diaphragm control with the shutter-speed control. Now if the photographer changes one control—either the diaphragm or the shutter speed—the other will automatically change by a corresponding amount in the opposite direction. In other words, increasing the diaphragm aperture decreases the time the shutter is open, and vice versa, with the result that over the entire range of possible exposure settings the exposure remains constant.

p. 135

According to lighting conditions, EV numbers can be divided into four groups:

Lighting condition	EV numbers	Exposure range
At night; indoors; in dim light	2 to 8	1 sec. f/2 to 1/60 sec. f/2
On overcast days; in deep shade	9 to 12	1 sec. f/22 to 1/1000 sec. f/2
Average subjects in sunlight	13 to 15	1/15 sec. f/22 to 1/1000 sec. f/5.6
Light subjects in bright sunlight	16 to 18	1/125 sec. f/22 to 1/1000 sec. f/16

Here is a summary listing the EV numbers 1 to 18 together with the respective shutter speed and f-stop equivalents that each number represents:

1 — 1 sec. at f/1.4

2 — 1 sec. at f/2
½ sec. at f/1.4

3 — 1 sec. at f/2.8
½ sec. at f/2
¼ sec. at f/1.4

4 — 1 sec. at f/4
½ sec. at f/2.8
¼ sec. at f/2
⅛ sec. at f/1.4

5 — 1 sec. at f/5.6
½ sec. at f/4
¼ sec. at f/2.8
⅛ sec. at f/2
1/15 sec. at f/1.4

6 — 1 sec. at f/8
½ sec. at f/5.6
¼ sec. at f/4
⅛ sec. at f/2.8
1/15 sec. at f/2
1/30 sec. at f/1.4

7 — 1 sec. at f/11
½ sec. at f/8
¼ sec. at f/5.6
⅛ sec. at f/4
1/15 sec. at f/2.8
1/30 sec. at f/2
1/60 sec. at f/1.4

8 — 1 sec. at f/16
½ sec. at f/11
¼ sec. at f/8
⅛ sec. at f/5.6
1/15 sec. at f/4
1/30 sec. at f/2.8
1/60 sec. at f/2
1/125 sec. at f/1.4

9 — 1 sec. at f/22
½ sec. at f/16
¼ sec. at f/11
⅛ sec. at f/8
1/15 sec. at f/5.6
1/30 sec. at f/4
1/60 sec. at f/2.8
1/125 sec. at f/2
1/250 sec. at f/1.4

10 — ½ sec. at f/22
¼ sec. at f/16
⅛ sec. at f/11
1/15 sec. at f/8
1/30 sec. at f/5.6
1/60 sec. at f/4
1/125 sec. at f/2.8
1/250 sec. at f/2
1/500 sec. at f/1.4

11 — ¼ sec. at f/22
⅛ sec. at f/16
1/15 sec. at f/11
1/30 sec. at f/8
1/60 sec. at f/5.6
1/125 sec. at f/4
1/250 sec. at f/2.8
1/500 sec. at f/2
1/1000 sec. at f/1.4

12 — ⅛ sec. at f/22
1/15 sec. at f/16
1/30 sec. at f/11
1/60 sec. at f/8
1/125 sec. at f/5.6
1/250 sec. at f/4
1/500 sec. at f/2.8
1/1000 sec. at f/2

13 — 1/15 sec. at f/22
1/30 sec. at f/16
1/60 sec. at f/11
1/125 sec. at f/8
1/250 sec. at f/5.6
1/500 sec. at f/4
1/1000 sec. at f/2.8

14 — 1/30 sec. at f/22
1/60 sec. at f/16
1/125 sec. at f/11
1/250 sec. at f/8
1/500 sec. at f/5.6
1/1000 sec. at f/4

15 — 1/60 sec. at f/22
1/125 sec. at f/16
1/250 sec. at f/11
1/500 sec. at f/8
1/1000 sec. at f/5.6

16 — 1/125 sec. at f/22
1/250 sec. at f/16
1/500 sec. at f/11
1/1000 sec. at f/8

17 — 1/250 sec. at f/22
1/500 sec. at f/16
1/1000 sec. at f/11

18 — 1/500 sec. at f/22
1/1000 sec. at f/16

Now it may seem as if it should suffice to equip a camera with *a single exposure control* calibrated in EV numbers instead of complicating matters by having to fool around with *two controls,* shutter *and* diaphragm. As far as the exposure itself is concerned, this is perfectly true. However, more is involved because, as already mentioned, in addition to controlling the exposure, the diaphragm controls the *extension of sharpness in depth,* and the shutter *also* controls the *degree of sharpness with which subjects in motion will be rendered.* It is for this reason that a camera must have *two separate* exposure controls: shutter *and* diaphragm. The following table shows the interrelationship between diaphragm opening (f-stop number), the comparative exposure factor, the corresponding shutter speed at EV 10, and the resulting effects.

p. 130

f-stop number*	1	1.4	2	2.8	4	5.6	8	11	16	22
comparative exposure factor†	1	2	4	8	16	32	64	128	256	512
corresponding shutter speed at EV 10††	1/1000	1/500	1/250	1/125	1/60	1/30	1/15	1/8	1/4	1/2

Diaphragm openings get larger	diaphragm openings get smaller
f-stop numbers get smaller	f-stop numbers get larger
sharpness in depth decreases	sharpness in depth increases
exposure times get shorter	exposure times get longer
groundglass image brightens	groundglass image darkens

* The sequence represents the so-called American f-number system. At present, no lens with a relative aperture of f/1 is available, although an f/0.95 lens for 35-mm cameras exists. The value f/1 is listed here only to complete the sequence.

† The comparative exposure factor shows the relationship between different f-stops in regard to exposure *time*. For example, if a picture requires a specific exposure time at a specific f-stop, if the lens is stopped down another f-stop (to the next-larger f-number), if the exposure is to remain the same, the exposure *time* must be *doubled* (i.e., the shutter speed halved) or multiplied by a factor of 2. If the lens is stopped down *two* more stops, exposure *time* must be *quadrupled* (i.e., multiplied by a factor of 2 x 2). If the lens is stopped down *three* more stops, exposure *time* must be increased *eightfold* (i.e., multiplied by a factor of 2 x 2 x 2); and so on.

†† The shutter speeds listed here apply only if film speed and lighting conditions require an exposure in accordance with an Exposure Value (EV) of 10. They are introduced to illustrate the relationship between diaphragm opening (f-stop) and shutter speed (exposure *time*). As can be seen, they almost (but not quite) correspond to the comparative exposure factors. The slight discrepancy is due to the fact that the exposure factors represent a mathematically accurate progression whereas the f-stop numbers and shutter speeds represent compromises made in the interest of simplicity. To be precise, f/11 should be f/11.2, and f/22 should be f/22.4. Similarly, 1/60 sec. should be 1/62.5 sec., 1/30 sec. should be 1/31.25 sec., and so on. These slight discrepancies are, of course, negligible.

133

The preceding table contains the secret of successful exposure control because it shows how closely the three operations, *focusing,* setting the *diaphragm,* and setting the *shutter speed,* are related. Invariably, a change in one necessitates readjustment of one or both of the others if the result is to be a satisfactory transparency. For example, selection of a *higher* shutter speed (*shorter* exposure time) —perhaps to avoid unsharpness due to inadvertent camera movement, or to "stop" subject motion—requires a corresponding *increase* in diaphragm opening (*smaller* f-stop number), which in turn *reduces* the extent of the sharply covered zone in depth, as a result of which the photographer must *focus his lens more carefully* since minor focusing errors are no longer covered by extensive sharpness in depth. Conversely, use of a *smaller* diaphragm opening (*larger* f-stop number), which might be required to render a subject with great depth sufficiently sharp in its entirety, requires a corresponding *increase* in exposure time (*slower* shutter speed), which in turn may necessitate mounting the camera on a *tripod* since now the shutter speed may be too slow for a hand-held exposure without invoking the danger of unsharpness due to inadvertent camera movement. And so on.

The Magic 16. Here is a useful formula for those who left their exposure meter at home or threw away the instruction sheet that came with their film: In average sunlight, for front-lighted subjects of average brightness, the normal exposure time at f/16 is $\dfrac{1}{\text{ASA speed}}$ second. For example, with Kodachrome-II, which has an ASA speed of 25, the correct exposure at f/16 would be 1/25 sec.; with Anscochrome D/200, which has an ASA speed of 200, the correct exposure at f/16 would be 1/200 sec.; and so on.

Given this basis it is easy to calculate data for other occasions. For example, if a *higher* shutter speed is required, *doubling* the speed (for example from 1/25 to 1/50 sec.) must be compensated for by *increasing the diaphragm aperture by one stop* (from f/16 to f/11); *quadrupling* the shutter speed (say, from 1/25 to 1/100 sec.) requires a diaphragm *two stops* larger (f/8 instead of f/16); and so on. Likewise, adjustments for lighting conditions different from average sunlight are easily made: in hazy sunlight, open up one-half to one full stop; if the sky is cloudy-bright, open up two stops; if the sky is solidly overcast, open up three stops. Admittedly, such exposure data are not as accurate as those determined with the aid of an exposure meter; but they are better than nothing and provide a sound basis for "bracketing."

p. 150

134

How to use an exposure meter correctly

Exposure tables and guides may be sufficiently accurate for average demands under average working conditions, but only a photo-electric exposure meter enables a photographer to do precise work. Correctly used, it not only permits him to measure the overall illumination of a scene and detect minor fluctuations in brightness, but it alone allows him to establish the contrast range of a subject through measurements of its lightest and darkest areas and, if photographs are taken indoors, to correctly adjust his lights. Shadows and backgrounds that are too dark can thus be detected and lightened with fill-in illumination, and over-lighted areas that otherwise would appear burned-out in the transparency can be toned down. But although an exposure meter is a marvelous instrument, it cannot think. No matter how expensive and reliable your meter, unless you correctly interpret its readings in the light of present circumstances, it may lead you astray. Here are some of the facts which must be kept in mind:

Exposure meters "think average." If you prepare a test object consisting of three large cards—one white, one black, and one medium gray (like a Kodak Neutral Test Card)—take *an overall brightness reading* with a reflected-light integrating exposure meter, and expose your color film accordingly, you will get a transparency in which the three different tone values are correctly rendered. However, if you take an individual brightness reading of each card and make a shot of each exposed in accordance with the respective meter reading, I'm p. 92 sure the result would surprise you: the tone values of the resulting three transparencies would be more or less the same. In other words, the white card would be rendered as a medium gray (*i.e.,* too dark); the gray card would also be rendered as a medium gray (in this case, correctly); and the black card too would be rendered as a medium gray (*i.e.,* too light).

The lesson which a photographer can learn from such a test is this: In combination, the three cards represented "a subject of average brightness" since the above-average brightness of the white card was compensated for by the below-average brightness of the black card. Consequently, an exposure based upon data furnished by an integrating reflected-light exposure meter produced a transparency in which the tone values appeared natural. And the same applied to the close-up of the gray card: representing a subject of average brightness, it too was rendered in its "natural" tone when exposed in accordance with the data furnished by the exposure meter.

135

The white card, however, represented something abnormal, a subject of above-average brightness. Now, as I said in the beginning of this chapter, exposure meters cannot "think," i.e., they cannot distinguish between subjects of average, above-average, and below-average brightness. And since they cannot make such distinctions, they treat *all* subjects as if they were of average brightness (since this is the way they are designed), i.e., furnish data which will make such subjects look in the transparency as if they actually were of average brightness. If you compare the individual brightness measurements that apply to the gray card and the white card, respectively, you will find that the white card gave a reading that was approximately *five times as high* as that of the gray card. However, an exposure based upon an integrated reading of all three cards (or a spot reading of the gray card alone by itself, which yielded the same result), lead to a transparency in which the white card appeared white. Therefore, it stands to reason that a shot of the white card made with an exposure *only one-fifth as long* as that which produced a correctly exposed transparency, must render the white card severely underexposed, i.e., too dark—as a medium gray. It is for this reason that subjects of *uniformly* higher-than-average brightness like snow or beach scenes, require *more* exposure than scenes of average brightness (although common sense would assume exactly the opposite) if they are to appear as light and bright in the transparency as they were in reality.

And the same apparent paradox—this time in reverse—is found in regard to subjects of below-average brightness. Because they are abnormally dark, such subjects produce abnormally low readings on the exposure meter dial, with the result that exposure will be too long—the dark subject will be overexposed and consequently appear too light in the transparency. It is for this reason that abnormally dark scenes require *less* exposure than the meter indicates (here too common sense would lead us to assume the opposite) if they are to appear as dark in the transparency as they did in reality.

Spot meter versus integrating meter. A spot meter (no matter whether separate or built into the camera) measures only a very small area of the subject; an integrating meter (no matter whether a reflected-light meter or an incident-light meter) takes into account everything within its considerable angle of acceptance and comes up with an averaged (integrated) reading. As long as subject contrast is low, these differences are of little consequence; but they matter enormously when subject contrast is high. Here is why:

Rendering a subject so that all its colors, from the lightest to the darkest, appear

natural in the transparency, is possible only if its brightness range does not exceed the contrast range of the color film. Unfortunately, as any color photographer knows from experience, the ability of color film to cope with contrast is much smaller than that of black-and-white film: a great many subjects exceed this limited contrast range with the result that some areas of the transparency are rendered too light or completely colorless while others appear too dark or black. It is in such situations that the difference between a spot meter and an integrating meter manifests itself: a spot meter enables a photographer to measure individually different areas of the subject and adjust his exposure accordingly; an integrating meter comes up with an averaged reading which, as far as the purpose of the picture is concerned, may be totally wrong. For example: a photographer wants to photograph a *deeply tanned* face (a "subject of average brightness") in front of a white sunlit wall. A brightness reading *of the face* with a *spot meter* will give him the correct exposure; a reading taken with an integrating *incident-light meter* might already lead to a slight underexposure of the relatively dark face; and an exposure according to data furnished by an integrating *reflected light meter* would surely result in underexposure of the face since the above-average brightness of the white sunlit wall would induce the meter to read too high. To avoid this, when using an integrating reflectance-type exposure meter, a photographer must go close enough to his subject to take a brightness reading of only its most important part, making sure not to falsify such a close-up reading by letting his hand or meter cast a shadow on the zone he is measuring.

Conversely, when a relatively light but small subject is surrounded by large dark areas, an integrating reflectance-type exposure meter will be overly influenced by the large dark parts and come up with an exposure that is too long, causing the light subject to be overexposed and its colors to be "washed out." Again, a separate reading of the light zone alone by itself with a spot meter, or a close-up reading with an integrating reflectance-type exposure meter, are the only methods of arriving at a *correct* exposure.

Light colors versus dark colors. As the above examples show, some picture areas may be more important than others. It is these areas which demand a photographer's particular attention. As I said before—if subject contrast is relatively high, it may be impossible to reproduce the lightest and the darkest subject areas *simultaneously* in natural-appearing color. If this is the case, a photographer must decide which are more important, the light colors or the dark colors, and adjust his exposure accordingly. Notice that I said subject "colors," not subject "areas." I did this because in color photography only those areas must be considered which

in the transparency are expected to show color or detail; black and white, being colorless as well as detailless, are disregarded.

Selenium cell versus cadmium-sulfide cell. No matter how bright or dim the illumination, *within the range of its sensitivity* (which at the low-light end of the scale is always less than that of a CdS-cell meter), a selenium-cell exposure meter, unless it had been dropped or otherwise mistreated, is extremely dependable and consistent. Not so a CdS-cell-equipped meter—and unfortunately *all* exposure meters built into cameras are CdS meters: if deliberately or accidentally exposed to very bright light, a CdS meter becomes "fatigued" and temporarily "blinded," with the result that pointer readings are too low, resulting in underexposure. And it may take many hours and, in severe cases, even days before such a "fatigued" CdS cell recovers and the meter becomes reliable again. There is no way of checking whether a CdS exposure meter is "fatigued" except by comparing its readings with those of another meter known to be accurate—and "fatigue" can set in quite unexpectedly, for example, when a CdS meter is accidentally set for low-light reading in bright light, or when it has been carelessly pointed at the sun. And only in extreme cases may a photographer notice this calamity in time which otherwise, undetected, might ruin an entire day's shooting. To avoid this, experienced photographers always carry a separate selenium-cell exposure meter against which they check their built-in meter periodically.

Another shortcoming of all CdS-cell-equipped exposure meters is "laziness," which manifests itself in that the pointer takes several seconds before it stops moving—and the dimmer the light the more time the pointer requires to arrive at its final position. Taking a hasty reading with a CdS exposure meter is a sure way to overexposed pictures.

Finally, CdS meters have a "memory": if a photographer takes point readings with a CdS spot meter to establish the contrast range of his subject and scans from a bright area to deep shade, the meter "remembers" the brighter light, gives a reading that is too high, and he underexposes. That is, unless he remembers to "think."

Reflected-light meter versus incident-light meter. If your subject should happen to be a pale-faced blond girl dressed in a light yellow sweater and a navy blue skirt standing in front of dark green shady magnolia leaves, chances are that you are faced with a brightness range that exceeds the contrast range of the color film. By using a *reflected-light* exposure meter, taking close-up readings

of the face, sweater, and background, and computing your exposure accordingly, you can still produce a pleasing transparency in which the important areas of your subject are reproduced in natural colors although the dark areas will be rendered too dark. On the other hand, if you take readings with an *incident-light* exposure meter, you will get the same reading no matter whether you hold the meter in front of the (very light) face or the (very dark) skirt. And if the girl had been dressed in a *white* blouse and a *black* skirt, as long as you use an incident-light exposure meter, you would still get identical readings for blouse and skirt. In other words, whereas the *reflected-light* exposure meter gives you detailed information, the *incident-light* meter, by measuring only the strength of the illumination but saying nothing about subject reflectance, leaves you more or less to your own devices.

Through-the-lens meter versus hand meter. Exposure meters built right into the camera are marvelously convenient but a photographer must be familiar with their peculiarities if he expects them to function satisfactorily, *i.e.*, aid him in producing correctly exposed transparencies. Since their advantages are obvious, I can limit myself to a discussion of their shortcomings.

Most through-the-lens meters are CdS meters with all their well-known faults: fatigue, needle creep ("laziness"), and "memory" (see our previous discussion). Another disadvantage which, at least at the time of writing, is shared by all through-the-lens meters, is that they have no zero-adjustment (and the few that have carry it inside the mechanism, where it is accessible only to a specialist). If a hand meter is jarred it can be checked by covering the cell window (if it is a selenium-cell meter) or removing the battery (if it is a CdS meter) and observing the pointer, which under these conditions should come to rest at zero. If the pointer is off zero position it can usually be brought back to zero (and the meter brought back to accuracy) simply by turning the zero-adjustment screw. With built-in meters, this accuracy check is not possible. If the camera has been jarred (knowingly or *unknowingly*), the photographer has no way of determining whether his exposure meter is still on the beam or way, way off. And if a comparison with a meter of known accuracy shows that the built-in meter is "off," there is no easy way of setting it back to normal.

Present through-the-lens exposure meters belong to one of three different designs: meters that measure at full aperture (without the need for stopping down the lens to shooting aperture) and do not require dial adjustments every time the photographer changes the lens; meters that measure at full aperture but require a

dial adjustment every time a photographer uses a lens of different speed, and meters that measure only at shooting aperture (requiring the photographer to stop down the lens before he can take a reading). The first type is most convenient but mechanically extremely complex and most likely to break down; the last type is least convenient but mechanically much simpler, smaller, and generally more reliable; the second type, which represents a compromise, shares to some extent both the advantages and disadvantages of the other two. As far as the photographer is concerned, the choice is therefore between convenience and reliability.

p. 136

Another choice a photographer must make when contemplating the purchase of a camera with a built-in exposure meter is whether to select one with a spot meter or one with an integrating meter, the advantages and disadvantages of which have been discussed. In the hands of a careful and methodical worker who understands its peculiarities (both good and bad), a spot meter, which is potentially a more versatile instrument, will probably lead to better results. On the other hand, in cases in which speed of operation is essential and subjects of average brightness range prevail, an integrating meter would be preferable. Besides, like a reflectance-type integrating hand meter, a built-in integrating meter can, of course, also be used to make close-up brightness readings and thereby, to a certain degree, assume the function of a spot meter in establishing a subject's brightness range.

Lastly, there is the problem of light-leakage—the danger that extraneous light may pass through the eyepiece of the viewfinder and reach the meter cell where it would inflate the reading. This possibility must be considered particularly by eyeglass wearers who cannot achieve as light-tight a connection between eyepiece and head as those who do not wear glasses. Although some camera manufacturers try to compensate for possible light leakage, this problem is still not completely solved.

By comparison, a hand meter is a marvel of ruggedness, simplicity, and reliability. In particular, I consider the Weston selenium cell reflected-light exposure meter ideally suited to the needs of a color photographer because of the way its dial is designed with the limited exposure latitude of color film in mind: in terms of brightness readings, the "A" and "C" marks represent the lower and upper limits within which color film will yield correctly exposed transparencies. In other words, if, instead of the arrow, you set the "C" mark opposite the brightness value of the *lightest color* of the subject (but NOT white!) as established by means of a

close-up reading, and a reading taken off the *darkest color* (but NOT black!) does not fall below the "A" mark, you are all right and *all* the colors of the subject will be rendered correctly in the transparency. But if the *darkest color* reads *below the "A" mark,* you either need fill-in illumination for the dark parts of your subject, or the dark parts will be rendered too dark. It is as simple as that. And like I said before, it is this simplicity and reliability which makes experienced photographers carry a hand meter despite the fact that their cameras feature built-in meters.

> The exposure is the most difficult operation in the production of a technically perfect transparency. It is for this reason that I spent so much time on preliminaries because, unless the underlying basic factors are understood—the "why?" that must guide the "what"—a photographer will not be able to use an exposure meter correctly.

How to use a reflected-light exposure meter

Set the film speed dial in accordance with the ASA speed of the color film. p. 108 Note, however, that ASA speeds are not absolutes, but intended primarily as guides that provide a starting point for tests. Some photographers prefer their transparencies a little darker because they like the resulting greater color saturation; or their shutters are a bit on the slow side; or their exposure meter reads somewhat slow. If this is the case, rather than constantly correcting the meter-derived exposure data, it is advisable to set the meter once and for all for a somewhat higher than the rated ASA speed of the respective film—for example, 80 and even 100 when using a color film with an "official" speed of 64. What counts are the results, and if a photographer gets consistently good results—results that please *him*—by using a film speed number that differs from the published one, he should use it.

Overall brightness reading. To take an overall reading, *aim the meter at the subject from the camera position.* However, keep in mind the fact that any abnormally bright area or light-source within the acceptance angle of the meter will inflate the reading and cause underexposure of the dark subject areas. Use your hand to cast a shadow over the meter cell to shield it from direct sunlight or the glare of photo lamps (for example, when measuring the brightness of a

backlighted scene); be careful that your hand does not obstruct the meter's view of the subject. Normally, outdoor light measurements should be made with the meter pointed halfway between the horizon (or subject) and the (dark) foreground to prevent excessive skylight from inflating the reading. This is particularly important on overcast days, when brightness of the sky is abnormally higher than brightness of the landscape. Note, however that a foreground consisting of white sand, large patches of snow, brilliant reflections on water, as well as unusually bright foreground matter such as a sunlit cement walk, if incorrectly handled, will inflate the reading.

An overall brightness reading is most likely to result in correctly exposed color transparencies if the scene is uniformly illuminated; if it contains about equal amounts of light and dark subject matter more or less evenly distributed; and if background and foreground are approximately equal in brightness.

Selective brightness reading. In cases in which subject contrast exceeds the contrast range of the color film, accurate rendition of both the lightest and the darkest colors is impossible. Under such conditions, by selectively measuring the brightness of the most important areas of the subject and computing the exposure accordingly, a photographer can at least make sure that the most important parts of his subject will be rendered satisfactorily in the transparency. Such situations are most likely to occur if the brightness values of subject and background differ widely; if a light subject is placed against a dark background or surrounded by dark subject matter; if a dark subject is placed against a light background or surrounded by light subject matter; if the subject is partly in the light and partly in the shade; and if the subject is exceptionally contrasty like, for example, backlighted scenes or scenes in which patches of bright sky alternate with dark foliage.

To take a selective brightness reading, hold the meter 6 to 8 inches from the subject but make sure that neither the meter nor your hand or body cast a shadow upon the area measured, for this would falsify the reading and cause overexposure.

By taking selective brightness readings of the lightest and darkest areas of the subject, a photographer can establish its contrast range. However, in doing this, *he must disregard black and white and measure only those areas which must show color or detail in the picture* (in color photography, gray is considered a color). For positive (reversal) color film, the readings of the lightest and darkest colors should generally not be more than two stops apart (equivalent to the interval between the "A" and "C" marks on the Weston exposure-meter scale), correspond-

ing to a contrast range of 4 : 1; the maximum at which satisfactory color rendition pp. 319-321 can be expected is 8 : 1, corresponding to a three-stop difference. For negative color film, the maximum contrast range is 16 : 1, the equivalent of a four-stop difference.

If subject contrast exceeds the contrast range of the color film, a photographer has the following alternatives:

If the photographer can control the illumination he can use fill-in illumination p. 253 to lighten shadows, add extra lamps to lighten a background, or increase the distance between lamp and subject to tone down overlighted areas. Outdoors, if subject distance is not too great, he can use blue flashbulbs or electronic flash, pp. 324-326 or reflectors consisting of panels covered with crinkled aluminum foil, to lighten shadows that are too dark and thereby decrease the contrast range of the subject to bring it within the contrast range of the film.

If the photographer cannot control the illumination and subject contrast exceeds the contrast range of the color film, he can do the following:

If he uses positive (reversal) color film, he can set the arrow of the meter dial one diaphragm stop *below* the value that corresponds to the highest brightness reading (the lightest color of the subject); or, if he uses a Weston exposure meter, set the "C" mark *opposite* the value that corresponds to the *highest* brightness reading. And if he uses a color film with relatively great exposure latitude, he may even set the arrow one and one-half or two stops *below* the highest brightness value on the meter dial (for negative color film, the respective data are two and two and one-half diaphragm stops, respectively). Such an exposure will yield good color rendition from the brightest subject areas on down, but dark subject areas and colors will be rendered too dark and show little or no detail. However, if subject contrast is abnormally high, this method, called *"exposing for the highlights,"* usually gives *the best results if positive color film is used.*

Conversely, if a photographer uses positive color film, he can set the arrow of the meter dial one diaphragm stop *above* the value that corresponds to the *lowest* brightness reading (the darkest *color* of the subject); or, if he uses a Weston exposure meter, set the "A" mark *opposite* the value that corresponds to the *lowest* brightness reading. And if he uses a color film with a relatively great exposure latitude, he may even set the arrow one and one-half or two stops *above* the lowest brightness value on the meter dial (for negative color film, the respective data are two and two and one-half diaphragm stops, respectively). Such an exposure will yield good color rendition from the darkest subject colors on up,

143

but light subject areas and light colors will be rendered too light or may even wash out completely. However, if subject contrast is abnormally high, this method, called *"exposing for the shadows,"* usually *gives the best results if negative color film is used.*

And finally, a photographer can settle for an intermediate (integrated) exposure, which will render all the intermediate colors correctly but dark colors too dark (or black) and light colors too light (or completely washed out). Unless excessively light and dark subject areas are small and unimportant, *this method usually produces the least satisfactory results.*

p. 266 **If glare is the cause of excessive subject contrast,** use of a polarizer is often sufficient to reduce the brightness range of the scene to more normal proportions. This method is particularly effective in cases in which excessive subject contrast is due to sun glitter on water, glare on pavement or foliage, or brilliant reflections on polished wood, glass, chinaware, and other materials *except metal,* or when it is desirable to reduce the excessive brightness of a pale blue sky to a deeper shade.

p. 135 **Gray-card reading.** I mentioned that exposure meters cannot "think" but react as if every subject were a "subject of average brightness," whether true or not. I also mentioned that taking a close-up or spot reading of a deeply tanned face —a "subject of average brightness"—in front of a white wall will give data that lead to a correctly exposed transparency whereas taking an overall or integrated reading will not. However, not all faces are "subjects of average brightness"; as a matter of fact, most faces of "white" people are considerably lighter than the proverbial "subject of average brightness" and, if exposed in accordance with an uncorrected close-up reading, would be rendered too dark. In such a situation, making an exposure determination with the aid of a Kodak Neutral Test Card is the simplest way to arrive at a correct exposure.

A Kodak Neutral Test Card is an 8 x 10-inch piece of cardboard that is gray on one side, white on the other. The gray side reflects 18 percent of the light that falls upon it, the white side 90 percent, *i.e.,* five times as much. The reflectance of the gray side is 18 percent because this is the percentage of light which "average" indoor subjects reflect; "average" outdoor subjects reflect a bit less.

In use, hold the gray card close to the subject (for instance, a face), with the gray side facing halfway between the (main) light source and the camera, then take a close-up brightness reading from the card, taking care not to let the shadow of hand or meter fall on it. Setting the camera controls in accordance with the respec-

144

tive data will give you a correctly exposed rendition of the face, no matter how light or dark its skin. This method, which is virtually foolproof, is particularly suited to indoor photography and to close-ups both indoors and out.

In effect, exposure determination with the aid of a gray card amounts to making incident light measurements with a reflected-light exposure meter. Consequently, by taking meter readings from the gray card at different positions within the picture area—with the gray card facing the camera at all times—a photographer can check the evenness as well as the contrast ratio of the illumination. Indoors, for example, he can make sure that the background will be rendered in its correct color by arranging the illumination in such a way that the background receives the same amount of light as the subject; or he can make the background appear lighter or darker in the transparency simply by adjusting the background illumination until he gets a proportionally higher or lower meter reading from a gray card held close to the background.

By taking gray-card readings both in the lighted and shaded subject areas, a photograper can establish the *lighting-contrast ratio* of the scene. With positive (reversal) color film, the lighting-contrast ratio should normally not exceed 3 : 1, equivalent to one and one-half f-stop on the exposure-meter scale (lighting contrast has nothing to do with color contrast, or reflectance ratio, which in turn is different from subject contrast; for specific information see pp. 320-321). However, *if subject-color contrast is abnormally low,* i.e., if *all* subject colors are either light, medium, or dark, a *lighting-contrast ratio of 6 : 1* (equivalent to two and one-half f-stops on the exposure meter scale) is still permissible. For negative color film the respective lighting-contrast ratios are 4 : 1 and 8 : 1.

Outdoors, taking brightness readings from a gray card will be found particularly helpful in conjunction with a spotmeter, which, as explained earlier, reads only a very small area of the subject at one time. If overall subject brightness is more or less "average," instead of having to average (or integrate) a confusing number of different spot readings, a single reading taken from the gray card can produce the data needed for a correct exposure. The illumination of the gray card at the camera position must, of course, be the same as that of the (distant) subject, and to arrive at a correct result, the card must be held so that it faces halfway between the sun and the camera. The only correction that must be made is that the exposure must be made with the diaphragm opened by one-half to one full stop since, as mentioned, the average reflectance of outdoor subjects is slightly less than the 18 percent reflectance of the card.

White-card reading. A clean white sheet of matte paper, or the white side of a Kodak Neutral Test Card, reflects approximately 90 percent of the incident light. This is five times as much as that reflected by the gray side of a Kodak Neutral Test Card, a fact which often makes it possible to get a meter reading in light that is too dim to produce a meter reaction from a gray card or the subject itself. Use the white card in the same way as a gray card, except that you must now *increase the exposure by a factor of 5.* The simplest way to do this is to divide the film speed by 5 (for example, Kodachrome-II, which has an ASA speed of 25, should in such a case be rated as if it had a speed of only 5) and set the film-speed dial of the exposure meter accordingly. You can, of course, also rate the film at its normal ASA speed and instead increase the exposure as indicated by the meter by a factor of 5; for example, if the meter indicates an exposure of 1/10 sec., multiply by 5 and expose 1/2 sec. instead.

Hand reading. In cases in which it is impossible, impractical, or undesirable to take a close-up brightness reading of the subject, a photographer can take a meter reading of the palm of his hand at the camera position, *provided the illumination is the same for both subject and hand and the meter indicated exposure is increased by one-half to one full diaphragm stop* (since a hand is a subject of somewhat higher-than-average brightness). This method is particularly useful in portraiture, where the brightness of the face closely matches the brightness of the hand, and on other occasions where light and middle tones dominate.

How to use an incident-light exposure meter

Set the film speed dial as described before, then, from a position immediately in front of the subject, measure the light that falls upon the subject *aiming the light collector of the exposure meter at the camera.* Outdoors, if the illumination is the same at both the subject and the camera positions, the reading can be taken from the camera position *with the meter held in front of the camera in line with the subject, its light collector facing the lens.* The incident-light-measuring method is especially suitable for indoor photography, particularly if more than one photo lamp is used, and outdoors for backlighted scenes.

Here is a summary of the most important requirements for correct exposure:

> Set the film speed dial of the exposure meter correctly. If exposure determination is made with the aid of a white card, the ASA speed of the film must be divided by 5.

> Shield the cell of the exposure meter from extraneous light and excessive

skylight. Color film has considerably less exposure latitude than black-and-white film and must therefore be more accurately exposed.

Exposure latitude varies with subject contrast: latitude increases as subject contrast decreases—the smaller the difference in brightness between the lightest and darkest areas of a scene, the greater the exposure latitude. The exposure of low-contrast subjects may vary up to two stops in either direction from "correct" before the transparency appears over- or underexposed, respectively.

As subject contrast increases, exposure latitude decreases and eventually becomes nil. Consequently, relatively contrasty subjects must be exposed "on the nose."

If subject contrast exceeds the contrast range of the color film, correct simultaneous rendition of both the lightest and the darkest colors becomes impossible. If this is the case, transparencies in which the light colors (and highlights) are correctly exposed while the dark areas (and shadows) are underexposed and appear too dark invariably look better than transparencies in which the dark are correctly exposed while the light are overexposed and "burned out."

In color photography, overexposure is the most serious mistake.

How to adjust the exposure

As already indicated, numerous occasions exist which require that the exposure data established with the aid of an exposure meter are modified if the result is to be a correctly exposed color transparency. In particular, the following must be considered:

The exposure must be increased by one-half to one and one-half f-stops (use a larger diaphragm aperture or a slower shutter speed) when photographing subjects that combine *low contrast* with *above-average brightness,* for example, many snow and beach scenes, and hazy aerial views.

Exposure must be increased by 1/2 to 2/3 f-stops if lighting contrast is low and the illumination flat, diffused, and uniform, for example, when taking pictures on a misty day or in the rain.

Exposure must be increased by one to one and one-half f-stops if lighting contrast is still lower as, for example, when taking pictures during a snowfall or in heavy fog.

Exposure must be increased by about one-half f-stop if the scene contains an abundance of dark green foliage.

The exposure must be decreased by one to two f-stops (use a smaller diaphragm aperture or a higher shutter speed) in sunset shots of the sky; when photographing a rainbow against a background of dark gray clouds while the foreground is illuminated by sunlight; when shooting across sun-sparkling water; and in cases in which the dark mood of dawn and dusk should be further emphasized.

Exposure must be decreased by one-half to one full f-stop if the subject is uniformly dark, and when taking pictures under abnormally dark outdoor-lighting conditions (but NOT at night).

The filter factor. If a color-conversion, light-balancing, color-compensating, or other kind of filter is used, the exposure must be multiplied by the respective filter factor (which is listed in the instruction sheet that accompanies the filter or in the manufacturer's promotional brochure). If two or more filters are used simultaneously, *their factors must be multiplied* by one another (NOT added), and the exposure must be *multiplied* by the common factor.

p. 37 **The polarizer factor.** If a polarizer is used, exposure must be multiplied by the polarizer factor, which is normally 2.5x. In this respect, it does not make any difference whether the polarizer is used in a position of maximum, moderate, or minimum efficiency—the exposure factor remains the same.

The distance factor. If *positive* (reversal) color film is used and the subject-to-lens distance is equivalent to or shorter than *eight times the focal length of the respective lens;* or if *negative* color film is used and the subject-to-lens distance is shorter than *five times the focal length of the respective lens,* the exposure must be multiplied by the corresponding distance factor, which can be determined by the following formula:

$$\frac{\text{lens-to-film distance x lens-to-film distance}}{\text{focal length of lens x focal length of lens}} \text{ or } \left(\frac{D}{F}\right)^2$$

For example: a photographer wishes to make a close-up of an insect using a lens with a focal length of 2 inches. After focusing, the distance between lens center and film measures 4 inches. He can find the corresponding exposure factor by using the following equation:

$$\frac{4 \times 4}{2 \times 2} = \frac{16}{4} = 4$$

148

This means that he must expose his subject four times as long as his exposure meter indicated in order to get a correctly exposed transparency. If the meter indicated an exposure of, say 1/40 sec. at f/11, he must multiply this by a factor of 4 and expose either 1/10 sec. at f/11, or 1/40 sec. at f/5.6.

A very practical aid for immediate determination of the exposure factor for close-ups is the Effective Aperture Kodaguide published by Kodak. This is a card with an attached dial, which after proper setting gives the *effective* aperture (*i.e.*, the value of the f-stop that applies in the respective case), the distance factor by which the exposure must be multiplied, and the scale of magnification (or reduction) of the image on the film.

The reciprocity factor. Theoretically, according to the law of reciprocity, the effect upon a photographic emulsion should be the same whether the film is exposed for one second at 100 foot-candles, or for one hundred seconds at one foot-candle. Actually, however, this holds true only if exposure times and light intensities are more or less normal. If exposure times are either abnormally long or short and if light intensities are either abnormally high or low, the law of reciprocity fails.

Reciprocity failure is manifest in the following way: if light intensity is very low, doubling the exposure time does not double the density of the color film but produces less than twice that density. And as far as very short exposure times are concerned, 1000 exposures of 1/1000 sec. each do not produce the same density as one exposure of one full second, but rather produce somewhat less than that density. Since different films react differently to reciprocity failure, tests alone p. 114 can reveal how much exposure must be increased if exposure times are abnormally long (minutes) or short (electronic flash).

In color photography, additional complications arise because reciprocity failure usually affects the differently sensitized layers of color film in different degrees. As a result, the color balance of the film will be changed and the film will have an overall color cast. To help photographers correct as far as possible the effects of reciprocity failure, Ansco and Kodak include supplementary data slips with their positive (reversal) color sheet films. These data slips show the factors by which abnormally long or short exposures must be increased and, if necessary, recommend the corrective filters that must be used for best results.

High-key and low-key renditions. If the photographer wishes to produce a high-key effect in pale pastel shades (possible only with low-contrast subjects; shadowless illumination and light colors are best suited to this form of rendition, which has been used with great success in fashion photography and portraiture of women),

exposure must be increased by one to two full f-stops. Conversely, exposure must be decreased by one-half to one full stop if the photographer wishes to produce a low-key effect with particularly rich, fully saturated colors (best results are achieved if subject colors are relatively pure, and subject contrast is low; when shooting color transparencies for reproduction, a slight degree of underexposure is always preferable to overexposure).

Bracketing

The observant reader will have noticed that many times in the previous sections instructions for supposedly "correct" exposure were somewhat less than precise. Phrases such as "increase exposure by one-half to one and one-half f-stop," "subjects of more-than-average contrast" (how much more?), etc., occurred again and again, indicating the large uncertainty factor inherent in all methods of color-film exposure. Add to this the fact that a transparency that pleases one photographer may be judged too light or too dark by another and you get an idea of how complex a subject color-film exposure is. The surest way out of this muddle, whenever possible, is to make a series of different exposures of the same subject under otherwise identical conditions grouped around an exposure which, according to exposure meter and experience, is most likely to be correct. This method is called "bracketing."

Bracketing has several advantages: It is the best guarantee for correct exposure. It gives a photographer a choice of several transparencies of the same subject which differ slightly in regard to brightness—some lighter, some darker—small differences in tone which, however, sometimes make the difference between an acceptable and a perfect transparency. And it provides one or several "spares" as insurance against accidental damage or loss of a potentially valuable transparency plus the always appreciated advantage of having several "originals" instead of only one. It is for these reasons that, wherever practicable, "bracketing" is a technique used by all successful color photographers; it is part of the "secret" of their success.

Under normal conditions in regard to lighting and subject contrast, in addition to the supposedly correct exposure, a second shot should be taken with a smaller, and a third shot with a larger, diaphragm opening. Under difficult conditions—if subject contrast exceeds the contrast range of the color film or if backlight provides the main source of illumination—a larger number of exposures should be made with different diaphragm stops. If positive (reversal) color film is used, the number of shorter-than-normal exposures should exceed the number of longer-than-normal

exposures. Conversely, if negative color film is used, more longer-than-normal than shorter-than-normal exposures should be made.

In color photography, the individual exposures of the "bracket" should be spaced one-half f-stop apart if positive (reversal) color film is used, one full f-stop apart if negative color film is used. Smaller intervals are wasteful; larger intervals may cause a photographer to miss the best exposure. The shutter speeds of all the exposures must, of course, be the same.

Inexperienced photographers often complain that "bracketing" is too wasteful for their means. This is a fallacy. What is wasteful is spoiling good color film through bad exposure and ending up with nothing. A photographer who brackets his shots may waste one or two exposures but is sure to come up with one perfect and very likely two or three acceptable transparencies. And—at least in my opinion—if a subject is worth photographing at all, it is worth photographing well. Photographers who really want to save on film should do this by being more selective—shooting *fewer* subjects but doing them *right*.

Subjects that cannot be "measured" by an exposure meter

Neon lights and city streets at night, fireworks, campfire scenes, the wheeling stars, and a few other subjects cannot be exposed according to exposure meter because no meter can "read" this kind of subject correctly. Instead, a photographer must rely on published exposure tables, experience, and tests. The following data are intended only as guides.

	ASA 25	ASA 64	ASA 160
Downtown city streets at night, bright neon lights	1/10 sec. at f/2.5	1/25 sec. c.t f/2.5	1/30 sec. at f/2.8
Fireworks. Set the shutter at B, include several rocket bursts	f/4.5	f/7	f/11
Campfire scenes, burning houses	1/25 sec. at f/2	1/30 sec. at f/2.8	1/30 sec. at f/3.5
Star tracks at night, no moon or haze, very black sky	3 hours f/3.5	3 hours f/5.6	3 hours f/6.3

Different shutters may be differently calibrated, and none has all the different speeds commonly found in exposure tables. However, for all practical purposes, the differences between, say, 1/25 and 1/30 sec., 1/50 and 1/60 sec., 1/100 and 1/125 sec., etc., can be disregarded.

How to take a photograph—summing up

It is of the utmost importance for the student of photography to realize how closely the three operations, FOCUSING, setting the DIAPHRAGM, and setting the SHUTTER SPEED, are interrelated. A change in one almost invariably demands a change in the others if the result is to be a technically perfect color transparency. For example, when shooting candid pictures of people, a photographer does not always have the time to focus as accurately as desirable if he wishes to capture the fleeting moment. To guard against out-of-focus pictures, he uses a smaller diaphragm aperture which gives him a more extensive "safety-zone" of sharpness in depth. A small diaphragm aperture, however, must be compensated by a correspondingly slow shutter speed which in turn might lead to unsharpness due to movement of the subject or the camera. To reduce this danger, a film of higher speed can be used which permits the use of higher shutter speeds but, on the other hand, yields transparencies that are more grainy and somewhat less detailed than if a slower film had been used. And so on.

In practice, perfect solutions to the problem of making a photo-technically perfect color transparency are rare. Usually, the best a photographer can do is to find the most *advantageous compromise* between conflicting demands. The basis for this are the data furnished by an exposure meter whose dials, correctly adjusted, simultaneously show all the possible combinations of diaphragm aperture and shutter speed which, in conjunction with a color film of a given speed, under the prevailing lighting conditions, will produce a technically perfect transparency. In particular, the following aspects must be considered:

Focusing. If the lens is accurately focused, there is no problem. In "grab-shooting," however, there is usually no time to focus carefully, and insurance against out-of-focus pictures must be taken out in the form of a relatively small diaphragm aperture, which creates a correspondingly extensive "safety-zone" of sharpness in depth.

Diaphragm. If sharpness in depth is important, a correspondingly small diaphragm aperture must be used and the shutter speed adjusted accordingly. This in turn may rule out a hand-held exposure because of insufficiently high shutter speed. How small the diaphragm aperture must be can be determined with the aid of the depth-of-field scale of the camera or by groundglass observation.

Shutter speed. Few people can hold a camera perfectly still at shutter speeds slower than about 1/60 sec. Accordingly, to avoid unsharpness due to inadvertent camera movement, if the picture must be taken with the camera hand-held, a

p. 135

shutter speed not slower than 1/60 sec. must be used and the diaphragm aperture adjusted accordingly. Also, if subject motion must be "stopped," shutter speed must be considered first and the diaphragm adjusted accordingly; see the table on p. 357.

Realization of the interdependence of the three operations, focusing, diaphragm setting, and shutter-speed setting, and their effects upon the picture, should make it obvious that they must never be considered separately; instead, they must be treated as a unit. The following graph shows the relationship of the main factors that determine the outcome of an exposure.

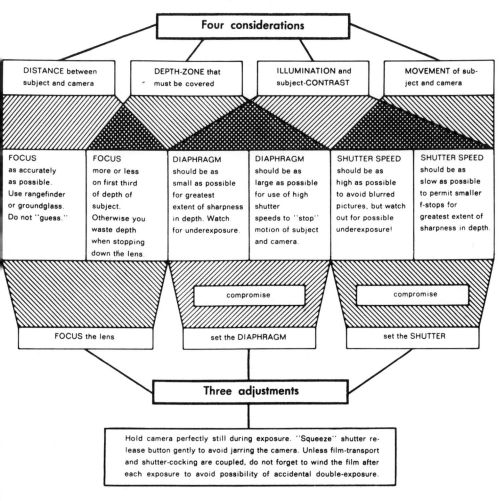

PRACTICAL ADVICE

Unless other more important considerations prevail, always use the highest practicable shutter speed. Even though your lens may be somewhat sharper at a smaller f-stop, the corresponding slower shutter speed may more than offset this gain through blur due to inadvertent camera movement caused by a shutter speed too slow to be hand-held safely.

p. 37

Remember to take the cap off the lens when working with an RF camera. The alternative: use a transparent lens cap—a colorless UV filter that can stay on the lens indefinitely without causing any undesirable color effects; it protects the lens against fingermarks, raindrops, ocean spray, dirt, and so on.

After loading the camera, do not forget to set the film counter back to zero.

Make sure the film is advancing properly by watching the rewind knob: if it turns as you wind the film, everything is all right; if it doesn't, the film does not move.

If you work with sheet film, don't forget to pull the slide of the holder prior to exposure. Outdoors in bright light, cover the back of a view camera with the focusing cloth to guard against light-struck transparencies.

A good way to remember the type of film a camera is loaded with is to tear the square top off the end of a rollfilm cardboard box and tape it to the camera. Don't forget to change this tag when loading a different type of film.

When using flash in conjunction with a variable synchronizer, do not forget to set the delay-dial in accordance with the type of flash you use.

Inch-wide white surgical tape is great for making labels on which to write notes. I use it on the backs of cameras and rollfilm holders, camera and lens cases, boxes, etc., and wouldn't want to go on any job without a roll of it. And black photographic (masking) tape is an invaluable aid in hundreds of situations.

The following paragraphs contain, in condensed form and with particular emphasis on problems that concern the color photographer, advice on the rendition of twenty-four popular subjects listed in alphabetical order:

Aerial photographs	Flowers	Sports
Animals	Gardens	Stage photography
Architecture	Interiors	Store windows
Close-ups	Landscapes	Sunsets and sunrises
Cold-weather photography	Night photography	Time exposures
Copying	People	Travel photography
Electric street signs	Photo-micrography	Tropical photography
Fireworks	Portraits	Winter

Aerial photography. Shoot only on perfectly clear days. Cloud shadows on the ground give the landscape a spotty appearance. The greatest problem is haze. Haze effect increases with altitude. For this reason, it is generally more advisable to photograph from a low altitude with a moderate wide-angle lens than from a high altitude with a long-focus lens. Side lighting gives improved rendition of detail. Overhead (noontime) light is flat and normally should be avoided. Back-lighting accentuates the haze effect and is likely to produce a strong blue overall cast in the transparency. The use of an ultraviolet filter is recommended to elimi- p. 37 nate the influence of ultraviolet radiation and minimize blue overall cast.

Engine vibration may create another problem. The following precautions must be taken to counteract its effects: do not allow the camera to touch any part of the plane, and also prevent any part of your body above the waist from similar con-tact. Since depth is no problem, use the largest diaphragm stop at which the lens will still give satisfactory definition, in order to secure the highest possible shutter speed. If shooting from a private plane, just before you make the exposure, ask the pilot to throttle down and reduce flying speed to the minimum consistent with safety. To reduce the angular velocity of the subject, use the camera the way you would use a shotgun on a flying bird: zero your aiming point in the finder and hold it there by following through with the camera; release the shutter while you swing.

If the picture must be taken through a closed window, hold the camera as close as possible to the glass without actually touching it with the lens. Overall color cast due to the color of the glass, however, is likely but can be minimized through use of a pale red color compensating filter if the glass has a greenish tint. Better p. 36 results will be obtained if a small plane can be used, a door removed, and photo-graphs taken through the opening with photographer and camera protected from the slip stream by the sides of the aircraft. As an essential safety measure, both photographer and camera must be securely roped to a structural part of the plane.

Because of the generally low contrast of aerial views, exposure is not as critical as for ground subjects which usually have a much greater contrast range. As a result, exposure latitude is increased, and transparencies of the same subject shot at different exposures, with the exception of slight variations in overall density, generally show little difference in highlight and shadow definition. However, lighter transparencies will appear more natural to the eye, whereas darker transparencies are more suitable for reproduction.

Animals. As far as exposure is concerned—primarily in close-ups—dark furry animals require exposure increases equivalent to one-half to one full diaphragm stop to show sufficient detail. Satisfactory color photographs of wild animals are difficult to get and necessitate the use of more or less extreme telephoto lenses.

p. 45 For close-ups of pets, electronic flash used in conjunction with daylight color film gives the best results.

Architecture. To avoid "converging verticals" and generally control perspective, a camera equipped with individually adjustable front and back movements must be used. A 35-mm photographer using an SLR will find the 35-mm f/3.5 Nikkor Perspective Control or the Schneider 35-mm f/4 PA-Curtagon wide-angle lenses, which can be raised or lowered, very helpful. Large film sizes produce more satisfactory transparencies than smaller ones. If possible, avoid the use of the more

pp. 86, 82 extreme wide-angle lenses, which often suffer from uneven light distribution that manifests itself in light fall-off toward the edges of the picture. Variations in the

p. 36 color of daylight may necessitate the use of light-balancing filters. Information

pp. 160, 170 on *interiors* and *night photography* will be given later.

Close-ups. If a subject is very small, exposure is best determined with the aid of a Kodak Neutral Test Card of 18 percent reflectance. Hold the card directly in front of the subject, facing halfway between the main source of illumination and the camera, then take a reading of the card with the exposure meter no more than 6 inchs away. Be sure that the shadow of the meter or your hand does not fall upon that part of the card from which you take the reading, and that the card does not reflect glare upon the photo-electric cell. Use the thus determined data as a basis for exposure but consider the following:

If the distance from subject to lens is less than eight times the focal length of the lens, the exposure must be increased according to the formula given on p. 148. If the exposure time runs into seconds, the effect of reciprocity failure must be considered; see explanations on p. 149.

156

Cold-weather photography. Subzero temperatures may reduce filmspeed to one-half of its rated value, make the film very brittle, and may also affect its color balance. Since actual effects are unpredictable, in cases where on-the-spot checks through tests are impractical, the best insurance against incorrect exposure is bracketing. Shutters are apt to perform erratically in very cold weather, or to p. 150 fail completely unless they are either lubricated with special cold-resisting lubricants, or completely delubricated. This is a job that only a competent camera repairman can do.

Copying. More than in any other type of color work, accuracy of color rendition is essential for succesful copying because the copy must stand direct comparison with the original. To assure the most faithful color rendition, the following precautions should be taken:

Test the color film emulsion and, if necessary, determine the appropriate color p. 114 compensating filter. Check the color temperature of your lights and, if necessary, p. 225 use the appropriate light-balancing filter. Evenly illuminate the original, placing p. 36 lamps of equal wattage on either side at an angle of approximately 45 degrees, making sure that no glare is reflected in the lens. Check the uniformity of the illumination by taking meter readings of a Kodak Neutral Test Card held in contact with the original first in the center, then in each of the corners. Determine the exposure with the aid of this test card as described above under "Close-ups." If the original is either lighter or darker than "average," increase or decrease, respectively, the exposure by one-half diaphragm stop. If the distance from subject to lens is equivalent to eight times the focal length of the lens or less, the exposure must be increased according to the formula on p. 148. If the exposure runs into seconds, the effects of reciprocity failure must be taken into considera- p. 149 tion. Bracketing is always recommended. p. 150

Complete elimination of glare from glossy oil paintings with pronounced surface texture is impossible unless they are illuminated by polarized light and photographed through a polarizer. One can use either Kodak Pola-Lights, or large polarizing screens (if necessary, taped together from smaller pieces) placed in front of ordinary photo lamps. The use of a polarizer will be explained later. The pp. 266-268 advantages of this method are twofold: the elimination of the problem of glare makes it possible to place the lights closer to the subject-camera axis, as a result of which the illumination becomes more even; and color, instead of being diluted with white because of glare, appears more fully saturated. While observing the image on the groundglass, adjust the polarizer at the lens. Sometimes it is ad-

vantageous to retain a small amount of glare in the copy in order to characterize more adequately in the transparency the surface texture of the original.

If the original is illuminated by Kodak Pola-Lights and photographed through a Kodak Pola-Screen "crossed" with the lights, the exposure must be increased by a factor of at least 24. As a safety measure, additional exposures should be taken with factors of 32 and 40. These factors include the factor for the required Kodak Color Compensating filters which must be chosen in accordance with the following table:

p. 36

Filters for Trial Exposures with Kodak Pola-Screens

Pola-Screen used:	At lens only		With Pola-Lights	
Lamp type:	3200 K	Photoflood	3200 K	Photoflood
Ektachrome* and Ektacolor, Type L	CC-10B +CC-05M	CC-05B	CC-20B +CC-05M	CC-10B
Kodachrome, Type IIA	CC-10B +CC-05B	CC-05B	CC-20B +CC-05M	CC-10B +CC-05R

* With the Pola-Lights, it may be necessary to change the filters on the basis of the recommendations for long exposure times in the supplementary data sheets packed with the film. For the usual trial exposure, however, no extra filters are needed.

p. 168 **Electric street signs.** In night photographs, daylight-type color film produces warmer transparencies which, in my opinion, are more compatible with the character of electric light than the colder, more bluish rendition of tungsten-light color film. Best results are obtained on rainy nights, when reflections on wet pavement double the existing colors. Use an umbrella to protect the tripod-mounted camera, and a lens shade to protect the lens from raindrops.

Fireworks. Best effects result if several bursts are superimposed upon the same
p. 47 film; a tripod is a necessity. Use either daylight or tungsten-light film (see above), set the diaphragm at f/4.5 if you use film with an ASA speed of 25, f/7 if ASA 64, and f/11 if ASA 160, open the shutter, and wait until several good bursts have registered on the film. Do not make the mistake of trying to get too much in one picture—overexposure will burn out the color.

Flowers. Close-ups are always more effective than long shots. The super close-up of a colorful flower properly lighted which fills the entire frame of the picture can be stunning. Masses of flowers photographed from a distance, so beautiful in nature, can make some of the most disappointing color photographs.

Strong direct sunlight illumination gives best results. Sidelight is best for texture rendition, backlight to bring out the delicate translucency of certain kinds of flowers. A large reflector consisting of a board covered with crinkled aluminum foil is a handy device to fill in from the front when side light or backlight is used. On windy days, take close-ups with multiflash to avoid blur due to movement of the flowers. Use a main light on an extension, a fill-in at the camera. p. 252

Watch the background. Out-of-focus patterns consisting of shapeless blobs of color are distracting. The best possible background is the unobstructed sky. Next best are completely out-of-focus greenery or large sheets of pale blue cardboard with mat surfaces which prevent reflection although the latter introduce an artificial element into the picture which may not always be desirable. Place these cardboards far enough back so that they will be rendered out-of-focus and make sure no shadows of plants appear on them since this would spoil the "sky effect." Leave a few leaves between the flower and its cardboard background to suggest space and depth and prevent the picture from looking "posed."

Movement due to wind is a problem. As a rule, there is less wind early in the morning than later in the day. Besides, low-slanting morning light is more photogenic than overhead noontime light. Dew drops on petals and leaves enhance the ethereal quality of flowers. If necessary, they can be applied with the aid of a watering can. If the ground appears in the picture, do not forget to give it a sprinkling to complete the realistic impression.

Gardens. Do not shoot everything in sight simply because "it looks so beautiful." In most cases, all that remains of this beauty in the transparency is a confusing pattern of tiny dots of unrelated color imbedded in masses of uninteresting formless green.

If a large groundglass-equipped camera is used, one glance at the image is usually sufficient to disenchant the photographer and make him realize the need for careful planning. Rule number one: get close enough to the subject to get enough color and not too much green in your picture; medium long-shots and close-ups of groups of flowers are more photogenic than overall views of an entire garden. Normally, the whole extent of the view should be rendered sharply; when shooting down on beds of massed flowers, those who use swing-equipped cameras (for extended sharpness in depth without additional stopping down) have the advantage over less suitably equipped photographers. pp. 52, 60

p. 334

An effective coverage of a garden consists of one or two overall shots from opposite angles for general orientation (one of them perhaps in backlight), a small

number of medium long-shots of groups of colorful flowers, and a large number of close-ups.

Interiors. *Daylight falling through the window* may contain an abnormally high percentage of blue, and this percentage increases as less direct sunlight and more blue skylight reaches the room. Under such conditions, color cast in the transparency is inevitable unless the light is correctly analyzed and the appropriate light-balancing filter is used. Another type of color cast can be caused by tinted window glass now frequently used in office buildings. Similar conditions may be encountered in churches, industrial plants, museums, etc. The double-thickness of Thermopane, for example, gives a slightly greenish tint to the light passing through it. In many instances, it is impossible to correct completely this type of illumination. If "natural-appearing" color rendition is essential, such interiors must be photographed at night with incandescent light.

p. 36

Incandescent light at night. If an interior is to be photographed in *existing* incandescent illumination, take a color-temperature meter reading of the lamps, then use the appropriate light-balancing filter. Often, however, a more realistic impression is produced NOT by fully correcting the existing light (which may produce a "cold" feeling incompatible with artificial, and especially incandescent light, illumination), but by retaining, to a certain extent, the warm character of lamplight. This can be done by using a filter which raises the color temperature of the light to a value which lies 200 to 300K *below* the color temperature for which the color film is balanced.

p. 36

Fluorescent light. As mentioned before, fluorescent light is basically unsuited to color photography. However, since fluorescent light is more and more widely used, taking photographs in fluorescent light is often unavoidable. If this is the case, the always necessary filtration should be based upon the table on p. 40.

p. 40

Suggestion for the illumination of interiors. In my opinion, the preservation of the character of the illumination which is typical of a specific interior is more important than accurate color rendition throughout the entire picture. For example, if the illumination is provided by a number of small lamps, each with its own circle of light, and other parts of the room are gloomy and dark, it would be a mistake to flood the whole interior with light merely for the sake of total color rendition. Such a gain seems to me valueless because it involves destroying the mood of the room. Supplementary illumination should be kept to the minimum required to duplicate on color film the impression which such a room presents to the eye.

160

Control in photography takes many forms, some of which are illustrated on this and the following pages. Using control is a sign of an experienced photographer, a pro; only snapshooters are always satisfied with the first appearance of their subject.

Photographic controls apply to subject selection, subject approach and subject rendition. The picture pair above, for example, shows how the rendition can be controlled in regard to color: the right view was shot without a filter and appears "cool"; the left version was "warmed up" with the aid of an 81B filter. The lower picture pair illustrates control at the subject level—it makes a difference whether a subject is shot on a clear or a hazy day. Neither of these pictures is "better" than the other; they are merely different. *More on pp. 204 and 226*

161

Control through subject approach. The same subject can always be rendered in many different forms. These are airhouses—inflated collapsible structures for temporary or permanent use.

Each of the three pictures, which were photographed from the same camera position but at different times of the day, shows a different aspect of the subject. The daylight shot illustrates the collapsible nature of these structures; the dusk shot shows them in relation to the landscape, and the night shot makes them appear completely fantastic.

This diversity of approach applies, of course, to any subject. Angle of view, direction and quality of the light, atmospheric conditions, perspective, etc., offer further possibilities for control, which can be used to improve the picture.

More on pp. 213–220

Control through subject rendition. The three different versions of New York's Times Square at night were all taken within a few minutes from the same camera position; yet they manage to convey very different impressions.

The picture above shows the view as it appeared to the eye. The photograph at the upper right is a composite of a sharp and an unsharp view superimposed one upon the other through double-exposure of the same sheet of film. And the view at the right is an out-of-focus rendition deliberately stressing the abstract beauty of this colorful scene.

This choice of means of rendition applies, of course, to any subject. Different lenses, filters, exposure times, etc., offer additional possibilities for controlling the rendition of a subject.

More on pp. 207, 219

Main light Fill-in light

How to light a portrait: a demonstration by Arnold Newman. On this page, the effect of each of the four lamps used is shown separately. The combined effect of these lights can be seen on the opposite page.

More on pp. 252–254

 Accent light Background light

Which type of film should you use? Normally, there is no question whether a photographer should use daylight film, Type A film, or Type B film. However, there are cases in which the answer is not so clear-cut as, for example, when shooting color film in mixed daylight and artificial light, or under fluorescent lamps. Which type of film should one use, since obviously, none of the available types will produce a natural-appearing color rendition?

The choice is up to you: if you prefer a rendition that is slightly warmer, more toward yellow, than the actual scene, you must use daylight type film; if you prefer colder tones, Type A or Type B. The two scenes shown on this page were both illuminated partly by daylight and partly by artificial light. The left half of each picture pair was shot on daylight type film, the right one on Type B film. The upper pair is by *Andreas Feininger*, the lower by *Al Francekevich*. More on p. 106

Particular attention should be given to the shadows. Shadows within shadows, caused by multiple light-sources and criss-cross illumination, are a sign of bad lighting. Supplementary illumination should be so diffused that it casts no shadows. Shadows within the picture area must look natural and should be caused, or seem to be caused, by the existing interior illumination, in daylight (light falling through the windows) as well as in artificial light.

In conjunction with daylight, because of their lower color temperature, blue photoflood lamps, used for supplementary illumination, produce a warmer light than blue flashbulbs or electronic flash. In my opinion, more pleasing effects result if this slightly warmer, more golden illumination is contrasted with the colder, more bluish daylight falling through the windows than if the illumination is uniform throughout the entire picture. If a window is included in the picture area, the outside view, if visible, should of course be rendered as accurately as the interior itself. Since daylight illumination normally is much brighter than indoor illumination, the brightness of indoor and outdoor illumination must be equalized—either by making the shot when the outdoor view is more or less in the shade, or by increasing the indoor illumination until it matches in brightness the outdoor light.

<div align="right">p. 38</div>
<div align="right">pp. 43, 45</div>

Landscapes. Nothing is easier than to take technically unassailable color pictures of landscapes. And nothing is more difficult than to make pictorially interesting landscape photographs. Most color shots of landscapes are dull because they are repetitions of pictures which one has seen innumerable times on calendars, in travel magazines, and in the work of other photographers. Good landscape photographs are the result of an eye for the unusual and careful planning with particular attention given to the photogenic qualities of the subject. The following suggestions may help:

<div align="right">p. 197</div>

Unusual atmospheric conditions—conditions under which average photographers do NOT take pictures—make unusual photographs: sunlight breaking through black thunderclouds while rain is still falling in the distance; fog drifting in from the sea or rolling in over mountains; curtains of rain trailing drifting clouds; a "bald" clear blue sky suggesting the immensity of infinite space; haze-veiled sun and softly diffused light.

Unusual hours of the day have their own unusual moods: rose-tinted grays of predawn skies; the burst of the rising sun; the golden light at daybreak; the drama of sunset; the cold blue light of the approaching night.

Backlight for glittering water, for luminous silver-edged clouds. Watch the shadows

169

of drifting clouds: against the gloomy background of mountains black in the shadow, nearby sunlighted colors appear radiantly brilliant.

Avoid clichés: the carefully arranged (often planted or hand-held) branch that "frames" the distant view; the meticulously posed girl in the bright red sweater who "accentuates the focal point of the composition" and "provides the human interest"; the S-curve of the snow-bordered creek, or the winding dirt road that "leads the eye into the picture."

p. 37
p. 37 *The technical requirements are few:* an ultraviolet or Kodak Skylight filter to prevent unwanted blue overall cast. A polarizer to darken a blue sky that seems too pale—particularly near the horizon—and to remove excessive glitter (blue skylight reflection) from foliage and grass to clean up and strengthen the underlying color. A polarizer can also be used to eliminate unwanted sky reflection from water and to make it appear more colorful. However, the complete elimination of reflection often leads to unnatural effects (water appears lifeless); in most cases, partial elimination of glare creates more pleasing results (use the polarizer midway between zero and maximum efficiency). A lens shade, of course, is a must.

p. 242 *The quality of daylight* changes almost constantly. But do not worry about colored light in landscape photographs. Such color shifts are as natural as shifts in the forms of clouds. Light of correct color balance, however, is important for close-ups of people and natural-appearing rendition of familiar nearby objects. Differences in the color of light provide the necessary variety in overall tone without which all landscape pictures would look more or less alike. Learn to use such color shifts deliberately to symbolize moods: warm rose and golden light for warm and pleasing moods; cold bluish light for cold and lonely moods (blue moods); white light for bright and sunny moods—and for neutral shades of gray, fog, and rain.

Night photography. *The best time* for most night photographs is twilight before the sky turns black. Then, outlines of objects, which later merge with the sky, are still discernible, and remnants of skylight, acting as fill-in illumination, or mirrored by water or rain-slick streets, still modulate areas which later would seem black and lifeless.

In the city, mist and rain lend atmosphere and sparkle to the picture, street lights and advertising signs appear to be surrounded by halos, which in pictorially effective form symbolize the radiance of direct light; reflections in wet pavement double the existing colors. If exposures are longer than approximately 1/5 sec., head and tail lights of passing automobiles register in the form of white and red

streaks in the picture. These streaks can often be used advantageously to symbolize the flow of traffic; or they can be avoided if the photographer makes the picture when cars stand still while traffic lights are red.

Technical requirements. Either daylight-type or tungsten-light color film can be used; the first produces warmer and, at least in my opinion, more pleasant color shades than the second. The only way to get consistent correctly exposed color photographs at night is to establish accurate data for different types of subjects through tests, with exposures bracketed in accordance with a factor of 2 (for example: 1/8, 1/4, 1/2, 1, 2, 4, 8 seconds). On the basis of such tests, compile an exposure guide for night photography in the form of a series of actual color transparencies complete with data which, taped together and folded accordion-fashion, you carry when you go out to shoot color at night. p. 168

p. 94

People. The most important picture quality is spontaneity. If people appear self-conscious and posed, the photograph is a failure, no matter how good the color rendition. In taking pictures of people, most photographers, trying for technical perfection, pay too much attention to technicalities and too little to their subjects. Live subjects must be approached differently from objects. Timing is important—only a quick reaction can catch the spontaneous gesture, the genuine smile. Liveliness is a quality which must be expressed in a photograph, not *suppressed* by a command: anyone who asks his subjects to "hold it" asks for a static picture.

A good way to natural-appearing pictures is to let people do things—something they are familiar with. Let children play, give them a new toy, get them interested in something—then call them, ask some questions, make them look up. . . . Don't pose people so they have to face the sun—it will only make them squint and look strained. Much better than direct sunlight is light in the open shade—with a pale red light-balancing filter used to compensate for the excessively blue skylight. Still better is the softly diffused light of a hazy or overcast sky—but don't forget that pale red light-balancing filter if the light seems "cold" and bluish. Another good way is to place your subject with her back toward the sun and use flash fill-in illumination to light the face. If well done, this method is capable of producing particularly beautiful results. p. 36

Photo-micrography. Since it is not possible to give detailed information within the limited space of this text, the interested reader is referred to the Kodak Industrial Data Book *Photography through the Microscope*, published by the Eastman Kodak Company and sold by Kodak dealers, which gives more information in its seventy-six pages than most amateurs and some professionals will ever be able to use.

Portraits. *Natural-appearing rendition of flesh tones* is vital for the natural appearance of portraits. If the incident light does not conform to the type of light p. 36 for which the color film is balanced, light-balancing or color-compensating filters in the appropriate color and density must be used. Normally, subject contrast should be kept within the contrast range of the color film with the lighting ratio not exceeding 3 : 1, although striking "glamour shots" with deep black shadows have been taken by photographers who know how to handle their lights. Fill-in p. 253 illumination is usually required. Lenses with relatively long focal lengths give better results in regard to perspective than standard lenses; wide-angle lenses produce caricatures.

A natural pose is as important to the general impression of the portrait as technically faultless color rendition. Above all, never try to force a smile; it simply cannot be done, as witnessed by countless "professional grins" displayed in countless ads. A natural relaxed pose is preferable to any kind of forced animation.

A suitable background is a must for a pleasing overall effect. Beware of backgrounds that are cluttered, "busy," or "loud" in regard to color or design. Bright patches of sky or spots of bright out-of-focus color are particularly distracting and must be avoided. Outdoors, the unobstructed sky is usually best. Indoors, a plain white or gray background is preferable to a background in color unless such color is chosen with great care. A great practical advantage of a neutral background is the fact that with the aid of colored light (gelatins in front of the photolamp) it can be given any color and, by placing the background light at the proper distance, can be made to appear lighter or darker.

Sports. Fast color films and telephoto lenses are prerequisites for success. Properly p. 357 controlled, blur effectively creates the illusion of motion. If the picture must be sharp, try to catch the relatively quiet moment at the "peak of action" when movement is slow or reverses itself, like a diver at the highest point of the jump, a shot-putter at the instant he lets go of the shot, or a pole-vaulter at the moment he clears the bar. Follow a runner, a horse, or a racing car with the camera, hold the image steady in the finder, and make the exposure with the camera swinging, thereby reducing the "angular velocity" of such speedy subjects to zero. As an alternative, if possible, photograph fast-moving subjects more or less "head on" rather than sideways to reduce angular velocity and get sharper pictures. In indoor arenas—boxing, ice hockey, etc.—electronic flash gives the best results, particularly if large units can be deployed strategically and fired by remote control p. 44 (radio) or with the aid of slave units. If necessary, the speed of many color films

172

can be "pushed" (increased) from one to two and one-half stops beyond their rated speed through appropriate development.

Stage photography. Most important: a seat near the center with an unobstructed view. Use a *quiet* 35-mm camera, a fast lens, high-speed tungsten-light color film, and expose according to exposure meter. Since exposure times are often relatively long and normally a tripod cannot be used in making the exposure, brace yourself well, press the camera against nose and forehead, hold your breath, and gently "squeeze" the shutter release. Try to catch a quiet moment during the presentation to avoid excessive blur due to movement of the actors.

Store windows. Shoot at night with tungsten-light color film. Reflections can be troublesome because headlights of automobiles and windows across the street will be mirrored in the store window. To block out such lights, professional photographers use a large piece of black cloth tacked on either side to a tall pole and held up behind the camera by two assistants. If the window is photographed at right angles, both camera and photographer may reflect in the glass. This can be prevented if the black reflection-shield is placed *in front of the camera* and the shot made with the lens poking through a hole in the curtain. Otherwise, the shiny parts of camera and tripod should be taped with black tape, the photographer should be dressed in black, and he should crouch low during the exposure.

Window-display illumination is often so contrasty that fill-in flash (clear-glass lamp) must be used for satisfactory rendition. To avoid reflection in the window, this flash must be fired at an angle to the glass. Test the intended "firing position" with a flashlight to be sure that no glare reflects in the lens. Instead of using the full brilliance of the flash, drape one thickness of white handkerchief across the reflector. Unless you have had previous experience with this type of work, bracketing is strongly recommended.

Sunsets and sunrises. Color photographs of sunrise and sunset skies can be breathtakingly beautiful, provided two precautions are taken. Rule number one: at the moment of exposure, the sun must be hidden behind a passing cloud; otherwise, flare and ghost images are almost unavoidable although, imaginatively used, they can effectively symbolize the radiance of direct light. Rule number two: determine the exposure by measuring the brightness of the lighter colors of the sky; if a Weston meter is used, set the C position on the calculator dial opposite the highest-indicated brightness value taken at a moment when the sun is behind a cloud; otherwise, colors will be rendered too pale and the dramatic effect will be lost. The landscape, of course, will be rendered in the form of a silhouette—more

or less black. However, in this case, blackness helps to heighten the effect of color

p. 297 through simultaneous brightness contrast, as will be explained later. Any attempt to arrive at a balanced exposure for simultaneous color rendition of landscape and sky is bound to end in failure.

Be sure that you have enough film available when you photograph sunset skies. The color display changes constantly, and so do cloud formations. Every new arrangement seems more beautiful than the last. Some of the most remarkable effects may occur ten or more minutes after the sun has disappeared below the horizon. Often, the whole sky flames up in bursts of pink and red before it changes to mauve and purple and finally fades into deep blue.

p. 149 **Time exposures.** As mentioned earlier, photographic emulsions may act inefficiently whenever exposures are abnormally long. This danger is particularly acute in close-ups and photographs taken at night. Before you start to work in either of these fields of color photography, read up on the effects of reciprocity failure and the necessary counter-measures that must be taken.

Travel photography. Before you go abroad, check the regulations governing the temporary import of photographic equipment with a consular representative of each country you plan to visit. Also, check with the nearest Field Service Office of the United States Department of Commerce on regulations applying to the import of processed and unprocessed film. To avoid paying duty on your foreign-made camera equipment when reentering the country, prepare a complete list in which every item is identified by its serial number and have it validated by a United States custom inspector before you leave the country.

Take as little equipment but as much color film as possible. One always uses more than one expects to, and to an enthusiastic photographer, few calamities are worse than running out of film at the moment when once-in-a-lifetime opportunities beckon. Although, officially, most foreign countries limit the import of film, I've never heard of a photographer who ran into trouble because he carried too much. An "official" letter by a magazine or book publisher addressed "To whom it may concern," explaining that so-and-so is on assignment photographing life in such-and-such a country, is always helpful should trouble arise. Once on location, take my advice: Shoot plenty! Waste film—but waste it sensibly. You may never get another chance, and once you are back again, may hate yourself for missing this subject and by-passing that shot. . . .

p. 112 If possible, get all your color film of one type with the same emulsion number.

174

Unless you are already familiar with its characteristics, test it to find out whether p. 114
a corrective filter is needed and how fast it *really* is. The expiration date should be p. 112
well ahead of the time of your return. As previously mentioned, color film is a
perishable commodity, twice so once it has been exposed. To guard against prema-
ture deterioration, particularly when traveling in hot and humid regions, take the
precautions recommended before. As soon after you shot it and as often as you p. 113
can, airmail exposed color film to a color-film processor back home with whom
you made arrangements in advance. Be sure to pack exposed color film so that
it will arrive in good condition—carry an adequate supply of wrapping material,
such as heavy-duty envelopes, corrugated cardboard, and gummed-paper tape.

If you buy new equipment for your trip, test it before you leave. Neither the fact
that the equipment is new nor that it is guaranteed by the manufacturer or dealer
proves that it will perform satisfactorily; tests do. If you take your old equipment,
check it against incipient breakdowns: shutters that have had much use and might
fail unless given a thorough overhaul; flash synchronizers that might be slightly
"off"; bellows that have chafed corners and might soon begin to let in light; cables
with worn connections and questionable insulation; and, if necessary, replace the
batteries in your speedlight unit and CdS exposure meter, also the one built into
your camera. If you expect to photograph in severe cold, have your shutter serviced
as recommended above under "Cold-weather photography." Finally, don't forget p. 157
to have your equipment adequately insured against damage and loss.

If you travel by air, try to take as much of your photographic equipment as pos-
sible with you as hand baggage on the plane—you know where it is, that it will
be treated carefully, and that it will be on hand when you arrive. If you are a
35-mm photographer, take a spare camera body as insurance against breakdown
or loss. When traveling in a foreign country, never lose your temper with anyone,
and particularly not with a customs official. Be patient, inscrutable like an Oriental,
and try to make yourself "invisible." If you are a professional photographer, pretend
to be a tourist and you will be bothered less. If you need help, an assistant, or a
guide, try to find a university student or an accommodating taxi driver—they know
the place, speak the language, and are always glad to earn a few extra dollars.
If the natives are unwilling to have their pictures taken, abstain—you might other-
wise get into serious trouble. Be courteous and polite wherever you go—and every-
one will treat you with courtesy. Together with money, it is the language most
readily understood anywhere.

Tropical photography. Contrary to general belief, daylight is NOT brighter in

the tropics than in temperate zones, provided the angle of the sun above the horizon is the same in both cases. However, because of the generally clearer atmosphere, lighting contrast is usually higher in tropic than in temperate zones. Furthermore, as a rule, subject contrast is also generally high, ranging from white buildings and light-colored beaches at one end of the brightness scale to dense dark foliage and dark-skinned natives at the other. For this reason, for pictures

p. 324

taken at short distances, fill-in illumination is generally required, and photographers traveling in tropic regions should carry a small speedlight unit or be well provided with blue flashbulbs.

pp. 112-114

To avoid premature deterioration of the color film due to humidity and heat, all the safety measures recommended previously must be taken. As a further precaution, it is advisable to airmail exposed color film home as soon as possible and to ask a competent person for a critical report on the results. Then, if anything should be wrong, corrective measures can be taken before too much damage has been done.

Winter. The contrast range of most snow scenes is low. To increase contrast, and to add highlights and sparkle to the picture, the use of low-slanting side- and backlight is recommended. In such cases, if the exposure is determined with the aid of a table, the customary increases for side and backlight are usually NOT necessary.

Snow scenes in bright sunlight are light subjects that must be exposed somewhat longer than normal. Likewise, snow scenes under a uniformly overcast sky, because of their extremely low contrast range, should be given half a stop more exposure than indicated by the meter.

Processing

At present, the number of color photographers who develop their own films is too small to justify including a detailed chapter on film processing in this book. With competent services available to anyone—if not directly, then by mail (see the advertisements in the photographic magazines)—and color-film processing being a complex and critical operation, it is not only understandable, but even advisable, that photographers leave this procedure to specialists. For this reason, and because *authoritative instructions accompany every color-processing kit,* I'll give in the following only a brief outline of Kodak Ektachrome film processing to show the interested reader what is involved. Although this summary is based on the latest data published by Kodak, he must realize that this procedure may be obsolete by the time this book appears in print.

Kodak Ektachrome film development (Process E-4)

Step	Operation	Temperature in degrees F	Time in minutes	Total elapsed time
	IN TOTAL DARKNESS			
1	Place film in prehardener	85	3	3
2	Place film in neutralizing bath	83-87	1	4
3	Place film in first developer	85	6¼	10¼
4	Place film in first stop bath	83-87	1¾	12
5	Wash film in running water	80-90	4	16
	TURN ON ROOM LIGHTS—no reversal exposure using lights is necessary, as reversal occurs chemically in the color developer			
6	Place film in color developer	83-87	9	25
7	Place film in second stop bath	83-87	3	28
8	Wash film in running water	80-90	3	31
9	Bleach film	83-87	5	36
10	Place film in fixing bath	83-87	6	42
11	Wash film in running water	80-90	6	48
12	Place film in stabilizing solution	83-87	1	49
13	Dry film in clean air at a temperature not exceeding 110° F.			Total processing time: 49 minutes

Maintenance of the prescribed temperature is critical for the prehardener (plus or minus ½ degree F.) and the first developer (plus or minus ¼ degree F.). The times given for each processing step include the 10 seconds required to drain the films.

Kodak Ektachrome film development—correction of abnormal exposures

Since Ektachrome is a reversible material, variations in the time of the first development in conjunction with certain chemical changes in the composition of the color developer cause changes in the effective film speed. As a result, in emergencies, where higher film speed is needed, or to counteract the effects of accidental overexposure, changes in the normal processing procedure can accomplish what in effect amounts to increases or decreases in the listed ASA speed. To bring about such modifications, Kodak has published the following instructions, warning, however, that the color rendition of the so-treated films will invariably be somewhat less faithful and pleasant than that of films that have been exposed and processed

in the standard manner. Such loss in picture quality, although relatively small as long as adjustments for under- or overexposure are limited to the equivalent of one f-stop, become quite noticeable with higher degrees of correction, manifesting themselves in overall color shift, color desaturation, and loss of maximum density which, of course, becomes most noticeable in the darker areas of the transparency.

Film	Equivalent ASA Speed	First developer time (min.)	Color developer pH change	Addition to color developer (per liter)
Ektachrome-X (64)	125	13	—	—
Ektachrome-X (64)	250	16	—	—
Ektachrome-X (64)	32	7½	+0.08	0.25 g sodium hydroxide†
Ektachrome-X (64)	16	5½	+0.15	0.50 g sodium hydroxide†
High Speed Ektachrome, Day (160)	320	13	−0.08	1.0 cc 7N sulfuric acid*
High Speed Ektachrome, Day (160)	640	16	−0.15	2.1 cc 7N sulfuric acid*
High Speed Ektachrome, Day (160)	80	7½	+0.08	0.25 g sodium hydroxide†
High Speed Ektachrome, Day (160)	40	5½	+0.15	0.50 g sodium hydroxide†
High Speed Ektachrome, Type B (125)	250	13	−0.08	1.0 cc 7N sulfuric acid*

† Kodak Sodium Hydroxide, Granular, is supplied in 1-pound bottles.
* You can make 7N sulfuric acid (20%) by adding 1 part concentrated (36N) sulfuric acid to 4 parts water. CAUTION: Always add the sulfuric acid *slowly* to the water, stirring constantly. Never add the water to the acid which would cause boiling and spatter acid on hands and face.

How to care for color transparencies

The dyes used in color films are as stable as chemical and optical requirements permit, but they are far from permanent. Although, in this respect, noticeable differences seem to exist between different types of color films, all transparencies are susceptible to the deteriorating influences of moisture, light, and heat. Consequently, processed color films—transparencies as well as slides—should be stored only in places that are dry, dark, and cool.

Kodak recommends that processed color films be stored under conditions of 25 to 50 percent relative humidity and temperatures of 70°F. or less. Such conditions are most likely to be found in a cabinet on one of the main floors of a building. Basements, as a rule, are too damp, and attics get too hot.

Humidity is the number one enemy of processed color films because it promotes fungus growth. If the relative humidity of the storage space exceeds approximately 50 percent, processed color films should be stored in a moisture-proof metal container with soldered corners and rubber-gasket fitted airtight lid. Activated silica gel should be used to keep the air dry within the box. Chemical companies offer prepared drying units consisting of a perforated metal container which holds the silica gel. A color indicator that turns from blue to pink as the gel absorbs moisture shows when the desiccant needs to be reactivated by heating.

Prolonged exposure to light, and exposure to excessive light and ultraviolet, bleaches the colors of a transparency. Usually, light affects the different layers of the color film to different degrees with the result that, eventually, all the colors may fade except, for example, the reds, turning the once colorful picture into a monochrome. To avoid this, slides must not be projected longer than absolutely necessary, and projection lamps must not exceed the wattage specified by the manufacturer since such lamps would produce more heat than the projector's heat-absorbing glass can handle.

To protect processed color transparencies from physical damage, sheet films should be kept in transparent sleeves, and rollfilms in suitable glassine envelopes with side seams. 35-mm color films, of course, are best protected when mounted between glasses in the form of "slides." That the surface of color transparencies must never be touched with the fingers should be self-evident. Accidentally incurred fingermarks and dirt can often be removed with Kodak Film Cleaner, which is available in most photo-stores.

4

How To See in Terms of Photography

By now the reader should have arrived at a point where the chances that he will make a "pictorially" bad picture are greater than the chances that he will produce a photo-technically unsatisfactory transparency. Unfortunately, this is also the point at which many students of photography stop growing as photographers. Laboring under the illusion that mastery of photo-technique is equivalent to mastery of photography, they feel they have nothing more to learn—they have arrived. Proof that this is not true is abundantly available in the form of innumerable color photographs which are competently made—crisp and sharp, good color—and yet somehow "wrong." The subject is trite and seems hardly worth photographing, the way of presentation is boring, composition poor, and numerous unfortunate occurrences make one wonder why the photographer didn't make this or that change, and how could he overlook this or that detail? These are the typical products of photographers who have mastered the technical aspects of color photography but haven't yet learned how to use their skill to make photographs that have something to say, let alone say it well. The main cause of this failure is the inability to see reality in photographic terms.

Why it is necessary to "see reality in photographic terms"

The eye and the camera "see" things in different ways, and what looks good to one may look bad to the other. The truth of this was again brought home to me only recently in conjunction with work on a book on trees. Many of my friends told me about the marvelous trees they knew, and when I went to see them, sure enough, there were the trees, and everything that had been said about their beauty was true. Unfortunately, however, not one of these truly beautiful trees could be photographed in a form that was satisfactory to me. Why? Because there were either buildings behind the tree, or a fence or highway in front of it, or telephone wires and powerlines criss-crossing the sky, or a mess of other trees in the background which made it impossible to isolate the specimen tree and come up with a meaningful picture. My well-wishers had seen their trees with "the eye of the

mind"—they had seen only what they wanted to see, the things that interested them, forgetting that the impersonal "eye" of the camera "sees" *everything* within its field of view.

I believe that the habit of comparing the eye to the camera and stressing the *similarity* of their construction while largely disregarding the *differences* in their function has done great harm to the cause of photography. For, at least as far as the making of *good* photographs is concerned, the similarities are superficial and of little importance whereas the differences are fundamental and their consequences decisive. This, of course, does not mean that the eye is superior to the camera, or the camera superior to the eye. But although generalizations are out of place here, the fact remains that, in certain respects, the eye is superior to the camera (for example, in its ability to concentrate on essentials and overlook superfluous detail whereas the camera treats essentials and nonessentials impartially); in other respects, the camera is superior to the eye (for example, lenses with different focal lengths and angles of view can be used whereas the focal length and angle of view of the eye are fixed). As a result, it is quite common for even a technically unassailable photograph to give an impression that is *inferior* to that created by the subject; on the other hand, it is just as possible for a picture to make a *deeper* impression than the actual event it depicts. To be able to avoid the first possibility and make use of the second, a photographer must be aware of the differences in "seeing" between the eye and the camera.

What are the differences in "seeing" between the eye and the camera?

The eye, guided by the brain, is selective. It sees subjectively, generally noticing only what the mind is interested in, wishes to see, or is forced to see. In contrast, the camera is indiscriminate, objectively "seeing" and recording *everything* within its field of view. This is why so many photographs are cluttered with pointless subject matter. Photographers who know how to see in photographic terms *edit* their pictures *before* they take them by eliminating superfluous subject matter through appropriate angle of view, subject-to-camera distance, choice of lens, or other means.

The eye sees everything it focuses on in the context of its surroundings, relating the part to the whole. We do not see sharp boundaries between the things we see sharply and the things we see vaguely or not at all because they are near the periphery or outside of our field of vision. As a result, we are generally not conscious of any particular overall design because we focus successively upon different parts of a much larger whole which we never take in all at once.

In contrast, a photograph shows the subject out of context, cut off from related subject matter, so that attention is centered upon it alone and the picture must stand on its own merit. Because it is a small, limited view it can be seen at a glance. Each component of the picture is seen in relation to the others in the form of a design, and if the design is weak, the picture "falls apart." As a result, a subject that was appealing in reality because it was contributed to by surrounding subject matter that gave it a special atmosphere or mood is dull in picture form when divorced from those elements.

Human vision is binocular and stereoscopic, that of the camera is monocular. This explains why so many photographs lack the feeling of depth—the photographer, through his stereoscopic vision, saw his subject as three-dimensional and forgot that, with only one "eye," his camera "saw" his subject without depth. Unless depth is expressed in a photograph in symbolic form, the picture must appear "flat."

The eye does not normally notice minor changes in the color of light. In contrast, the camera—through the color film—is very sensitive to small changes in the color of light. Since we generally do not notice small changes in the color of the light which, however, causes corresponding changes in the color of objects, we are astonished when we see such changes recorded on color film. It is the failure to notice such changes in the color of the incident light which accounts for the majority of color transparencies in which color appears "unnatural." However, if we could compare such transparencies with the subject seen under the same conditions under which the picture was made, we would most likely find that the color film was right and our judgment wrong.

To the normal eye, all things *appear* sharp simultaneously—an illusion caused by its ability to adjust focus automatically and virtually instantly as it scans a scene in depth. In contrast, the camera can produce not only pictures with any desired degree of blur or fuzziness—deliberately on the part of the photographer or accidentally—but can also make pictures in which a predetermined zone in depth is rendered sharp while everything else is unsharp.

p. 72 The focal length of the lens of the eye is fixed, but a camera can be equipped with lenses of almost any focal length. As a result, the scale of the photographic image is virtually unlimited.

The focusing range of the eye is severely restricted in regard to near distances; anything closer than approximately 10 inches can be seen only indistinctly, increasingly so, the shorter the distance between the subject and the eye. And small objects can be perceived less and less clearly the smaller they are, until a limit is

182

reached beyond which they become invisible to the unaided eye. The camera, however, equipped with a lens of suitable focal length or in conjunction with a microscope, has none of these restrictions.

The angle of view of the eye is fixed, but lenses range in angle of view from extremely narrow to 180 degrees. Unlike our own vision, a photographic angle of view can be chosen to give a desired effect.

Our vision functions so that we see three-dimensional things in the form of recti-linear perspective. Although most photographic lenses are designed to produce p. 329 this type of perspective, other lenses produce perspective that is cylindrical or spherical. The remarkable properties of these types of perspective make it pos- p. 343 sible to create impressions and show relationships between a subject and its sur-roundings which are beyond the scope of other graphic means.

The eye adjusts to changes in brightness, its pupil contracting and expanding as it scans the light and dark parts of a scene. As a result, the contrast range of our vision is remarkably wide, enabling us to see detail both in the brightest and darkest parts of a scene. In contrast, the "pupil" of the camera—the diaphragm—although variable and adjustable, can be set at only one specific aperture for each exposure, regardless of the contrast range of the scene, making it necessary to record brilliant highlights and deep black shadows with the same f-stop. The well-known results are pictures in which overexposed and underexposed areas occur side by side if subject contrast exceeds the contrast range of the color film and the photographer forgot or was unable to take appropriate counteraction.

The eye cannot "stop" very rapid motion, cannot retain the image of a subject that is no longer there, and cannot combine a number of images in one impression. The camera can do all three. As a result, a photographer can either "stop" a pp. 356, 361 subject in motion, symbolize motion graphically through blur, or indicate it through multiple images—thereby expressing movement in heretofore unknown beauty and fluidity of form.

The eye cannot store and add up light impressions—the dimmer the light the less we see, no matter how long and hard we stare. Photographic emulsions, however, can do this and, within certain limits, produce images whose strength and clarity increase with increases in the duration of the exposure. This capacity to accumulate light impressions makes it possible to take detailed photographs under light condi-tions of a level so low that little or nothing can be seen by the eye.

The above summary lists only those differences between eye and camera which are

of interest to the color photographer. There are others—for example, the inability of the eye to see a colorful scene in terms of neutral shades of gray, as black-and-white film renders it; or its unresponsiveness to infrared, ultraviolet, and X-ray radiation—forms of energy to which photographic emulsions are sensitive; and so on. What I want to point out here is the fact that fundamental differences between eye and camera exist; that a photographer must be aware of these differences; and that he must take advantage of the desirable qualities and avoid or mitigate the undesirable qualities of the camera (*i.e.*, the entire photographic process) if he ever expects to make the transition from the second level of photography to the third.

What it means to "see reality in photographic terms"

Every photograph which, though "technically faultless," didn't "come off"; every picture that is unsatisfactory because it does not express what the photographer had felt when face to face with his subject; every objectionable "distortion," ugly shadow, flaring highlight, etc., is proof that the author of such pictorial misfits was unable to "see reality in photographic terms."

Most photographic booboos occur as the result of their perpetrators' childlike faith in the old saying "the camera doesn't lie." But if the camera cannot lie, how can it record something the photographer hadn't seen when he made the picture or, conversely, why didn't it record what the photographer thought he had seen? Why didn't the picture represent the subject as the photographer remembered it—and wanted to preserve it in his photograph?

Although it is true that, strictly speaking, the camera does not lie (insofar as it slavishly registers everything in front of it), anybody knows that a photograph often fails to convey the impression which the photographer wanted to capture when he made his picture. This, however, is usually not the fault of the camera but rather the fault of the photographer, who was unable to "see his subject in photographic terms." Actually, he was betrayed by his own eyes—it was he who "lied"—and not his camera; for example:

Looking into the viewfinder of his trusted SLR—the diaphragm wide open for easy seeing—a photographer focuses the image of his lovely mistress and gently "squeezes off" the shot like a marksman careful not to spoil his aim. The picture turns out razor sharp and crystal clear, color is beautiful, but—What in blazes is that confounded telephone pole doing there apparently growing right out of my girl's head? It certainly wasn't there when I took the picture . . . at least I don't think it was . . . anyway, I didn't see it. . . .

And that's exactly it—the photographer didn't see the pole (although it was there big as life). Completely engrossed in his beautiful model, he forgot entirely to look at anything else, watch the surroundings, or check the background for distracting subject matter, and consequently overlooked the telephone pole, which, because of the wide-open diaphragm and resulting shallow zone of sharpness in depth, appeared on the groundglass out-of-focus, blurred, and insignificant. But since the day was bright, the diaphragm closed down to f/16 for the exposure, depth of field increased enormously, and the objectionable telephone pole appeared in the picture.

Other mishaps of this kind are noses that appear too big in close-ups of faces; hands and feet that seem unproportionally large; buildings that converge toward the top of the picture because the photographer tilted the camera; telephone wires or powerlines messing up an otherwise beautiful sky; ugly shadows that make young faces seem old; eyes that squint into the light; branches that appear to sprout from a lovely head because the lovely head was posed in front of a tree to which the photographer hadn't paid sufficient attention; busy backgrounds that in the picture merge with the subject, and innumerable other calamities that should never have happened. However, the unwanted objects and phenomena were there, the photographer didn't see them in time to do something about them, the incorruptible camera "did not lie" but rendered everything exactly as it was—including the pictorial junk that nobody wanted—and there you are: another disappointment, another picture that "didn't quite come off."

One of the most popular arguments in favor of single-lens and twin-lens reflex cameras is that "you get just what you see." The great question is: What *do* you see? Or more precisely: What did you overlook this time? The answer, of course, depends largely on whether or not you know how to see reality in photographic terms.

Seeing reality in photographic terms means realizing potentialities—the potentialities of the subject in terms of the picture: light, color, contrast, perspective, sharpness, blur. . . . It means not only *seeing what's in front of your lens*—from the subject itself to everything else alongside, behind, and in front of it—but also *analyzing what you see* in terms of light and shadow, color harmonies, space and depth. It means seeing not only in the physical sense—with your eyes—but also in a wider sense: seeing with the eye of the mind. Anticipating possibilities both good and bad: a more effective angle of view, a different way of "cropping" the subject in the viewfinder, a more effective illumination, a different scale . . . trouble in the form of perspective distortion, unsightly juxtapositions and over-

lappings of forms, phases of motion "stopped" at an awkward moment, ugly shadows, excessive contrast, glare and flare . . . and taking corrective measures in time, before it is too late, before the opportunity is lost, the damage done, the picture spoiled.

Of course the camera "does not lie" . . . how could it since it obviously shows *everything* within its field of view exactly as it is. And by the same token, the camera *does* "lie"—*precisely because* it shows everything within its field of view exactly as it is—which normally is *not* the way a photographer sees things. And this brings us to one of the most fundamental differences between the eye and the camera: The camera is a machine, objective, unthinking, brainless. The eye is part of a human being, possessor of a guidance system and information center called the brain, which coordinates a multitude of different sense-impressions and combines them into concepts and images which are subjective, screened, edited, and formed in accordance with the tastes and preferences, the prejudices and dislikes, the wants and needs of the individual. In other words, as far as the photographer is concerned, human vision is not something that can be evaluated out of context and defined by itself—it is NOT like the "vision" of the camera—because it is always augmented by other sense-impressions: sound, smell, taste, and tactile sensations combine with vision to inform us about the various aspects of our environment. If we stand by the ocean, we *see* the water, sand, and sky; we *hear* the wind and the waves; we *smell* the kelp, *taste* the salty spray, and *feel* the pounding of the surf. No wonder that, if we try to record these impressions on film, we are so often dismayed that our pictures lack the impact of the experience.

How you can see reality in photographic terms

To be able to bridge successfully the gap between human and photographic seeing, a photographer must train himself to see as the camera sees. He must familiarize himself with the principles of *"photographic* vision" so that he in turn can use the camera to produce images—pictures—which, although created mechanically with photographic means, nevertheless express the essence of the subject in *human* terms.

He must begin by muting all his senses except sight because, to the camera, a person is merely a shape consisting of various planes, some lighter, some darker, in this color or in that, each characterized by its own texture; a dinner plate is an oval form of a specific color and brightness, or a circle if the lens looks straight down on it; a building is a pattern consisting of a repetition of rectangular or

trapezoid forms which differ in texture and color; and so on. There is no feeling, meaning, implication, or value involved except the graphic values of form and color, texture, light and dark. No depth and perspective, only monocular projection of reality onto the surface of the film and paper, where two-dimensional shapes lie side by side. No motion or life, only sharpness, unsharpness, or blur. No radiant light, only the white of the paper or screen.

Start your exercise in photographic seeing by imagining that your subject has no depth. Try to see it as "flat" as it will later appear in the transparency, in the color print, or projected on the screen, where all its components lie within one plane. The simplest way to accomplish this is to look at it with only one eye. This changes your normal stereoscopic vision to monocular vision and you will see as the camera sees. Relationships between picture components that might have gone unnoticed will now become apparent: the aforementioned telephone pole, for example, previously overlooked, will now be seen as the disturbing picture element it is. Other parts of the background, unnoticed before, will suddenly relate to the subject, probably weakening, though occasionally strengthening, the effect of the future picture.

Study your subject's overall design (often called "composition"), the arrangement of its components in terms of mass, form, line, color, light and shadow. The simplest way to do this is to make yourself a "viewing frame" by cutting a rectangular hole some 4 x 5 inches in the center of a piece of cardboard, holding it in front of one eye, closing the other, and looking through the aperture at your subject. A similar but more versatile frame can be made from two L-shaped pieces of cardboard; it has the advantage that the opening can be varied both in size and proportions. Lacking such frames, of course, a frame can always be improvized by using the hands to form an opening through which to study the subject.

Studying a subject through a frame has several advantages. First of all, the frame blocks out extraneous subject matter and makes it easier to concentrate one's attention upon the subject itself. In addition, by isolating the subject from its surroundings, a frame makes it possible to see it "out of context"—see it as the camera sees it and as it will appear in the future picture: whether its boundaries are well chosen, whether it is strong enough to stand on its own merit without the helping influence of additional subject matter, whether it will be a self-contained unit in regard to editorial content and graphic design.

By gradually and progressively studying the subject through your frame—now holding the frame very close to your eye, then farther away, then at arm's length

p. 72

—you can locate the boundaries of the most effective view. To duplicate this view on film, select a lens that has a focal length that will make the view that you saw through your frame exactly fill the camera's viewfinder or groundglass. If the subject looked best when the frame was held very close to the eye, a lens

p. 86

of relatively short focal length—a wide-angle lens—must be used; conversely, the farther the frame was held from the eye to yield the most effective view, the longer the focal length of the lens must be.

By moving the frame vertically and laterally, you can establish the most effective location for the focal point of your composition within the borders of the pictures (the focal point is also known as the "center of interest"—the place where the action is—the group of people, the figure, the face). Should it be higher or lower, near one side or the other, or perhaps in the center of the picture? Each placement will produce a different impression: the more toward the center, the more static, balanced, peaceful and serene the composition; the more off-center, the more dynamic the design. Similar considerations also apply to the placement of the horizon: a high location stresses earthy qualities, nearness, and intimacy; a low location promotes a feeling of freedom and space. Which placement is most in accordance with the nature of the subject?

Analyze the subject's design in terms of shapes and masses. Does it consist primarily of a few large forms or a multitude of smaller shapes? Is there an overall organization discernible, a "pattern" which can be used advantageously to lend order and graphic interest to your composition? Perhaps in the form of a repetition of similar picture elements? Or is there no particular design but only a jumble of unrelated forms, making it advisable to scratch the entire project?

What are the dominant lines, forms, and features? Vertical shapes? Horizontal shapes? Diagonal lines? Irregular configurations? Is there a dominant theme that can be used as the "backbone" of the overall design around which other picture elements can be arranged to complete a self-sufficient design? How do such considerations influence the proportions of your picture? Should you compose for a horizontal or a vertical shot? Regardless of the film format, should the photograph be oblong or square, perhaps very narrow and wide, or very narrow and high? Such deliberations are just as important in color as in black-and-white photography because transparencies can be masked and color prints cropped, and the decision in which direction to proceed must be made *now*—before one makes the exposure, while choice of methods and means still exists and decisive changes are possible.

188

Analyzing your subject in abstract terms may seem difficult at first but will soon become routine. Begin such exercises in photographic seeing by studying simple forms like, for example, a leafless tree. Try not to see the tree but the linear design—the lines thin or heavy, the curves and bends, the angles and branchings—in short, the *pattern* that is typical for this tree. Not *any* tree, but a specific kind of tree: an elm, a maple, an oak—because each kind of tree has its own characteristic growth pattern; each kind of tree has its own particular "design."

From simple subjects proceed to more complex ones—a face, a room, a street. See them in terms of masses, forms, and lines; light and shadow; color and contrast—each aspect related to all the others, each forming part of the whole. It is this relationship which constitutes the design which a photographer must discover. More often than not he will find that the design is not clear, but obscured by extraneous subject matter. He'll sense it rather than see it. This is the moment which shows whether he is a *good* photographer. It is the mark of a good photographer to sense the design, to find it, and to reveal it in his picture. To do this he may have to eliminate disturbing subject matter; select a different angle of view, a different type of perspective; or change the distance from the subject and use a lens of different focal length; rearrange the lights and change the placement of the shadows, or wait for more suitable illumination outdoors; or employ other photographic controls. How a photographer can do these things will be the subject of subsequent chapters; the point which I wish to make here as strongly as I possibly can is that he can employ these controls only *before* he makes the exposure, because only *before* this "decisive moment" can he radically influence or change the concept, design, and ultimate effect of his picture.

Study your subject in regard to illumination. Most photographers consider light only in *quantitative* terms: As long as there is sufficient light to make a hand-held exposure with a shutter speed high enough to rule out camera shake as a cause of blur, they are satisfied. In contrast, photographers who know how to see in terms of photography perceive light *qualitatively:* to them, it makes a great difference whether the light is directional or diffused; whether it is front, side, back, or top light; whether its "color" is "white" or tinted; whether there is one source of light or several. They are also aware of contrast: they know that high-contrast illumination and low-contrast illumination produce entirely different impressions. As a result, unlike one who, seeing a subject that appeals to him, shoots it without considering that it might be more effective in a different kind of light—or with different shadows—the photographer who knows how to see in terms of photography is aware of these different aspects of light; and if the light is not to

p. 220

p. 222
p. 223
p. 319

his liking, he waits for the light to change, changes the illumination if he can, or does not take the picture.

To learn to see light in terms of photography, a photographer must constantly ask himself questions like these: Is the intensity of the illumination high, medium, or low? Does the light strike the subject from the front, the side, the back, or from above? Is the source of illumination pointlike or an area-type? Is it direct or reflected light? What is the color of the light, and how will it affect my color film?

If the light is unsatisfactory, a resourceful photographer has a number of means by which he can change it. These will be discussed later. What is important here is that the reader becomes aware of the fact that differences in the quality of light are as consequential as the quantity of the available light. The *quantity* of light influences the *exposure* of the film; the *quality* of the light influences a picture's mood. And if the mood of a picture is wrong for the depicted subject, not even a perfect exposure can make such a picture "good."

Study your subject in regard to color. Similar considerations as those that apply to light also apply to color. Since color is one of the most important subject qualities as well as one of the most important contributors to the overall design of a photograph, it is understandable that most color photographers pay more attention to the colors of their subjects than to any of their other qualities. Unfortunately, however, most photographers see color only in *quantitative* terms: the more colorful a scene, the better they like it. And if it isn't colorful enough they are quick to add more color, preferably red: a red-checkered shirt or bandanna if the subject is a man, a red sweater, scarf, or bathing suit if it is a girl. The unfortunate consequence of this mania for polychrome subjects in garish colors is that color becomes isolated, the means become the end, and the end a cliché.

In contrast, photographers who know how to see color in photographic terms see color *qualitatively:* to them, color is one of the *characteristics* of their subject, a significant attribute that has a *meaning,* a *symbol* that evokes a specific reaction in the observer of the picture and conveys to him something about the subject which, without this particular color, he would not have felt. And, unless there was a valid reason, they would no more think of putting a red sweater on a girl merely to give their picture "snap" than they would attend a funeral dressed in red. Instead of piling color upon color, they think of color in terms of color harmonies and clashing color; related and complementary color; colors that are "warm" or "cold," aggressive or receding, saturated or soft. They have trained themselves

p. 13

p. 282
p. 314

190

to see color *not* with the eye of the calendar photographer who evaluates color only in relation to its "naturalness," but with the eye of the painter who, if he finds it necessary, paints a face green, a horse blue, or a shadow pink. Shocking? Unnatural? Modernistic nonsense? Not at all—as any color photographer knows: if he photographs a person sitting under a big tree with the light filtering through green leaves, the face will have a greenish cast in the color photograph; if he photographs a white horse in the shade of a barn under a deep blue sky, the horse will have a bluish tint in the color photograph; and if he photographs the shadow of a building cast on freshly fallen snow at sunset when the sky is red, it will appear pink in the color photograph. Unnatural? Distorted color? Inherent weakness of the color film? Not at all. Under such conditions, things actually look like that, and the reason that most people don't notice such "abnormal" color in reality is that they tend too see color as they remember seeing it in average "white" daylight and *not* as it is. I'll say more about this later.

pp. 294-301

The first result of a newly acquired ability to see color as an independent quality, disassociated from the subject, will be the realization that there is no such thing as "true" color. Skin color is *not* necessarily pink or tan in a "white" person, nor is freshly fallen snow necessarily white. All colors change with changes in the color of the incident light. As a result, since the color of the light is almost constantly changing, even though changes are minute, what at one moment looked white at another may have pink, blue, yellow, or green overtones. Color may be *unusual* but it is rarely "unnatural." If I see a picture in which a face is blue, I say the color is true because the photograph was made either in blue light or through a blue filter, and under such conditions a face must appear blue. And had I seen it in blue light or through a blue filter, my eyes would have received exactly the same impression.

p. 308

It seems to me that awareness of this interrelation between light and subject color should do away with the notion according to which one of the criteria of a "good" color photograph is "naturalness." Actually, what do we mean when we speak of "naturalness" in connection with photographic color rendition? Do we mean that the color of the transparency should match the color of the subject as it appeared at the moment of the exposure (for example, should a face photographed in the glow of a red sunset sky look red?); or should color in the transparency appear as we think the subject ought to look (*i.e.*, should a face have "normal" skin tones no matter how colorful the light that illuminated it?). It seems to me that only in the first case can we truly speak of "naturalness," and yet it is precisely this kind of photograph which most people would reject as "unnatural."

191

Such pictures don't conform to "the rules" set down by the makers of color film according to which the incident light must be of the same type as the light for which a color film is balanced—the rules by which color photographers grew up (and magazine editors, and art directors, and anybody who ever snapped a color picture in his life, which today means almost everybody), the rules which are not really rules at all but defenses put up by the film makers against accusations that the colors which their products deliver might not be true. But "true" color does not exist. And people who still believe in this myth are fighting windmills, not to mention the fact that by sticking to the obsolete concept of "naturalness" they deprive themselves of some of the most rewarding photographic experiences.

Another change of a photographer's attitude toward color that will result from an awareness of color as a dimension in itself will be the realization that color does not have to be bright and loud to be effective. If anything, the opposite is true. Loud color has been used so much in our loud and ruthless society that we are quite immune to it. On the other hand, soft, muted colors are rarely used and thus they automatically attract attention. Besides, their subtleties can express feelings and moods which loud color cannot. In these delicate shades a color photographer will find a scarcely touched world of sophisticated color. Fog and mist, the subtle tints of rainy days and overcast skies, of dawn and dusk, and indoors the use of bounce-flash and shadowless lighting arrangements, offer limitless opportunities for discovery and invention to anyone who has learned to see color in photographic terms.

Through seeing color in photographic terms, a photographer will become aware of color to a degree he would not have thought possible. He will not only become *consciously* aware of color, but he will become aware of its subtle shades and changes. Where he had seen color quantitatively, he will now see and appreciate it qualitatively. The world will look marvelously rich and beautiful, ever-changing. The photographer will feel his imagination stir in this discovery. He will now wonder whether color could be made better, more interesting and more significant by waiting for changes in the color of the light—toward sunset or dusk, very early in the morning, or under a different sky—or by using special filters: to "warm up" a scene or to "cool it off," to give it a pink glow, or to soften it and create a sense of mystery by giving it a purplish tint. Who is to say this should not be done? Who is to dictate how one should create?

pp. 326-348 **Study your subject in regard to perspective,** paying particular attention to the problem of "naturalness"—the same problem which occupied us in the previous chapter. This time the question is: when is photographic *perspective* "natural,"

192

when "distorted"? Or differently formulated: which instrument renders three-dimensional objects accurately—the human eye or the camera?

To avoid getting lost in semantics, let's take a specific example, say, the convergence of actually parallel lines in a photograph as the result of "perspective." The most familiar example of this, of course, is the apparent converging of railroad tracks at a distance, a phenomenon accepted by everybody as "natural." However, if the same phenomenon manifests itself in the *vertical* instead of the horizontal plane, it is usually rejected as "perspective distortion" because normally we do not consciously see it in reality. For example, as any photographer knows, tilting the camera when making a shot of a building produces "converging verticals," i.e., the sides of the building will be rendered inclined like the sides of a house on the verge of collapse. But since this is the way a camera "sees" a building, and since the camera "does not lie," this form of perspective obviously must be "true," although it doesn't look "right." Therefore, two forms of "correct" perspective apparently exist side by side— one that is "true" as far as the camera is concerned, and the other that is "right" as far as the eye is concerned. Unfortunately, matters are still more complicated because, in addition to the "ordinary" photographic perspective (called rectilinear perspective) and the human-eye perspective (which might be called pseudo-rectilinear perspective), there are also cylindrical and spherical perspectives (the latter also known by "fish-eye" perspective)—two forms of perspective which are characterized by the fact that they render straight lines as curves. I'll have more to say about these interesting forms of perspective later.

p. 329

p. 343

pp. 343-346

The problem then remains the same: which type of perspective should a photographer employ in his picture (since, as we will see later, he has full control over the rendition of his subject in regard to perspective)? To this I can only answer: it all depends . . . on the purpose of the picture; the intention of the photographer; the circumstances under which the shot is made; and the attitude of both the person who made the picture and the one who looks at it. But apart from such considerations, none of these different forms of perspective should be considered more "true" than any of the others; they are merely different.

It is the habit of seeing their surroundings always "in the same perspective" which makes most people believe that only one "correct" type of perspective exists and that any perspective which does not conform to this concept must be "distorted." The explanation of this, of course, is that the brain corrects our visual sensations in the light of knowledge and previous experience. We therefore generally "see"

193

things not as they are but as we think they ought to be. For example, looking up at a building, we see its walls as parallel because we *know that they are parallel,* our brain automatically corrects the "laws of perspective," which state that receding parallel lines must appear to converge toward a common vanishing point. The camera, of course, lacking a brain, objectively registers this convergence. To convince yourself that this photographic type of perspective is "true," look at a building p. 187 through the cardboard viewing frame previously recommended as a valuable aid in photographic seeing: If you tilt both your head and the frame as you tilt the camera, the vertical lines will seem to converge, *i.e.,* will no longer be parallel with the (obviously) parallel sides of the frame. And if you had set up a groundglass-equipped camera and were to compare the groundglass image with the image you see through the cardboard frame, you would find that the angle of convergence in the two would be the same. Similarly, you can also prove that the apparent "compression of space" in telephotographs is real. To do this, hold the frame at arm's length and center in its opening a subject, such as the far end of a street. You must look carefully because the image is so small. You will see, perhaps to your surprise, that the highly foreshortened buildings give exactly the same kind of compressed effect that you have seen in telephotographs, in which this phenomenon was more obvious because the image was larger.

Seeing in terms of photography means training one's eye to see consciously, and training one's mind to accept as true, these and other phenomena of perspective. The phenomenon known as "wide-angle distortion," for example, is not *true* dis- p. 340 tortion (as will be explained later), but a perfectly natural effect produced by a combination of relatively short subject distance and a lens that has a wide angle of view. This kind of "perspective distortion" too can be recognized more easily by studying the subject through a viewing frame than when seeing it without the benefit of this helpful device. Objects which, because of their nearness to the camera, would be rendered unproportionally large (best-known example: hands and feet extended toward the photographer), will clearly reveal themselves in their exaggerated size when studied through a frame, *i.e.,* when seen out of context, but may not when seen without it, *i.e.,* when seen in the context of their surroundings. Whether such an "exaggerated" perspective should be considered a fault of the picture, or the natural manifestation of nearness which it is, depends upon the intent of the photographer and the purpose of the photograph. What matters here is that the photographer should be aware of the "perspective" of his subject and learn how to recognize its particular type in actuality—*before* he discovers it, too late, in his picture—so that he can either use it to good advantage or change it.

194

Another phenomenon that relates directly to photographic seeing is scale. Time and again people take pictures of landscapes or other very large subjects and are dismayed to find that in the photograph the subject looks so small. This effect is caused by the photographer's inability to see space in photographic terms. Such photographers forget that in reality they experience the landscape in relation to themselves—as small human beings surrounded by its immensity. As a result, their experience has scale. But in their photographs the landscape is without an indicator of scale. If a human figure were included and placed far enough from the camera so that it appears small, in contrast to the figure's smallness the landscape would appear large. Without such an indicator of scale, the landscape, or any other large subject, appears no larger than the picture.

Study your subject with the aid of optical devices. Valuable aids in learning to see in photographic terms are viewfinders, particularly multifocus and zoom finders, which enable a photographer not only to isolate effectively a potential subject from its surroundings but to study it in more or less tightly "cropped" form and in different degrees of scale. And studying reality at close range through a 100-degree wide-angle viewfinder is an almost traumatic experience but very much recommended because it is bound to lead to a better understanding of perspective and space. Any serious student of photography would do well to carry a viewfinder in his pocket and use it at every opportunity.

Another powerful tool for studying reality in terms of the camera is the groundglass panel of an SLR, TLR, press-type, or view camera (TLR's, because their viewing lenses cannot be stopped down, are less suitable than other types). Studying a subject on a groundglass has the advantage that it enables a photographer to observe the degree of sharpness in depth. This phenomenon is difficult to visualize without this direct visual aid; it cannot be seen through a viewfinder or viewing frame. By gradually stopping down the diaphragm while studying the effect on the groundglass, a photographer can observe the increase of sharpness in depth and study its effect on the subject, the relationship between subject and background, and the resulting feeling of space and depth.

Another advantage of groundglass observation is that it permits a photographer to visualize and evaluate a subject in terms of masses, color, and distribution of light and dark. All he has to do is to throw the image out of focus. In doing this, he denaturalizes the subject and reduces it to its basic graphic constituents—the "picture" is transformed into an abstract arrangement of blurred forms, daubs of color, and areas of light and dark. The underlying design—the composition—

195

emerges more clearly than in an ordinary view, in which it is always difficult to see beyond realistic qualities and penetrate to the underlying graphic-abstract design.

To further increase his experience and his understanding of photographic phenomena, a photographer should look at things through as many suitable devices as possible. For example, study landscapes, street scenes, buildings, ships, etc. through *binoculars* and you will see things in *telephoto perspective*—space "compressed" and objects in more nearly true proportions to one another. In such views, perspective and distortion will be largely eliminated and *you will be able to see things as they are,* not as you *think* they are. This is an important step in learning to see space in photographic terms.

Study your nearest surroundings *through a magnifier.* This will develop your feeling for surface textures and later help you to characterize more efficiently different materials through appropriate photographic treatment—rough textures through the right kind of slanting side- or backlight, smooth surfaces through highlights and reflections. In addition, you will discover a whole new world—the world of little things: small forms of nature—the intricacies of flowers, the faces of insects, the ornamental design on butterfly wings—an indescribably rich world of fascinating subjects otherwise not clearly seen because of small size and closeness which offers a lifetime of pleasure and fascination to any interested photographer.

Look at *reflections in shiny curved surfaces.* Study the images of familiar objects which are, through distortion, turned into caricatures whose grotesque shapes are often extraordinarily expressive. Study *reflections in a mirrored sphere* (a Christmas tree decoration or a garden ornament). You will see your surroundings in p. 343 spherical perspective, exactly as a 180-degree fish-eye lens would render them. You may have seen pictures with such perspective reproduced in magazines or books. Looking at images reflected in a mirrored sphere, you can study such perspective, learn to translate the images, and see for yourself what is represented.

pp. 32, 35 Study objects through *filters* of different colors. See how a subject looks in a rose light, a cool blue light, etc. Remember that there are no "true" colors, as the color of all things changes with the color of the incident light. In rose light, a face appears rosy, in blue light, blue. Although you may not be able to change the color of the light, you can get exactly the same, desired effect by using a filter of the right color in front of your lens.

A creative photographer is not satisfied with passively receiving visual impressions;

instead, he actively takes part in the creation of the picture, interferes, makes things happen. He looks at objects through rippled and pebbled glass, through the bottom of a beer bottle, the stem of a wine glass, or other likely materials that promise new effects. Instead of using a photographic lens, he puts a magnifying glass, a condensor, a spectacle lens, or a pinhole in front of his camera and studies the images they produce on the groundglass. He experiments with diffusion screens of various kinds to find new ways of expressing concepts of radiance and light, and later uses such images to show in symbolic form subject qualities he could not express directly. He violates "the rules," questions old-established photographic "procedures," finds new solutions to old problems, and renders common subjects in new and fascinating forms. It is the creative photographer who, through daring and imagination, experimentation and inventiveness, by fascinating and sometimes shocking his audience, revives our visual experience and keeps photography alive and growing.

Photogenic qualities and techniques

Technical advances in photography have made it possible to photograph *any* subject and come up with a faithful rendition. But "faithfulness" is no criterion of artistic quality, and many a faithful rendition is as meaningless and trite as the subject it represents. Faithfulness, particularly in regard to color rendition, is, of course, essential in scientific, medical, documentary, educational, catalogue, etc., photography, but not in creative photography, where other considerations come first: stopping power, meaning, impact, graphic qualities—the qualities which pp. 15-20 make a photograph "good."

In their quest for "good" photographs, it has been the experience of all perceptive p. 13 photographers that certain subjects are effective in picture form while others are not. Those subjects that make "good" photographs have attributes popularly known as photogenic qualities, qualities that unphotogenic subjects lack. Therefore, whenever they have a choice, experienced photographers avoid unphotogenic ones because they have found that it is more rewarding to pass up an unsuitable subject and find a better one than it is to try to make a good photograph of a subject which is deficient in photogenic qualities.

A definition of what constitutes photogenic qualities depends, of course, to a large degree upon the taste and preference of the person asked. Blue eyes, blond hair, or a configuration that makes it possible to "compose" the picture in the form of a triangle or an S-curve may be photogenic qualities in the eyes of a beginner, but a more experienced and in matters of taste more mature photographer has

considerably more sophisticated ideas. Personally, I find it difficult to list *specific* subject qualities which I consider photogenic, although I have learned from experience that certain *combinations* of subject quality, condition at the moment the picture was made, and photo-technique, produce better results than others. In particular, I'd like the reader to consider the following:

Simplicity, clarity, and order head, at least in my opinion, the list of photogenic subject qualities. Since the camera shows *everything* within its field of view but people, as a rule, are interested only in certain *specific* aspects of a subject or scene, it is always advisable to "clean up," both literally and figuratively speaking, before making the exposure. Such a clean-up should include the physical removal of superfluous subject matter as far as this is practicable, and also the exclusion of extraneous picture material through selection of a more advantageous angle of view, changes in distance between subject and camera, choice of a lens with longer focal length, and other photographic controls.

If the subject in question is very complex, it is usually advantageous to show it, once in an overall view and again in a number of close-ups, each showing one specific aspect or detail of the subject in a clear and well-organized form that effectively supplements the overall view. If only a single photograph can be used, it is often possible to convey the essence of the subject through a part.

Maximum clarity and graphic impact are found in subjects that have "poster effect"—subjects that are so simple and at the same time so bold in design that they are effective even at a distance that obscures detail. The ultimate in this respect is the silhouette.

Spontaneity and authenticity are qualities difficult to define but easy to recognize in a picture. Spontaneity is revealed in a natural expression or gesture, movement, arrangement of forms, and many other ways. Authenticity is the quality that gives a photograph the stamp of honesty, believability, and conviction. Over-direction of a subject weakens these most important picture qualities, posing destroys them.

The unusual is *ipso facto* more interesting and informative than the common and familiar. This applies to the subject itself, its coloration, the circumstances surrounding the making of the picture, and the form of rendition selected by the photographer. In an unusual light, for example, even an ordinary landscape can become attractive, and seen in a new and unusual way even a commonplace subject will arouse the interest of the beholder. However, unusualness used merely for its own sake—i.e., without contributing anything positive to the content

of the picture—is valueless and becomes a "gimmick." Photographers who are aware of this avoid, whenever possible, not only commonplace subjects and situations, but also tricky techniques.

Subject coloration. In color photography, color, of course, is a very important, and certainly the most obvious, quality of a subject or picture. As far as photogenic considerations are concerned, experience has shown that ordinary everyday colors, no matter how accurately rendered in a photograph, are less interesting than colors that are unusual. Particularly effective are: colors that are exceptionally strong and saturated; very pale soft colors and pastel shades; subjects that are virtually colorless, i.e., characterized by only the most subtle shades of delicate color—scenes photographed in dense fog or mist, in the rain, during a heavy snowfall; subjects that are mainly black, gray, and white but also possess one or two very strong colors of limited extent; unexpected and "unnatural" color—like pp. 306-307 the "blue face" mentioned earlier. However, in his quest for "unusual" color, a pp. 191, 308 photographer must not lose sight of the fact that color must relate to the nature of the subject and the purpose and meaning of the photograph; otherwise, color becomes a "gimmick" and the picture a farce.

Subjects that are animate or in motion are, on the whole, more likely to make good photographs than subjects that are inanimate or at rest.

Telephoto and long-focus lenses are, in my opinion, preferable to standard and wide-angle lenses because they preserve to a higher degree the true proportions of the subject by forcing the photographer to keep a greater distance from it. Information on the advantages, uses, and effects of telephoto lenses will p. 341 be given later.

Close-ups, as a rule, make more interesting pictures than overall shots because the subject is more tightly seen and shown in larger scale.

Backlight is, to me, the most dramatic (and the most difficult) form of illumination, superior in beauty and strength to front or side light. For specific informa- pp. 222, 257 tion concerning its use see the chapter on light.

Unphotogenic qualities and techniques

Sometimes, advising a student what *not* to do can be more helpful than telling him how to proceed. This is the case in regard to photogenic qualities where it is often easier to recognize a subject, situation, or technique that lacks photogenic qualities than to define unequivocally those which possess these desirable proper-

ties. The following is a summary of subjects, practices, and techniques which, at least in my opinion, are unphotogenic, almost invariably lead to unsatisfactory pictures, and should be avoided.

Insipidity and lack of subject interest are probably the two most common causes of worthless pictures. They can be overcome only through discrimination and self-discipline on the part of the photographer.

Disorder and complexity rank high among unphotogenic subject qualities. Never forget that the camera shows *everything* within its field of view whereas normally a photographer is *interested only in some specific aspect or part of a subject or scene* and regards everything else as superfluous and therefore distracting. Photographs that are overloaded with pointless subject matter are confusing and ineffective.

Unsuitable backgrounds have ruined more potentially successful pictures than any other single fault. In particular, avoid telephone wires and powerlines that cross the sky; utility poles; trees and branches that conflict with the subject; bright patches of sky surrounded by dark foliage; strongly colored objects which are rendered out-of-focus and, because they are not easily recognizable, become objects of curiosity which detract from the subject proper of the picture; shades and colors so similar to those of the subject that they blend with the subject and cause it to "fade into the background"; backgrounds that are unnecessarily contrasty, "busy," and "loud."

Other unsuitable backgrounds are those the color of which is too strong, particularly if they are used in conjunction with subtly colored subjects, such as jewelry, pottery, chinaware, sea shells, etc., or female nudes. It almost seems as if photographers were trying to make up for such subjects' lack of brutal color by setting the background on fire, a practice which, of course, kills the effect of the subject.

Another mistake frequently made is to let the shadow of the subject fall on the background. This fault is particularly unsightly if several lamps are used and criss-crossing shadows result. An attempt to correct this fault by using additional lamps to "burn out the shadows" merely makes matters worse by adding new sets of shadows. The only way to avoid such shadows is to place the subject at a sufficiently great distance from the background.

Meaningless empty foreground is a fault of many otherwise acceptable pictures. It is easily avoided by decreasing the distance between subject and camera or, better still, by making the shot with a lens of longer focal length.

Awkward shadows in a picture unmistakably spell "beginner at work." In particular, avoid: getting your own shadow into the picture; casting the subject's shadow on the background unless this shadow contributes to the effect of the picture; harsh shadows in a face, particularly around the eyes and underneath the nose and chin; sets of shadows that criss-cross one another in indoor shots lighted with more than one light.

Multiple lighting. As a rule, *not counting fill-in lights,* one light source is preferable to two, and two are preferable to three or more because the greater the number of lights, the greater the danger of overlighting, shadows within shadows, and shadows pointing in different directions—some of the most unsightly photographic faults.

Overlighting and indiscriminate shadow fill-in. Outdoors on sunny days, contrast is often so great that shadows would appear too dark in close-up photographs if not lighted by fill-in illumination. However, unless correctly used, fill-in p. 324 illumination will create a shadow within a shadow or make shadows appear too light. Both mistakes are common, perhaps because overlighted pictures are commonly used by flashbulb and speedlight manufacturers in their promotion. "Filling-in" has also been so publicized that many photographers seem to have forgotten how to take outdoor pictures without flash. If not well used, flash destroys the mood of a subject.

Flash at the camera. This method of illuminating a subject makes areas close to the camera appear unproportionally light in relation to areas farther away, which appear unproportionally dark. Furthermore, it destroys the feeling of depth because, like all front light, it produces virtually shadowless illumination—and shadows are the strongest means for creating the illusion of depth in a photograph. p. 260

Flash at the camera as the sole source of illumination, however, must not be confused with flash at the camera for purposes of shadow fill-in, *i.e.,* as provider of p. 324 supplementary illumination, or bounce-flash at the camera for overall illumina- p. 242 tion in depth. These two uses of flash at the camera are, of course, highly commendable photographic techniques which, in the hands of competent photographers, produce excellent results.

Shooting from too far away and thereby including too much extraneous subject matter are typical faults of the beginner. In this connection it is interesting that when a beginner acquires a second lens, it is usually a wide-angle lens (which includes even more subject matter than a standard lens), whereas the

second lens of a more experienced photographer is usually a telephoto lens (which takes in a narrower angle of view and thus improves the picture).

Posing. Highly photogenic subjects can easily be made into bad photographs by photographers who confuse posing with directing. Directing is often vitally important. Posing, with its commands, destroys naturalness, as we can see in advertisements in which beautiful girls have frozen grins instead of smiles. And the results of posing are just as unfortunate in most academic studies of the nude.

Faking is another approach that results in bad photographs. Faking, as I see it, is tampering with the authenticity of a subject, scene, or event. The most common example is shooting an "outdoor" scene in the studio. No matter how resourceful and skilled the photographer is and how well equipped the studio, there is always something that marks it as a fake: the background has no depth; there are shadows within shadows, and shadows too well filled in that show the use of artificial light; the hair too well groomed, the faultlessly fitted dress, the immaculate accessories and "props," the perfection of the entire set-up. All these combine to destroy a feeling of reality and life which the picture is supposed to have. In a picture taken outdoors, light comes from only one direction, shadows on a sunny day are harsh, people are windblown, and perfection is absent.

Faking, as I see it, also includes the use of professional models dressed as doctors, nurses, photographers, workers, etc., who in photographs are obviously not what they are claimed as, betrayed by hands too well manicured, fingernails too long, hairdo too stylishly perfect, and poses that would not fit the real work. Such things are quickly seen by an observant eye and the picture is rejected as false.

The "gimmick." In our fast-changing society, "newness" is an almost indispensible quality. Anything goes—as long as it is "new": in art, in merchandising, in photography. . . . As a result, photographers often try to be "original" at any price, even if the price is a silly picture. Shots taken through prisms or the grid of an exposure meter; photographs in which perspective distortion does not contribute anything to a better understanding of the subject but is employed as a means for being "different"; the indiscriminate use of colored gelatins in front of photolamps, and other "novel" approaches motivated solely by a desire for "newness" are, in my opinion, "gimmicky" and in bad taste.

Summary and conclusion

We have learned that the eye and the camera "see" things differently; that the eye is superior to the camera in some respects and the camera superior to the

eye in others; that any subject can be photographed in many different forms; and that some of these forms are more effective than others. If we now consider each of these statements in relation to the others and draw the logical conclusions, it becomes obvious that (1) a badly seen subject *must* result in a photograph which is *inferior* to the impression received by the eye at the moment the picture was made, while (2) a well-seen subject—a subject "seen in photographic terms"— can result in a picture that is potentially *stronger* than the impression which the eye received at the time the photograph was made. In other words, it depends on the photographer whether the photograph will be good or bad—HE HAS A CHOICE.

In order to make the right choice a photographer must know three things: what to do, how to do it, and why it should be done. This in turn presupposes that he knows how to "see in terms of photography"; knows how to control the graphic components of his rendition; and is familiar with the meaning of the photographic symbols. We just finished discussing the first of these premises; the second and third are the subject of Part V, which follows.

5

How To Control the Picture

Every photograph is a translation of reality into picture form. And similar to a translation from one language into another, the visual translation of reality into the "picture language" of photography can be accomplished in two different ways: literally or freely.

As in translating from one language into another, in photography too the *literal* approach, concerned primarily with preserving the *superficial form,* is often clumsy and inadequate. In contrast, the *free* approach, concerned above all with the *content* of the original or subject, concentrates on meaning and feeling. As a result, whereas the literal approach is likely to produce a "translation" or photograph which is inferior to the original, a free translation can not only match but may even surpass the original as far as beauty, impact, and clarity of expression are concerned. The literal approach is typical of the beginner—and the snapshooter; the free approach is that of the accomplished photographer—and the artist.

That there are two approaches to the problem of rendering a subject with photographic means is due to the fact that, contrary to popular belief, photography is not a purely mechanical medium of reproduction, nor is a photograph a "reproduction" of reality. That photography is not a "purely mechanical" process should be obvious to anyone who has ever watched an expert photographer at work and realized the high degree to which the physical part of picture-making is dominated and controlled by the mind and imagination of the photographer. And that a photograph is not a "reproduction" of reality is obvious because a reproduction is a replica which in every respect is identical with the original. However, except perhaps for the photographic reproduction of a page of print, few photographs can truthfully be called reproductions because most photographic subjects have three dimensions whereas a photograph has only two—depth is lost. Furthermore, the majority of photographic subjects move or change, but a photograph is a "still" —motion and change are lost. A still photograph reveals only a single instant in time—continuity is lost. Some of the most exciting photographic subjects are alive,

but a photograph is an object—life is lost. Most subjects evoke other sensations besides visual ones—sensations of touch—hot, cold, wet, dry, soft, hard, smooth, rough, etc.—sound, smell, or taste—but a photograph involves only the sense of sight. No wonder so many photographs seem "incomplete," are disappointing, ineffective, dull.

To overcome the deficiencies inherent in the photographic medium, photographers express in symbolic form subject qualities which cannot be rendered directly. Color, for example, can be rendered directly, motion cannot. A sharp picture of, say, an automobile in motion, is in no way different from a sharp picture of the same car standing still—the feeling of movement, perhaps the most important aspect of the subject, is missing in such a photograph, the camera *did* indeed "lie." However, all is not yet lost because motion can be indicated in symbolic form: by taking the picture with a shutter speed just a little slower than required to "stop" motion, a photographer can render the automobile just a bit blurred—enough to create the illusion of motion. Blur is one of the photographic symbols of motion. p. 357

Likewise, depth is a subject quality which cannot be rendered directly within the two-dimensional flatness of a photograph. But with the aid of "perspective"—the apparent converging of actually parallel lines—foreshortening, diminution, overlapping, light and shadow, and other "depth symbols," a photographer can create pp. 326-350 the *illusion* of depth in his picture—or fail to create this feeling if he does not know how to handle his symbols as proved by all those pictures that look "flat."

Now the reader may perhaps think: well, all this is very interesting but why make so much fuss about the obvious? After all, when I take, say, the photograph of a street, the buildings are automatically shown "in perspective," will automatically diminish in size toward depth, and people and cars will automatically overlap and thereby strengthen the feeling of depth—whether or not I want it, am aware of it, or deliberately strive for it!

True enough—but you forget one most important thing: the conclusion we reached at the end of Part IV, the fact that YOU HAVE A CHOICE!

You have the choice of making your picture with a lens of standard focal length, a wide-angle, or a telephoto lens; you have the choice of innumerable different camera positions and angles of view; you have the choice of different types of daylight, or waiting for the sun to hit the buildings "just right" to give you the best effect of light, shadow, and texture; you have the choice of different diaphragm stops for different degrees of sharpness in depth; you have the choice of different shutter speeds which will give you different degrees of blur to symbolize motion

(or "stop" motion if this is your wish); you have the choice of waiting for different traffic patterns, or specific groupings of people . . . and so on. And each of these different ways of seeing things, and different ways of rendering things, will result in a different picture of what basically remains the same subject. And each effect will be different—be it ever so slightly—*but some will be more significant than others.* This is the reason why I make so much ado about "the obvious"—because YOU HAVE A CHOICE!

This choice is yours no matter what the subject, whether a landscape or the close-up of a flower, an industrial shot or the picture of a face. . . . Just for argument's sake, let's see how many different choices are involved in the making of a portrait: You have the choice of different types of light—daylight or artificial light—in particular the sun, open shade on a sunny day, light from an overcast sky, daylight in the home or studio, electronic flash, flashbulbs, photo lamps. . . . Choice of camera: 35 mm or 2¼ x 2¼-inch for rapid shooting, for capturing the fleeting expression, the genuine spontaneous smile . . . or a larger size for a more formal study. . . . Choice of lens: focal length, speed—for different types of perspective, sharpness in depth, or "selective focusing," which concentrates sharpness on the eyes while leaving the rest softly blurred . . . or perhaps a soft-focus lens for a more idealized view. Choice of pose: standing, leaning, sitting, reclining, at rest or doing things, smoking a cigarette, discussing the latest play. . . . Choice of view: front, semiprofile, profile, close-up of only part of the face, head shot, head-and-shoulders, level view or looking slightly up or down. Choice of horizontal, vertical, or square picture. Choice of diaphragm aperture: smaller or larger, for overall sharpness or for sharpness limited to only a specific zone. Choice of color: the dress, the accessories, the background, the "props." Choice of timing: determination of the "decisive moment"—the moment when a gesture is significant, an expression meaningful, the face "alive."

It is a sign of the novice—of insecurity—to put on a show of confidence by approaching his subject authoritatively, taking but one look, ostentatiously setting up his equipment, firing away—once—and departing with a casual "got it," leaving the audience impressed. In contrast, an experienced photographer acts very differently. Aware of the enormous range of possibilities and choices, he studies his subject from many angles and sides, from nearby and farther away, is not afraid of climbing a vantage point or lying flat on the ground for a view from above or below, unmindful whether he looks dashing or silly to other people because all he thinks of is how to make the best of his privilege of CHOICE. And for the same reason he is not content with making only a single photograph but keeps on shoot-

206

ing while the shooting is good, aware of the fact that the first shot rarely, if ever, is the one that yields the best picture. And the longer he works with his subject, the more he gets involved, the more he sees, the greater the stimulation. Aspects overlooked at first become apparent, new concepts suggest themselves, a different angle, a different perspective, a different lighting effect, a different "twist" (which is a far cry from a "gimmick"). And not before he feels he has exhausted all the possibilities of his subject does he stop, satisfied that he has made the best possible choice.

THE CONCEPT OF THE PHOTOGRAPHIC SYMBOL

Photography is picture language and, like all communication, based upon symbols. I already mentioned that, for example, depth can only be *symbolized* in a photograph—by the apparent converging of actually parallel lines, diminution, foreshortening, overlapping, light and shadow, and other graphic devices that create the *illusion* of the real thing. Unfortunately, most photographers are so used to this kind of pictorial symbolism that they are no longer aware of it, particularly since the camera apparently "automatically" produces all the necessary symbols any time they take a picture.

Nevertheless, I believe that a deeper understanding of the symbolic nature of photography would benefit a photographer, mainly because thinking in terms of symbols necessitates thinking of the subject and its specific qualities in terms of the photograph and its specific qualities—light and shadow, color, contrast, perspective, sharpness, blur, and so on—which is the way a *good* photographer sees his subject: in photographic terms. pp. 180-197

An analogy between photography and language might clarify this. Letters, for example, are symbols which stand for sounds, and combinations of sounds or letters—words—are symbols that stand for concepts, objects, actions, events. . . . Anyone familiar with the English language and able to read, understands the meaning of the symbols g-i-r-l, although he first has to translate them in his mind into the concept which they represent. This process is, of course, completely automatic and most people are not even aware of it.

But professional speakers and writers—experts in the use of words—are very much aware of the importance which the right kind of expression, the right kind of *symbol*, has upon the effect of their speeches and writings, and they take great care to choose the most expressive words. Writing about a girl, for example, any writer is aware that there are other terms from which to choose, such as gal, miss, lass,

maiden, damsel, virgin, wench, tomboy, hussy, broad, baby, babe, chicken, chick, or twist . . . each in essence meaning "girl," yet with a different connotation.

Similarly, a *good* photographer realizes not only that he has a large number of different symbols at his disposal, but also that each of these symbols appears in many different forms. Light in conjunction with shadow, for example, is one of the symbols for depth. A face illuminated by flat front light—shadowless light—appears "flat"; but move the lamp to one side, or turn the head so the sun illuminates the face more or less from the side, and the face acquires "depth" through shadows. This is elementary, as any draftsman knows who in his drawing creates the illusion of depth through "shading." Light-plus-shadow is, in effect, a "symbol" of depth. Obviously there are innumerable different ways of arranging the illumination, each way producing different proportions between the areas of light and shadow and also making shadows fall differently, thereby producing different depth effects. Furthermore, there are degrees of contrast: softer, more transparent and "filled-in" shadows, or harsher, deeper, blacker shadows. . . . Such variations are the equivalent of synonyms for the writer. *In addition* to creating the illusion of depth, predominance of light over shadow, for example, creates a brighter, more youthful, joyous, and festive impression, while predominance of shadow over light produces a darker, more powerful, serious, or tragic mood. For a photographer to pay attention to such subtleties—i.e., using the right kind of symbol, and in *the right degree*—is equivalent to the writer choosing the most effective synonym: a means to sharpen the impact of his work.

This "choice of synonyms" pervades all of photography. A photographer wishing to symbolize depth through the apparent converging of actually parallel lines, for example, can, through appropriate choice of camera position in conjunction with a lens of wider or narrower angle of view, create any number of "synonymous" perspectives, *i.e.,* any number of variations of perspective in which actually parallel lines converge *more* or *less abruptly,* thereby producing *different* depth-effects. Likewise, a photographer wishing to indicate in his picture the "speed" of a moving subject through blur can, through appropriate choice of shutter speed, create any desired *degree of blur.* And so on. Total picture control is yours if you know your "symbols" and "synonyms"—and know how to choose and control them.

Whether or not he likes it—or is aware of it—a photographer cannot avoid working with symbols. It is because of this symbolic nature of photography that, as shown before, a photograph can never be considered a "reproduction" of the subject it depicts; nor is it an inferior "substitute." If anything, it is a work in its own right created with graphic-symbolic means. Therefore, "naturalism" in photog-

raphy is a fallacy, and anyone trying to limit his photographic activities to "natu-
ralistic" renditions would soon find himself a very frustrated photographer indeed
because he would quickly run out of subjects that can be rendered "natural-
istically."

As a matter of fact, if "naturalism" were the criterion of a "good" photograph, we
should have to reject all wide-angle and telephotographs because they show the
world to be different from what it appears to our eyes; likewise, we should have to
repudiate all high-speed photographs and time-exposures of subjects in motion,
and most photographs that make use of blur and unsharpness, because they show
things in a form in which the eye cannot see them. And we would have to reject
as "unnaturalistic" all black-and-white photographs because they lack color, and
most color photographs because they have no real depth. This shows the absurdity
of this concept.

Now, since a photograph is *ipso facto* unnaturalistic, a photographer might as well
cease to strive for a "naturalism" that can never be more than superficial—a pseudo-
realism based upon antiquated academic standards that can only lead to stan-
dardized photographs. And instead of accepting stifling restrictions, he should use
to the best of his ability the fabulous potentialities of the photographic medium
and exploit it to "break the vision barrier" imposed upon us by the shortcomings
of our eyes. He should think of the camera as a means of exploring the world and
extending his horizon, as an instrument for making life richer and more meaningful
by acquiring insight into many of its aspects which otherwise would remain un-
known, as a powerful tool of research, and ultimately as a disseminator of knowl-
edge and truth.

To be able to do this he must be in command of his symbols and know how to
exert control.

THE CONCEPT OF PHOTOGRAPHIC CONTROL

The means and techniques of photography have been refined to such a degree that
even a rank beginner will find it difficult *not* to render almost any subject in the
form of a recognizable photograph. However, there is a vast difference between
a recognizable and a significant picture of a subject. The picture in which the
subject is merely recognizable may be adequate for many purposes, but it will
rarely leave a lasting impression, nor will it greatly stimulate the mind. The dif-
ference between that kind of photograph and one that does impress, the kind of
picture one *remembers,* is largely accounted for by the extent of control the
photographer was able to exert over his medium.

209

Unfortunately, when applied to photography, the term "control" is sometimes mis-understood—as if it implied either falsification through use of retouch or other extraneous means, or certain antiquated "pictorial" printing processes. Needless to say, I have neither of these or similar things in mind. When I speak of control I literally mean what the word implies: power and ability to choose from the different means and techniques of photographic rendition those that are most suitable to perform a required task.

This form of control is in no way different from that which other craftsmen or artists exercise in their work. Any sculptor has dozens of chisels and any painter dozens of brushes, all slightly different, from which he chooses the one most suitable to create a certain effect. Of course, a differently shaped chisel or a brush of different size and form would probably do the job too, *but not quite as well.* In other words, these experts use control, which is merely a shorter way of saying that they do their work in the best and most efficient way.

p. 85

Similarly, in photography, any lens will project an image of the subject on the film. But since there are many different types of lenses with widely differing character-istics, some lenses will do a specific job better than others, and often only one type of lens will do it to perfection. The photographer who realizes this and selects the best-qualified type of lens uses control.

I know that photographic purists frown upon the concept of symbols and the use of control, although they themselves unknowingly use them, for example, perspec-tive that symbolizes space and depth. The only apparent difference is that they accept the chance appearance of these symbols and make no effort to control (and thus to decide) their final form, and that they regard control as equivalent to faking. Their ideal is the "straight" photograph. But what actually does the purist mean when he speaks of straight photography as opposed to controlled photog-raphy? Unquestionably, Mathew Brady's Civil War photographs are examples of straight photography, as are Atget's pictures of Paris. But is this definition still applicable to Edward Weston's work, which is dodged (*i.e.,* contrast-controlled) during contact printing? And what about "converging verticals" in photographs of buildings? This form of perspective, accurate and natural as it may be, is uni-versally frowned upon by conservative photographers who maintain that this is not the way in which a building appears to the eye—looking as if it were about to collapse. But this effect can be avoided only through perspective control with the aid of the front and back adjustments of a view-type camera—is this acceptable to the purist, or does he regard it as "faking"? And should the image of a racing car streaking down the track be sharp or blurred—appear to be standing still or

p. 329

in motion? If the practice of dodging is acceptable to the purist, why not perspective control or the use of blur? Where should one draw the line between reporting and faking?

How meaningless such squabbles are becomes apparent in considering a situation such as the following: Two photographers record a boxing match. One shoots by available light, the other uses synchronized electronic flash. The pictures of the first are partly blurred and suggest action. Those of the second are sharply defined, the motion "stopped." Let us suppose that the pictures of both, each set in its own way, report the event dramatically. Now, of the two sets of pictures so different from each other, can we say that only one is "straight" photography? And which of the two?

To me, both sets are an honest and effective representation of the event, although each reflects a different approach. One has what the other lacks. The first, through blur, suggests the violence of action and dramatically illustrates the concept "fight." The second, through precision of rendition, shows that which could not have been seen in reality because it happened too fast: the impact of fist on chin and its effect upon the face. Either approach is legitimate. This example merely indicates the need for planning and control if one is to present in his pictures those aspects of a subject or event which he considers most important for effective characterization. To my mind, theorizing about straight versus controlled photography, experimental versus pictorial approach, artistic dramatization versus falsifying interference, etc., is a waste of time—indulged in by those who prefer talk to the more exacting task of making pictures. There are only *two* kinds of photographs and photographers: good and poor. The poor photographers, unimaginative and timid in their work, imitative rather than inventive, are enslaved by antiquated rules. In contrast, good photographers continuously search for new means of graphic expression, improving their craft through imaginative use of any means at hand.

THE RANGE OF PHOTOGRAPHIC CONTROL

Control in photography can be exercised by means of a complex of methods. These methods operate on three different levels:

Subject selection
Subject approach
Subject rendition

Although these levels may at first appear in no way related to one another, noth-

ing could be less true. Each one is an important link in a chain that ends with the picture, the effect of which depends to a large degree upon the skill with which the photographer had been able to utilize and integrate the various controls into one overall plan. Any mistake on one of these levels is invariably transferred to the next, and no effort can ever completely correct it. This interrelationship of the different levels of photographic control cannot be overemphasized; awareness of it on the part of the photographer is one of the prerequisites for success.

Subject selection

p. 197 The reader will remember our discussion of photogenic qualities where I said that, whenever they have a choice, experienced photographers concentrate on photogenic subjects and avoid unphotogenic ones because they have found that it is simpler and more rewarding to pass up an unsuitable subject than it is to try to p. 180 make a good photograph out of it. He will also remember the example of the beautiful trees which my friends suggested that I photograph for my Tree Book which, although eminently photogenic, could not be made to yield good photographs because of unsuitable surroundings. I hope he will draw the proper conclusion: to yield good photographs, a subject must be *photogenic in every respect*. The most beautiful girl, photographed in an unphotogenic pose, in an unphotogenic setting, in unphotogenic light, will turn into a photographic disaster. One of the most common mistakes made by inexperienced photographers is that they don't see the whole picture, they see only part of it—the part they are interested in. If the girl is beautiful, the natives colorful, or if the Acropolis or the Taj Mahal beckon, they take pictures, no matter how unphotogenic the surrounding, the background, or the light. A *good* photographer, realizing the impossibility of turning this kind of subject material into effective photographs, either changes his camera position to change the background, waits for better light, comes back some other time—or abstains from making the picture, saving his film for a more worthy cause.

Practicing control on the first level—the level of subject selection—enormously increases a photographer's chances for success because it gives him the invaluable advantage of a good start. In this respect, a photographer who is discriminate in regard to subject selection—who chooses his subjects on the basis of photogenic qualities—can be likened to a craftsman who makes certain that his raw material is flawless as well as suitable for the work intended before he spends (and possibly wastes) time and effort on it. Any fashion editor, art director, or commercial photographer who critically screens a number of models before he selects one as right for a specific job is concerned with control on the first level—subject selection. This kind of critical approach to the problem of subject selection is almost always

possible in other fields of photography also. It is, of course, easiest when the number of subjects is large, as in travel or landscape photography, where the photographer can choose from hundreds of different subjects. It becomes more complicated when the subject is more clearly defined, as in architectural or industrial photography. And it is most difficult when a photographic assignment is very specific, although even under such restrictions a resourceful and experienced photographer can, as a rule, avoid those hopeless shots which a less experienced and less discriminating photographer might take—and regret when he sees the outcome.

In spite of the most careful subject selection, many things, of course, may still go wrong later and the photograph turn out disappointingly. Remember—the picture of a beautiful girl is not necessarily a beautiful picture. But applying straightforward techniques to a photogenic subject is, in my opinion, a surer way to good photographs than to spend the most sophisticated efforts on a subject that is basically unphotogenic. In this sense, CHOICE—subject *selection* as well as subject *rejection*—is the photographer's most powerful control.

Subject approach

Having made up his mind *which one* of a number of potential subjects to choose for rendition, a photographer must next decide *how* to render it. This decision involves two phases: subject approach, and subject rendition. The first takes place in the photographer's mind; the second involves the physical implementation of making the picture.

Subject approach is strategy—making a plan for making the picture which takes into consideration all the factors involved: the nature of the subject with particular attention to its characteristics, the purpose of the picture, and the available phototechnical means. At this moment, a photographer once again has a choice—the choice between a literal and a free translation, *i.e.*, between an illustrative-documentary and an interpretive-creative approach. The difference between these two approaches is essentially the difference between fact and feeling. If one were to draw a parallel between picture language and word language, one might say that illustrative-documentary photographers could be compared to journalists, and interpretive-creative photographers to writers of fiction or poetry.

The illustrative approach is impersonal and factual—basically a documentarian's or scientist's approach to a pictorial problem. It is direct, unbiased, and objective inasmuch as the photographer tries to refrain from injecting his own opinion of the subject into the photograph, which should be as factually accurate and informa-

tive as possible, enabling the viewer to provide his own interpretation and draw his own conclusions.

The interpretive approach is personal, opinionated, emotional—basically an artist's or poet's approach to a pictorial problem. It is imaginative and often prejudiced, a frank attempt at expressing a personal opinion of the subject. This approach is less concerned with facts and surface appearances than with feelings and implications. Instead of limiting himself to a physically accurate rendition of the subject, an interpretive photographer tries to include in his picture, and convey to the viewer, something of what he felt and thought in response to it. This is a more difficult approach—but potentially more rewarding because the picture, if successful, instead of being merely informative will show the subject to the viewer in a new light, providing a new insight and an unexpected visual experience.

Since they serve different purposes, neither approach is better than the other. Which should be chosen depends upon the purpose of the picture and the "audience" for which it is intended. Because a fact is incontrovertible, either "true" or "false," the factual photographer's subject approach is, of course, much more restricted in regard to the number of available forms of expression than is the approach of the interpretive photographer, whose range of expression is limited only by the scope of his imagination. Each approach, of course, can borrow elements of the other. A strictly factual photo-report can be made pictorially attractive through the incorporation of certain imaginative touches without loss of accuracy; and an interpretive subject approach need not be so "far out"—so "experimental"—that the subject or idea behind the photograph become unrecognizable, since inclusion of factual aspects does not necessarily destroy its subjective, interpretive-creative character. At its best, an illustrative photograph is interesting and informative; but an interpretive photograph at its best is not only interesting but stimulating to the mind.

The physical aspects of subject approach

The overwhelming majority of photographs involve three-dimensional subjects located in three-dimensional space. This brings up the question: Where should the camera be located in relation to the subject? Which one of a theoretically infinite number of different camera positions should the photographer select?

Once again, control has to be exerted, a choice has to be made, and the basis for this choice is the same as everywhere else in creative control: reject the obviously unsuitable, impractical, and impossible camera positions, and from the

214

remaining possibilities select the best. But which one is the best? The task of choosing immediately becomes less difficult if one approaches it logically and explores its two aspects separately:

Subject distance
Direction of view

Subject distance

Choice of the best distance between subject and camera demands careful attention because this factor determines two important picture qualities:

The scale in which the subject is rendered
The proportions of the picture components

The scale in which the subject is rendered. The shorter the subject-to-camera distance (and/or the longer the focal length of the lens), the larger will be the p. 72 image of the subject on the film but the smaller the included subject area, and vice versa. In this respect, distinguish between three basically different types of photographs:

The overall shot
The medium-long shot
The close-up view

The overall shot (or long shot) shows the subject in its entirety together with its surroundings and background. Its purpose is to provide a general impression of the total subject complex—to orient the reader of a magazine, for example, and prepare him for the more specific views that will follow as the picture story unfolds. Since photographs of this kind are usually made with a lens of standard focal length at a comparatively great distance between subject and camera or, when enough distance is not available, with a wide-angle lens, the scale of the subject is always relatively small and detail often too insignificant to be effective. Furthermore, because of the large angle of view included, there is always the danger that too much extraneous subject matter might clutter up the scene and "dilute" the impression of the picture. Beginners in particular commonly make the mistake of taking an overall view where a medium-long shot (or a shot with a lens of longer focal length) would have been more effective, apparently in an attempt at matching the impression received by the eye and the picture produced by the lens. However, because of differences in "seeing" between the eye and the camera, p. 181 such photographs usually disappoint—the sweeping grandeur of the panoramic

view is reduced to insignificance, detail is much too small to be effective, and the feeling of boundless space is lost.

The medium-long shot—the most common type of view—is usually made with a lens of standard focal length from an average distance—"average" meaning a distance great enough to show the subject in its entirety but not too great to make recognizing detail impossible. This is the approach most often used to photograph people, objects, events. The effect of a medium-long shot is comparable to the average view of the eye—like seeing a flower patch from a distance of 3 to 6 feet, a person from 10 to 15 feet, or a building from 50 to 100 feet. Although the medium-long shot is the generally most useful and therefore most common type of photograph, it rarely represents a very exciting subject approach since, normally, it does not show us anything we have not seen before.

The close-up represents a form of intensified seeing—a dramatic and intimate view which is usually more effective than a picture of the entire subject. Close-ups are made from relatively short subject-to-camera distances with any kind of lens from wide-angle to telephoto, and render the subject in larger scale and with more detail than it appears in reality to the unaided eye. As far as viewer impact is concerned, close-ups generally score higher than the two other types of photographs because of three specific qualities:

p. 198 As a highly concentrated and more critically "edited" version of the subject, close-ups contain less superfluous and distracting subject matter than medium-long and overall shots. They are therefore a particularly clear form of pictorial statement and, as I mentioned earlier, simplicity, clarity, and order head the list of photogenic qualities.

Close-ups show the subject in larger scale than it is shown in the average picture, with correspondingly improved rendition of surface texture and essential detail. Because of this, they often show features and phenomena the viewer had not noticed before and, as opposed to the ordinary picture in which such subject matter appears too small to be effective, they give a stronger and more significant impression of the subject, thereby deepening the viewer's experience.

Since the majority of photographs are medium-long shots or overall views—i.e., taken at average or greater-than-average distances between subject and camera—close-ups are comparatively rare, and rare types of pictures automatically arouse more interest than common ones.

The proportions of the picture components. If a picture contains a subject in

216

front of a background, a photographer can control the scale of one relative to the other, and the apparent extent of the intervening space, without changing the distance between the two, by

> choosing the appropriate distance between subject and camera, and choosing a lens with an appropriate focal length for making the shot.

For example, you wish to photograph a monument in the center of a plaza with old historical buildings forming the background. The monument, being the subject proper of the picture, should fill the entire slide, while the buildings provide "atmosphere" and background. Set up your camera equipped with a lens of standard focal length, choose your distance so that the monument fills the entire picture, and check the groundglass image: the buildings in the background will appear in a certain scale. If you don't like this scale, this size-relationship between subject and background, you can change it without changing the scale of the monument by making appropriate changes in subject distance and focal length of the lens: if you want the background to appear *larger* relative to the monument, exchange your standard lens for a lens of *longer* focal length and *increase* the distance between subject and camera until the entire monument is again included in the picture, then make the shot: the buildings in the background will now appear *larger* than before. Conversely, if you want the buildings in the background to appear *smaller* relative to the monument, use a lens of *shorter* focal length and *decrease* the distance between monument and camera until the monument again fills the entire picture, then make the shot: the buildings in the background will now appear *smaller* than before. You can proceed similarly if, instead of a monument in front of buildings, you wish to photograph a figure in front of a castle, or any specific subject in front of any kind of background. You can control their relative scales and make the intervening space appear larger or smaller in your photograph, simply by taking the picture from the appropriate distance with a lens of appropriate focal length.

Direction of view

A photographer working in three-dimensional space has two basically different possibilities of physically approaching his subject: he can approach it in a straight line, i.e., change the distance between subject and camera and thereby *control in the picture the subject's scale;* and he can encircle the subject laterally and vertically, i.e., look at it more from the left or right, look up to it or down on it, and thereby *control the direction of view.* We discussed already control of scale;

when contemplating the direction of view, a photographer must make his choice under consideration of the following factors:

> The characteristics of the subject
> The purpose of the photograph
> The relationship of subject to background
> The direction of the incident light

The characteristics of the subject. Some subjects (a person, an automobile, a house) have definite front, side, rear, and top views. Others (a tree, a landscape) more or less lack such distinctions but may still look quite different from different directions. And a few subjects appear pretty much the same regardless of the direction from which they are seen. If the subject is complex, its components will probably appear in more satisfactory relationships to one another if seen from some directions than from others; overlapping of the various elements in depth may make for a clearer rendition and foreshortening look better from this direction than from that. Such reasons make it advisable to study, as far as circumstances permit, a subject from all possible angles and viewpoints, including views from above and below eye level.

The purpose of the photograph. The more literal the translation of reality into picture form, the more conventional the angle of view; conversely, if a free translation is permissible, a more unusual and fantastic angle of view may be chosen. Certain purposes require that perspective distortion is avoided as much as possible; in such a case, a "head-on view"—making the shot from a direction which places the principal plane of the subject (for example, the front of a building or the side of an automobile) parallel with the plane of the film—will yield the picture with the least degree of perspective distortion.

The relationship of subject to background. The camera position which affords the best view of the subject may show it against an unsuitable background. If the subject is movable or the background can be changed (for example, when photographing a person, or a sculpture in a museum), the remedy is simple, *provided the photographer notices the necessity for such a change before it is too late.* On the other hand, if change is impossible, an unsuitable background can often be made less offensive by rendering it unsharp through selectively focusing on the subject proper and making the shot with a relatively large diaphragm aperture, stopping down only as far as required to bring the entire depth of the subject into focus. In other cases, it may be possible to tone down the background by

218

keeping it in the shade—either by waiting until the sun has moved into a more suitable position, or by placing shadow-casting panels, etc., between the background and the source or sources of light. An "impossible" background that cannot be changed or modified is, of course, a valid reason for abstaining from making the picture.

The direction of the incident light. If the photographer has control over his illumination (indoors, by shifting the lights; outdoors, by changing the position of the subject), there is no problem. However, if an immovable outdoor subject is badly illuminated (like a building or landscape in flat light), a photographer has very few choices: he can wait for the light to change (clouds to pass; the sun to move to a more suitable position); come back another time (when atmospheric conditions have improved); or abstain from taking the picture.

Subject rendition

Having decided upon a specific subject, and having made his choice of approach, a photographer is at last ready to choose his means of rendition. Here, on the third level of control, the choice of possibilities—of "symbols" and "synonyms"— is virtually unlimited. In particular, he must distinguish between three groups of controls, the components of which, through differential use, enable him to create almost any imaginable effect in his picture.

Mechanical devices

Camera	Shutter	Polarizer	Photo lamp
Lens	Swings and tilts	Film type	Speedlight
Diaphragm	Filter	Film size	Flashbulb

Photographic techniques

Subject selection	Focusing	Timing	Developing
Subject approach	Composing	Exposing	Printing

Picture aspects

Illumination	Motion symbolization	Sharpness
Color rendition	Light symbolization	Unsharpness
Contrast range	Glare rendition	Graininess
Space symbolization	Texture rendition	Mood rendition

Each of these devices, techniques, and aspects can be modified to various degrees, each modification having a corresponding effect upon the appearance of the picture. Since any one of these modifications can be used in combination with any

modification of any of the other controls, the number of possible variations in the rendition of any given subject is truly astronomical, permitting a resourceful and imaginative photographer almost unlimited control over the final appearance of his picture. Some of these possibilities are discussed in the following sections.

LIGHT

Light is a form of radiant energy produced by atomic interaction in the physical structure of matter. It flows from its source in all directions and is propagated in the form of waves. Two characteristics of any wave are wave length and frequency. Wave length is the distance between the crests of two adjoining waves. Frequency is the number of waves that pass a given point per unit time. The product of wave length and frequency is the speed of propagation. The wave length of light ranges from approximately 380 millimicrons* for blue light to 760 millimicrons for red.

Frequency is of the order of 600,000 billion, *i.e.*, if we used sufficiently sensitive instruments we would find that the intensity of light varies periodically at the rate of 600,000 billion times per second. Speed of propagation is approximately 186,000 miles per second in the near-vacuum of space, somewhat slower in denser media.

As far as the color photographer is concerned, light has four main qualities:

Brightness
Direction
Color
Contrast

In addition, he must differentiate between three main forms of light:

Direct light
Reflected light
Filtered light

For practical reasons, he must distinguish between two main types of light:

Natural light
Artificial light

* A millimicron is the millionth part of a millimeter (a millimeter is approximately 1/25 of an inch); it is usually abbreviated mμ.

As far as the photograph is concerned, light has four main functions:

It **illuminates** the subject
It **symbolizes** volume and depth
It **sets the mood** of the picture
It **creates designs** in light and dark

Brightness

Brightness is the measure of the intensity of light. It can be measured with an exposure meter, determines the exposure, decides whether the camera can be p. 135 hand-held or must be mounted on a tripod, and influences the color and mood p. 119 of the picture.

Brightness runs the gamut from the almost unbearably intense illumination found on snowfields and glaciers to the darkness of a starless night. It affects not only the exposure, but also the color rendition and the mood of the picture. Bright light is crisp, often harsh, and always brutally matter-of-fact; dim light is vague, restful, and mysterious. High-intensity illumination makes subjects appear not only lighter, but also more contrasty and their color more brilliant than low-intensity illumination. Accordingly, through choice of the intensity of the light, a photographer can control the feeling and mood of his picture.

Outdoors, if the illumination is too bright, intensity can be reduced with the aid of a neutral density filter (available in different densities) which cuts down the brightness without affecting the color rendition. This may become necessary if a shot is to be made with a large diaphragm aperture for deliberate restriction of the extent of sharpness in depth (selective focus) and the light is so bright that use of the optimum shutter speed would cause overexposure. Waiting for different atmospheric conditions is an alternative.

Indoors, brightness at the subject plane is determined by the distance between subject and photo lamp and, at least theoretically, controlled by the inverse-square law: the intensity of the illumination is inversely proportional to the square of the distance between the illuminated surface and the illuminating light-source. Expressed in more practical terms, it means that if the distance between subject and lamp is doubled, the intensity of the illumination at the subject plane is reduced to one-quarter; if the distance is tripled, it is reduced to one-ninth; and so on. However, since this "law" applies only to point sources of light in the absence of reflecting surfaces, when used to determine the effect of a photo lamp (an area source of light in combination with a reflecting surface), it gives only approximate

p. 144 values that should be checked with the aid of an exposure meter and a gray card and, if necessary, refined. The inverse square law is even less trustworthy when appreciable amounts of reflected light contribute to the illumination, for example, p. 242 light reflected from walls or a ceiling (bounce-light). And it does not apply at all to line sources of light such as fluorescent tubes, the fall-off of which is directly proportional to the distance between subject and light, *i.e.*, doubling the distance between subject and fluorescent tube halves the intensity of the illumination at the subject plane, tripling cuts it to one-third, and so on. Incidentally, guide num- p. 249 bers for flashbulb and speedlight exposures are calculated in strict adherence to the inverse-square law—the explanation why they should only be regarded as "guides," not absolutes.

Direction

The direction of the incident light determines the position and extent of the shadows. In this respect, distinguish between five main types of light and their characteristic effects upon the picture:

Frontlight. The light-source is more or less behind the camera, illuminating the subject more or less "head-on." Subject contrast is lower than with light from any other direction, a basic advantage in color photography. However, frontlight is also the "flattest" type of light because shadows are partly or entirely hidden behind the subject and thus not visible to the lens. As a result, while frontlight is particularly suitable to accurate color rendition, it makes objects appear less "rounded" and space less "deep" than light that casts more extensive shadows. Incidentally, 100 percent frontlight is extremely rare because even the sun behind the photographer's back or flash at the camera is slightly off-axis light and there- fore casts some shadow; the best source of true frontlight is a ring-light—an elec- tronic flash lamp that encircles the lens and produces completely shadowless il- lumination.

Sidelight. The light-source is more or less to one side of the subject but always more in front than in back. This is the most commonly used type of light and the one most suitable for making photographs in which good color rendition and a feeling of three-dimensionality are equally important. Sidelight is easier to handle than light from any other direction, consistently produces good results, but rarely creates spectacular effects.

Backlight. The light-source is more or less behind the subject, illuminating it from the rear, shadows pointing toward the camera. Subject contrast is higher than with light from any other direction, a fact which makes backlight basically un-

suitable to color photography. On the other hand, it creates illusions of space and depth more convincing than those created by any other type of light. As far as the color photographer is concerned, backlight is the most difficult type of light, but also the one which, if handled well, is the most rewarding. Almost invariably, its use either leads to outstandingly beautiful and expressive pictures or to failure. It is the most dramatic form of light and unsurpassed ,for expressing mood.

Toplight. The light-source is more or less above the subject. This is the least photogenic of the five types of light because vertical surfaces are insufficiently illuminated for good color rendition and shadows are too small and poorly placed for good depth symbolization. Outdoors, this is the typical high-noon light, the light beloved by most beginners because it is "nice and bright." In contrast, experienced photographers know that the best times for making outdoor pictures are the early-morning and late-afternoon hours, when the sun is relatively low.

Light from below. The light illuminates the subject more or less from below. Because it almost never occurs in nature, this type of illumination produces unnatural and theatrical effects (the effect of old-fashioned footlights). It is a difficult light to use well because it is conducive to the creation of weird, unreal, and fantastic effects that easily appear forced and "gimmicky"—novelty for novelty's sake.

Color

Light emitted by a source of radiation—the sun, a gaseous discharge tube, an incandescent filament—is not homogeneous. It is a mixture of different kinds of light—light of all the wave lengths from 380 to 760 millimicrons in nearly equal quantities. It is an "accord," an accord of radiant energy. But unlike an accord in music in which a trained ear can distinguish between the different components and single out the individual tones that make up the accord, the human eye cannot separate and distinguish individually the different spectral components of white light.

As far as the color photographer is concerned, this is a very consequential fact because differently composed types of light exist which *appear white* to the human eye but *colored* to the color film. Color film is much more sensitive to differences in the spectral energy distribution of light and, if the light does not conform to the standard for which the film is balanced, reacts by yielding transparencies that have a more or less pronounced color cast. To prove this, one has only to photograph a chart containing a number of color samples plus a patch of white in the apparently "white" light of, say, the sun, the light of an overcast sky, a photoflood

lamp, and a fluorescent tube. To the eye, the colors and white patch of the chart will appear virtually the same in any of these four types of light. But the differences in rendition between the color chart and the various transparencies will be great enough to make most of the color pictures unacceptable.

p. 106 Now, since color films are balanced to give satisfactory color rendition in only a few specific types of light, and since our eyes are incapable of distinguishing with sufficient accuracy between the different forms of apparently "white" light, how does one know whether or not the light is "white" as far as the respective type of color film is concerned, i.e., whether it conforms to the standard for which the film is balanced? And if the light is "off," how does one know how much?

To answer these questions, color photographers need a gauge by which to measure the color of light. Then, if they find that the incident light does not conform to the standard for which their color film is balanced, they can determine to what degree it does not conform and, by using the appropriate filter, they can in effect convert the light to standard. This measure for the color of the incident light is the Kelvin scale.

The Kelvin scale, which derives its name from the British physicist W. T. Kelvin (1824–1907), measures the color of the incident light in terms of "color temperature" in Kelvins (formerly degrees Kelvin), i.e., in Centigrades starting from absolute zero, which corresponds to —273°C. The reddish light emitted by a piece of iron heated to 1000°C., for example, would have a color temperature of 1273 K.

The color temperature of any given light source can be found by heating what is called a "black-body radiator" (a hollow sphere with a circular opening cut into one side that absorbs all outside light entering it) until the color of the light which it emits matches the color of the light source under examination. Then the temperature of the black-body radiator is taken and translated into Kelvins. The resulting figure is the color temperature of the light source in question.*

In this connection it is interesting to note that artists distinguish between "warm" (reddish) and "cold" (bluish) light. According to the laws of physics, however, the contrary is true: reddish light is produced by radiation at relatively low temperatures, whereas blue-white light is emitted only by the hottest stars. In terms of color temperature, reddish light rates around 1000 K while blue light (for example, from a blue northern sky) may rate as high as 27,000 on the Kelvin scale.

* Actually, because all substances reflect a certain amount of light which mixes with the light emitted on heating, the spectral composition of all incandescent light-sources except true black-body radiators is not exactly proportional to their temperature; but the discrepancy is usually so small it can safely be disregarded.

And this observation brings us up against one of the most important, and most consistently misunderstood, concepts in color photography: the color temperature of light that has been reflected, scattered, filtered, or otherwise altered in regard to its spectral composition since emission from its radiant source.

True and false color temperatures. The concept of color temperature is based upon the observed uniformity in relationship between the *temperature* of an incandescent body and the *color* of the light emitted by it. Therefore, only incandescent light-sources can have a color temperature in the true meaning of the term. The so-called color temperature of nonincandescent light-sources, for example, a clear blue northern sky, is not a true color temperature since the sky is obviously not radiating at a temperature of some 25,000°C. above absolute zero, as its "color temperature" would indicate.

Unfortunately, matters are still more complicated because color temperature is only a measure of the color of light but gives no indication of its spectral composition. Now, as I mentioned, different types of "white" light exist that have the same color (and therefore the same color temperature) but differ in regard to spectral composition (and therefore react differently with color film). For example, a color-temperature meter reading of standard daylight and light emitted by a daylight-type fluorescent tube may produce the same result, indicating identical color temperatures. As far as the color of their light is concerned, two such light-sources would appear identical to the eye. But since the spectral composition of one is quite different from that of the other, the same subject photographed once in standard daylight and again in the light of the daylight-type fluorescent lamp would appear very different in the two transparencies.

The spectral composition of light emitted by incandescent lamps conforms very closely to the spectral composition of light emitted by a true black-body radiator, the standard of all color-temperature measurements. Color-temperature meter readings taken of their light therefore provide reliable data on which to base the selection of light-balancing filters. In all other cases, however, *i.e.*, as far as light p. 36 from gaseous discharge tubes (speedlights), fluorescent tubes, the sky, etc., is concerned, color-temperature meter readings may be misleading rather than helpful, unless they are evaluated in the light of previous experience based upon experiments and tests. It was for this reason that I advised in the beginning of this book against the use of color-temperature meters. Instead, selection of corrective filters should be based upon data taken from published tables such as the following, which list true color temperatures of incandescent light-sources and em-

225

pirically determined equivalent values of light-sources that have no true color temperatures.

Light-source	true or equivalent color temperature in Kelvins	decamired values
Candle flame	1500	66
Standard candle	2000	50
40-watt general-purpose lamp	2750	36
60-watt general-purpose lamp	2800	36
100-watt general-purpose lamp	2850	35
500-watt projection lamp	3190	31
500-watt professional tungsten lamp	3200	31
250-watt amateur photoflood lamp	3400	29
500-watt amateur photoflood lamp	3400	29
clear flashbulbs (press type)	3800	26
daylight photoflood lamps (blue glass)	4800–5400	21–19
white flame carbon arc	5000	20
daylight flashbulbs (blue lacquered)	6000–6300	17–16
electronic flash	6200–6800	16–15
morning and afternoon sunlight	5000–5500	19
sunlight through thin overall haze	5700–5900	18
noon sunlight, blue sky, white clouds	6000	17
sunlight plus light from clear blue sky	6200–6500	16
light from a totally overcast sky	6700–7000	15
light from a hazy or smoky sky	7500–8400	12
blue skylight only (subject in shade)	10,000–12,000	9
blue sky, thin white clouds	12,000–14,000	7
clear blue northern skylight	15,000–27,000	6–4

NOTE: The color temperatures listed above for incandescent lamps apply only if these lamps are operated at the voltage for which they are designed.

How to select the correct light-balancing filter. The task of selecting the correct light-balancing filter, *i.e.*, the filter which in effect will convert a given type of incident light into the type of light for which the respective color film is balanced, has been simplified enormously through a filter classification system based upon decamired values. These values are equivalent to color temperature values expressed in the mired or micro-reciprocal scale divided by 10. To arrive at the decamired value, divide the color temperature in Kelvins into 1,000,000 and divide the result by 10. For example, a professional tungsten lamp with a color temperature of 3200 K is equivalent to 1,000,000 divided by 3200, which is 313

mireds; to arrive at the decamired value, divide 313 by 10. The decamired value of a 3200 K photolamp (or light with a color temperature of 3200 K) is therefore 31 as indicated in the table above.

Now, since Type B color film is balanced for light with a color temperature of 3200 K, which has a decamired value of 31, this particular type of color film can be said to have also a decamired value of 31. Likewise, other types of color film can be said to have the same decamired values as the light for which they are balanced, see the following table:

Decamired values for color films

Daylight-type color films	16
Type A (3400 K photoflood lamps)	29
Type B (3200 K tungsten lamps)	31

In similar fashion, light-balancing filters have been assigned specific decamired values (see the following table which lists the Kodak Wratten Light-balancing Filters Series 81 and 82 together with their decamired values and exposure-increase factors).

Kodak Filter reddish filters	Conversion power in decamireds	Exposure increases in f-stops (approx.)
81	1 (1.0)	1/3
81A	2 (1.8)	1/3
81B	3 (2.7)	1/3
81C	4 (3.5)	1/2
81D	4 (4.2)	2/3
81E	5 (4.9)	2/3
81EF	6 (5.6)	2/3
81G	6 (6.2)	1
blue filters		
82	−1 (−1.0)	1/3
82A	−2 (−2.0)	1/3
82B	−3 (−3.2)	2/3
82C	−5 (−4.5)	2/3
82C plus 82	−6 (−5.5)	1
82C plus 82A	−7 (−6.5)	1
82C plus 82B	−8 (−7.6)	1 1/3
82C plus 82C	−9 (−8.9)	1 1/3

To find the correct light-balancing filter, calculate the difference between the

decamired values of the film you wish to use and the type of light in which you wish to use it. This figure is the decamired value of the filter you must use.

Now, reddish filters lower the color temperature, raise the mired value, and have a positive-mired shift; conversely, blue filters raise the color temperature, lower the mired value, and have a negative-mired shift. Therefore, *if the light has a higher decamired value than the color film, you need a blue filter* (Kodak Wratten Filter No. 82 in the correct density); *if the film has a higher decamired value than the light, you need a reddish filter* (Kodak Wratten Filter No. 81 in the correct density). For utmost ease in selecting the right kind of filter, use the Color Filter Nomograph on the opposite page, which is based upon a chart designed by C. S. McCamy of the National Bureau of Standards in Washington, D.C.

If a decamired filter of relatively high value is needed but not available, it is possible to produce the same effect by combining two or more filters of lower value. For example, instead of a 9 filter, a 2 and a 7 can be used together, or a 5 and a 3 and a 1. However, for optical reasons, it is always desirable to use as few filters as possible.

Contrast

Since the contrast range of color film is relatively narrow, a low-contrast illumination is usually preferable to a high-contrast illumination. In this respect, a photographer must know that the degree of contrast of an illumination is inversely proportional to the *effective* size of the light source (the *effective* size of, for example, the sun, is very small although its *actual* size is, of course, immense): the smaller the effective size of the light-source or the more parallel the beam of light it emits, the more contrasty the light and the more sharply defined and darker the shadows it casts. Conversely, the larger the effective size of the light-source and the more diffused the light it emits, the less contrasty the light and the softer and more transparent the shadows it casts.

Examples of high-contrast illumination are direct sunlight on a cloudless day and light from a spotlight; of low-contrast illumination, light from an evenly overcast sky and from banks of fluorescent tubes. The most contrasty light is produced by a circonium arc lamp, which casts shadows as sharp as if cut with a razorblade, followed closely by the end-on ribbon filament lamps used in point-source enlargers and photoengraving. The softest light is the shadowless illumination produced by a "light-tent." Between these extremes, there is light of intermediate contrast: outdoors, sunlight in conjunction with white clouds of different sizes, and

228

(continued on p. 230)

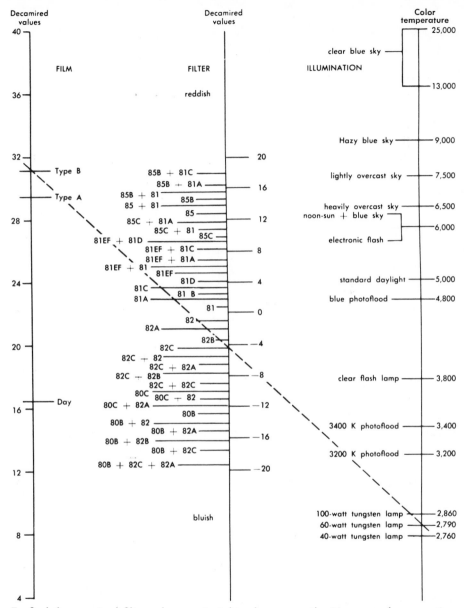

To find the required filter, place a straight edge across the Nomograph connecting the type of color film you are using with the type of light in which the shot will be made. Find the correct filter at the point where the straight edge crosses the center column. Example: Type B color film and a 60-watt bulb require an 82C filter.

sunlight diffused to different degrees by haze; indoors, light from photoflood lamps, flashbulbs, and speedlights.

As far as artificial light is concerned, degree of contrast varies widely with the type of reflector and/or diffuser used. The same bulb can be made to produce a relatively contrasty or diffused illumination. To effectively diffuse a light-source and make it cast softer shadows, its luminous area must be increased. A diffuser of the same size as the reflector placed tightly in front of a lamp does not increase its effective size or diffuse its light but only cuts down its brightness. To be effective, a diffuser must therefore be larger than the reflector, and it must be placed far enough in front of the reflector so that its entire area is illuminated. Kodapak sheeting is excellent. The following combinations of bulb, reflector, and diffuser would produce different illuminations beginning with relatively contrasty light, going through increasingly less contrasty light effects, and ending with practically shadowless illumination: photoflood lamp used without a reflector; with a small, deep and narrow reflector; with a small, shallow reflector; with a medium-size reflector; with a large, shallow reflector; with a large, shallow reflector equipped with a large spun-glass diffuser 6 to 10 inches in front of it; with a large, shallow reflector 2 feet behind a diffuser made of a sheet of translucent paper stapled to a 3 x 3-foot frame.

Completely shadowless illumination can be produced with the aid of a light-tent: white background paper is used to surround the subject, enclosing it within a kind of large, cubical "tent" that has no opening other than an aperture large enough to accommodate the lens. A number of photoflood lamps are placed *outside* the tent—more or less evenly distributed around it, light from these lamps shielded, if necessary, so that direct light cannot accidentally fall upon the lens —and *directed toward the center of the tent* so that the light penetrates the white paper walls and, thoroughly diffused, completely envelops the subject inside the tent.

Direct light

Direct light is light which has not been reflected, filtered, scattered, or otherwise altered since emission from its original source. It is therefore *predictable* light insofar as its spectral composition is constant and identical to that of its source. For example, the direct light emitted by the gaseous discharge tube of a speed-light is compositionwise always the same and, in regard to color rendition, will give predictable results. However, if the same speedlight were directed toward the ceiling and used for "bounce light," its light, before illuminating the subject, would

p. 242

230

be *reflected* by the ceiling and, if the ceiling is not pure white, altered in regard to its spectral composition, as a result of which the color of the subject would be rendered differently and the transparency acquire a "color cast."

Normally, direct light should not be permitted to strike the lens since this might cause objectionable flare and halation in the transparency. To avoid this, make sure that the source of light itself is not within the field of view of the lens, nor close to, though outside, the boundaries of the picture. And, of course, use an effective lens shade, or use your hand or other handy object to cast a shadow over the lens during the exposure.

Occasionally, however, it is desirable (or unavoidable) to include the source or sources of light in the picture. In order to produce the effect of direct or radiant light (instead of reflected light or "white") it may then become necessary to create the impression of radiance through the use of symbols.

The traditional symbols of radiance have always been the halo and the star. Artists wishing to create the impression of radiant light in their paintings invented the four- or many-pointed star—a manmade symbol that has no counterpart in reality because real stars appear to the eye as pinpoints of light. They also depicted candle flames as surrounded by circular halos of light. Such halos don't exist but are another figment of the imagination.

Photographers wishing to symbolize the radiance of direct light in their pictures in more expressive form than that of a blob of white have several techniques at their disposal:

Flare and halation. According to academic rules, these are "faults" that must be avoided. According to modern creative thinking, however, if used in the right place with daring and imagination, these onetime "faults" can become powerful means for expressing in graphic form the radiance of direct light. Although not present in reality, flare and halation in the picture correspond closely to the sensations we experience when we look at a bright source of light: we get more or less blinded temporarily, we see spots in front of our eyes, things get blurred, in short, the image seems dissolved in light. To produce equivalent impressions in picture form, don't hesitate to shoot smack into the light—and accept what you may get. Results will vary with the type and intensity of the light source, its position in the picture, the design of the lens, the size of the diaphragm aperture, and the duration of the exposure. In other words, the effect is unpredictable—a challenge to daring and imaginative photographers willing to gamble the loss of a piece of film against the chances of getting a terrific picture.

231

Wire screens. Placing a piece of ordinary copper fly-screen in front of a lens will turn dotlike sources of direct light (for example, street lights at night) into four-pointed stars. If eight-pointed stars are desired, two such screens, one rotated against the other by 45 degrees, must be used. The size of these starlike images increases with exposure. Since the wire screen acts as a diffuser, the image is never perfectly sharp. However, the resulting slight degree of unsharpness and overall halation is usually inconsequential in the kind of picture for which this device is best suited: romantic high-key photographs of women, and night photographs of city scenes in which documentation is subordinated to mood.

Small diaphragm apertures. In photographs taken with diaphragm apertures as small as f/16 and smaller, the images of bright, dotlike light sources are rendered as many-pointed stars, their size increasing with increases in exposure. In night photographs that include street lights, in photographs of sun-glittering water, or in pictures in which the sun itself appears, star shapes effectively symbolize the radiance of direct light. This method of light symbolization has the advantage that it affects only the brightest lights within the picture; the rest of the image is crisp and sharp.

Diffusion screens. Placed in front of a lens, a diffusion screen differentially softens the entire image: bright picture areas are more strongly affected than darker areas. For example, in a photograph showing sun glitter on water, each highlight would be surrounded by a tiny halo, whereas the rest of the picture would appear more or less normal. Likewise, sparkling jewelry, highlighted hair, and the edge-lighted silhouettes of backlighted objects would seem to be edged by softly diffused light. The effect is best in very contrasty scenes containing brilliant highlights; in the absence of highlights, sparkle and direct light, diffusion screens produce disappointing results.

Similar yet even more spectacular and unusual effects are produced by the Rodenstock Imagon lenses which, with the aid of variable sieve-like diaphragm stops, permit the photographer to adjust the degree of diffusion in accordance with the nature of the subject and the purpose of the picture. Dotlike sources of light and small but brilliant highlights, for example, appear in flowerlike shapes—as if surrounded by petals of light. These lenses, which are particularly suited to making romanticized portraits of women but otherwise rather restricted in their use, are available in focal lengths suitable for use with 2.1/4 x 2.1/4-inch SLR and larger cameras.

Out-of-focus rendition. Throwing the image of a dotlike light source out of

Effective color. What looks good to the eye does not necessarily have to look good in the form of a color transparency. A superabundance of different colors, for example, is usually less effective in picture form than limitation to a few harmonizing shades, and loudness less appealing than sophistication as proved by this elegant study by *John Rawlings* of a young woman on a sun-flooded beach. *More on pp. 314–316*

233

Bold color effects. The strongest color impact is always achieved if two complementary or contrasting colors are placed in juxtaposition, as in these pictures by *John Launois* (left) and *Kay Harris*.

More on pp. 282, 304

Color monochromes. Although shooting a more or less monochromatic subject in color may seem to most people a waste of color film, it is nevertheless a fact that many such subjects are much more effective in color than in black-and-white. For example, consider the nostalgic New York photograph above by *Kay Harris*. Shot at dusk when the color of the sky fades from blue to black, it captures the mood of what the French so expressively call *l'heure bleue*—the blue hour—in a way no black-and-white picture could match. Similarly, the excitement of a fiery sunset sky—a monochrome in red—can only be captured on color film and would be ineffective in black-and-white.

More on p. 315

Don't be afraid to "break the rules." I cannot overstress the importance of experimentation as a prerequisite for the creation of expressive color photographs. Here, *Al Francekevich* used *daylight* type color film in conjunction with *incandescent* light to come up with this delightful "monochromatic" study of a girl and her cat.

More on pp. 316–319

Muted color. Photographers preoccupied with strong and "loud" colors can learn much from this beautiful study by *Al Francekevich* which derives its powerful effect from the realized potential of muted color.

More on p. 190

focus turns the dot into a circle, the larger, the more it is out of focus. Occasionally, this technique of deliberately unsharp focusing can be used to symbolize graphically the radiance of direct light. Street lights at night, for example, if rendered out of focus, no longer appear as rows of small white dots but as strings of great luminous pearls, softly diffused, partly overlapping and semi-transparent, creating the vision of a fairy-tale street. Naturally, since the rest of the picture will appear as much out of focus as the lights, this method is limited in its application. But there are always times when its results, which must be observed on the groundglass, offer a new and stimulating possibility for symbolizing the radiance of light in night photographs of a city, particularly if the intent is to create an unrealistic, dreamlike mood.

Reflected and filtered light

Unlike the spectral composition of direct light, which is always the same as that of its source of emission, the spectral composition—the color—of light that has been reflected, filtered, scattered, or otherwise altered after its emission, is different from that of its source of origin. If a reflecting surface is, for example, blue, the light it reflects will also be blue, even if the light which illuminated it, as far as the color film is concerned, was "white." A similar effect results, of course, when white light passes through a colored medium. For example, light in a forest or under a big tree is always more or less green from being reflected and filtered by green leaves. And the color of sunlight changes with the position of the sun in the sky because, in overhead position, the path of the light through the atmosphere is shorter than at sunset. As a result, sunlight is scattered less at noon than at sunset, explaining why the color of sunlight changes with the time of day. Such "accidentally" colored light is a frequent cause of unexpected color cast in a transparency—the photographer thought he was working with a specific type of light but forgot to make allowances for the changes this light had undergone since its emission.

Reflected light is commonly used both indoors and outdoors to lighten shadows which otherwise would be rendered too dark. The usual means for this are plywood panels covered with crinkled aluminum foil placed so that they reflect the principal source of illumination onto the shadow areas of the subject. Indoors, a very effective indirect illumination can be arranged with large frames covered with white muslin or paper, their angle and height precisely positioned in relation to the subject. Floodlamp or speedlight illumination is then directed toward and reflected from these surfaces which illuminate the subject with either softly diffused

or shadowless light, depending upon whether this illumination is used alone or with direct front or sidelight.

A variant of this method—bounce-light—is used primarily for making candid indoor photographs: the reflector of the flashgun or speedlight is turned up and slightly forward so that the light strikes the ceiling, is reflected or "bounced" by it, and thus illuminates the subject with evenly diffused light. If bounce-light is used with reversal (positive) color film, the ceiling must, of course, be white, otherwise the transparency will have a color cast in the ceiling color. If negative color film is used, such a color cast can be corrected through appropriate filtration during enlarging.

p. 249 Exposure with bounce-light is usually computed with guide numbers: use the focusing scale of the lens to establish the distance from the light-source (flash at the camera) to the reflecting point on the ceiling and from there to the subject; divide the guide number by the sum of these two distances to find the basic f-stop number, then make the exposure with the diaphragm opened up by two full stops beyond the basic f-stop, three full stops if the room is unusually large.

Natural light

As far as the color photographer is concerned, natural or daylight is the most difficult and troublesome type of light because it is unpredictable and inconsistent, varying frequently not only in brightness (which can be checked with an exposure meter), but also in color (which is difficult to notice and virtually impossible to check accurately). On a bright and sunny day, when the light is presumably p. 243 identical with the type of light for which daylight-type color film is balanced, pictures taken in the open shade will be too blue, pictures taken under trees too green, and pictures taken next to a brick wall too red. In addition, contrast in close-up shots will probably be too high because, contrary to artificial light where several photo lamps can be used simultaneously, outdoors there is only one source of light, the sun. As a result, shadows, illuminated only by blue skylight or hardly at all, may be so dark that subject contrast exceeds the contrast range of the color film, unless shadows are artificially lightened with supplementary fill-in illu- p. 324 mination: flash at the camera, or sunlight reflected by means of aluminum-foil-covered panels, sheets of white paper, white cloth, etc.

Off-color daylight leads, of course, to off-color transparencies. Whether or not such off-color pictures are objectionable depends on a number of factors. For example, it makes a difference whether the "true" subject colors are familiar or

unfamiliar to the viewer of the transparency; in the first case, particularly if skin tones are involved, demands for "natural" color rendition are much higher than in the second case, in which the subject conceivably might have had any color as is true of many manmade objects and structures. Furthermore, subjects characterized by strong and saturated colors will tolerate a much stronger color cast without appearing objectionable than subjects in delicate or pastel shades. Most sensitive in this respect are portraits and close-ups of people because skin tones, unless they correspond to what the viewer of the transparency expects, appear easily "unnatural." But here too differences exist insofar as a higher degree of color degradation toward ruddy colors will be accepted than one toward blue and green which makes the depicted person look sick.

Nevertheless, to reject outright any color photograph which doesn't conform to academic concepts of color rendition is foolish. On the contrary, photographers and nonphotographers alike should learn to "see" subject color in off-color light —and accept it as natural, which it is. In the glow of a golden sunset sky, a face *must* appear more golden than in bluish midday light—why shouldn't we record it in its golden beauty?

"White" daylight. As far as daylight-type color films are concerned, "white" light or *"standard daylight" is a combination of direct sunlight and light reflected from a clear blue sky with a few white clouds during the hours when the sun is more than 20 degrees above the horizon.* This kind of light has an equivalent color temperature of 5800-6000 K and a decamired value of 18-17. When this combination of sunlight and clouds exists, color rendition in a correctly exposed and processed transparency made on daylight-type color film appears natural and corrective filters are not needed.

pp. 224, 226

The only other type of daylight that approximates white as far as daylight-type color film is concerned is light from a uniform low-altitude haze dense enough to completely obscure the sun. However, since even slight changes in the nature of such an overcast can shift the color balance of the illumination toward blue, use of a No. 81 light-balancing, an ultraviolet, or a Kodak Skylight filter is often advisable.

pp. 36, 37

Blue daylight. On a cloudless day, shadows are always blue (unless a strongly colored object adds its color to the shadow area, in which case the shadow color becomes an additive mixture of both colors) because they receive their illumination from the blue sky. This is easily seen by comparing the color of a shadow on a white surface with the color of the blue sky: hold a mirror against the shadow on

the white surface and tilt it so that it reflects the sky; thus seen together, the two blues, the shadow and the sky, will match.

If subjects are photographed in open shade, *i.e.*, if they are illuminated exclusively by the blue light of the sky, their color will naturally be distorted toward blue. Likewise, pictures made on cloudy days tend to be bluish in character, particularly if the sun is hidden behind heavy clouds and large areas of the sky are clear, or if the sky is uniformly covered by a high, thin haze. Under such conditions, if a bluish color cast is unacceptable, it can be avoided by using a reddish light-balancing filter in the appropriate density; see the tables on pp. 226 and 227.

Red daylight. Shortly after sunrise and toward sunset the sun appears yellow or red. This is caused by light-scattering within the lower, heavily dust-laden layers of the atmosphere which only the longer, yellow- and red-producing wave lengths of light can penetrate, making such early-morning and late-afternoon light appear yellowish or reddish. The colors of subjects photographed in such light appear "warmer" than they would in white light. To avoid such color casts, manufacturers of color film recommend taking color photographs only from two hours after sunrise to two hours before sunset. Otherwise, the color cast can be avoided by using a blue light-balancing filter in the appropriate density. However, once a photographer learns to see color in terms of photography, he will be aware of the inherent beauty of the different kinds of daylight and find that color pictures taken in the early morning and late afternoon hours have a mood and beauty of their own.

p. 36

Artificial light

Unlike natural light, the light emitted by artificial photographic light-sources is predictable and constant in regard to both brightness and color—provided, of course, that incandescent lamps are operated at the proper voltage and that this voltage is constant. As a result, correctly exposed color photographs taken in the type of artificial light for which the color film is balanced usually have excellent color rendition.

Another basic difference between natural and artificial light is that, if necessary, any number of separate artificial light-sources can be employed. Whereas the outdoor photographer is limited to a single light-source—the sun—and a single rather unsatisfactory type of shadow fill-in illumination—the sky—the indoor photographer is free to arrange his illumination in any desired way. Not only can he draw upon as many individual lights as he needs to illuminate his subject perfectly, but he is also free to choose exactly the type of lamp which he feels will best meet

244

specific requirements. Spotlights ranging from giant sun spots for sunlike effects down to tiny baby spots for accent lights, open floodlights for general illumination and diffused floodlights for shadow fill-in, are at his disposal for use in accordance with his plan. And, if he so desires, action-stopping electronic flash or flashbulbs permit him to cut exposures down to fractions of a second. Here is a listing of the most commonly used types of artificial light:

3200 K light is produced by professional tungsten lamps which are available in the form of floodlamps, reflector floods, reflector spots, halogen lamps, and projection bulbs for spotlights in different sizes with different wattages. Type B professional color films are balanced for use with this type of light which has a decamired value of 31.

3400 K light is produced by amateur photoflood lamps which are available in the form of floodlamps, reflector floods, and halogen lamps in different sizes with different wattages. Type A color films are balanced for this type of light, which has a decamired value of 29.

3800 K light is produced by clear press-type flashbulbs which are available in different sizes with different light-outputs. This kind of light is intended mainly for black-and-white photography although satisfactory color photographs can be made on daylight color film in conjunction with an 80C color-conversion filter. The decamired value of this type of light is 26.

4800-5400 K light is produced by blue photoflood bulbs that are available in different sizes with different wattages. This kind of light is primarily intended for shadow fill-in when making indoor photographs in daylight on daylight color film. It is not recommended as the sole illumination in conjunction with daylight color film because the resulting transparencies would have a somewhat warmer, more yellow tone than photographs taken in standard daylight. The decamired value of this type of light is 21-19.

6000-6300 K light is produced by blue-lacquered flashbulbs. This kind of light is intended mainly as shadow fill-in when making outdoor photographs on daylight color film. The decamired value of this type of light is 17-16.

6200-6800 K light is produced by electronic flash. Daylight color films are balanced for this type of light, which has a decamired value of 16-15.

Advice on the use of electric power. Photographic lights take relatively large amounts of power, but ordinary home wiring is dimensioned only for average household needs. To calculate how many photo lamps can safely be connected to

one circuit, multiply the voltage of the powerline by the number of amperes of the fuse. The resulting figure represents the number of watts that can be safely drawn from the circuit. For example, if the line carries 120 volts and the fuse can take a load of 15 amperes (this is the most common combination), multiply 120 by 15. The result is 1800 watts, the maximum load that may be drawn from the circuit without blowing a fuse. This means that you can simultaneously use three 500-watt and one 250-watt bulbs, or two 500-watt and three 250-watt bulbs, or one 500-watt and five 250-watt bulbs, or seven 250-watt bulbs; this leaves 50 watts available for other purposes, for example, a weak desk lamp or ceiling light for general illumination between shoots.

If more photo lamps are needed, to avoid blowing a fuse, additional lights must be connected to a different circuit. You can determine the different circuits by connecting lamps to different outlets and unscrewing fuses one by one. All the lamps that go out when a certain fuse is unscrewed connect to the same circuit, while the lamps that stay lit are controlled by a different fuse.

The fuse is the safety valve of the powerline. It is an artificial weak link designed to break under overload to protect the line from destruction. An accidentally blown fuse must never be replaced with a stronger fuse, a coin, or a wad of aluminum foil instead of a fuse. Otherwise, the next overload will cause the powerline itself to melt and the resulting short-circuit may start a fire that can burn down the house.

When buying electrical equipment or wiring, preference should be given to those items that carry the UL (Underwriters Laboratories) label. It is your guarantee that they meet certain safety standards which merchandise that lacks this label may not meet.

Do not overload wires. Make certain your wires are of sufficiently heavy gauge to carry the intended electrical load. Ask the clerk at the hardware store for the right gauge. Touch the wire after the equipment has been used for a while: it may get warm but it must never get uncomfortably hot.

Place your temporarily strung wires so that people do not trip over them. Place them along the walls or furniture or cover them temporarily with a rug.

To splice two wires together, first solder both connections, then insulate each of the two strands separately with moisture-proof electrical tape before you tape the entire splice. Better still, make a plug connection.

When disconnecting an electric wire, do not grab the cord and jerk; instead, grip the plug and pull it out straight.

Do not nail or staple ordinary rubber-insulated electric wires to baseboards, walls, or ceilings. This type of wire is not meant for permanent installations. Depending on the local building code, only metal-sheathed cable or Flex should be used for fixed installations, and it should be installed by a licensed electrician.

Do not use electric wires with cracked, frayed, gummed, or otherwise damaged insulation or broken plugs. Do not reconnect equipment that caused a fuse to blow without first finding and eliminating the cause of the short-circuit.

Do not indiscriminately fire flashbulbs with house current, for example, in an attempt to simulate light from a table lamp. Although they may fit a lamp socket, most flashbulbs will blow the fuse. Flashbulbs that can be safely fired with house current up to 125 volts are General Electric's Nos. 22 and 50 and Sylvania's Nos. 2 and 3. If several flashbulbs have to be fired simultaneously, connect a large incandescent bulb in series to absorb shock and avoid blowing a fuse.

Voltage control. Only if a photo lamp is operated at the voltage specified by the manufacturer does its rated color temperature apply. Even changes of a few percent in line voltage are sufficient to alter the effective color temperature of the lamp. For example, a line fluctuation of 5 volts in a 120-volt circuit, applied to a high-efficiency photo lamp, changes the color temperature by about 50 K, the light output by about 12 percent, and the life of the lamp by a factor of 2. In general, within the normal limits of voltage fluctuation, it can be assumed that the color temperature of a photo lamp intended for operation at 120 volts increases or decreases, respectively, about 10 K with each increase or decrease in line voltage of one volt.

p. 224

Color changes in transparencies due to changes in line voltage are most noticeable in pastel colors of low saturation and in neutral grays. If such colors predominate, a change in color temperature of only 50 K may produce noticeable changes in color. If highly saturated colors predominate, color temperature changes up to 100 K produce no serious color changes.

Below-normal voltage causes a color shift toward yellow and red; a rise in voltage above the specified rate produces transparencies with a cold bluish cast in addition to shortening lamp life.

Fluctuations in line voltage are usually caused by abnormally high or low consumption of electric current. Fluctuations that originate in the same building in which the studio is located can be avoided through the installation of a direct line between the studio and the power main in the street. Such fluctuations are usually

247

caused by elevators, refrigerators, or electric motors going on and off, temporary overloading with electric equipment, and occasionally by improperly dimensioned wiring.

p. 224

p. 36

If the line voltage is *consistently* too low, the simplest way to compensate for voltage deficiency is to measure correctly the color temperature of the lights under actual working conditions with all lights turned on simultaneously, and to correct the yellowishness of the illumination with the aid of the proper blue light-balancing filter. If the voltage *fluctuates constantly,* the only way to get consistently good color rendition is to stabilize the voltage through the installation of special voltage-control equipment.

How to expose by artificial light

p. 135

pp. 144, 320

If the illumination is provided by lamps that produce continuous light, exposure data are determined on the basis of exposure-meter readings taken as described earlier. Particular attention should be paid to lighting contrast range (take readings from a gray card), subject-contrast range (take individual readings of the lightest and darkest colors), and, if applicable, the background (make sure it receives sufficient light for satisfactory color rendition).

If the illumination is provided by lamps which produce discontinuous light—flashbulbs or electronic flash—exposure data are determined with the aid of guide numbers, as described on the opposite page.

Gray scale as color guide. If a transparency is intended for reproduction, either in the form of a color print on paper or by a photo-mechanical process, whenever possible, a paper gray scale or a Kodak Neutral Test Card should be included in the picture as a color guide for the printer or engraver. If positive (reversal) color film is used, this practice considerably facilitates balancing the color separations; if negative color film is used, it is almost a necessity for accurate color rendition in the print. Such a gray scale or card should be placed near the edge of the picture where it can be trimmed off later without affecting the appearance of the photograph. If it is impractical to include such a color guide in the picture, it can be photographed under otherwise identical conditions on a separate piece of film of the same emulsion number, which must be processed together with the film on which the subject is photographed.

To be reliable as a color guide, the gray scale or card must receive the same amount of light as the most important areas of the subject. This should be checked with an exposure meter. Furthermore, the color guide must be placed in such a

248

way that its image on the groundglass is free from glare and is illuminated by light of the same quality as the subject, *i.e.*, free from colored light reflected upon it by an adjacent colored surface. Outdoors, for example, the gray scale or card must not be placed directly on the ground since the unavoidable color cast from grass, sand, etc., would destroy its value as an aid to the proper color balance of the separations or the print.

Exposure determination with flashbulbs. The basis for calculating an exposure with flashbulb illumination is the *guide number* that applies to the respective combination of flashbulb and reflector, film, and shutter speed. Guide numbers are listed on the flashbulb carton and in the flashbulb manufacturer's data sheets, which are available free of charge at camera stores. This method, which is both simple and accurate, is based upon the fact that a definite relationship exists between film speed, light output of the flashbulb, reflector-efficiency factor, distance between subject and flashbulb, shutter speed, and diaphragm stop. In any given case, five of these six factors are either constant—the film speed, the light output of the flashbulb, and the reflector efficiency—or can easily be determined—the distance between subject and flashbulb and the shutter speed that will be used. This leaves only one unknown factor, the diaphragm stop. It is easily found with the aid of the following formula:

$$\text{f-stop} = \frac{\text{guide number}}{\text{distance in feet between subject and flashbulb}}$$

For example, let us assume that the guide number for a specific combination of color film, flashbulb in a certain type of reflector, and shutter speed is 110 and the distance between subject and flashbulb is 10 feet. In this case, divide the guide number by the subject-to-flashbulb distance, *i.e.*, 110 by 10, and get as the correct diaphragm aperture f/11.

Alternatively, you may wish to make the shot with a preselected f-stop for controlled sharpness in depth. In that case, you have to find the corresponding distance between subject and flashbulb, which you can do with the aid of the following formula:

$$\text{Subject-to-flashbulb distance in feet} = \frac{\text{guide number}}{\text{f-stop number}}$$

For example, let's assume that the guide number is once more 110; now, with the diaphragm stopped down to f/11, how far from the subject must the flashbulb be placed to insure a correct exposure? The answer is 110 divided by 11, or 10 feet.

Note, however, that guide numbers are literally only what the term implies—"guide" numbers, *i.e.*, approximations, not absolutes. This is so because some of the factors that influence the exposure cannot be standardized precisely. For instance, the *actual* shutter speed of the respective camera may be different from the speed engraved on the shutter control dial (this is the rule rather than the exception); the efficiency factor of the reflector may be different from the one for which the guide number is calculated (very likely since reflector size, shape, and surface polish are important influencing factors—and the number of different reflectors is great); or the photographer himself may prefer a transparency that is somewhat lighter or darker than what the flashbulb manufacturer had in mind. To avoid disappointment, it is therefore recommended that each photographer establish his own guide numbers: the guide numbers that apply to his own equipment, ways of working, and taste. This can be done as follows:

p. 96 Make a series of test shots with the respective type of flashbulb of the same subject under identical conditions except for the diaphragm aperture, using your regular equipment and color film. Shoot five or seven pictures "bracketed" by half-stop intervals around the exposure, which, according to guide number, should produce the best result. Use the same shutter speed and subject-to-flashbulb distance for every shot. Make notes so you can later identify the shots or, better still, write the respective exposure data on a sheet of paper or cardboard and let your subject hold them against his chest so they appear prominent in the picture, making it impossible later to mix up the shots. Subsequently, pick the transparency with the best color rendition and density, determine the diaphragm stop with which it was shot, and multiply this f-number with the subject-to-flashbulb distance in feet. The resulting figure is your "personal" guide number, the number which applies to *your* equipment and ways.

F-stop values established with the aid of guide numbers apply only if a single flashbulb at or near the camera is used and if subjects with average colors are photographed in a room of medium size that has light (but not white) walls and a white ceiling. Under other conditions, the following corrections must be made:

If subjects are predominantly light, if color film is used, *decrease* the diaphragm opening by one-half stop.

If subjects are predominantly dark, if color film is used, *increase* the diaphragm opening by one-half stop.

In small rooms with white walls and ceiling, decrease the diaphragm opening by one full stop.

250

If two identical flashbulbs are placed at equal distances from the subject—one bulb at the camera (for shadow fill-in light) and the other at an angle of 45 degrees to the subject-camera axis (acting as a main light)—*decrease* the diaphragm opening by one full stop.

If two or more flashbulbs of the same type are used to illuminate evenly a large area—each bulb illuminating its own area with very little overlap of illumination—the exposure must be computed as if a single flashbulb were used.

If two or more of the above conditions apply, they must be considered together.

Exposure determination with electronic flash. Speedlight exposures are calculated according to the same guide-number method as that used for flashbulb-exposure calculation, except that now the shutter speed can be disregarded as a factor since the duration of speedlight exposures is timed by the duration of the flash, not the shutter speed. However, it has been my experience that guide numbers provided by speedlight manufacturers often overestimate the power of the respective unit. Making a series of test shots to determine the *true* guide number for a specific unit in conjunction with a specific type of color film is therefore strongly recommended. How such a test should be conducted was described before. That the synchronizer must be set for X or zero-delay and the capacitor fully charged before the next shot is fired goes, of course, without saying.

p. 249

pp. 250, 96

The functions of light

Every art form has its specific medium. That of the photographer is light. He literally creates with light, and is helpless without it. Light alone enables him to make photographs, to communicate, to express himself in picture form. To be able to make the fullest use of his own potentialities as well as those of light he must be aware of the four main functions which light fulfills in regard to his pictures:

> Light makes the subject visible
> Light symbolizes volume and depth
> Light sets the mood of a photograph
> Light forms designs of light and dark

Light makes the subject visible

In the absence of light we cannot see. Hence, in a deeper sense, light is synonymous with seeing. "Seeing is believing," says an old proverb. And seeing is one of the few priceless bridges between reality and the mind.

What I wish to say is this: There are different stages of seeing: the casual glance, the interested look, the curious investigation, the search for knowledge and insight. If you see a subject that interests you, don't be satisfied with the first look. If a subject is worth photographing, it is worth photographing well. In other words, the first view is rarely the best. Study your subject from different angles, literally as well as figuratively speaking. See it with the eyes as well as with the eye of the mind: see its significance, its implications; bring out important features, concentrate, clarify, and condense, show *more* in your pictures than what the casual eye saw in reality! Light made the subject visible to you and gave you your chance; now it is up to you to make the viewer of your photographs "see."

Light symbolizes volume and depth

Any draftsman knows that "shading" adds "depth" to his drawing. It does the same in photography: a subject illuminated by shadowless frontlight appears "flat"; but if we move it relative to the sun, or move our photo lamp relative to the subject—*if we create shadows*—the impression of flatness disappears and is replaced by one of three-dimensionality. Flooded with shadowless light, the Venus de Milo itself appears flat as a paper doll; on the other hand, properly lighted to create shadows, even a shallow bas-relief acquires depth. It is the interplay of light and shadow which graphically symbolizes depth.

However, in order to create convincing illusions of substantiality, roundness, and depth, light and shadow must organically follow and accentuate the subject's forms. Unfortunately, this is not always the case, and often rampant shadows criss-crossing important forms of the subject destroy its design. To acquire a feeling for the importance of the interplay between light and shadow, I recommend that the reader perform the following experiment in portrait lighting. Step by step it
pp. 166-, 167 will teach him how to arrange an effective illumination.

p. 38 **Preparations.** You need four photo lamps and one model. Pose the model comfortably 6 feet in front of a neutral background. Darken the room until there is just enough light left to see what you are doing, but not enough to interfere with the effect of the photo lamps.

The main light. This is the lamp that plays the role of the sun, the one dominating light. It has the double purpose of illuminating the subject in such a way that its forms are brought out as clearly and significantly as possible, and creating in terms of light and shadow a graphically effective design. In comparison to the main light, all the other lamps are merely subordinate auxiliary lights the object

252

of which is to elaborate further the design established by the main light. They must not be brought into play until the position of the main light has been finally established.

The best main light is a large spotlight approximating the effect of the sun. If not available, a No. 2 photoflood lamp in a reflector, a reflector spot, or a reflector flood can be used. Place this light approximately 45 degrees to one side and 45 degrees above the head of the model. This position automatically produces a good illumination. Watch the distribution of light and shadow—particularly the shadows in the corners of the eyes near the nose, in the angles between nose and mouth, and beneath the chin; and above all, watch the shadow cast by the nose. This is the single most important shadow in any portrait; it must never cross or even touch the lips—the effect would be that of an ugly mustache.

As a photographer becomes more experienced, he can try to place the main light in other positions for more unusual effects. But in the beginning it is wise to use a safe arrangement. The total flexibility of artificial illumination makes it only too easy to end up with contrived light-effects—novelty for novelty's sake. But as long as the main light is correctly placed the basic design will be good, and what remains to be done is mainly a matter of contrast control.

The fill-in light. Its purpose is to lighten the shadows cast by the main light—not too much, not too little, just enough so that they will not appear black in the transparency but show some color and detail—without in any way changing the character of the illumination established by the main light. The fill-in light should be a well-diffused photoflood lamp. It should be placed as close to the camera-subject axis as possible and slightly higher than the lens. Such a position reduces as much as possible the danger of producing shadows within shadows—separate criss-crossing sets of shadows cast by the main and the fill-in light. Such shadows are extremely ugly and must be avoided at any price. The exact distance between fill-in light and subject is determined by the desired subject-contrast ratio, as will be explained later.

p. 38

pp. 320-323

The accent light. Its purpose is to enliven the rendition by adding highlights and sparkle—in this case, to the hair of the model. The accent light should be a small spotlight that can be focused on a specific area. It is used as a backlight to highlight the outline of cheek and hair of the subject, to add texture, catch-lights, and glitter. Since it must be placed somewhere in back and to one side of the subject—directed toward, but outside the field of view of the lens—it cannot cast secondary shadows. It must be prevented from shining into the lens because this might pro-

p. 39

p. 231 duce flare or halation on the film. A piece of cardboard placed between the light and the lens will accomplish this.

The background light. Its purpose is to insure that the background gets sufficient light to be rendered in the desired color—even if this "color" should be neutral p. 38 gray or white. A large photoflood lamp directed toward the background is best. p. 144 Use an exposure meter in conjunction with a Kodak Neutral Test Card to check that the illumination levels of background and face are the same. Underlighted backgrounds that turn out too dark in the transparency are common mistakes of the beginner.

The principles of good lighting. The lighting scheme described above produces what might be called a "standard illumination." Although never spectacular, it is always successful and can be used equally well to light a girl, a gadget, or a geranium. It can be used with incandescent light, flash, or speedlight illumination. It can be varied in innumerable ways by varying the position, intensity, or spread of the different lights. By changing the ratio of light to dark, one can produce pictures that are either gayer or more somber. By increasing the contrast until the shadows are pure black, one can create the typical Hollywood glamour lighting, guaranteed to produce the most seductive effects. Once a photographer knows the purpose and effect of the different lights he can do anything he likes, and he will succeed as long as he observes the following basic rules that apply to any type of lighting:

> Arrange the illumination step by step. Always start with the main light. Never add an additional light until the previous one is placed to your satisfaction.
>
> Too much light and too many lights will spoil any lighting scheme.
>
> Multiple sets of shadows that criss-cross one another, and shadows within shadows cast by separate lights, are extremely ugly and must be avoided.
>
> Don't be afraid to use pitchblack shadows if such shadows are expressive in form and placed in such a way that they accentuate the subject's forms and strengthen the graphic design.
>
> In portraiture, the most important shadow is that cast by the nose. It must never touch or cross the lips. If it does, the effect suggests an ugly mustache, even if the subject is feminine.
>
> Watch for the "blind spots" in a face and make sure they receive enough

light. You find them in the corners of the eyes near the nose, in the angles between nose and mouth, and beneath the chin.

Keep your fill-in light well diffused to avoid shadows (cast by the fill-in light) within shadows (cast by the main light). Because it produces completely shadowless light, the best fill-in lamp is a ringlight—an electronic flash tube that encircles the lens.

Place your fill-in light above the level of the lens so that its shadow will fall low. Placed too low, a fill-in light can cast shadows that can ruin an otherwise clean background.

A fill-in light that is too weak is better than one that is too strong. A fill-in light that is too strong produces the same effect as single flash at the camera.

Concentrate your light toward the background and keep the foreground darker. A dark foreground suggests a frame and takes the eye toward the center of the picture, where interest belongs.

An underlighted background is a common fault of many color photographs. Use an exposure meter in conjunction with a Kodak Neutral Test Card to check the illumination levels of subject and background and make sure they are the same by arranging the lights accordingly.

Light is the strongest creator of mood. Arrange your illumination to fit the mood of the subject.

Backlight is the most dramatic illumination, and the one most difficult to handle in color. p. 257

Low-skimming sidelight or three-quarter backlight brings out surface texture better than any other type of light.

Single flash at the camera is pictorially the worst kind of light.

Texture lighting. Texture is surface structure—an aggregate of minute elevations and depressions. To bring out texture photographically the elevations must be illuminated and the depressions filled with shadow. Since the elevations—the grain of stone, the nap of a rug, the weave of cloth—are usually very small, they can be made to cast effective shadows only if they are illuminated by low-skimming light. Up to a point, the more the incidence of the light approaches parallelity with the textured surface, the better the texture rendition will be. Directionally,

255

three-quarter backlight is most effective. For best results, use a pointlike light-source or a light-source that emits parallel or near-parallel light, which casts hard shadows; best of all is direct sunlight or light from a spotlight. Next in line are undiffused photoflood or flash illumination. Diffused or reflected light is useless. Since the components of texture are usually very small, texture can be rendered satisfactorily only if, in addition to having sufficient contrast, the photograph is also perfectly sharp.

Light sets the mood of a photograph

The mood of a landscape changes with the time of day and atmospheric conditions —it makes a difference whether it stretches boring and monotonous in glaring noonday light, lies brooding under an overcast sky, or comes to life in a burst of color at sunset. A subdued low-level illumination creates a feeling which is totally different from that evoked by brilliant sunshine. The pink light of dawn puts us in a different mood from the cold blue light of dusk. These differences in mood are the result of differences in the brightness and color of light.

Most photographers know this instinctively and prove it by pictures they take primarily for the sake of a mood—a special kind of light. They call it "atmosphere" and realize that had they found the subject in a different light—in a different "mood"—they might not have taken the picture; because mood and atmosphere (in the psychological, not the meteorological, sense) are largely created by light.

As an example, consider the atmosphere of the interior of a church. We feel a different mood in a whitewashed New England church with bright sunlight streaming through large clear-glass windows than in a cathedral where mysterious light dimly filters through deeply colored stained glass.

The specific mood induced by a specific light can only be preserved in the transparency if the characteristics of the illumination which created it are preserved too. Photographers who tamper with the special quality of such light—who use corrective filters in an attempt at bringing it back to "standard," who indiscriminately use auxiliary illumination to fill in shadows and reduce contrast in an effort to record every detail that otherwise would have been lost to darkness—destroy its mood. Every experienced photographer knows that the use of fill-in light is often a necessary requirement for an effective rendition; but he also knows that such auxiliary light must be used in a way that does not destroy the very thing that made him take the picture—its mood.

Today, an increasing number of photographers realize the significant influence

that the illumination has on the mood of a picture and, as a result, available light is increasingly used. To me, a grainy and slightly fuzzy photograph taken under marginal conditions in available light, *that preserves the mood of the subject,* is far more meaningful than the sharpest and most detailed picture in which the mood is destroyed or falsified by tampering with the light. As a matter of fact, when the illumination level is too low to make detailed photographs at shutter speeds sufficiently fast to prevent blur due to subject motion, the actual subject when seen creates the same slightly vague impression typical of a photograph taken of it in "available light."

In mood pictures, light is used for making emotional statements. The subject proper of such pictures is not something concrete but an intangible—a feeling. Tangible subjects appearing in the rendition are merely the means by which we convey the specific mood. Occasionally, color and light are the subject proper of such pictures, as in sunset shots and many pictures of the city scene at night—the "neon jungle." Abstract concepts like mood cannot be photographed directly; they can only be suggested. A photographer must direct the viewer's imagination through use of symbols that will lead him to contemplate in his mind the indicated mood. To suggest mood, muted illumination is usually needed, supplemented by color of suitable quality—warm or cold as the case may be, soothing or exciting, clashing or harmonious—and large areas of the picture must be filled, not with detailed factual subject matter, but with intangible color, shadow, and light.

As a means of creating mood, backlight is the most suggestive type of light. Backlight tends to subordinate reality by submerging concrete subject matter in darkness or light and to emphasize instead intangibles—atmosphere, mood. Although it is the most difficult type of light to use—making it easy to combine underexposure and overexposure within the same picture—nevertheless, if used with daring and skill, it enables a photographer to produce transparencies that are more suggestive and powerful than those produced by any other type of light. p. 222

The special significance of backlighted pictures lies in the interplay of luminosity and darkness. In addition, shadows extending toward the viewer create particularly effective impressions of depth. This depth effect is often increased by delicate seams of light that outline objects, separate different zones in depth, and further heighten the spatial effect.

To preserve the character of backlight, the photographer must above all preserve the contrast between darkness and light. The worst mistake he can make is to use too much fill-in illumination. Anyone who seriously believes that black detailless

shadows are invariably a sign of incompetence on the part of the photographer should avoid using backlight. Although black areas are obviously undesirable in many types of photographs, this is not always true. Competently handled, black areas in backlighted shots are NOT "necessary evils" but compositional picture elements which give backlighted photographs their particular strength and character. That this type of rendition is unsuitable for certain purposes and subjects does not negate the value of backlight as a powerful means for symbolizing mood. Whenever definition in shadow areas is important, backlight should normally not be used. In portraiture, for example, backlight is used only as auxiliary illumination to add sparkle and highlights. But in landscape photography, particularly if the scenery contains a body of water or a dramatic sky, backlight is unsurpassed for producing meaningful effects. For satisfactory results, three conditions must be fulfilled:

pp. 166-167

The subject must be suitable for a rendition that emphasizes outline and silhouette, exaggerates contrast, and minimizes or obliterates detail. Subjects that fulfill these demands are, among others: landscapes; bodies of water which, without the glitter and sparkle induced by backlight, often appear characterless and dull; silhouettes of city skylines; nude figure studies; all pictures that include large areas of sky with the sun behind a cloud, and, of course, sunsets.

Flare and halation must either be accepted as symbols of radiant light and creatively incorporated into the picture design, or avoided. The latter is often more difficult than the former and possible only if circumstances permit the photographer to shield his lens from direct light—by waiting until a passing cloud temporarily covers the sun, or by using the shadow cast by the trunk or limb of a tree, an arch, a doorway, an advertising sign, a canopy, etc., to prevent direct light from striking the lens. Under certain conditions, the light-source can even be hidden by the subject itself. A lens shade provides adequate protection against halation and flare only if the light-source is outside the picture area, provided the lens shade is sufficiently long, a requirement which few lens shades fulfill. For larger cameras, unsurpassed in regard to efficiency is the bellows-type Graphic lens shade, which, because it expands or contracts as circumstances require, affords the best available flare control.

p. 29

The exposure must be calculated in accordance with the *light* colors of the subject. For example, if the subject is a sunset sky, forget about detail in the landscape, take an exposure-meter reading of the bright areas of the sky at a moment when the sun is hidden behind a cloud, and expose your film accordingly. Parts of the

picture, particularly in the foreground, will go black. But this darkness, far from being objectionable, will actually enhance the effect of the color through contrast between light and dark. If the exposure were "averaged," because of excessive subject contrast, parts of the scenery would be underexposed anyway and thus appear black; but in addition all the subtle colors of the sky would be burned out through overexposure, the colorful sunset effect would be lost, and the photographer would only have succeeded in combining under- and overexposure in the same picture.

Light forms designs of light and dark

Brightly illuminated subject areas appear very light and areas in deep shade appear black. Between these extremes lies the range of intermediate colors and tones. Contemplated as an abstract design, these graphic effects produced by light are as important to the effect of the picture as the space- and mood-suggesting qualities of light.

In analyzing the graphic and emotional effects of black and white, one finds that white is dominant and aggressive, black passive and receding. In a photograph, since white (or light areas) attract attention first (exception: bold dark silhouettes), they can be used to lead the eye of the viewer to points of major interest. An effective way to draw attention to the subject proper is to deliberately keep it light and "frame" it with dark areas along the margins of the picture. White (or a transparency in light colors) suggests lightness, gaiety, happiness, youth. Black (or a transparency in dark colors) suggests strength, solidity, and power, but also seriousness, age, sorrow, and death. To make white appear as bright as possible it must be contrasted with black. Similarly, to make black appear as dark as possible, it must be contrasted with white.

A convincing demonstration of the potentialities of light as a design control can be had by performing the following experiment: With a single photo lamp (preferably an adjustable spotlight), illuminate and photograph a white plaster statue in front of a white background in five different ways: (1) Using flat frontlight, illuminate the statue and the background so that both appear as white in the transparency; to do this, you must increase the exposure as indicated by an exposure meter accordingly, or expose in accordance with data determined with p. 146 the aid of a Kodak Neutral Test Card. Your properly lighted and exposed trans- p. 144 parency should show both the statue and the background as white. (2) Repeat the shot under identical conditions but this time expose in accordance with the data established by the exposure meter. Your transparency should now show a

gray statue in front of a gray background. (3) Take a third shot under identical conditions, but with the diaphragm aperture decreased by three full stops. This time you will get a rendition which shows a nearly black statue in front of a nearly black background. (4) By using a combination of front and overhead light with appropriate shielding by means of a piece of cardboard, arrange the light so that the statue appears fully illuminated and the background in the shade. A correctly exposed transparency will show a white statue in front of a nearly black background. (5) Use more or less the same arrangement but direct the light so that the background is fully illuminated while the statue is in the shade. This time, you should get a picture in which a nearly black statue appears in front of a white background.

As this experiment proves, merely through skillful use of light, it is possible to create design effects as different as white against white; gray against gray; black against black; white against black, and black against white. Isn't this a convincing demonstration of the creative potential of light?

The functions of shadow. As the above experiment shows, light and shadow are like positive and negative, two equally important forms of the same element although of opposite values, complementing and reinforcing one another through the contrast of their characteristic qualities. But whereas most photographers pay considerable attention to the quality and distribution of the light in their pictures, they commonly neglect the shadows, not knowing or caring that, as far as graphic picture impact is concerned, shadow fulfills three functions:

Shadow symbolizes depth. To appreciate the importance of shadow as a symbol for depth make the following experiment: Take three "head-on" photographs of a bas-relief. Illuminate the first view with shadowless front light; the second with low-skimming light coming from the upper left-hand corner of the picture; and the third with low-skimming light coming from the lower right-hand corner of the picture. Compare the effects of the three transparencies. Notice that the first one appears "flat"—absence of shadow means absence of depth; that the second one appears "natural" insofar as it gives the impression of "depth"; and that the third also seems to have "depth," but depth is reversed—forms that in the original were elevations appear as if they were depressions, and forms that were depressions appear to stand up in high relief.

The same effect can be seen in aerial photographs of mountainous landscapes taken from directly above. Such photographs have, of course, neither "top" nor "bottom." If such pictures are held vertically, with the shadows pointing more or

less downward and toward the lower right, the scenery will appear true to reality. However, if the picture is held "upside down," i.e., so that the shadows point toward the upper left, the landscape will appear turned inside-out—a mountain will appear as a crater and a valley as a mountain range.

In a landscape photograph that includes mountains, the shadows of passing clouds can be used to make the scenery stand out in bold relief. By waiting until the position of the cloud shadow is right—one range in shadow and the other in light— a photographer can indicate the interval between neighboring ridges and thus create an effect of greater depth in his picture.

Shadow as darkness. The value of the shadow lies in its depth of tone. It is the picture element which, in contrast to its own darkness, makes color appear more saturated and intense, gives white additional brilliance. You can easily prove this to your own satisfaction by placing a frame cut from a piece of black paper or cardboard over one of the color illustrations in this book: the color will appear brighter. Subsequently, place a similar but white frame over the same picture and notice how its colors seem now dulled: white, being brighter than any color, in contrast to its own brightness makes color appear not only darker, but also less intense—producing exactly the opposite effect from black. It is this quality of black—of darkness and shadow—which the good color photographer utilizes to give his transparencies added brilliance and luminosity.

Darkness—shadow—in conjunction with lighter picture areas, creates graphic contrast from which comes strength, impact, and power. In addition, it provides forceful accents upon which sometimes the entire design of a photograph can be based, as in the case of a silhouette, or a semisilhouette, i.e., a strong dark form which still shows traces of color and detail within its darkness. Furthermore, darkness suggestively symbolizes intangible concepts such as power, drama, strength, poverty, suffering, or death. And it is the most effective means for creating a serious, somber, or mysterious mood.

Shadow as form. Grotesque shadows that repeat in distorted form the shapes of the subject by which they are cast, can be used to create strong interpretative pictures and, similar to a caricature, through exaggeration emphasize a subject's qualities in a highly expressive form.

Although shadows with forms strong enough to be the principal subject of a photograph are rare, the main shadows within the field of view of the lens should be observed and analyzed since imaginative use of shadows can sometimes give

a photograph a feeling of greater power and distinction. In the early morning and late afternoon, long slanting shadows can assume a strange life of their own. There are bird's-eye views of people hurrying along the street which show weirdly distorted shadows, fantastically elongated by a low-riding sun, which express in almost surrealistic intensity the hectic way of life in a big city. And I'll never forget an aerial photograph of a bombed city made by Margaret Bourke-White. It was taken straight down from a low altitude in late afternoon, and the shadows cast by the roofless empty-windowed houses formed a macabre black-and-white pattern of hollow squares that reflected in the form of a "city of shadows" a mood of horror and senseless destruction impossible to forget.

COLOR

Color is a psycho-physical phenomenon induced by light. Its effect in terms of color sensation depends upon three factors:

>**the spectral composition** of the incident light;
>**the molecular structure** of the light-reflecting or transmitting substance;
>**our color receptors,** eye and brain.

The nature of color

Color is light. In the absence of light—in darkness—even the most colorful objects appear black. They lose their color. This is the literal truth. It does NOT mean that their color still exists but cannot be seen because of lack of light. It literally means that *in darkness color ceases to exist.*

The fact that color is light is easily proved: in daylight, a white building is white; illuminated at night with red floodlights it looks red; illuminated by blue, it looks blue. In other words, its color changes with the color of the light by which we see it.

But what about pigments, paints, and dyes—the stuff that gives objects their colors—are they not absolute, existing as colors in their own right?

No—the colors of such substances are also produced by light. Consequently, they are subject to change with changes in the color of the illumination. Any woman knows that dyed fabrics and materials appear different in daylight than at night in incandescent light and different again in fluorescent light. Why? Because of the different colors of the light: daylight is "white," incandescent light yellowish, fluorescent light deficient in red.

262

Conclusive proof can easily be obtained by anyone who examines an array of pigments or paints in differently colored lights (cover a lamp with sheets of cellophane in different colors). The paints will change color each time the color of the light is changed. Why? Because color is light.

The spectrum. Any high-school student today knows that what we perceive as "white" light is not a homogenous medium but a mixture of many different wave lengths that can be separated from one another and made visible individually with the aid of a prism or a spectroscope. The result is a "spectrum"—a band of brilliant color in which light of different wave lengths manifests itself in the form of different colors.

The most familiar example of a spectrum is a rainbow. Its colors are produced by sunlight that is dispersed due to refraction by innumerable droplets of water suspended in the air. The most spectacular rainbows occur in the late afternoon immediately after a thundershower when the sun breaks forth and projects a rainbow against a background of black clouds. Always look for a rainbow directly opposite the sun. The lower the sun, the higher and more arched the rainbow.

Other natural spectra are produced by sunlight dispersed by the prismatic edges of cut glass and mirrors, or by rays of sunlight hitting a jeweler's display where the refracting substance of gems produces a shower of sparkling color.

The classic Newtonian spectrum distinguishes seven different colors: red, orange, yellow, green, blue, indigo, violet. In reality, of course, the number of different colors is ever so much larger since even a small change in wave length produces a new and different color. However, as far as human color perception is concerned, all colors can be classified as variations and combinations of only six basic colors: red, yellow, green, blue, white, black. These are called the "psychological primaries." Actually, if necessary in conjunction with modifying adjectives, these color names are sufficient to describe all other colors. Orange, for example, could be described as red-yellow, and violet as blue-red, etc.

The only colors that are pure in the scientific meaning of the word are the colors of an actual spectrum. All other colors are mixtures of several colors in various proportions. But each one of the hundreds of colors of an actual spectrum is produced by light of a single wave length. Because of this unearthly clarity and brilliance, the contemplation of a large spectrum is one of the most profound, moving, and exciting of all visual experiences.

"Invisible light." A physicist might define "light" as the form of radiant energy which, by stimulating the retina of the eye, produces a visual sensation in an observer. This automatically precludes the concept of "invisible light." All light is visible. If it is not visible, it is not light. We sometimes read or speak about "ultraviolet light" or "black light." Scientifically, these terms are not correct. Since ultraviolet is invisible to the human eye (although certain animals, insects, and photographic emulsions are sensitive to it), it cannot properly be called light; the correct term is "ultraviolet radiation." The same applies to infrared, which also is not a type of light but a form of energy closely related to radiant heat.

How color is produced

Color can be produced in many different ways, most of which are governed by a common principle: only those colors that exist in latent form in the spectrum of the light by which they are observed can be seen and photographed. If the spectrum of a certain type of light does not contain those wave lengths which, for example, produce the sensation "red," then an object which appears red in sunlight will not appear red when viewed under such illumination. For example, light emitted by a mercury-vapor lamp has a spectrum which lacks most of those waves which produce the sensation "red." Anyone who has taken a sunbath under a mercury-vapor lamp knows that its light gives lips and fingernails a cadaverous appearance. They appear purplish black because this type of light contains almost no red.

Here is a list of some of the processes which can produce color:

> **Absorption** — all body and pigment colors
> **Selective reflection** — all metallic colors
> **Dispersion** — the rainbow, the spectrum
> **Interference** — oil slicks on asphalt; opals
> **Diffraction** — the colors of diffraction gratings
> **Scattering** — the blue color of a cloudless sky
> **Electric excitation** — colored neon signs
> **Ultraviolet excitation** — fluorescent minerals

Absorption. Most of the object colors we see and photograph are body or pigment colors. Among others which belong to this category are all nonfluorescent and nonmetallic pigments, paints, and dyes, and most of the colors of objects of nature, such as the green of plants, the blue and yellow of flower petals, the red of clay. Such colors are produced by absorption of light. What happens is this:

White light composed of all the colors of the spectrum falls upon an object. Of this light, certain wave lengths representing certain colors penetrate the surface of the object and are *absorbed* by the material. Other wave lengths representing other colors are *reflected*, giving rise to the sensation "color." Which of the wave lengths of the incident light, *i.e.*, which portions of its spectrum, will be absorbed, and which will be reflected, depends upon the physical structure of the material.

For example, the red color of a piece of red fabric is produced as follows: "White" or "colorless" light falls upon the material and infiltrates the tangle of semi-transparent fibers that have been impregnated with a dye. The molecular structure of this dye is such that it absorbs the green- and blue-producing wave lengths of the incident white light, but does not affect the red-producing wave lengths. These red-producing wave lengths remain free to either penetrate through the material, or to be reflected. In either case, if they happen to strike the eye of an observer, they produce in his brain the sensation "red."

All other body colors are similarly produced. Light which falls upon a surface and penetrates to a certain depth undergoes a change caused by the selective absorption of the molecules of the material. Certain parts of the spectrum are filtered out through absorption by the surface material. The remainder is reflected and thus gives the surface its color.

If a surface is very smooth and glossy, incident light is reflected in two different ways. First, we observe the type of reflection described above, which gives rise to the color of the surface. Second, we notice another type of reflection, which we perceive as "glare."

Diffuse reflection. The color-producing type of reflection is caused by light that penetrates the surface to a certain depth, deep enough so that it loses part of its spectrum through absorption by the materia. The part of the light that is not absorbed but reflected gives the surface its color and is called "diffuse reflection."

Specular reflection. The glare-producing type of reflection appears the more pronounced the more the viewing angle equals the angle of incidence. This type of reflection is caused by light that does not penetrate the surface, and consequently is reflected without undergoing selective absorption by the material. As a result, it retains its original composition. If the incident light is white, the glare will also appear white, even though it may be reflected by a colored surface. This type of reflection is called "specular reflection."

In color photography, specular reflection, or glare, is sometimes undesirable because it obscures the underlying color of a surface. For example, the colors of the four-color reproductions in this book are produced by absorption, and they reach your eye in the form of diffuse reflection. As an experiment, hold a color page toward the light, gradually tilt it more and more away from you, and see how glare slowly obliterates its colors. Finally, when the angle of observation is sufficiently narrow, only the glare will be visible; the underlying colors will be completely obscured. Except when reflected from metallic surfaces, such glare consists of "polarized light."

Polarized light and glare control. A beam of *nonpolarized* light vibrates in every direction at right angles to its axis. Such a beam of light can be compared to a tightly stretched string that can freely vibrate sideways in every direction.

A beam of *polarized* light vibrates in one plane only. Such a beam can be compared to a tightly stretched string that passes through a narrow slot in a piece of cardboard that restrains its freedom of vibration to a single plane, the plane of the slot.

p. 37 Polarized light and glare can be controlled with the aid of a "polarizer." A polarizer is a piece of transparent material that is unique insofar as it polarizes light: ordinary, nonpolarized light strikes one side of the polarizer, is transmitted, and emerges on the other side in the form of polarized light. In effect, a polarizer does to a beam of light what the piece of slotted cardboard does to the tightly stretched string.

Imagine two such slotted pieces of cardboard, one superimposed upon the other, with a tightly stretched string passing through the slot. As long as the slots coincide, the vibration of the string within the plane of the slots is unrestricted. But as soon as one piece of cardboard is rotated while the other remains stationary, the vibration of the string will become more and more restricted and will finally cease completely at the moment when the two slots cross each other at right angles.

If we substitute a beam of nonpolarized light for the tightly stretched string, and two polarizers for the two pieces of slotted cardboard, we get the following picture:

As long as the two polarizers are superimposed in such a way that their axes of polarization are parallel, they act like a single polarizer and nonpolarized light falling upon them will after transmission be merely polarized upon emergence. However, if we rotate one of the polarizers, the vibration of the light polarized by the first polarizer will be more and more restricted by the second polarizer.

Finally, after a 90-degree angle of rotation, the vibration of the light that was polarized by the first polarizer will be completely stopped by the second, and as a result no light will be transmitted.

This effect can easily be observed: take two polarizers, hold them up toward the light, and slowly rotate one in relation to the other. The light you see through the polarizers will vary from maximum brightness to no transmission at all, darkness.

Light reflected in the form of glare, since it is polarized, is the same as light that has passed through one polarizer. As a result, its freedom of vibration, hence its brightness, can be controlled with the aid of a single polarizer. This can be verified by looking through a polarizer or a pair of Polaroid sunglasses at the glare reflected from one of the color pages in this book: slowly rotate the polarizer while observing the glare, and notice how the intensity of the glare changes from maximum brightness to zero, depending upon the position of the polarizer. At the zero position, glare is practically eliminated—vibration of the glare-producing beam of polarized light has been arrested—and the underlying colors of the printed reproduction stand out once again in their original brightness. If the polarizer had been used in front of a lens instead of the eye, a clear and brilliant color photograph of the reproduction could have been made.

Similarly, *with the exception of polished metal*, glare can more or less be eliminated from shiny surfaces such as glass, water, paint, varnish, polished wood, asphalt, etc. Light reflected from metallic surfaces is *not* polarized, and consequently cannot be eliminated with the aid of a single polarizer.

The degree to which glare can be eliminated with the aid of a polarizer depends upon the angle between the reflecting surface and the source of the glare. Maximum effect, *i.e.*, almost complete extinction of glare, results if the angle is in the neighborhood of 34 degrees. At other angles, glare can be reduced but not completely eliminated.

Incidentally, glare and what is commonly called "reflection" are the same. For example, if a photographer wishes to take a picture of a shop window but the exhibits are obscured by reflections of the sky, buildings, trees, or automobiles in the street, the use of a polarizer will more or less eliminate such reflections and permit the photographer to take a clearer picture of the contents of the window. If the picture is taken at an angle of 34 degrees with respect to the reflecting surface, the window, elimination of reflection will be complete. At other angles, reflections are more or less diminished but not eliminated. At an angle of 90 degrees, reflections are not affected at all.

In color photography, polarizers provide the only means for darkening a pale blue sky without affecting the other colors of the picture. Maximum effect takes place in that band of the sky which is at an angle of approximately 90 degrees to an imaginary line drawn between the camera and the sun.

The effect of a polarizer upon glare and reflection can be determined only visually. Either attach the polarizer to the lens and observe its effect on the groundglass of the camera while slowly rotating the polarizer; or hold the polarizer to your eye and observe the subject through it while slowly rotating the polarizer. When you observe the desired effect, carefully transfer the polarizer to the lens, making sure that the point of the polarizer that was at the stop is still at the top when the polarizer is placed in position in front of the lens. A change in the position of the polarizer during the transfer from eye to lens will result in a picture in which the effect of the polarizer is different from that which was observed.

Polarizers used in color photography must be colorless in order not to change the color balance of the transparency. Some polarizers have a greenish, purplish, or yellowish tint. While such a tint is of no consequence in black-and-white photography, it makes such polarizers unfit for use with color. Special polarizers for color photography are made by the Polaroid Company, Kodak, and others.

Selective reflection. Metallic colors, such as gold, copper, brass, or bronze, appear markedly different from ordinary body or pigment colors. This difference is produced by a difference in specular reflection.

Light reflected from most shiny surfaces in the form of specular reflection retains the spectral composition of the incident light. If the incident light is white, light reflected as specular reflection will also be white. If the incident light is blue—for example, light reflected from a clear blue sky—specular reflection will consist of the same type of blue light. And so on.

However, there are exceptions. Metals, for instance, have the property of "selective reflection." Light which they reflect in the form of specular reflection has undergone certain changes and its spectral compositon differs from that of the incident light, producing the surface or metallic color that is typical of the particular metal. For example, white light which is reflected in the form of specular reflection from a piece of polished copper is no longer white but copper-red; reflected from gold it is yellow; etc.

A further characteristic of selective reflection is that the color of the light reflected

268

in the form of diffuse reflection is different from the color of the transmitted light. If color is produced by absorption, the color of the light reflected in the form of diffuse reflection and the color of the transmitted light are the same. The color of the piece of red fabric mentioned as an example is the same in both reflected and transmitted light; looking *at* the piece of red cloth, or holding it up against the light and looking *through* it, both produce the same sensation, "red." However, a film of gold leaf that is thin enough to transmit light behaves quite differently. If we look *at* this film of gold we see the typical gold color since it strongly reflects yellow and red. If we look *through* it, however, it appears green. The explanation is as follows:

White light strikes the film of gold. The red and yellow components of this light are reflected back, or away from us, as we look through the film, and therefore they cannot reach our eye. The blue component of the white light is absorbed by the atoms of the metal. What remains and is transmitted by the gold leaf are the green-producing wave lengths, and as a result, in transmitted light, the gold leaf appears green.

Incidentally, this phenomenon has been put to practical use in certain types of rangefinders for better separation of the two images which, upon coinciding, indicate that the lens is correctly focused. The mirror in such rangefinders is coated with a semitransparent film of gold. As a result, the image seen *through* the mirror appears green, whereas the secondary image *reflected* by the mirror appears orange (yellow plus red). Such a difference in color greatly facilitates visual separation of the two images and thus is an aid to accuracy of focusing.

This type of metallic coloration is also found in certain insects and in some crystals of organic chemicals.

Dispersion. Light travels faster through air than through denser media. For example, a beam of light which enters a piece of glass will be slowed down to a certain extent and, upon emergence, will resume speed. However, different wave lengths are affected to different degrees. Short wave lengths, like violet and blue, are slowed down more than long wave lengths, such as red. It is this characteristic of light that causes the "spectral colors" that can be observed when light is *dispersed* by the prismatic edges of cut glass, the facets of a diamond, or the droplets of moisture suspended in the air that produce a rainbow. For explanation, see the following drawing.

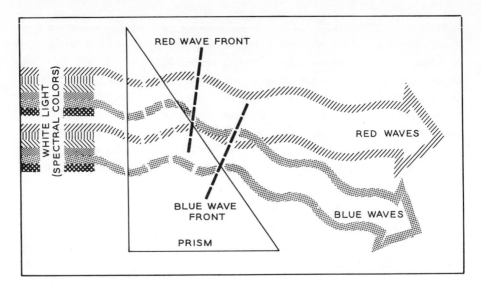

RED WAVE FRONT

WHITE LIGHT (SPECTRAL COLORS)

RED WAVES

BLUE WAVE FRONT

BLUE WAVES

PRISM

A beam of white light enters a prism of glass, passes through it and, upon emergence, is refracted, *i.e.*, deflected from its straight path. Such refraction always occurs when a beam of light passes obliquely from a rarer into a denser medium, for example, from air into glass or water, or vice versa. However, light of longer wave length, in passing through the denser medium, is slowed down to a lesser degree than light of shorter wave length. As a result, refraction is not uniform, the beam of white light is dispersed, *i.e.*, split up into its different components and, upon emergence from the denser medium, appears in the form of a spectrum.

Interference. Light that falls upon a thin layer of transparent material, such as a soap bubble or a thin film of oil, is reflected twice: once from the surface, and once from the bottom of the film. Even though both the incident light and the material of the film itself are colorless, such a film will appear in different colors, depending upon the angle from which it is observed. Such colors are caused by interference among the individual waves of light.

On p. 271, in the left drawing, white light falls on a film of oil at a 60 degree angle. The thickness of this film is such that the total distance which the light travels inside the film, measured from the surface to the bottom and back to the surface again, is the equivalent of one wave length of red light, or one and a half of the shorter wave length of blue light. As a result, red light reflected from the bottom of the film is, upon emergence, exactly one wave length behind the red light reflected from the surface of the film. Consequently, the undulations of the red

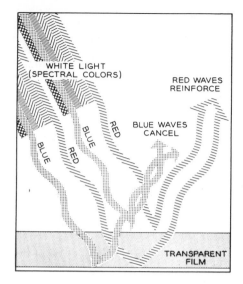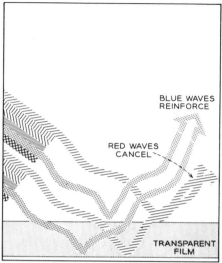

waves coincide, they are in synchronization, reenforce each other, and become visible as red.

On the other hand, the blue light reflected from the bottom of the film is, upon emergence, half a wave length behind the blue light reflected from the surface of the film. As a result, the two beams of blue light will be out of step with one another, cancel each other, and become invisible. Seen from an angle of 60 degrees, this particular spot in the oil slick will appear red.

In the right drawing, conditions are similar except that at this angle the path of the light within the film is of such length that the emerging red-producing light waves cancel one another whereas the blue-producing light waves reenforce and become visible. Seen from this angle, the oil slick will appear blue.

Different parts of a soap bubble or an oil slick appear in different colors because the thickness of such films is not uniform. Furthermore, every change in the angle of observation causes a different color to appear because it involves a change in the distance that the incident light must travel through the film of soap or oil on its way to the eye.

Another manifestation of color by interference are Newton's rings, those colorful ring patterns well known to, and dreaded by, photographers. These colors are also produced by light reflected from two surfaces in close but not perfect contact: the glass of the negative carrier of the enlarger, and the base of the photo-

graphic film. Depending upon the distance by which these surfaces are separated, and the angle from which they are observed, different colors appear as a result.

Incidentally, since the same thickness of film observed at the same angle always shows the same color, such "color by interference" is used not only to measure accurately the thickness of thin films of transparent material but to measure the size of individual molecules by measuring the thickness of monomolecular films.

Other familiar colors produced by interference are the colors of certain iridescent butterflies, and of opals. If an opal were pulverized, only a colorless powder would remain since no pigment is present. The colors we see are caused by light which is reflected back and forth in the innumerable minute cracks in the gem.

Diffraction. Like the thin films described above which produce color through interference, a series of very fine parallel grooves closely spaced also convert white light into bright colors through a process of reenforcement and cancellation. This phenomenon is called diffraction.

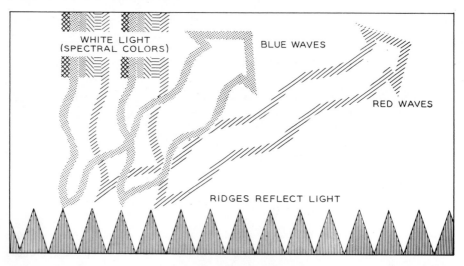

When a beam of white light strikes a large number of very fine parallel grooves, for example, the grooves of an LP record, it is dispersed in all directions from the crests of the ridges. However, seen from a specific angle, the undulations of, for example, the blue-producing wave lengths, reflected from adjacent ridges, will coincide as they travel toward the eye of the observer, who consequently will see this part of the record as blue. Other wave lengths of the incident light, producing other colors, are also reflected. But at this particular angle they appear more or

less out of phase, *i.e.,* they cancel each other to a greater or lesser degree, and consequently produce only weak colors, or no color at all. However, seen from a different angle, another color would be dominant.

One of man's most powerful tools for the exploration of the universe is the spectrograph, the heart of which is a "diffraction grating." Such a grating consists of a plate of metal or aluminum-coated glass on which are ruled a great number of very closely spaced, extremely fine parallel grooves—ten thousand and more to the inch. The spacing between these grooves must be accurate to within one-millionth of an inch.* This grating, the most precise object ever made by man, splits up light emitted by the sun, a star, or a galactic nebula, into its spectrum, which then is recorded upon a photographic plate. Through the study of such spectra, physicists can learn as much about a star's nature and composition as from an actual specimen of its substance.

Scattering. Light which passes through a medium that contains large numbers of very fine particles undergoes a slight change of direction every time it strikes one of those particles. Thus sunlight in its passage through layers of air filled with droplets of water and particles of dust is deflected innumerable times before it falls upon the eye of an observer at ground level. However, such deflection is not uniform in character. If the particles are relatively large, *i.e,* if their diameter is many times that of a single wave length of the incident light, light striking such a particle is deflected without undergoing any change. For example, sunlight that filters through a layer of water vapor, clouds, still appears white, giving an overcast sky its typical whitish appearance. This type of deflection is called diffusion.

However, if the deflecting particles are exceedingly small, *i.e.,* if their diameters are in the neighborhood of the length of a single wave length of light, deflection becomes selective, and the phenomenon is then called scattering.

Scattering affects short wave lengths at the blue end of the spectrum more strongly than those at the red end. As a result, sunlight passing through clear air which mostly contains particles of exceedingly small diameter is widely scattered, giving rise to the blue color of a clear sky.

Incidentally, this same phenomenon causes the bluishness of objects seen from a great distance through haze, the blue appearance of distant mountains, and the

* To visualize a millionth of an inch, imagine the following: The vertical shaft of the letter "I" in this type is approximately one-hundredth of an inch wide. Mentally divide it into 10,000 parts, and you get the maximum distance by which the grooves of a diffraction grating may vary.

bluish color of diluted milk and tobacco smoke. Some blue feathers also appear blue *not* because they contain a blue pigment (which they don't), but because they contain within a translucent substance minute particles that scatter the blue-producing wave lengths of light more effectively than those of other colors.

The reddish coloration of the rising and setting sun, and the reddish color of the sky near the horizon and of sunlight at dawn and dusk, are also phenomena caused by scattering of light. For an explanation, see the accompanying drawing.

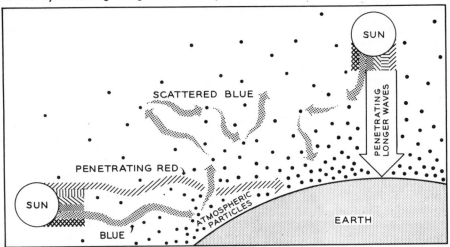

When the sun is near the zenith, its light passes through a relatively thin layer of dust-laden air. As a result, only a comparatively small part of the shorter wave lengths is scattered. Consequently, the sun, and sunlight at noon, appear still white. At sunrise and sunset, however, sunlight strikes the earth approximately at a tangent and must traverse a much thicker layer of dust-laden air. As a result, it encounters a larger number of particles, and particularly a greater number of relatively coarse particles within the lower layers of the atmosphere, which scatter a much wider range of wave lengths of light. Under such conditions, only the long red-producing wave lengths remain unaffected and are able to penetrate the atmosphere.

Electric excitation. Under certain conditions, changes in the atomic structure of matter can produce light in different colors. We may visualize an atom consisting of a nucleus surrounded by different shells of electrons. Electrons in each shell or orbit carry a specific charge of energy. Outer-orbit electrons carry a higher charge than electrons that are closer to the nucleus. Each time a high-energy

electron enters a low-energy shell it must release its excess energy. Under certain conditions, that extra amount of energy is released in the form of light.

The most familiar example of color caused by such a change in the atomic structure of matter is the light of neon tubes. A neon tube consists of colorless glass tubing filled with one of several types of colorless gas. Inside, it has two electrically charged plates, a negative plate at one end of the tube, and a positive plate at the other. At all times, a large number of the atoms of the gas are short of

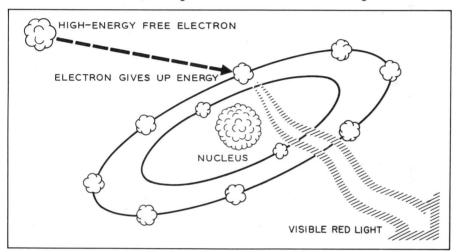

HIGH—ENERGY FREE ELECTRON

ELECTRON GIVES UP ENERGY

NUCLEUS

VISIBLE RED LIGHT

one electron, and thus are left with a slight positive charge.* Such incomplete atoms are called ions. Since opposite charges attract each other, these positive ions will rush toward the negative plate of the tube. During this rush they collide with other atoms and knock out some of their electrons which, being negative, will rush toward the positive plate of the tube. During this process, some of the free high-energy electrons will attach themselves to some of the electron-short atoms, and in doing so will release part of their energy in the form of visible radiation. The color of this radiation depends on the type of gas in the tube: neon, electrically excited, produces light that is red; xenon, blue; argon, mauve.

Ultraviolet excitation. Changes in the atomic structure of matter can, in certain instances, also occur under the influence of ultraviolet radiation. Certain minerals, such as calcite, fluorite, willemite, or wernerite, absorb ultraviolet radiation and convert it into visible light. This is what occurs:

* A complete atom is neutral, since its negatively charged electrons and its positively charged nucleus balance one another.

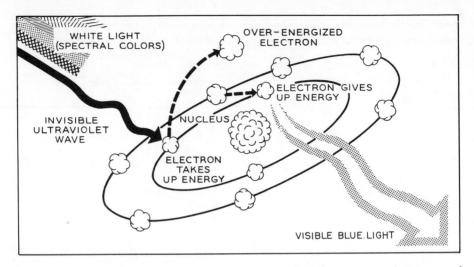

WHITE LIGHT
(SPECTRAL COLORS)

OVER-ENERGIZED
ELECTRON

ELECTRON GIVES
UP ENERGY

INVISIBLE
ULTRAVIOLET
WAVE

NUCLEUS

ELECTRON
TAKES
UP ENERGY

VISIBLE BLUE LIGHT

Short-wave ultraviolet radiation strikes an atom of a fluorescent substance and is partly absorbed by one of the atom's electrons. As a result, this electron becomes too highly charged to remain in its original orbit. Instead, it jumps into a higher orbit, knocking out one of the higher-energized electrons. In doing so it leaves a gap in its shell which immediately is filled by the knocked-out higher-energy electron. However, since this second electron is too highly energized to fit into the lower-energy orbit, it must lose part of its energy in the process of transfer from higher to lower orbit. It releases this energy in the form of light, the color of which depends upon the type of atom: calcite, for example, glows red under ultraviolet excitation, fluorite glows dark blue, wernerite yellow, and willemite green.

Because their extraordinary brilliance far exceeds the intensity of ordinary body and pigment colors, fluorescent dyes are becoming increasingly popular for use in textiles, poster printing, advertising, and displays. Another example of the use of fluorescent dyes is seen in stage presentations: on the darkened stage, costumes dyed with fluorescent dyes literally glow in weird and beautiful colors. These colors are brought out by excitation of the fluorescent material with invisible ultraviolet radiation produced by spotlights covered with suitable filters that absorb most of the visible light.

The composition of color

With very few exceptions—the spectral colors produced by dispersion or diffraction—colors as we commonly see them are not pure, i.e., each color is NOT pro-

duced by the light of a single wave length or a narrow band of wave lengths. Instead, most colors are mixtures of several often very different colors like blue and red, or red and green. We'll prove this in a moment, but first, to avoid endless confusion, we must clarify the situation by making a clear distinction between two things: color as we see it, *i.e.*, the personal and private experience of color within the brain; and the colored surfaces or objects, which give rise to this sensation. Color is based upon subjective feeling and is beyond analytical investigation; colored surfaces are physical objects which can be analyzed with suitable scientific means. Let's distinguish between the two by referring to them in different terms:

Color — the private psychological response to color within the brain;
Colorant — the colored objects that give rise to the sensation "color."

To study the interaction between light and a colorant, look at colored objects through differently colored filters. For instance, if you look at a blue object through a red filter, the object will appear black. This is so because the red dye of the filter absorbs the blue component of "white" light—blue light is not transmitted. This, of course, explains why in black-and-white photography a red filter darkens a blue sky and thus brings out white clouds: by selectively *absorbing* the blue component of the skylight, this filter reduces the exposure of the blue sky proportionally more than it reduces the exposure of the white clouds, the light of which also contains red and yellow, which are transmitted by a red filter. Therefore, it increases the contrast between the clouds and the sky.

The effect of any colorant is to *absorb* light of certain wave lengths from the incident light, NOT to add its own color to it. In other words, what we perceive as color is what remains of the incident light after it has been modified by the colorant. For example, in daylight, green leaves appear green because chlorophyll strongly absorbs the blue and red components of white light but rejects green, which is reflected; similarly, a red automobile appears red because its colorant absorbs the blue and green components of white light but rejects red, which is reflected.

The light-modifying effect of a colorant is, of course, the same whether the colorant reflects the light (as a surface does) or transmits it (as a filter does). If we look at the sun *through* a green leaf we see the same green as that which we see if we look *at* the leaf in sunlight. And if we were to paint a thin coat of red on a sheet of glass, we would see the same color if we looked at it or through it. This

277

is so because color is produced by the interaction between light and the molecules of the colorant, the atoms of which either absorb, or do not absorb, specific wave lengths (colors) of the incident light. And it is those wave lengths that are *not* absorbed that we see as color.

This explains why an object can have only those colors which are present in latent form in the spectrum of the illuminating light. Therefore, an object that appears red in daylight (which is rich in red-producing wave lengths) appears black when illuminated by green light (which does not contain light of red-producing wave lengths) or when seen through a green filter (which absorbs red). Fluorescent light is so unflattering because it is deficient in red-producing wave lengths: objects illuminated by it often look "unnatural" in comparison with their familiar appearance in daylight, which is richer in red; in fluorescent light, a rare roast looks positively putrid, and a pink complexion assumes a corpselike hue. Even more "unnatural" are the effects of sodium and mercury-vapor illumination, which, being almost monochromatically amber and blue-green, makes everything appear either amber or blue-green, and no filtration can change this appreciably. Renditions of this kind appear totally "unnatural" in color photographs.

All the colors we encounter in daily life—painted surfaces, colored textiles, the color reproductions in this book, color transparencies and color prints, color TV, and so on—are formed in accordance with two basic processes:

<p style="text-align:center">Additive color mixture

Subtractive color mixture</p>

Either one of these processes makes it possible to produce a very large number of different colors from the mixture of only *three basic colors*. The first process applies to mixtures of colored lights, the second to mixtures of colorants—pigments and dyes.

Additive color mixture

We know that with the aid of a prism, "white" or colorless light can be broken down into its color components and made to produce a spectrum. We are now going to reverse this process and see how light of different color can be combined to produce other colors and ultimately white. To do this, we need three sources of light. Slide projectors are best, but flashlights will also do provided their batteries are fresh and the light they produce is strong and white. We also need three filters in the colors red, green, and blue. These colors are called the pri-

p. 40

278

maries, more specifically, the "additive primaries" since, mixed in the proper proportions, they add up to make white.

In a darkened room, we proceed by placing the red filter in front of one of the three light-sources and projecting it onto a sheet of white paper. This paper will now appear red. Next, we place the blue filter in front of the second light-source and project it onto the same paper. Where red and blue overlap, a new color appears: a blue-red or purple, which is called "magenta." Finally, we place the green filter in front of the third light-source and project it onto the paper. Where green and blue overlap we get a blue-green color called "cyan." Where green and red overlap, we get yellow. And where all three primaries are superimposed we get white. Those who do not have an opportunity to actually perform this experiment can get an idea of how the result would look from the following diagram:

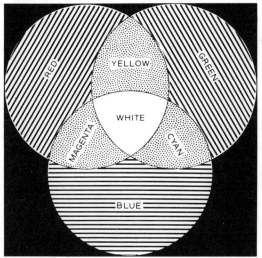

The above diagram graphically illustrates the principle of additive color mixture reduced to essentials. By varying the relative intensity of one, two, or all three of the colored light beams involved, virtually any desired color can be produced, plus any shade of gray and, by reducing all three intensities to zero, black. That the colors blue and red should combine to form magenta (purple) was to be expected; likewise, that green and blue should form cyan. But that a mixture of red and green should produce yellow comes as a surprise. Actually, however, yellow is a mixture of all the colors of the spectrum *except blue*. Even if none of the yellow-producing wave lengths of light were involved in the production of this

279

yellow color, such a mixture would appear yellow because equal stimulation of the red and green color receptors of our eyes produces the sensation "yellow." As a matter of fact, all yellow body or pigment colors are produced through surface absorption of blue. Red and green are reflected and, by equally stimulating our red and green-sensitive color receptors, produce the sensation "yellow." If a surface reflected only the yellow-producing wave lengths from 575 to 590 mμ, which represent only a minute percentage of the incident light, it would appear almost black.

Subtractive color mixture

We have seen how light in the three primary colors, red, green, and blue, can be added to produce three new colors—magenta, yellow, and cyan—and ultimately white. Similarly, by mixing these primaries in different proportions, almost any other color can be produced, including colors that do not even exist in the spectrum, for instance, the purples, magentas, and browns.

This process of additive color mixture, however, has one serious disadvantage: Since it applies only to colored light—NOT colorants—it necessitates the use of three separate light sources. We could *not* have produced any of our colors by placing three color filters in front of a single light-source. Why? Because each filter would have absorbed practically all the light transmitted by any one of the other two. Filters in the primary colors are mutually exclusive and, used in conjunction with each other, absorb all visible light. The result, of course, would have been black.

However, the problem of producing color by mixing colorants can be solved if, instead of working with the additive primaries, red, green, and blue, one uses filters in the new, primary-created colors, magenta, yellow, and cyan. These are the subtractive primary colors, and filters in these colors transmit not one-third but approximately two-thirds of the spectrum:

> Magenta — transmits red and blue — absorbs green
> Yellow — transmits red and green— absorbs blue
> Cyan — transmits blue and green— absorbs red

Consequently, filters in magenta, yellow, and cyan can be used in conjunction with a *single light-source* for the production of other colors, since each filter pair has one of the additive primaries in common: magenta and yellow both transmit red; yellow and cyan both transmit green, and magenta and cyan both transmit blue. As a result, where any two of these filters overlap, they produce one of the ad-

280

ditive primaries by subtracting from the white transmitted light the other two additive primaries: color is produced by subtraction of color—hence the name "subtractive color mixture." Where all three of the subtractive primaries overlap, of course, no light is transmitted and the result is black. The following diagram illustrates in graphic form this process of subtractive color mixture.

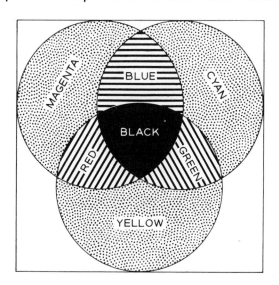

By varying the densities of the three filters in the colors magenta, yellow, and cyan, virtually any desired color can be produced. If one wishes to try the experiment, he can easily do so by using three sets of Kodak Color Compensating p. 36 Filters in the colors magenta (CC-M), yellow (CC-Y), and cyan (CC-C). Each set contains filters of six different densities. Or he can use ordinary pigments—watercolors or oils—in the subtractive primary colors, magenta, yellow, and cyan.

Colorants	Absorb	Produce
magenta plus yellow	green and blue	red
yellow plus cyan	blue and red	green
cyan plus magenta	red and green	blue
magenta yellow cyan	green and blue and red	black

All modern photographic color and photo-mechanical reproduction processes are based upon the principle of subtractive color mixture. And all the colors in our transparencies are mixtures of the three subtractive primaries, magenta, yellow, and cyan. This can easily be verified by tearing apart a color transparency (not

by cutting it) with a twisting motion so that a ragged edge results. In many places the different layers of the transparency will then become separated so that their individual colors show, revealing only three: magenta, yellow, and cyan.

Complementary colors

In our first experiment with colored light beams, each pair of (additive) primary colors produced a new color through overlapping ("addition"): red plus blue produced magenta; green plus blue produced cyan; red plus green produced yellow. If any of these "combination colors" (magenta, cyan, yellow) is added to that particular primary color (red, blue, green) which did *not* contribute to the combination color, the result will be white light.

As we have seen, as long as the three additive primaries, red, blue, and green, are present in approximately equal proportions, the end result will be white light. Consequently, if we combine three primaries, or one primary and that combination color which represents the sum of the other two primaries, the result will be the same. Any two such colors which, in combination, add up to produce white light form a "complementary-color pair." Such complementary-color pairs are, as we can now easily deduce,

> red and cyan (cyan is the mixture of blue and green)
> blue and yellow (yellow is the mixture of red and green)
> green and magenta (magenta is the mixture of red and blue)

The complementary color to any given color is that color which, when added to the given color, will produce white light. This principle of complementary colors is utilized, among others, in color filters since a filter transmits light in its own color and absorbs light in the corresponding complementary color; a yellow filter, for example, absorbs blue and transmits yellow, which, as we now know, is a mixture of red and green, *i.e.*, a yellow filter transmits yellow, red, and green. And when we work with negative color film, we produce in the color negative a picture that is made up of colors which are complementary to those of the actual subject. Subsequently, in printing, we again reverse the colors and produce a positive color print on paper the colors of which are complementary to those of the negative and therefore, at least theoretically, identical with those of the subject. (Note, however, that the overall orange tone of Kodacolor and Ektacolor negatives has nothing to do with the colors of the subject but is due to the presence of unused color couplers, which remain in the film after development and provide automatic masking for color correction.)

A note of clarification. It is a rather unfortunate fact that in speaking of color the term "primary colors" or "primaries" can have different meanings to different people. The following should clarify the situation:

The psychological primaries are: red, yellow, green, blue, white, black.

The additive primaries are: red, blue, green. These are the physicist's primaries and apply only to colored light. When superimposed in the form of colored light, they add up to make white.

The subtractive primaries are: magenta, yellow, cyan. These are the complementary colors to the additive primaries and apply to pigments and dyes. They might also be called "the modern color photographer's and engraver's primaries" since all *modern* photographic color processes and methods of photo-mechanical color reproduction are based upon these primaries.

The artist's primaries are: red, yellow, blue, white, black. These primaries apply to pigments and paints but are really not true primaries since, unlike the subtractive primaries, they don't combine to form a multitude of other colors unless the red is modified to become purplish red, or *magenta*, and the blue to become blue-green, or *cyan*. In other words, the so-called artist's primaries are in fact identical with the psychological primaries except that they don't include green, which artists don't consider a "pure" color because they can produce it by mixing yellow and blue. The artist's "primaries" are called primaries only because they represent apparently "pure" colors that are uncontaminated by other hues.

Summing up our findings in diagrammatic form we arrive at the following picture:

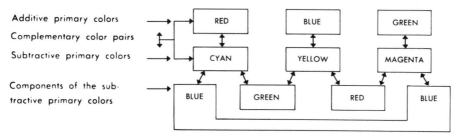

The terminology of color

If we want to be scientifically correct, we must attribute color not to an object itself, but only to the light reflected from that object. Remember that in red light a white object appears red, and that color appears different in artificial light than it does in daylight.

However, it is both customary and practical to speak of the "surface color" of objects. In that case, of course, it is usually understood that the object colors are described as they appear in white light, the standard of which is "daylight," *i.e.*, a combination of sunlight and light reflected from a clear blue sky with some white clouds. Otherwise, color cannot be described in definite terms, since any change in the color of the light by which such color is observed would make a definite description meaningless.

p. 243

To describe a specific color, three different qualities must be considered. In the terminology of the Optical Society of America (OSA), the standard terms for these qualities are hue, saturation, and brightness.

Hue is the scientific counterpart for the popular word "color." Red, yellow, green, and blue are the major hues; orange, blue-green, and violet are secondary hues. Hue is the most noticeable quality of color; it is the factor that makes it possible to describe a color in terms of wave lengths of light (the ICI System is based upon this concept). Under the most favorable conditions, the eye can distinguish about two hundred different hues.

p. 288

Saturation is the measure of the purity of a color. It indicates the amount of hue a color contains. The more highly saturated a color is, the stronger, more brilliant, and vivid it appears. Conversely, the lower its saturation, the closer a color approaches neutral gray.

Brightness is the measure of the lightness or darkness of a color. In this respect, brightness corresponds to a gray scale in black-and-white photography, light colors rating high on the brightness scale, dark colors rating low.

Unfortunately, in popular language, the meaning of the term "bright" often differs markedly from its color-technical definition. A "fire-engine red," which commonly would be called bright, actually does not rate very high on the color technician's brightness scale. On the other hand, a grayish pink is, scientifically speaking, a bright red of low saturation, while popularly, this same color would probably be called dull.

Besides these three terms, two other terms are frequently encountered in color specifications (these terms are used in the Munsell System, see further below):

Chroma. This term corresponds essentially to "saturation" as defined above.

Value. This term corresponds essentially to "brightness" as defined above.

284

Systems of color specification

The number of different colors is so great that the names of the various hues, even in combination (for example, blue-green), or in conjunction with qualifying adjectives such as "light," "medium," "dark," "pale," etc., are inadequate to describe accurately a specific shade of color. To reach a higher degree of accuracy, popular language has coined a number of qualifying terms such as "cherry red," "chartreuse," "champagne-colored," "rust-colored," "auburn," "moss green," "sea green," "Kerry blue," "navy" and "royal blue," etc. However, all these terms are vague and generally unsatisfactory because they do not describe color in reference to a definite set of standards.

To satisfy the general need for an orderly classification of color, which in the case of manufacturers and users of pigments, paints, dyes, and inks amounts to a vital necessity, several systems of color specification have been developed. In the United States, the most important are the Munsell System and the ICI (International Committee on Illumination) System. Even though familiarity with these systems does not contribute appreciably to becoming a better color photographer, the author feels that these systems are of sufficient interest to anyone concerned with color to merit a brief description in this text.

Since color can be described in three terms, a three-dimensional system of color arrangement in which hue, saturation (chroma), and brightness (value) are plotted along the three coordinates can easily be visualized. Two such systems, based upon the concept of a "color solid," are the Ostwald System in Germany, and the Munsell System in the United States.

The Munsell System. Imagine an orderly progression of color from red through orange, yellow, green-yellow, green, blue-green, blue, purple-blue, purple, red-purple, and back to red again, arranged in the form of a circle. Through the center of this circle, imagine a vertical black-to-white axis, similar to a vertical gray scale with black at the bottom and white at the top. Finally, imagine flat planes radiating from this axis through each of the different colors, like the pages of an open book in vertical position whose covers have been doubled back until both sides are in contact.

This, in principle, is the arrangement of the Munsell System, in which hue varies with position around the axis, chroma (saturation) varies with distance from the axis, and value (brightness) varies with position along the axis, as shown in the following drawing.

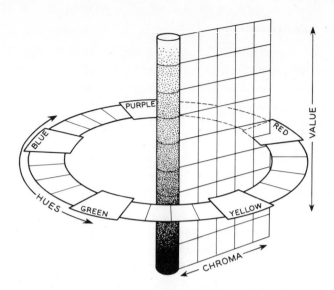

This drawing is incomplete insofar as, for purposes of clarity, only one of the vertical planes is shown. Actually, there is a separate plane for every hue in the color circle. Each one of these planes represents a color chart on which swatches of actual color are arranged in such a way that value (brightness) increases from very dark at the bottom to very light at the top; and chroma (saturation) increases with distance from the axis from zero (i.e., achromatic gray) to the highest attainable saturation at the outer edge of the chart.

The Munsell System classifies color according to ten *major hues*, which are subdivided into the five *principal hues*, red, yellow, green, blue, purple; and the five *intermediate hues*, yellow-red, green-yellow, blue-green, purple-blue, red-purple. The total number of hues in the circle is one hundred.

Within the individual color charts, value (brightness) is divided into eleven sections, starting with zero at the bottom (0 percent reflectance, i.e., theoretically perfect black) to 10 at the top (100 percent reflectance, i.e., theoretically perfect white). In between, numbered from 1 to 9, steps of intermediate values (brightness) are arranged in the form of actual color samples. These color samples are chosen visually in such a way that the whole series from 1 to 9 appears equidistantly spaced, i.e., lightness appears to increase in equal steps. However, this is only a visual phenomenon. Brightness values, in order to appear to increase evenly, must be spaced so that each consecutive step in the progression has roughly twice the value of the preceding step, in accordance with a progression of 1-2-4-8-16-32,

etc. If brightness values are spaced evenly, *i.e.*, in accordance with a progression of 1-2-3-4-5-6-7-8, etc., they would not appear evenly spaced to the eye. As a result of this peculiarity of vision, the gray halfway between black and white along the axis of the color solid, which to the eye appears midway between black and white, does *not* have a reflectance of 50 percent as one might assume, but of approximately 18 percent. This fact, incidentally, is the reason why the Kodak Neutral Test Card has been given a gray tone that reflects approximately 18 percent of the incident light.

The steps of chroma (saturation) on each color chart are chosen in a similar way. They also appear to be equidistantly spaced, increasing in purity along a horizontal line from zero (which is a neutral gray along the vertical axis of the color solid) to a highest number of 16 at the outer edge of the chart. However, since chroma depends to a high degree upon value, and to some extent upon hue, many of the outer spaces in the chromatic progression remain empty since it is not possible to produce colors with the necessary degree of purity to fill these spaces. For example, the highest chroma of red is 14 on the Munsell Scale, whereas the highest chroma of blue-green is only 6.

The particular arrangement of colors in the Munsell System makes it easy to identify each of the represented colors samples by means of a simple combination of letters and numbers. The sequence of hue, value, and chroma is H V/C. A specific green, for example, might be identified as G 5/4. Colors that are not represented by actual samples in this system can be identified by intermediate numbers.

The advantage of the Munsell System lies in the fact that it is based upon actual samples of color, arranged in a form which is derived from our own mental or psychological concepts of color in terms of hue, brightness, and saturation. One glance at these color samples shows how variations in brightness or saturation affect the appearance of any color, and colors can be matched simply by comparing one sample with another.

However, there are disadvantages. This system applies only to a single type of surface—the surface of matte paper—and color on a slick surface can appear very different from color on such a dull surface. Furthermore, the spectral composition of color printed on paper is unique and consequently not suitable for comparison with other types of spectral composition. For example, it would be rather difficult, if not impossible, to match accurately a color in a stained-glass window with one of the samples in the *Munsell Book of Color*. And finally, since the represented samples are chosen on a visual basis, merely reading a specific color notation

such as the G 5/4 mentioned above does not enable a person to visualize or reconstruct the appearance of this color if he does not have a Munsell sample book at hand.

To overcome these disadvantages, several other systems of color specification have been developed, of which the ICI System recommended by the International Commission on Illumination is the one which has been most widely accepted.

The ICI System. In contrast to the Munsell System, which is based upon the psychological concept of hue, value, and chroma, the ICI System is based upon the physical standards of *dominant wave length, excitation purity,* and *luminous intensity.* Since these standards are internationally accepted, specifications can be universally understood, their meaning not being subject to a number of subjective and different interpretations.

The ICI System is based upon measured data according to which colors can be matched by mixing proper proportions of the three additive primaries red, green, and blue. According to this system, a given color is specified in terms of the amounts of each of these primaries which, in mixture, will produce a color that matches the color in question. To insure complete accuracy, all the factors involved in taking the necessary measurements are strictly standardized. The results obtained are plotted in what is called a "chromaticity diagram," or the ICI Diagram. Such a diagram is shown in the following drawing.

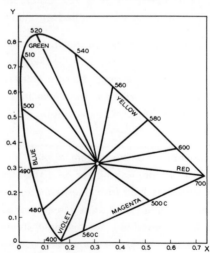

In this diagram, the horseshoe-shaped curve indicates the positions of the pure

spectral colors, some of which are named here and identified by their wave lengths in millimicrons. The straight line connecting the open ends of the horseshoe indicates the positions of the purples and magentas. Since these colors do not occur in the spectrum, they are expressed in terms of the wave lengths of their complementaries in the greens and blue-greens. The point near the center indicates the position of the standard light-source, or of any neutral gray. p. 220

To specify a color in terms of the ICI System, its spectral reflectance curve is determined with the aid of a spectrophotometer. By simple mathematics, this curve is then translated into values of x and y and plotted on the chromaticity diagram. The purer the color, i.e., the higher its degree of saturation, the closer its position will be to the boundary in the diagram; conversely, the lower its degree of saturation, i.e., the more diluted with gray, the closer its position will be to the neutral point.

In the ICI Diagram, the given color appears positioned in relationship to all the colors. However, being a two-dimensional representation of color, this type of diagram indicates only two of a color's qualities: hue and saturation.

Hue is specified in terms of the *dominant wave length*. To find the dominant wave length, the point of position of the color in the diagram is connected with the neutral point by a straight line. This line is then extended until it intersects with the horseshoe-shaped boundary line of the diagram. The wave length which is represented by this point of intersection of the two lines is the dominant wave length for the color in question. If this color happens to belong to the magentas or purples (which, since they do not occur in the spectrum, do not have a wave length of their own), the line connecting color position and neutral point is extended beyond the neutral point until it meets the horseshoe-shaped boundary line. In such a case, hue is specified in terms of the wave lengths of its complementary in the greens or blue-greens.

Saturation (purity) is expressed in percent. White, gray, and black have 0-percent purity (represented in the diagram by the position of the neutral point). Spectral colors have 100-percent purity (represented in the diagram by all the points along the horseshoe-shaped boundary line). The percentage of the purity of any given color represented in the diagram is found by dividing the distance from the neutral point to the position of the given color by the total distance from the neutral point to the spectrum line (the point of the dominant wave length of the particular color in question). The result is expressed in percent and is called the *excitation purity* of the respective color.

Brightness, as previously mentioned, cannot be plotted directly in the ICI Diagram. It must be measured separately, and is expressed in terms of *luminous reflectance* or *luminous transmittance*. The established value for the luminous reflectance (or transmittance) of a given color sample, which theoretically can be anywhere from 0 to 100 percent, is then noted in the chromaticity diagram beside the position of the color in question. Thus colors which differ only with regard to their brightness plot in the same position in the ICI Diagram and are distinguished only by the figures which indicate their respective luminous reflectance or transmittance.

The nature of color perception

Up to now we have studied color from the viewpoint of the physicist. We have learned that color is light and that light is a form of energy. We have examined the different forms which this energy can take; how it is produced and modified; and how it can be measured in terms of wave length and millimicron; hue, value, and chroma; dominant wave length, excitation purity, and luminous reflectance or transmission. We have acquired knowledge which will prove itself invaluable when the time arrives to execute technically a color photograph. But we still have no satisfactory explanation of why eye and color film differ so often in their response to color.

The answer to this question is just as important to the creation of effective color photographs as, for example, the color of the incident light is to the quality of color rendition in the transparency. After all, color is as much a psychological factor as it is a physical quality; and color photography, like any other work of a creative nature, is a mixture of technique and art. The impact of a color transparency is as much dependent upon the psychological effect of its colors as it is upon the skill with which these colors are rendered. We have studied color quantitatively and have acquired a basic understanding of the physical aspects of color. To be able to put this knowledge to practical and creative use, we must now investigate the physiological and psychological aspects of color—we must study color qualitatively. To do this we must begin at the beginning, with the eye.

The eye

If I were to tell you that your eye is so sensitive that it can distinguish millionths of an inch, would you believe me? And yet, it is true. Color vision in most people is so acute that they can distinguish between colors whose wave lengths differ by as little as one-millionth of an inch. As a result, the normal human eye can perceive close to a hundred and fifty different hues, many of which may appear in more

than a hundred different stages of saturation, each stage in turn manifesting itself in over a hundred variations from very light to very dark. All in all, the number of different colors, shades, and tones which we can see probably exceeds one million.

The evolution of the eye. It probably began with a light-sensitive "eyespot" similar to the one still found today in certain unicellular forms of life which, half-way between animal and plant, depend upon sunlight to synthesize their food.

The next step may have been a light-sensitive patch upon the skin of a form of worm burrowing along the shore of a primeval sea to which sunlight meant desiccation and death; a group of light-sensitive cells enabled it to turn back into the damp protective ground. Those that had such light-sensors survived; those that didn't, eventually died out.

Improvement slowly followed. A layer of pigmentation developed beneath the light-sensitive patch to utilize more effectively the stimulus of light.

As a second step, for increased protection, this improved light-sensitive patch began to recede below the surface of the skin and formed a depression lined with light-sensitive cells. As a result, this primitive "eye" enabled its owner—a sea snail—to tell in a reasonably effective way the direction of the light.

Gradually, in the course of eons, the light-sensitive depression deepened and its shape became more spherical. The edges of the depression began to close in toward the middle until only a tiny opening in the center was left. Not only was such a "pinhole eye" relatively well protected, but it could also, in a blurred way, distinguish shapes and forms. The "inventor" was a nautilus, a mollusk living in the warm Devonian seas. The time was half a billion years ago.

In the beginning, life was confined to the oceans. It did not matter then that the precious pinhole eye was open since there was no dust to clog and damage it. But as the primeval seas receded, life began to invade the land, and the eye needed further protection. A land snail made the next "invention" by covering its pinhole with a transparent skin.

Slowly, over millions of years, this transparent skin grew thicker, began to curve, and eventually developed into a lens capable of focusing an image upon the light-sensitive cells at the bottom of the eye. Some mollusks, ancestors of our squids, improved this already quite efficient type of eye and further refined it by recessing the "lens" and protecting it with a separate layer of transparent skin.

This was the prototype of our "modern" eye. Like Daguerre's "camera obscura,"

which, despite all its crudeness, at least in principle contained all the basic elements of today's most modern cameras, so these crude eyes of prehistoric squids also, at least in essence, contained the elements of the human eye.

How we see. In terms of the camera, the human eye has a four-element zoom lens with a focal length that varies from about 19- to 21-mm, giving it a focusing range from approximately 8 inches to infinity. Focusing is accomplished with the aid of delicate muscles attached to one of the elements which change the shape of the lens instead of the distance between lens and "film," here, the retina. The "speed" of this lens is about f/2.5, but a built-in "automatic" diaphragm, the iris, stops down the lens as needed in accordance with the brightness of the incident light, reaching its minimum aperture at about f/11. As far as total vision is concerned, the angle of view of the eye is close to 180 degrees but, since the "quality" of its lens is rather poor, it suffers badly from sharpness fall-off toward the edges; as a result, we see sharply only those objects that are at or near the center of our field of vision. However, similar to a photographic lens, the lens of the eye improves with stopping down and, in bright light with the iris aperture decreased, we see considerably better than in dim light when the iris is "wide open."

The image formed by the lens of the eye falls upon the retina, which corresponds to the film in the camera. The retina consists of millions of tightly packed nerve endings which, like microscopic photo-electric cells, transform light impulses into electrical impulses. Two types of these light-sensitive cells exist which, in accordance with their shapes, are called cones and rods. The cones, of which there are some 7 million in each eye, get more plentiful toward the center of the retina —the ½-mm-diameter *fovea*—which consists entirely of cones. The cones, characterized by high resolution but comparatively low light-sensitivity, function only in relatively bright light and enable us to distinguish fine detail and perceive color. The rods, of which there are some 170 million in each eye, are more plentiful toward the edges of the retina and completely absent from the fovea; they are much more light-sensitive than the cones but believed to be insensitive to color, which they register only as brighter or darker shades of gray. The rods enable us to see when the light gets too dim for the cones to function and are particularly sensitive to movement. Thus in effect we have two different types of vision: day vision (phototopic vision), and night vision (scotopic vision).

Day vision. Cones and rods both function together. If we wish to resolve fine detail (reading), we must look directly at the thing we want to see clearly (central vision). In this way, the lens of the eye projects the image upon the fovea, which

consists entirely of cones, those light-sensitive cells whose function it is to resolve fine detail and to distinguish color. But when we cross the street and have to watch out for traffic, we rely mostly upon the rods which, though unable to produce sharp images, are particularly sensitive to movement and therefore enable us to notice approaching cars out of the corner of the eye (peripheral vision).

Night vision. Only the rods function. The cones don't work because of lack of light. As a result, nothing we see appears really sharp. Instead, objects seem blurred and indistinct. This general unsharpness is due to the fact that vision now is based entirely upon the rod-type cells, which are unable to resolve fine detail. As a further result, if we look directly at a small *faint* object it seems to disappear because its image then falls upon the fovea, and the fovea is not sensitive enough to respond to very faint light. This, incidentally, explains the fact that when we look directly at a faint star the image disappears, whereas if we look at it slightly from the corner of the eye, we see it fairly distinctly.

So far we have been dealing with facts. However, these facts comprise only what might be called the first phase of seeing. Much more complicated phenomena are involved. The following "explanation" seems to be supported by experimental evidence but remains unconfirmed by the dissecting microscope. This is what scientists believe occurs:

Color vision starts with the cones.* In order to explain the actual process of color vision it is assumed that three separate light-sensitive systems exist of which the retina forms only a part, whereas the remainder is situated somewhere within the fantastically complicated nerve circuits which connect the eye with the brain. Each of these three systems is supposed to be sensitive to one of the primaries, red, green, and blue. The sensation of color is assumed to be produced, in accordance with the laws of additive color mixture, through simultaneous, and unequal, stimulation of the receptors of these three color-sensitive systems. This hypothesis seems to be supported by the fact that we can "see yellow" although virtually no yellow-producing wave lengths are present to excite the color receptors of the eye.

Up to this point, seeing can be explained by this reasonably likely hypothesis. However, this hypothesis comprises only what might be called the second phase of seeing. To account completely for all the known effects, still other phenomena, belonging to a third phase, must be involved, and of the nature of these phe-

* This is known from the microscopic examination of animal eyes in conjunction with experiments with live animals which showed that animals having only the rod-type cells can distinguish only degrees of brightness but do not react to differences in color, whereas those that have both rods and cones also react to differences in color.

nomena we know nothing at all. In simplified form, here are the two main questions for which we have no answers:

As in any simple optical system, the image projected by the lens upon the retina is upside-down. This is a fact. Why, then, don't we see everything upside-down? Or do we, but without knowing it, *i.e.*, do we subconsciously correct this state of upside-downness, as clinical evidence based upon certain disturbances of the nervous system of the eye seems to indicate?

Radiant energy, of course, has no color. What, then, is that unfathomable, unimaginable process which, somewhere within the brain, converts electro-magnetic impulses into color-sensations, and makes us aware of color? How do these fantastically precise sensors operate which can distinguish between wave lengths only millionths of an inch apart?

Summing up, we realize that seeing is a fabulously complicated process of which we know nothing except the most rudimentary facts. These facts point to the existence of a system which operates at three different levels: the eye, the brain, and the mind. Of these, only the eye can be more or less satisfactorily explained in terms of optics (the lens), mechanics (the focusing mechanism and the operation of the iris), and chemistry (the "visual purple"—a fluid covering the retina which, through a continuous cycle of chemical destruction (bleaching) and reconstruction, contributes to the transformation of light impulses into nerve impulses).

The brain and the mind, however, are at present largely beyond our understanding. All we can say about them must be confined to vague generalizations which hardly describe anything and explain nothing at all. What we might say is that the brain, through its extension, the optical nerves, receives the impulses generated by the action of the visual purple and, somehow, converts them into—what? sensations?—which the mind (what is that?) interprets (how?) in terms of color.

Subjective seeing

The practice of comparing the eye to a camera has had an inhibiting effect upon a proper understanding of the fundamental differences between human and camera "seeing" in the larger sense of the word. This is so because this concept leaves out the fact that the camera-film combination represents a complete system whereas the eye-retina combination is only one part of a larger system, playing the subordinate role of a receiver of information which collects light impulses and relays them to the brain, where they are "processed" and interpreted in the light of such diverse factors as memory, previous experience, mood, susceptibility, mo-

mentary interest and attention, fatigue, etc. The importance of these psychological factors alone should be sufficient to make it obvious that, despite the striking mechanical similarity between eye and camera, the phenomenon of human color perception must be very different from the process of photographic color reproduction, and that similarities must be confined to a very superficial level. Even if it were possible to develop a perfect color film which would reproduce color exactly, it would still be impossible to produce color transparencies or color prints that would appear "natural" no matter what the conditions under which they were made. For the basic difference which will always exist is the fact that the color film renders color objectively, whereas the eye sees color subjectively.

Adaptation to brightness

Everyone knows that the iris contracts in bright illumination and that, like the diaphragm of a lens, it regulates the amount of light that falls upon the retina. Less well known is the fact that the retina itself also has the ability to vary its sensitivity. In dim light, the sensitivity of the retina increases; in bright light, it decreases. As a result, within reasonable limits, we are able to see equally well, whether the light is bright or dim. Like a camera with only a single shutter speed, the scope of our vision would be quite limited without this very useful property which is called "brightness adaptation."

General brightness adaptation. We have all experienced the sudden effects of stepping out of the darkroom into bright light, and the necessary adaptation to the new level of brightness. And the opposite: of going from bright light into a dimly illuminated room in which we see at first almost nothing. And how our eyes adjust to the dimness, objects appear more clearly, and after a while the dim room seems nearly as bright as the brightly lit space from which we came. And every photographer who has had to load or unload film holders in improvised "darkrooms" knows that a closet which at first appeared completely black is actually "full of holes" and, within a few minutes, there is light enough to read the label on the film box.

In such instances, brightness adaptation occurs under circumstances which make it easy to recognize consciously the effect. However, at most times, brightness changes in the illumination occur gradually, and the eye adapts itself without our becoming aware of such changes. But even brightness changes which are great enough to be consciously noticed generally seem less serious than they actually are, because the eye adapts so well to different levels of illumination that the ease of seeing remains practically the same. As a result, levels of illumination which actually are very dif-

ferent may appear nearly or completely identical; and if a photographer were to guess an exposure, unless guided by previous experience he might easily make a serious mistake. Brightness adaptation of the eye is the factor which makes it

p. 135 advisable always to determine exposures with the aid of an exposure meter. This is particularly necessary in color photography in which accurate rendition of color can be expected only if exposure is within half a stop of "perfect."

Two other factors which further contribute to misjudgment of overall brightness are contrast and color saturation. As a rule, flat, contrastless lighting appears less bright than contrasty lighting although, in terms of overall brightness, the opposite may actually be true. And a scene containing mostly highly saturated colors appears brighter than a scene in which the colors are more diluted with gray, even though in the latter case illumination may actually be brighter. For example, a modern interior at night in which vivid colors are contrastily illuminated by electric light generally appears much brighter than an outdoor scene on an overcast day when contrast is low and colors are dull. But a check with an exposure meter would undoubtedly prove the outdoor scene to be several times as bright as the interior.

Local brightness adaptation. The same phenomenon of brightness adaptation also occurs on a local scale. For example, if we walk in a forest, our eyes constantly adjust to the brightness level of whatever spot we look at. If we look at a sunlit spot on the ground, the iris immediately contracts and the sensitivity of the retina decreases. And if we look at the dark bark of a tree trunk deep in the shade, the iris opens up and the sensitivity of the retina raises to its highest level. As a result, contrast as a whole appears lower than it actually is. But if we were to check its range with an exposure meter by taking readings of the brightest and darkest parts of the scene, we probably would find that actual contrast by far exceeds the contrast range of the color film.

Somewhat similar conditions prevail in portraiture. Familiarity with the normal appearance of a face, in conjunction with local brightness adaptation of the eye, frequently makes photographers overlook the fact that shadows around the eyes and mouth, beneath the nose and chin, and the brim of a hat, are actually so dark that subject contrast also considerably exceeds the contrast latitude of the color film. As a result, such shadows photograph too black and the portrait appears unnatural. Photographers who are aware of this phenomenon of brightness adaptation notice this effect *before* they make the exposure and decrease contrast

pp. 322, 324 with the aid of fill-in illumination.

Another frequently encountered mistake, underlighting of the background, is due to the same cause. Again, the eye adjusts its sensitivity in accordance with the respective brightness levels of subject and background, and actually great differences in intensity of illumination appear so small that corrective measures are not even considered. The only way to guard against such self-deception is to check the contrast range with an exposure meter.

Simultaneous brightness contrast. Most photographers know that a light subject appears even lighter if placed against a dark background; that dark subjects in a picture appear even darker when contrasted with white; and that a white border around a color print tends to make the adjoining light colors of the print appear muddy and dull. These phenomena are caused by "simultaneous brightness contrast." They can be explained as follows:

When we look at a bright object or area, the sensitivity of that part of the retina on which the image of the brightest object or area has been projected by the lens of the eye decreases. However, this decrease in sensitivity is not confined to the exact image area, but extends somewhat beyond its border into that part of the retina upon which the image of the adjacent darker area is projected. As a result of this decrease in sensitivity, a dark area next to a lighter one appears even darker, and a light area next to a dark one appears even lighter, than they actually are, as shown in the following drawing: although identical, the gray circles appear lighter or darker in accordance with the brightness of their surrounding areas.

Similar value changes through contrast also occur, of course, in the field of color. For example, a medium blue-green by itself may seem to have a specific ar 1 unalterable quality. However, by performing the following experiment, anyone can easily prove that, as far as the psychological effect of this or any other color

is concerned, this is not the case. Purchase an assortment of papers in the colors yellow, blue-green, dark green, green, blue, and black from an artist's supply shop. Cut a square from a blue-green paper and place it successively in the middle of each of the colored papers. Observe how its color seems to change in quality, particularly in regard to hue and brightness. Against yellow, the blue-green will appear considerably darker than if placed against the dark green. Against green, it will appear bluish; against blue, it will appear much more green. Against white, it will appear much duller than it will look if placed against black, where it will appear vivid and bright.

Brightness constancy. Without realizing it, we constantly deceive ourselves in regard to the actual brightness of objects. For example, a white object will appear white under almost any circumstances, even if it is in the shade and its actual brightness only equivalent to a medium gray. Similarly, many familiar objects, and particularly the faces of people, appear in more or less constant brightness regardless of the actual intensity of the illumination.

Brightness constancy, *i.e.,* the tendency to see familiar objects and colors in terms of brightness as remembered (*i.e.,* reflective power) rather than in terms of actual brightness (*i.e.,* effective reflection at the moment of observation) is one of the main causes for overcontrasty color photographs due to uneven illumination. Particularly in an interior shot, familiarity with its colors and the actual brightness values of the scene tends to dull a photographer's critical faculties and, being unaware of this, makes him rely on memory rather than observation when he arranges his illumination. Once again, that a checkup of the actual brightness of different parts of the scene with particular consideration of dark-colored objects, or areas that are remote from the light or windows, and the background, is of the highest importance to the successful outcome of the transparency can hardly be sufficiently stressed.

Adaptation to color

As might be expected, the eye reacts subjectively not only to brightness, but also to saturation and hue. As a result, unfortunately, we constantly see color the way we think it ought to be, and NOT as it actually is, and as it is rendered by the color film.

General color adaptation. Unless the illuminating light source is definitely and strongly colored, the eye adapts its color sensitivity in such a way that it sees a scene as if it were illuminated by white light. As a result, object colors appear as

remembered, *i.e.*, as they would appear in average sunlight. In this way, objects seem more familiar and more easily recognizable than if their appearance were constantly changing in accordance with the color of the incident light.

While brightness adaptation must be considered the most common indirect cause of overcontrasty and underexposed color photographs, "color adaptation" is usually to blame for color that in the transparency seems distorted by a color cast. However, whereas the pitfalls of brightness adaptation can easily be avoided with the aid of an exposure meter and, if necessary, corrected with the aid of fill-in illumination, the dangers resulting from color adaptation are much more difficult to avoid. If the cause of the color distortion is due to a colored light-source, a checkup with a color-temperature meter might conceivably lead to its detection; in that case, correction with the aid of the proper filter is usually not difficult. But pp. 226-229 if the color cast is caused by light other than that emanating from an incandescent source (for example, fluorescent light), or by light which is colored by filtering pp. 40, 241 (through window glass, green leaves, etc.) or by reflections from colored objects (a brick wall, colored walls in a room, etc.), the color-temperature meter is useless. In such cases, only an awareness of the problem followed by a close inspection of the purity of subject colors can prevent a distorted rendition of color in the transparency.

The classic example of unsatisfactory color rendition due to color adaptation of the eye is, of course, the case of the color portrait taken in the shade of a big tree. Skillfully utilizing the softly diffused, beautifully modeling light, the photographer apparently had reason to expect a particularly successful transparency. But look what happened: instead of the natural-appearing portrait he anticipated, he got the picture of a face in which a healthy tan was transformed into a greenish color cast that made his lovely model look more like a seasick person than the radiant girl he knew. What happened?

What happened was this: Owing to the presence of large amounts of green light reflected and filtered by the foliage of the tree, and blue light reflected from the sky, at the moment of exposure the face *actually* was just as it later appeared in the color shot. However, on seeing the transparency, the photographer refused to accept its colors as "true" because his "color memory" held an entirely different conception. In most people, color perception is not developed to such a degree that they *consciously* notice minor aberrations from the memorized "normal" colors of familiar objects. As a result, they judge color by memory rather than by eye. And if actual colors differ from the norm—which automatically hap-

pens when the illumination is not "pure white" (green reflected from the foliage, blue reflected from the sky)—they fail to notice the resulting color distortion. Color film, however, renders color shades, at least theoretically, more or less as they are. Whenever a correctly exposed and processed color photograph strikes us as unnatural because its colors appear distorted, it is usually *not* the fault of the color film but that of our own persistent color memory which prevented us from seeing colors as they are in reality. To return to the example given: the conclusion we are forced to draw is that, in color photography, a rendition may be rejected as "unnatural" *precisely because its colors are true.*

That even a reasonably experienced color photographer is not immune to misjudging the color of the existing light is illustrated by the following experience of the author during an assignment in the United Nations Building in New York. It was a rainy day, and the illumination came from an overcast gray sky. Two sides of the building consist entirely of greenish glass, as a result of which the light inside the building is pale green. However, the eye adapts so completely to this greenish light that, within a few minutes, the colors of the interior, its white walls, and the faces of people appear normal.

Entering a large room with white walls, I noticed that through one of the windows the sky did not appear gray (as it appeared through the other windows although I knew that it actually ought to look pale green), but a very vivid pink. I couldn't imagine why one of the windowpanes should be pink, so I investigated. Imagine my surprise when I found that there was no windowpane! For some reason, the glass was missing, and through the empty frame the sky looked *pink*—not a pale grayish pink, but a pink so strong that it could almost be called a magenta! Why? Because of color adaptation. My eyes had completely adjusted to the prevailing greenish light of the interior which by now seemed white, and when suddenly confronted with a neutral gray (which was the actual color of the sky), they reacted by seeing it in the complementary to green, which is magenta. The same experience, of course, happened to me upon leaving the building. My eyes were still adapted to the greenish light of the interior, and when I opened the door and stepped into the street, the sky and the city beneath seemed bathed in beautiful pink.

To convince himself of the degree to which the eye can adapt to colored light and still regard it as white, the reader might perform the following experiment: Take p. 36 a few light-balancing or color-compensating filters in pale shades and, for half a minute at a time, look through them at the view outside the window. Of course,

300

at a first glance through, for example, a pale blue filter, everything appears slightly blue. However, within a very short time, the eye will adapt itself to the bluish light and object colors will appear once more as if the light were white. Then, put the filter down, and everything will look decidedly yellow-pink—the complementary to pale blue—and it will take a little time before the eye is back to normal again and sees color as if the light were white.

Conversely, observed through a pink filter, at first everything seems bathed in rosy light. But quickly the eye adapts itself to this new light, and the colors of the view appear normal. But when you put the filter down, you will be surprised to see that suddenly everything looks blue; however, it will take your eye no more than a few moments before it sees color again as if the light were white.

Approximate color constancy. Color memory or, as it is scientifically called, "approximate color constancy," causes us to see color as we think it should look, not as it actually is. For example, because we *know* that snow is white, we see it as white at all times, even in the open shade where it might be strongly blue because it is illuminated only by blue skylight, or late in the afternoon when it is rosy in the light reflected from a reddish sunset sky. Similarly, because we have definite conceptions of the color of human skin, we expect to see the skin of people in color photographs rendered in a certain way; otherwise, we are likely to reject the picture as "unnatural," no matter how accurately it may actually represent the skin tone as it appeared at the moment the picture was taken as, for example, in the case of the previously mentioned portrait made in the shade of a tree. p. 299

While the untrained eye consistently fails to notice the changes of color that constantly occur around us, painters have long been aware of this fact. In 1886, the French novelist Emile Zola, in his book *L'Oeuvre* (*The Masterpiece*), wrote about this conflict between actuality and appearance in a scene in which he describes the reaction of a young wife to the "impressionistic" paintings of her husband:

> And she would have been entirely won over by his largesse of color, if he had been willing to finish his work more, or if she had not been caught up short from time to time by a lilac-toned stretch of soil or a blue tree. One day when she dared to permit herself a word of criticism, on the subject of a poplar tree washed in azure, he took the trouble of making her verify this bluish tone in nature itself; yes, sure enough, the tree was blue! But in her heart she did not accept this; she condemned reality; it was not possible that nature should make trees blue. . . .*

In a similar way, color photography can open our eyes to the true nature of color. Often, in looking at a transparency, we are dismayed and think that a certain color could not possibly be true. But if we take the trouble to check the subject under conditions which are similar to those that prevailed at the moment of exposure we will find that all too often it is we who are mistaken. And learning from this we will become more observant, and more fully aware of the changing aspects of our ever-changing world.

The psychological effects of color

p. 299

To be effective, a color photograph must be efficacious. This may sound like a joke, but only as long as we don't try to answer the question: What is that elusive quality that makes a color photograph effective? Is it accuracy of color rendition, truthfulness? Not necessarily, as proved by the case of the portrait taken under a tree which was rejected precisely because its color was "true." Is it beauty? Perhaps— but can you give a simple yet meaningful definition of the concept of beauty? Is it surprise value? Sometimes yes, sometimes no, because a surprise can be unpleasant as well as pleasant. Shock value? Same comment. Even if we analyze specific color photographs and try to nail down that elusive quality that makes them "effective" we'll have trouble reaching valid conclusions because different people will react differently or, for that matter, may not react at all although we may feel strongly . . . which brings us back to where we started . . . efficacy . . . which is no help at all. . . .

However, we'll have better success if we tackle the problem from the other end and start with those qualities which are likely to lead to effective color photographs. Using this approach, we might arrive at the following conclusions:

We must begin by accepting as a fact that color is the most powerful quality of any picture. It is stronger than outline and form, stronger even than content and design. For example, in contemplating the picture of a green nude most people would comment first on the green before they comment on the nude; and the color photograph of a gory event has greater impact because the blood is red than a black-and-white rendition in which the blood is black. Consequently, a color photographer must give maximum attention to the colors which will appear in his pictures and, as far as possible, choose colors for their associate values. He can do this in three ways:

He can choose his subject for its color. For example, a blond girl instead of a brunette; a pink sunset sky under which to shoot a certain landscape instead

302

of a sky that is blue; a white automobile instead of a red one (if choosing a white, or "colorless," subject for a color photograph seems strange to you, keep reading; you still have much to learn).

He can choose specific colors as supplementary picture elements. For example, a blue-green scarf; red shoes; a vase with yellow flowers; a pale gray background; a purple pillow; a deep blue sky.

He can choose the mood-setting color for a picture. For example, shoot in "warm" and golden sunset light instead of working with "cold" blue-white noontime light; change the color of the incident light by taking the picture through the appropriate light balancing or even color compensating filter; place colored gelatins in front of the photo lamps. p. 36

To be able to choose colors in accordance with the mood and meaning of his picture, a photographer must be familiar with the psychological effects of color. This, of course, is a vast, complex, and controversial field which I can touch upon here only briefly.

As we know by now, the three dimensions of color are hue (color), chroma (saturation), and value (brightness). Between these qualities, certain relationships exist which divide colors into groups. Each of these groups evokes specific psychological responses which can be used advantageously to produce specific effects. To examine the hereby-created possibilities let's start with the Munsell Color Wheel. p. 284

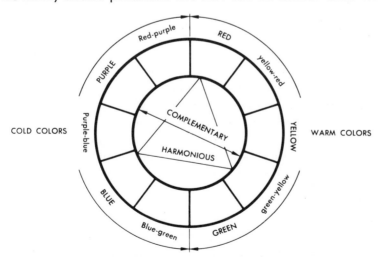

The Munsell Color Wheel is divided into five major hues: red, yellow, green, blue,

purple; and five intermediate hues: yellow-red, green-yellow, blue-green, purple-blue, red-purple. Although these are the only colors indicated in the above drawing, it must be understood that in the original Munsell Wheel each of them is further subdivided into ten hues so that the complete circle encompasses 100 different hues. The following relationships between these hues and groups of hues can be observed:

Complementary colors. Any two colors directly opposite on the color wheel
p. 282 form a complementary-color pair; for example, red and blue-green. Esthetically, complementary colors enhance one another and, similar to black if contrasted with white, make each other appear more brilliant—a red rose against a background of blue-green leaves makes a striking color composition. If a photographer wants to create maximum impact in the most direct way, his best chance is to use
p. 234 a color scheme based upon highly saturated complementary colors. The explanation of this fact lies in a phenomenon called the *afterimage,* something most of us have experienced at one time or another after having looked at a bright source of light, for example, the sun: closing our eyes, we immediately seem to see the light source floating in space against a dark background; but within a short time, the afterimage will reverse itself into the negative and we seem to see a blue-black sun against a lighter background. The first kind of afterimage is called "positive," the second "negative."

A similar phenomenon occurs when we look at a patch of strong color. For example, when we take a concentrated look at the picture of a red rose, our eyes adapt to the color "red," and if we now turn away quickly and look at a sheet of white paper we will see on it a "negative afterimage," *i.e.,* the picture of a blue-green rose—blue-green being the complementary color to red. Here is the explanation why any color appears more brilliant in juxtaposition to its complementary than when combined with any other color: when we look at any color, our eyes become prepared to "see" in the form of a negative afterimage its complementary color; hence, having looked at red, we are prepared to see blue-green, and if we actually see it in a color photograph, it appears more intense than it would have appeared had our eyes not been "sensitized" for this particular hue by having first looked at its complementary color.

Related colors. Colors that are neighbors on the color wheel, or groups of neigh-
p. 236 boring colors, are related to one another. For example, red, yellow-red (orange), and yellow are related because they share a common factor: they are "warm"
p. 237 colors. Similarly, blue-green, blue, and purple-blue are related by the fact that

(continued on p. 314)

Gray as color. This sophisticated picture by *Kay Harris* shows how gray can be used effectively to create a mood of serenity and, in contrast to its own neutrality, make color appear more colorful.

More on pp. 190, 315

Sophisticated color. A semi-abstract study by *Al Francekevich*. Its graphic impact brings to mind early works by Picasso. On the facing page, the photographer tells in his own words how he made this shot.

312

Gray as color. This sophisticated picture by *Kay Harris* shows how gray can be used effectively to create a mood of serenity and, in contrast to its own neutrality, make color appear more colorful.

More on pp. 190, 315

Black as color. In this photograph by *Al Francekevich*, powerful black, by virtue of its depth, enhances the luminosity of color. Used here as a frame, it also becomes an element of composition.

More on pp. 259, 315

White as color. Photograph by *Al Francekevich.* Whereas black makes color appear luminous, white, in contrast to its own lightness, makes color appear more saturated and deep, important, rich and powerful.

More on pp. 142, 315

Imaginative color. These two photographs by *Kay Harris* prove convincingly that color does not necessarily have to be natural or loud to be appealing. As a matter of fact, natural-appearing or loud colors are frequently boring because they are too common. On the other hand, imaginatively used color, creating surprise effects, can stimulate the viewer and give him new visual experiences like this girl's head suffused in mysterious blue, or the prism shot in subtle shades of pink.

More on pp. 191, 318

You always have a choice... Two views of Machu Picchu (© 1966 by Weston Kemp) illustrate dramatically how the same subject can be rendered in two totally different forms: above, photographed on Kodachrome II, the scene as it appeared to the eye; on the opposite page, as rendered on Kodak Ektachrome Infrared Aero Film. Should the latter version be condemned as "unnatural" merely because our eyes happen to see verdure as green instead of red? Or shouldn't we rather value the new experience provided by new photographic means?

More on pp. 204–207

Sophisticated color. A semi-abstract study by *Al Francekevich*. Its graphic impact brings to mind early works by Picasso. On the facing page, the photographer tells in his own words how he made this shot.

Color posterization, by Al Francekevich

The photograph on the facing page is an example of a technique that I call color posterization. My purpose in making this and similar photographs is to introduce pure bold colors in simplified forms. The colors are used arbitrarily. They are not related to the colors in the original subject. Just as in toning black-and-white prints, the photographer chooses the colors he wants.

The first step, using a black-and-white original negative (I have used color negatives and transparencies as well), is the making of a number of Kodalith positives. These are made by enlarging the original negative to the size of the final print. I try to produce at least three large line positives that look different from each other. In black-and-white, these are merely variations of exposure to produce light, medium, and dark line positives. If a color transparency or negative is used, you can either do the same thing on Pan Kodalith Film, or use highly selective color filters (No. 25—red, No. 58—green, and No. 47B—blue).

You now have a number of line positives (unless you started with a color transparency, in which case you now have negatives). These positives have to be spotted with opaque (Kodalith Film has pinholes in black areas) and then printed by contact on Kodalith Film to produce negatives. Again, spotting, etc.

The final step is contact printing the Kodalith negatives onto Color Key material. This material is a product of the 3M Company and is available from graphic arts supply houses and large art stores. Color Key is available in yellow, magenta, cyan, red, orange, brown, dark blue, black, and opaque white. It is also available in positive acting form, in fewer colors, and in opaque colors. I work principally with the normal negative acting colors.

Each sheet produces only one color. The various colored layers are assembled on a white paper base, and taped into place. This is the final print.

I have found it convenient to make as many Kodalith "separations" in the first darkroom step as possible. These and the contact printed negatives are kept together in one file folder. All of these variations are then available to me when I am printing the Color Keys. Usually I do not have a fixed idea of the color scheme or how simple or complex the final print will be. It's easier to make a decision not to use all the separations available than to lack them should I want to make a very complex print.

The illustration on the opposite page uses only three layers of Color Keys. The print consists of a white board, yellow tissue paper (this produces an overall yellow effect), a red color key made from a medium value separation, and a black color key made from a very light separation. The orange outline is made directly from the dark Kodalith positive, which was not used for the face. (Areas on a color key sheet can be removed by vigorous rubbing with the developer on a cotton pad.)

all three share the color blue; and so on. Compositions in related colors automatically acquire a unity and a feeling of "belonging" which is lacking in aggregates of unrelated colors. In addition, they exert a quiet and soothing effect upon the eye and mind—exactly the opposite from the active and exciting effect of compositions based upon complementary colors.

Harmonious colors. Any three colors connected within the circle by an equilateral triangle are said to be harmonious, which means they go well together, like the individual tones that form an accord in music.

p. 236 **Warm colors** are those that contain yellow: red, yellow-red (orange), yellow, green-yellow, green—one half of the color circle. The "warm" feeling which these colors evoke is probably due to associations with the sun, incandescent metal, or fire—all of which radiate heat and are also rich in light waves which create the sensation "yellow." In a color photograph, this feeling of "warmth" can usually be created, if necessary, by shooting the picture through the appropriate "warm-p. 227 up filter"—a Series 81 or CC-Y filter in the right density.

p. 227 **Cold colors** are those that contain blue: blue-green, blue, purple-blue, purple, red-purple—the other half of the color circle. The "cold" feeling which they evoke is probably due to the fact that blue is complementary to yellow and yellow-red—the "warmest" colors—and also to associations with "blue ice" and a deep blue, cold, northern sky. In a color photograph, the feeling of "coldness" can usually be created, if necessary, by shooting the picture through an appropriate "cooling-down filter"—a Series 82 or CC-B filter in the right density.

Highly saturated colors—colors undiluted by black, gray, or white—create vigorous and aggressive impressions, emphasizing strength and power, creating joyous and positive moods. These are the colors most easy to reproduce accurately on color film because even relatively large deviations will normally pass unnoticed. Underexposure by the equivalent of one-half f-stop accentuates the brilliance of highly saturated colors in the transparency.

Pale colors and pastel shades—colors highly diluted by white or gray—are particularly suitable for the creation of sophisticated and delicate effects and to suggest more pensive and languid moods. These are the colors most difficult to reproduce accurately on color film since even the slightest deviation will cause a noticeable change. Overexposure by the equivalent of one-half to one and one-half f-stop decreases color saturation and may be used for the creation of pastel color shades in the transparency.

314

Color monochromes are color photographs that consist largely of one color in different shades of chroma and value, like the different color samples on a single card of a Munsell color solid. Telephotographs in color, for example, often turn out virtual monochromes in blue. But whereas such monochromes are usually disappointing due to lack of contrast, color monochromes that are skillfully arranged and controlled—for example, in fashion photography—can be extremely striking, particularly if additional contrast is introduced into the color scheme by incorporating black and white.

p. 238

p. 285

Black and white play an important role in color photography. They enable a photographer to give his picture a high-contrast effect without having to pay the penalty in the form of light colors that are overexposed and dark colors that are underexposed; since contrast is now provided by black and white, the photographer can limit his colors to those of medium brightness. And because it is impossible to underexpose black or overexpose white, exposure can be calculated accurately for best possible rendition of color. White, incidentally, is the "color" most difficult to reproduce accurately in a color photograph since even the slightest suggestion of a color tint destroys the impression of "whiteness."

pp. 306, 307

Color by association. Many colors have specific connotations which sometimes can be used to give a color photograph additional impact and significance. For example, red is the most aggressive and advancing color of the spectrum, active, exciting, and therefore widely used for advertisements, book jackets, and posters.

Red suggests blood and flames and is associated with danger (warning signals are usually red). It is also the symbol of revolution, violence, and virility (we speak of a "red-hot" temper and "red-blooded Americans").

Blue, at the opposite end of the spectrum from red, is the most passive and receding of all colors, restful, remote, and "cool." We speak of a "blue" mood, and the French have their *l'heure bleue,* the blue hour of dusk, a time of relaxation. One has "the blues"—one feels low, the opposite of excited, as in "He saw red."

Yellow has two connotations: it is associated with pleasant feelings—the sun, warmth, cheerfulness, and spring (yellow baby chicks and daffodils)—but also suggests cowardice and disease (someone is said to have "a yellow streak," he is "yellow-bellied"; the yellow flag of quarantine, the yellow color of a sick face).

Orange, the color between yellow and red, is "hot," somewhat less hot in feeling than red but hotter than yellow, which is only a "warm" color. Orange brings

to mind pumpkins, witches, and our celebrations of Thanksgiving and Halloween.

Brown suggests earthiness and the soil, autumn and falling leaves, tranquility, serenity, and middle age; someone is in "a brown study."

Green, the dominant color of nature, is the least "artificial" of all colors. It seems neither aggressive nor passive, neither hot nor cold, neither advancing nor receding; it is neutral without being dull.

Violet is either mildly active or passive depending on its red or blue content: as purple (high red content) it is often associated with the Roman Catholic Church and royalty; as lavender (high blue content) it makes us think of old ladies.

White is the color of innocence, and **black** is the color of death.

Three different approaches to color

Experienced photographers know that there are no infallible "rules" for the production of good color photographs; that the color experience is subjective and, consequently, what pleases one person may leave another cold; that "accurate" color rendition is not necessarily equivalent with "good" color photography; and that a picture may be rejected as "unnatural" precisely because its color is "true." However, although no single infallible approach to color photography exists, experience has shown that color rendition may be accepted as "good" for three different reasons:

> Color rendition *appears natural* but may not be accurate;
> color rendition *is accurate* but may not appear "natural";
> color rendition *is effective* but obviously "unnatural."

Color rendition appears natural but may not be accurate. Subject color in the transparency will appear natural if it matches the color of the subject "as remembered," which usually means as it appeared in standard daylight. In addition to correct exposure, the main prerequisite for a natural-appearing rendition is that the spectral composition of the illumination is identical with that of the light for which the respective color film is balanced. If it differs, the appropriate light-balancing or color-compensating filter must be used. If the color of the incident light is wrong in regard to the color film and a corrective filter is not used, or cannot be used, it is not possible to make a natural-appearing color rendition as defined above with positive (reversal) color film. If negative color film is used, however, the effects of fairly large deviations from the recommended illumination can be successfully corrected in printing.

pp. 298-302

p. 36

316

Light-sources which are strongly deficient in any part of the spectrum cannot be "corrected" with the aid of filters and made to yield "natural-appearing" color photographs; the most common are: mercury-vapor illumination, daylight after sunset, certain types of fluorescent lamps, mixtures of daylight and fluorescent light, and underwater light without auxiliary illumination.

To produce a natural-appearing transparency, it may become necessary to "falsify" subject color. As mentioned earlier, photographed in the shade of a large tree, a face, for example, would acquire a greenish tint. Although this color would be true to reality because it would match the color of the face at the moment of exposure, it must be corrected with the aid of a reddish color-compensating filter, i.e., *falsified,* to make the face appear as we remember it, i.e., as it would have appeared in "white" light. In this connection, it is interesting to note that most people prefer in a transparency, and deem more "natural," skin tones that are somewhat more yellowish than the actual pinkish or reddish tones of the original—further proof of the "subjectivity" of our way of seeing.

p. 299

p. 36

Whether or not a color photograph *appears* natural depends, of course, to a large extent on the personal judgment of the observer, and pictures that are accepted by one may be rejected by another. To the untrained eye, a shadow that is even slightly blue may seem "unnatural," and color renditions that experienced photographers, observant persons, and those with artistic training accept as natural may appear exaggerated and "false" to others.

Natural-appearing color rendition is particularly desirable in scientific and utilitarian photography, in copying, portraiture, and in photographing people.

Color rendition is accurate but may not appear "natural." Subject color in the transparency matches the color of the subject as it appeared at the time of the exposure. Example: the "green" face photographed in the shade of a large tree. This approach to color preserves the identity of the occasion by accurately reflecting the conditions which existed when the picture was made. It represents a welcome relief from the bore of standardized "natural-appearing" color and gives a better idea of the immense diversity in regard to light and color of our world.

p. 299

Accurate color rendition usually (but not infallibly) results if photographs in daylight and outdoors at night are made on daylight-type color film without benefit of filters of any kind, and indoor photographs in incandescent light on Type A or Type B color film, again without benefit of filters. However, as indicated above, because of the particular spectral response of color film, color rendition may not

always match accurately the colors of the subject as we saw them at the time of exposure. Occasionally, if a photographer feels that a slightly more natural-appearing color rendition would be in the best interest of the picture, he can use a filter which *partly* corrects the light and makes the subject appear somewhat less unusual yet still manages to preserve the typical character of the illumination, for example, the yellowish warmth of ordinary incandescent light.

Accurate color rendition is particularly desirable in documentary photography and reporting since it provides a factual basis for a more objective evaluation of the depicted subject or event.

p. 308 **Color rendition is effective** but obviously "unnatural." Subject color in the transparency is thought-provoking and significant although obviously neither natural-appearing nor accurate. As an example, I'd like to mention a picture I once saw, the color photograph of a snow scene in which the sky was a deep and velvety purple—a fantastic fairy landscape of the imagination that was enormously effective.

Whereas it is easy to lay down rules for natural-appearing color rendition and possible to give advice for accurate color rendition, it is hopeless to tell a photographer how to create *effective* color photographs that are beyond naturalness and accuracy without looking contrived or "gimmicky"—sorry examples of effect for effect's sake. However, the following suggestions might provide some starting points.

p 231 Shoot smack into the source of light and hope that the resulting flare and halation will produce patterns that effectively symbolize the intensity and brilliance of direct light.

p. 36 Use CC filters to change the color of the illumination in accordance with the spirit and mood of the subject or event. Usually such overall tints are most effective if they are subtle; the mood-creating color should be sensed rather than seen.

Use colored gelatins in front of photo lamps. Whereas a filter in front of the lens tints the entire photograph, filters in front of individual lamps (Roscoe Theatrical gels) enable a photographer, if necessary, to treat the illumination of different areas differently. The advantage of this method is that by limiting the effect of colored light to certain sections of the picture, natural-appearing and fantastic color can be used side by side. For example, the foreground of a scene might be rendered moody and blue, the middle distance "natural," and the background

318

rosy and gay. In this respect, the more white a subject or scene contains, the greater the potential of artificially colored light.

Combine different types of light. For example, in conjunction with daylight-type color film, use daylight (window light, or blue flash or blue photoflood illumination) and incandescent (tungsten) light together, but *do not mix* these different types of light. Instead, use each to illuminate its own section of the picture with the least possible overlap. Notice that one type of light appears blue and "cold," the other yellow and "warm." Use this difference between warm and cold color creatively, for example, to symbolize the "coldness" of outdoors (as seen through the windows) and contrast it with the warm and cozy feeling of the interior space.

Use actual colors (not only colored light) to symbolize mood and feelings. In motion pictures, Antonioni painted automobiles, buses, houses and entire sections of a street in strong colors to achieve specific effects. On a smaller scale—in the studio, at home, in a tabletop arrangement—anybody can do similar things. Or drape your model in brilliant colors, or subtle colors, as the case may demand . . . combine colors for harmonious—or clashing!—effects, invent, imagine, dream. . . . The field of creative photography is unlimited and offers exciting opportunities to anyone who dares to "break the rules."

CONTRAST

We have learned that satisfactory color rendition is possible only if the contrast p. 142 range of the subject does not exceed the contrast latitude of the color film. Therefore, just as important for the making of good color photographs as awareness of light and color, is awareness of contrast. Contrast is the difference in brightness between the lightest and darkest parts of the subject which, ideally, for perfect color rendition throughout the entire transparency, should not exceed the equivalent of 2 diaphragm stops although, in practice, a 4-stop span usually yields acceptable transparencies. On the Weston exposure-meter scale, a 2-stop span corresponds to the dial positions A and C. To utilize this valuable feature, instead of placing the arrow opposite the number that represents an integrated meter reading, *place the C-mark opposite the number that corresponds to the highest meter reading*, i.e., the value for the *brightest* area of the subject that still has color (i.e., is *not* white) or must show detail in the transparency. Subsequently, take a second meter reading of the darkest subject area that still has color (i.e., is *not* black) or must show detail in the transparency. If the corresponding number

falls on, or to the right of, the A-mark (with the C-mark remaining where you had set it), the contrast range of the scene does not exceed the contrast latitude of the color film and color rendition from the brightest to the darkest colors should be excellent. If contrast is too high and the photographer *cannot* control the contrast range of the subject, he must find the best compromise solution and expose

p. 143 his film in accordance with the instructions given before; if he *can* control his subject, he must know the following:

Subject contrast is the product of two factors: lighting ratio and reflectance ratio. For example, let's assume we have to photograph a painting illuminated by perfectly even light, perhaps outdoors in the sun. To check the *lighting ratio,* we must

p. 144 use a *gray card,* hold it flat against the painting in different places, and take meter readings which, in this particular case, will be identical: lighting ratio, *i.e.,* the ratio between the parts of the painting that received maximum and minimum illuminations, is 1 : 1 since lighting was assumed to be uniform, which means that all parts of the subject receive equal amounts of light.

However, if we take a second set of meter readings, this time *without* benefit of a gray card, by measuring directly the brightness of the lightest and darkest colors of the painting, the values which we'll get will, of course, be different, representing the reflectance ratio of the subject (that these will be *true* reflectance values was assured by our initial assumption that all parts of the subject received *equal* amounts of light). Let's assume that the highest reading is 2½ stops higher than the lowest, corresponding to a reflectance of 2½ : 1. Now, since subject contrast is the product of lighting ratio and reflectance ratio, in this case, since lighting ratio was 1 : 1, subject contrast would be 2½ : 1 which is still well within the practical (although not the ideal) limits for satisfactory color rendition.

If the subject is not flat but three-dimensional, matters are slightly more complicated since spatial characteristics introduce a new element—shadow—which, of course, influences the lighting ratio. As an example, let's discuss the situation as

pp. 166, 252 it applies to an indoor portrait that is to be made with the aid of two photo lamps *of equal wattage* (this is a "must" for our demonstration), a main light and a fill-in light. These lamps should be placed at *equal distances* from the subject: the main light at an angle of approximately 45 degrees to the subject-camera axis, and the fill-in light as close as possible to the camera.

Lighting ratio (this is the difference between the maximum and minimum amounts of light that illuminate the subject—the span from highlights to shadows). Under

the above assumed conditions, subject areas illuminated by *both* lamps receive *twice* the light that areas in the shadows cast by the main light receive which are illuminated by only *one* lamp, the fill-in light. Under these conditions, the lighting ratio is 2 : 1. In relation to the fill-in light, if the main light were placed at *half the distance* from the subject, it would throw *four times more light* on the subject than the fill-in light does, since the brightness of illumination is inversely proportional to the square of the distance between subject and light source. In such a case, the subject areas illuminated by *both* lamps would receive *five* units of illumination and the shadows still receive only *one;* consequently, in that case, the lighting ratio would be 5 : 1.

Reflectance ratio (this is the difference in brightness between the lightest and darkest colors of the *uniformly* illuminated subject). To establish the reflectance ratio, *uniformly* illuminate the entire subject with shadowless front light. Check the evenness of the illumination by taking meter readings off a Kodak Neutral Test Card held at different positions within the picture area and be sure that all the readings indicate the same value; if they don't, arrange the illumination accordingly. Then, *disregarding black and white,* measure the reflectance of the lightest and darkest subject colors with an exposure meter. Let us assume that you find a ratio of 4 : 1, *i.e.,* that the lightest color reflects four times as much light as the darkest. This ratio of 4 : 1 would represent the reflectance ratio of the subject. p. 144

Subject contrast (this is the product of lighting ratio and reflectance ratio). In our example, in which the lighting ratio was 2 : 1 and the reflectance ratio 4 : 1, the lightest colors of the subject, which are illuminated by both lamps, were 4 times as bright as the correspondingly illuminated darkest colors, and 2 x 4, or eight times as bright as the darkest-colored parts of the subject, which received their illumination only from the fill-in light. Therefore, the subject contrast ratio would be 8 : 1.

In color photography, for natural-appearing color rendition, the lighting ratio of subjects with average reflectance ratios should normally not exceed 3 : 1. However, if the subject reflectance ratio is lower than average, *i.e.,* if *all* the subject colors are *either* light, or medium, or dark, and therefore light and dark colors do not occur together, the lighting ratio can be increased to 6 : 1 without subject contrast exceeding the contrast latitude of the color film. In this respect, transparencies intended primarily for viewing and projection can stand a somewhat higher contrast ratio than transparencies from which prints or four-color engravings are to be made.

The f-stop substitution method. A simple way for calculating lighting contrast ratios in portraiture and other fields of near-distance photography in conjunction with a lighting scheme in which two identical photo lamps function as a main light and a fill-in light, respectively, is to think of lamp-to-subject distances in terms of f-stop numbers. This concept works because the inverse-square law (p. 221) applies equally to f-stop numbers and lamp-to-subject distances. For example, if the f-stop number is *doubled,* say, from f/4 to f/8, a photographer must expose at f/8 *four times* as long as at f/4 if the color rendition in both transparencies is to be the same. Similarly, if the subject-to-lamp distance is *doubled,* say, from 4 feet to 8 feet, exposure at 8 feet must be *four times* as long as at 4 feet if the color rendition in both transparencies is to be the same because at twice the subject distance the effective brightness of any (point-type) light source is only one-fourth. Accordingly, it is possible to establish specific lighting contrast ratios by thinking of the lamp-to-subject distances of the main light and the fill-in light in terms of f-stop numbers and comparing the differences. Utilizing this concept, we arrive at the following table:

Equality of f-stop numbers is equal to a 2 : 1 lighting contrast ratio
a 1-stop difference is equivalent to a 3 : 1 lighting contrast ratio
a 1½-stop difference is equivalent to a 4 : 1 lighting contrast ratio
a 2-stop difference is equivalent to a 5 : 1 lighting contrast ratio
a 2½-stop difference is equivalent to a 7 : 1 lighting contrast ratio

To give an example, let's go back to our first setup, in which main and fill-in lights were placed at equal distances from the subject, say, each 8 feet. Seen in terms of f-stop numbers, this would correspond to f/8 and f/8 for the two lights, *i.e.,* equality of f-stop numbers, corresponding to a lighting contrast ratio of 2 : 1 (which, of course, is the same value as that at which we originally arrived).

Next, let's see how well our second example in which we placed the main light at *half the distance* from the subject as the fill-in light fits in with our new formula. Half the distance of 8 feet is 4 feet or, seen in terms of f-stop numbers, equivalent to f/8 and f/4, a difference of two full stops (f/4—f/5.6—f/8). According to both the above table and our previous demonstrations, such a main light to fill-in light distance ratio corresponds to a lighting contrast ratio of 5 : 1. The same result would, of course, have been accomplished if the main light had been placed at a distance of 5.6 feet and the fill-in light at 11 feet, or 8 and 16 feet, respectively, or X and 2X feet—because in all these cases the difference in terms of f-stops would have been equivalent to two full stops.

Conversely, of course, any desired lighting contrast ratio can be established on the basis of the following table:

Desired lighting contrast ratio:	2 : 1	3 : 1	4 : 1	5 : 1	6 : 1
Fill-in light distance factor:	1	1.4	1.7	2	2.2

To establish the desired lighting contrast ratio, place the main light at the most advantageous distance from the subject. Multiply this distance in feet by the fill-in light factor which, according to the above table, corresponds to the desired lighting contrast ratio, and place the fill-in light at this distance from the subject, as close as possible to the subject-camera axis. Note, however, that both *these tables apply only if identical lamps in identical reflectors are used for the main light and the fill-in light,* whether they are photoflood lamps, flashbulbs, or electronic flash. Incidentally, this "f-stop substitution method" does not preclude the use of an accent light or a background light as described before since neither one has an effect upon the lighting contrast ratio of the subject.

pp. 253, 254

How to control contrast outdoors

In bright sunlight, the contrast range of nearby subjects frequently exceeds the contrast latitude of color film. To avoid the possibility of inky shadows and burned-out highlights, color photographers have three methods to reduce excessive contrast:

Front light. As mentioned before, frontlight casts proportionally less shadow than light from any other direction ("pure" frontlight—for example, light emitted by a ring-light, an electronic flash tube encircling the lens—is completely shadowless and therefore particularly well suited for shadow fill-in); consequently, frontlighted subjects *appear* generally less contrasty than side- or backlighted subjects—the reason manufacturers of color films generally recommend shooting color pictures "with the sun looking over your shoulder." Although this appearance is often illusory—contrast between illuminated and shaded areas may very well be just as great as in sidelighted views—the actual shadow areas are proportionally so small that they seem insignificant in comparison with the well-lighted areas of the subject, which can easily be rendered in natural-appearing color. Therefore, unless other considerations prevail—perspective, depth-illusion through light and shadow, need for good texture rendition, or simply the impossibility to shoot in frontlight—

p. 222

choosing frontlight instead of light from another direction is often the easiest way to satisfactory color rendition.

Reflectors. Complete contrast control of outdoor subjects at a distance up to 20 feet is possible with the aid of suitable reflectors which permit a photographer to lighten inky shadows with reflected sunlight. Unlike flash as a provider of fill-in light, reflectors have the great advantage that one can see the result *before* the picture is taken and, if necessary, make the appropriate adjustments in distance and direction which may be required to reduce contrast without eliminating it entirely—excessive shadow fill-in is the most common fault of pictures made with the aid of daylight-flash.

The most effective reflectors consist of a thin plywood board covered with crinkled aluminum foil; they should not be smaller than approximately 20 x 30 inches. But reflectors can consist of almost any white material (colored material would reflect colored light upon the subject and might cause a color cast)—white cardboard or paper, a bed sheet, a towel, a handkerchief, a whitewashed wall . . . and on the beach, of course, the clean sand; although sand is usually slightly colored, the warm yellowish light reflected by it will only enhance the warm glow of sun-tanned skin and provide excellent shadow fill-in.

Daylight-flash. Since the purpose of fill-in illumination is to bring subject contrast into balance with the contrast latitude of the color film, the flash intensity must be related to the brightness of the main light—oudoors: the sun. The problem is to lighten shadows sufficiently to bring out detail and color without destroying the effect of sunlight through overlighting the shadows. Fill-in illumination that is too strong obliterates all shadows, causes the subject to appear as flat as if only frontlight had been used and, since the range of the flash is limited and exposure adjusted for flash, often shows the subject unnaturally light in front of an un-naturally dark background.

There are many ways to arrive at a supposedly correct exposure since each photographer and textbook author seems to have his own ideas on how to proceed. Many, however, seem to forget that the light from the flash adds itself to the daylight that illuminates the subject, or advocate procedures that lead to overlighted shadows. In my opinion, the best way to consistently arrive at correctly exposed daylight-flash color photographs is to proceed like this:

Let's assume you are using Kodachrome II (ASA 25) and an electronic flash unit with a guide number of 80 for this particular film. Start by taking a close-up meter

reading of the subject. Since the shot is to be made by sunlight, you might get an exposure of 1/125 sec. at f/8. However, since your focal-plane shutter equipped camera doesn't X-synchronize at shutter speeds faster than 1/50 sec., you have to convert your data and arrive now at 1/50 sec. at f/11. Consequently, set your shutter speed at 1/50 sec. and your diaphragm aperture, NOT at f/11, *but* half-way between f/11 and f/16, to allow for the increase in subject brightness due to the flash.

Next, calculate the flash-required exposure on the basis of the guide number of your flash unit in conjunction with Kodachrome II. Guide number, according to our assumption, was 80, and the distance between subject and flash (at the camera) should be 6 feet. Guide number divided by flash-to-subject distance equals correct f-stop number: 80:6 = approximately 13, or f/13, *i.e.*, about halfway between f/11 and f/16.

However, you do not want a fully flash-exposed transparency—you only want to lighten the shadows to a certain extent, just enough to show some detail and color; besides, your subject is already fully illuminated by sunlight. Therefore, you must now *decrease* the calculated flash-required aperture by one full stop; here, from halfway between 11 and 16 to halfway between 16 and 22.

And now comes the problem: the correct exposure for the sunlit areas of subject and background was 1/50 sec. at f/13 (halfway between f/11 and f/16, re-member?), but your fill-in flash requires an exposure of 1/50 sec. at f/18 (*i.e.*, halfway between f/16 and f/22). How can you bridge this gap of one f-stop? You can do this by cutting down the brightness of the flash by an amount equiva-lent to one f-stop, and you do this with the aid of a translucent flash-shield.

To find the right kind of shield proceed as follows: collect a number of different translucent *colorless* materials like tracing paper, translucent acetate, translucent plastic, etc. Establish their light-transmittance with an exposure meter by first taking a meter reading of an ordinary window roller shade transluminated by the sun and making a note of the brightness value; then, *without changing the posi-tion of the exposure meter* in regard to the transluminated window shade, hold each sample of potential shielding material immediately in front of the meter cell and note the resulting drop in transmitted light. The point is to find a material that will cut down brightness by *exactly one-half f-stop* (and perhaps a second one that reduces the incident light by one full f-stop). Having found such materials, cut a few shields to the size of the reflector and prepare them so they can be at-tached in front of the flash either with tape or clips.

Now back to our example. As you will remember, there was a difference of one f-stop between the daylight and the flash fill-in exposures. You can now bridge this gap by placing shielding material equivalent to one f-stop in front of the flash—either two layers of the half-stop material, or one layer of the full-stop material. This will reduce the flash intensity from the original f/16-22 level to the actual shooting level of f/11-16. To check your calculations, make a few tests under different outdoor lighting conditions and at different subject-to-camera distances, using the shields which your exposure calculations demand. If you like the results, you can from then on shoot with confidence. Otherwise, you'll find it easy to make the necessary changes in your formula which, once established to your satisfaction, will continue to work indefinitely.

If all this sounds very complicated to you, rest assured—it isn't. Read this chapter twice, prepare your flash shields, make your tests, shoot a few pictures, and already the next time the whole procedure will seem routine.

SPACE AND DEPTH

Creating some kind of space illusion in a photograph is easy; creating *the right kind* of space illusion may require a little bit of work, and thought. Anybody who ever photographed a heroic landscape and ended up with a picture in which the grandeur of the scenery was lost; anybody who tried to convey the feeling of rush-hour traffic jamming a downtown street and found himself with a picture of six people blocking the view; anybody who attempted to capture the spatial experience of one of the great works of architecture and got only a picture of a building with leaning walls—they all know what I am talking about: although, when photographing a three-dimensional subject, it is impossible *not* to get some kind of space-impression in the picture, this chance-presented space-impression is frequently inadequate to tell the *whole story convincingly*. This is possible only if the photographer carefully and knowingly chooses those space symbols which are best suited for translating his intentions, his feelings, into graphically expressive forms. This is so because "depth" cannot be rendered directly within the two-dimensional plane of a photograph but can only be indicated symbolically. The symbol of depth is contrast between near and far; in terms of photography, this contrast can be expressed in several forms:

> contrast between **light and shadow;**
> contrast between **large and small;**
> contrast between **sharp and unsharp;**
> contrast between **light and dark.**

Contrast between light and shadow

Take any flat surface and hold it up to the sun, you'll find it impossible to destroy the "flatness" and evenness of the illumination or to cast a shadow on this surface without interposing a second object between surface and sun; but by this very act you already introduce an element of spatiality into the setup. What we can learn from this experiment is this: an even illumination suggests flatness and two-dimensionality; an uneven illumination—a combination of light and shadow—is graphic proof of three-dimensionality: depth, volume, space.

I have already discussed the function of light as a symbol for space and depth p. 252 but will add the following: Symbolically, light is positive, aggressive, advancing, and implies convexity; conversely, shadow is negative, passive, receding, and implies concavity.

The standard of light is the sun—a single light-source positioned overhead casting a single set of parallel shadows in the direction of the ground. Consequently, any lighting scheme employing multiple light-sources casting several sets of shadows pointing in different directions, as well as any light-source pointing upward and illuminating the subject from below, will *ipso facto* appear artificial and often also "unnatural." Such lighting schemes must therefore be used with particular discrimination and skill.

As a rule, predominance of shadow over light within the picture area creates a stronger spatial effect than the reverse. It is for this reason that backlighted photographs generally produce particularly strong impressions of depth. The explanation of this phenomenon probably goes back to the fact that uniformity of illumination suggests "flatness"—two-dimensionality, absence of depth; that shadows suggest three-dimensionality and depth; and that abundance of shadows is equated with abundance, *i.e.*, great extent, of depth.

Contrast between large and small

A nearby person appears larger than a person farther away, and a person very far away appears minute. It is this phenomenon called *diminution* which forms the basis of *perspective, i.e.*, the representation of three-dimensional objects with two-dimensional means.

The essence of perspective is *distortion*. Whatever we look at, and no matter how we look at it, with very few exceptions, we see things distorted. A nearby person appears larger than the same person farther away. Looking along a railroad track, the ties appear to diminish with distance and the rails seem to converge;

this also is distortion because, actually, all the ties are, of course, equally long and the rails are parallel. Seen at an angle or, as we say, "in perspective," a wheel appears elliptical and a window as a trapezoid; this too is distortion because, in reality, wheels are round and windows rectangular. And so on.

Now, some readers might object and maintain that, as far as they are concerned, most photographs appear distortion-free because they show things as they see them, and that "distortion" is a phenomenon restricted to pictures taken with the more extreme kinds of wide-angle lenses. They are wrong. Without exception, all renditions of three-dimensional objects by two-dimensional means are "distorted," and the difference between a "normal-appearing" picture and one in which objects appear "distorted" is only a difference of degree—some forms of perspective involve higher degrees of distortion than others.

p. 85
The explanation of why most photographs appear distortion-free is that they were made with lenses of standard focal lengths which, as far as "perspective" is concerned, produce images that closely resemble those produced by our own eyes. This, of course, does not imply that they are distortion-free—it merely means that we are so familiar with this particular form of distortion that we are no longer aware of it. A truly distortion-free rendition is possible only if the depicted subject is two-dimensional and flat, and if its position relative to the camera is such that it is parallel to the plane of the film. For example, photographed head-on, a painting or a stone wall not only will *appear* distortion-free, but also *be* distortion-free; right angles will be rendered as right angles, and parallel lines will be rendered parallel. But if parallelity between subject and film is disturbed, *i.e.*, if the photographer tilts or turns his camera and takes the picture "at an angle"—be it ever so slight—depth becomes involved and will manifest itself in the photograph in the form of distortion: right angles will no longer measure 90 degrees, and actually parallel lines will converge.

By now, two things should be obvious: (1) Only a two-dimensional and flat subject can ever be rendered distortion-free in a photograph, and only if it is parallel to the plane of the film. (2) Only one side of a three-dimensional subject can be rendered distortion-free in a photograph, and this only if it is flat and in such a position that it is parallel to the plane of the film; the other sides, seen "in perspective," *i.e.*, in terms of receding lines and planes, *must* appear distorted. However, the form which this distortion will take—the degree of diminution, the extent of foreshortening, and the angle of convergence of actually parallel lines—is subject to the photographer's control.

328

Rectilinear perspective.

When we speak of "perspective," we usually think of rectilinear perspective and not of cylindrical or spherical perspectives, two other forms which will be discussed later. Rectilinear perspective occurs in two forms, academic and true. Here are the rules of academic rectilinear perspective:

pp. 343-346

1. All straight lines must be rendered straight.

2. All two-dimenstional forms parallel to the plane of the film are rendered distortion-free. For example, parallels are rendered parallel, circles are rendered round, angles are rendered in their true forms.

3. All actually parallel lines which are not parallel to the plane of the film, *with the exception of verticals,* converge toward vanishing points. If such receding parallels are horizontals, their vanishing points are located on the true horizon, whether or not the horizon appears in the photograph.

4. All vertical lines must appear vertical and parallel in the picture.

True rectilinear perspective is identical to academic rectilinear perspective in regard to points one, two, and three; it differs in regard to point four: verticals are rendered parallel *only* if they fall under point two. If the film is *not* parallel to the verticals, *i.e.,* if the camera is tilted either upward or downward, verticals must converge in the picture. Although this convergence may seem "unnatural" and be objectionable in the photograph, it is nothing but the perfectly natural manifestation of perspective in the vertical plane. If unwanted, this phenomenon can be avoided by proceeding as follows:

Control of vertical lines on the film. To preserve parallelity of vertical lines in the transparency, the film inside the camera must be parallel to the vertical lines of the subject. This condition is fulfilled if the photograph is made with the camera in level position. Unfortunately, if the subject is a building and the picture taken from street level, the consequence of this basic condition is often that the top of the building will be cut off in the photograph and the foreground appear unproportionally prominent. On the other hand, if the camera is tilted, the top of the building would be included and the amount of foreground reduced but vertical lines would converge in the picture. The only way to achieve satisfactory results is to use a view-type camera *equipped with a rising front and a lens of sufficient covering power,* or a 35-mm SLR camera equipped with a Nikkor PC (perspective control) or Schneider PA-Curtagon lens, and proceed as follows:

p. 60
pp. 76, 59

If a 35-mm SLR camera equipped with a Nikkor PC-lens or a Schneider PA-Curtagon lens is used, the shot can be made hand-held; if a view-type camera is used, the camera must be mounted on a tripod because after all the adjustments are made the viewfinder image no longer coincides with the image registered on the film.

Tilt the camera upward until the entire subject is included in the view and focus as usual, observing the image on the groundglass: the vertical lines will converge toward the top of the picture. To avoid this, tilt the camera forward until it is level. In this position, the vertical lines will appear parallel, but the top of the building will be cut off and the foreground appear excessively prominent. To correct these shortcomings, without altering the camera position in any other way, elevate the lens by raising the movable front of the camera (or the Nikkor PC or Schneider PA-Curtagon lens) until the entire building appears on the groundglass. As long as the camera remains level, vertical lines will remain parallel.

Control of vertical lines in the print. Any color negative, whether an original or an internegative subsequently made from a positive transparency, in which actually parallel lines converge, can be made to yield color prints in which verticals appear parallel again. This kind of control, which is applied during the process of enlarging, restores parallelity by reversing the process which caused actually parallel lines to converge in the first place: negative and paper are not parallel to one another as in ordinary projection printing, but inclined in such a way that the side of the projected image toward which the parallel lines converge is farther away from the enlarger lens than the other side. If the angle of inclination is correctly chosen, actually parallel lines which converged in the negative will appear restored to parallelity in the print.

To effect this condition, raise the appropriate side of the paper easel by propping it up with some suitable support until, after refocusing, the converging lines appear parallel in the projected image. Unfortunately, a side-effect of this procedure is

that the resulting picture will be sharp only within a very narrow zone. If the required degree of tilt is only very slight, the entire image can be brought back into focus by stopping down the enlarger lens. More often than not, however, this will be insufficient, and overall sharpness must be restored in one of two ways:

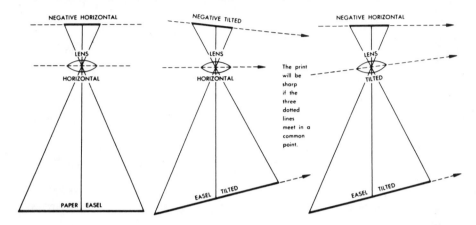

Either, *tilt the negative in the opposite direction* from that in which the paper is tilted, until the image appears uniformly sharp; this requires only a slight degree of tilt. To accomplish this, some enlargers are equipped with a tilting negative carrier. In the absence of this extremely useful feature, support the negative carrier in a tilted position by blocking up one of its sides as best you can.

Alternatively, *tilt the enlarger lens in the same direction* the paper is tilted; this requires only a very slight degree of tilt. To accomplish this, some enlargers are equipped with a tilting lens stage. How these tilts must be adjusted to assure uniform sharpness over the entire area of the print is illustrated above.

Uniform sharpness in the print will result if the tilts are adjusted in such a way that imaginary lines drawn through the planes of the negative, the diaphragm, and the sensitized paper, if sufficiently extended, would meet in a common point. Under these conditions, the entire print will be sharp without the need for stopping down the lens beyond normal. If the tilt of the easel is considerable, to achieve an even light distribution, additional exposure must be given to that part of the image which is farthest from the lens.

Perspective control in two dimensions. The foregoing gave directions for controlling perspective in one dimension—height. If perspective must be controlled in two dimensions—height and width—the photographer must use a view-type camera p. 60

p. 76 equipped with a complete set of "swings"—individual front and back adjustments—and a lens of more than average covering power. Here is a rundown of the functions of the different "swings":

The back-tilts and swings are primarily intended for controling the "perspective" of the photograph, among others, to assure that vertical lines will be rendered parallel in the picture. In addition, they can be used to extend the zone of sharpness in depth in certain types of oblique views.

The front-tilts and swings control overall sharpness and, under certain conditions, can be used to extend in the picture the zone of sharpness in depth.

The vertical and lateral front and back adjustments (slides and rises) control the position of the image on the film.

Before a photographer attempts any kind of perspective control he must realize two things:

Only flat surfaces parallel to the plane of the film can be rendered distortion-free. Therefore the side of the subject that must be rendered distortion-free must be parallel to the film. This can be accomplished in one of three ways:

1. The camera must be positioned in such a way that it faces the subject "head-on," *i.e.*, the lens axis must be perpendicular to the side of the subject that is to be rendered distortion-free.

2. The subject must be placed in such a way that the side which is to be rendered distortion-free is parallel with the film.

3. If neither 1 nor 2 is possible, parallelity between the side of the subject that is to be rendered distortion-free and the film must be accomplished by turning the swing-back of the camera accordingly, regardless of the direction in which the lens is pointed.

If neither one of these conditions can be fulfilled, distortion-free rendition in the film is impossible.

p. 76 *The lens must have sufficient, i.e., more than average, covering power.* Otherwise, because the front of the camera may have to be adjusted in such a way that the lens axis points no longer at the center of the film, part of the film may be outside the sharply covered area and, as a result, the transparency may be either partly unsharp or blank. To avoid this, experienced photographers, instead of using a p. 86 standard lens designed merely to cover the respective film size, use a wide-angle

lens of similar or slightly longer focal length capable of covering the next larger p. 77
film size, thereby making sure they have sufficient leeway for utilizing the full
potential of their camera's "swings."

To familiarize himself once and for all with the principles and techniques of per-
spective control, I recommend that the interested reader who also owns a swing-
equipped view-type camera set himself the task of photographing, for example,
a large cereal box (or similar boxlike subject) in such a way that three of its sides
are visible in the picture, one of which—the front—must be rendered distortion-
free, *i.e.*, its vertical lines parallel, its horizontal lines parallel, and its angles 90
degrees. He should proceed as follows:

1. Mount your swing-equipped view-type camera on a tripod and position it to
show two sides of the subject—the box—and high enough to provide an oblique
view of its top. However, keep in mind that there are limits to perspective control
and, if the side that is to be rendered distortion-free is positioned at too sharp an
angle relative to the camera, mechanical and optical limitations will make it impos-
sible to adjust the camera for complete correction of distortion. With the diaphragm
wide open and the front and back adjustments in neutral position, center the
image of the box on the groundglass.

2. Tilt the adjustable back of the camera backward until the film is parallel with
the vertical lines of the box. In this position, the vertical lines of any subject will
be rendered parallel instead of converging. The image will, of course, be partly
out of focus; disregard this unsharpness temporarily.

3. Should any of the required camera adjustments result in an objectionable dis-
placement of the image of the subject on the groundglass, *do not change the
camera position*. Instead, center the image again by using the vertical (rising) and
lateral (sliding) adjustments of the lens.

4. Swing the adjustable back of the camera laterally until it is parallel to the
front of the box. In this position, the horizontal lines of the front of any subject
will be rendered parallel instead of converging. In making this adjustment be
careful not to upset the parallelity between the camera back and the vertical lines
of the subject. The image will now appear very unsharp.

5. Refocus as best you can; then tilt and swing the lens to further improve overall
sharpness. This is a delicate adjustment because only very small deviations from
the neutral position of the lens are required. As adjusting the lens improves sharp-
ness, keep on refocusing until you get the sharpest possible image. Although all

333

these adjustments will not bring the entire depth of the subject into sharp focus, they will improve overall sharpness to a point where stopping down the diaphragm will be sufficient to produce a critically sharp rendition of the entire box.

How to extend the zone of sharpness in depth with the aid of "swings." An added bonus of camera swings is that they enable a photographer to extend enormously, without having to resort to undesirably small diaphragm apertures, the sharply covered zone in depth in *oblique shots of relatively flat subjects.* To learn how to take advantage of this I recommend the following experiment:

Mount your swing-equipped view camera on a tripod, tilt it forward at an angle of 30 to 40 degrees from the horizontal, place a few pages of newsprint in front of it flat on the floor, and focus on a line of print more or less in the center of the test object. The line on which you focused will appear sharp, but the lines closer to the camera as well as those further away from it will, of course, appear blurred, increasingly so, the farther they are from the sharply rendered line.

Next, without changing the position of the camera itself, slowly tilt the adjustable back of the camera backward while observing the change on the groundglass. If the tilts of your camera are "on axis," i.e., if the pivoting points of the front and back are located at the height of the optical axis, you will observe that the entire area of the newspaper-covered floor will appear sharp without the need for refocusing or stopping-down the lens, as soon as a certain tilt-angle of the back has been reached. If the tilts of your camera are *not* "on axis," however, i.e., if front and back pivot near the camera bed, you will have to refocus the lens while you tilt the back of the camera backward in order to achieve uniform overall sharpness. The back-tilt is correctly adjusted if imaginary lines drawn through the planes of the film, the diaphragm, and the subject, if prolonged, would meet in a common point, as shown in the following drawing.

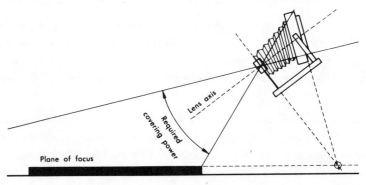

The same gain in sharpness can, of course, be achieved by tilting the lens forward instead of tilting the back of the camera backward, to the point where imaginary lines drawn through the planes of the film, the diaphragm, and the subject, if prolonged, would meet in a common point. This method must be used when the back of the camera must be kept vertical to render vertical lines within the picture area parallel in the transparency instead of converging (for example, a building at the far end of a plaza the ornamental pavement of which is the subject proper of the photograph). However, in comparison to the method described above, tilting the lens instead of the back of the camera has the disadvantage that it throws the lens axis off the center of the film, as shown in the following drawing.

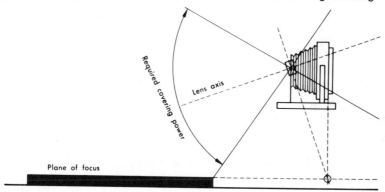

If the covering power of the lens is insufficient, this would cause partial unsharpness or vignetting in the transparency (vignetting manifests itself in the form of under-exposed or completely blank corners in the transparency). This danger can be avoided by raising the back of the camera and lowering the lens until the lens axis points again at the center of the film, as shown in the drawing below.

p. 76

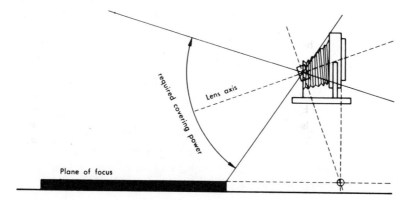

The method of extending the sharply covered zone in depth with the aid of camera "swings" works the better, the flatter the subject that must be photographed obliquely. In this respect, of course, it makes no difference whether the subject is in a horizontal position (like a rug on a floor) or in a vertical position (like a bas-relief set into a wall) except that in the latter case the back of the camera (or the lens) must be swung around a vertical axis instead of being tilted around a horizontal axis. As long as the camera is correctly adjusted, sharpness in the picture will extend all the way from the nearest to the farthest point.

If the subject is *not* entirely flat, however, or if parts of it project beyond the inclined plane to which the camera is adjusted, a certain amount of stopping-down the lens is required to bring such protruding parts into focus. But even in cases in which such additional stopping-down is necessary, the overall gain in sharpness achieved by using "swings" is so great that not only the entire depth of the subject can be rendered sharp with considerably less stopping-down than would otherwise be required, but also that subjects of such great extension in depth that they could never be covered sharply merely by stopping-down the lens can now be rendered sharp in their entirety.

Perspective control in three dimensions. What we call "perspective" is the combined effect of four graphic picture aspects:

> Scale of rendition,
> angle of view,
> angle of foreshortening,
> degree of diminution.

Virtually complete control over these aspects, and therefore over perspective itself, is possible through making the appropriate choice in regard to two factors:

> Camera position, and
> focal length of the lens.

Scale of rendition. The size of the image on the film, say, the height of a human figure, is controlled by two factors: subject-to-camera distance, and focal length of the lens. The shorter the distance between subject and camera, and/or the longer the focal length of the lens, the larger the scale of rendition; and vice versa. Consequently, if the subject appears too small in the viewfinder or on the ground-glass, shortening the distance between subject and camera, or switching to a lens of longer focal length, or a combination of both, will increase the image size.

However, if the focal length of the lens is *relatively* short (wide-angle lens), shortening the distance between subject and camera may lead to excessive "distortion." In such a case, switching to a lens of longer focal length is the better choice. However, in conjunction with the same camera position and film size, because of its narrower angle of view, a lens of longer focal length will render a proportionally smaller area of the subject than a lens of shorter focal length.

Angle of view. The angle of view included in a photograph is controlled by the focal length and covering power of the lens relative to the film size: the shorter the focal length, the greater the covering power, and the larger the film size, the larger the rendered angle of view. Other factors being equal, angle of view and scale of rendition are inversely proportional: making the photograph with a lens which encompasses an angle of view twice as large as that included by another lens, produces a picture in which the subject appears only half as large—more is shown, but what is shown is shown in smaller scale. Wide-angle lenses encompass large (60 to 100 degrees and more), standard lenses medium (45 to 60 degrees), and telephoto lenses small (30 degrees and smaller) angles of view. Some photographers make the mistake of confusing the effects of subject-distance and angle of view encompassed by the lens: increasing the subject-to-camera distance will, of course, include a proportionally larger part of actual scene in the picture; but unless the lens is also exchanged for one of different focal length, the angle of view will remain the same regardless of subject distance. The *only* way of controlling the angle of view is through the focal length of the lens.

pp. 72, 76

p. 86
p. 85
p. 88

Angle of foreshortening. It makes a great difference whether we photograph, say, an automobile, from the side or in a three-quarter front view. In the first case, we would get a virtually distortion-free picture of the car whereas in the second case, seen "in perspective," the car would appear more or less "distorted" insofar as its front would be rendered larger than its rear. Furthermore, the first view would show only *one* side of the car, the second view, *two.* And if a third picture were made from the same angle but a higher vantage point than the second, it would show *three* different sides of the car—front, side, and top—the maximum number of sides of any three-dimensional object that can be shown within a single view. This aspect of perspective is controlled through appropriate choice of camera position relative to the subject.

Before a photographer makes this decision he should consider the following: Photographing a three-dimensional subject at an angle of view of 90 degrees to one of its principal planes (front, rear, right side, left side, bottom, top) has two im-

portant consequences: (1) the subject will appear virtually or completely distortion-free, and (2) it will appear relatively or entirely "flat." Seen in a head-on view, a cube, for example, appears (1) distortion-free and (2) "flat," i.e., indistinguishable from a square—a two-dimensional form—because only one of its six sides would be visible. Photographed at an angle—shown in foreshortened form—however, it would acquire "depth" in the picture because two or even three of its six sides would be visible, making its three-dimensionality obvious. Its actually parallel edges would, of course, be rendered converging and its actually right angles more or less acute; but it is precisely this "distortion" which in the photograph creates the illusion of three-dimensionality—distortion is a symbol for "depth." Similarly, photographed "head-on" a circular form appears round—undistorted—and "flat" —lacking "depth." But seen "in perspective," or photographed "at an angle," a circular form will be rendered as an ellipse—i.e., "distorted,"; and it is precisely this "distortion" that creates the illusion of "depth." Here, as so often in photography, a photographer must make a choice: on one side, he has the choice of a "distortion-free" rendition; on the other, he can create an illusion of "depth." Unfortunately, these two picture aspects are mutually exclusive, although both are subject to the same control: appropriate choice of camera position relative to the subject.

p. 336 **Degree of diminution.** We have learned that the scale of rendition is controlled by two factors: subject-to-camera distance, and focal length of the lens. And then I said: ". . . if the subject appears too small in the viewfinder . . . shortening the distance between subject and camera, or switching to a lens of longer focal length . . . will increase the image size." This seems to imply that these two controls are interchangeable. They are—under certain conditions; under other conditions, they are not. For example: for the reproduction of a painting, it makes absolutely no difference whether we make the shot with a lens of 2-inch focal length from 6 feet away, or with a lens of 4-inch focal length from 12 feet away—the two photographs would be identical. And the reason they are identical is that, strictly speaking, "perspective" is not involved—there is no question of *diminution* because the subject has no "depth."

When depth becomes involved to any noticeable degree, matters are somewhat different. For example: a photographer intends to photograph his wife standing in a plaza against a background of old historical buildings; the image of the figure should fill the height of the picture. His camera is equipped with a lens of 2-inch focal length, but he also has a 4-inch telephoto lens. He is going to make one shot from the appropriate distance with the 2-inch lens, then double the distance be-

338

tween wife and camera and make a second shot with the 4-inch lens. Under these conditions, both pictures would show the figure in identical scale, but the "perspectives" of these two shots would be different. In the first picture, the buildings in the background would appear relatively small and insignificant; in the second, they would be almost twice as high and prominent as in the first. Why? Because now we are dealing with a subject that has "depth"—*diminution* is involved, and *the degree of diminution is controlled by the distance between the subject and the camera.* The two pictures were taken from different subject distances, and differences in subject distance cause differences in the rate of diminution which cause differences in the impression of "depth."

This brings us to one of the most consistently misunderstood aspects of space symbolization with photographic means: the fallacious assumption that changing the focal length of the lens will effect a change in the perspective of the picture. This is simply not true, and anyone willing to take the trouble to perform the following experiment can prove it: mount your camera on a tripod, set it up near a window and, without changing the camera position, take two shots down the street, the first with a wide-angle lens, the second with a moderate telephoto lens. Subsequently, project the two slides in such a way that, on the screen, the scale of rendition is the same for both. To do this you must, of course, project the wide-angle slide from a greater distance than the telephoto slide, and a considerable part of the image will fall outside the screen. However, that part of the wide-angle slide which corresponds to the view encompassed by the telephoto slide, if projected in identical scale, will exactly match the telephoto rendition in regard to scale, angle of view, angle of foreshortening, and degree of diminution. In other words, as far as *perspective* is concerned, there is absolutely no difference between the two—they are identical. And they are identical because they were made from the identical camera position; and it is the camera position which controls the "perspective" of a photograph. As long as the camera position remains the same, perspective remains the same, no matter whether a wide-angle, a standard, or a telephoto lens is used.

If you are still unconvinced, perform this second experiment: take two pictures of the house across the street through an open window, the first with a moderate telephoto lens with the camera positioned deep within the room, the second with a wide-angle lens from a position near the window. To get comparable results, the camera must in both cases be on axis with, and at right angles to, the window, and the distance between window and camera must be adjusted in such a way

that the window frame appears in identical size in both shots. If you subsequently compare the two photographs you will find that their "perspectives" are quite different, and regardless of the scale in which you project them, you will never be able to get them to match. Because, in this case, the two comparison pictures were made from different camera positions.

Now you may say, "Of course they are different, they were made with lenses of different focal length." Okay—make a third picture pair taken from the same two camera positions as the previous pair, only this time take both photographs with the same lens. If you later project these two slides, adjusting the projector-to-screen distances so that the window will appear in the same scale in both shots, you will find that their "perspectives" are just as different from one another as the perspectives of the previous picture pair. This, of course, was to be expected, since they were made from different camera positions.

As these examples should prove, it is *not* the focal length of the lens, but the distance between subject and camera—the point of view—which controls the perspective of a picture, *i.e.,* its space and depth effect, which in turn is determined by the relationship of the picture components to one another in regard to diminution and scale. In portraiture, for example, experienced photographers use lenses with relatively long focal lengths, *not* because long-focus lenses are less likely to produce "distorted" pictures than short-focus lenses, *but* because long-focus lenses produce images in larger scale than short-focus lenses which in turn makes it possible to get sufficiently large renditions from relatively great subject-to-camera distances—and the greater the distance between subject and camera, the less "distorted" the perspective of the resulting picture. As a matter of fact, if a photographer were to make two portraits from a distance of 12 feet, one with a wide-angle and the other with a telephoto lens, both would have exactly the same perspective. The only difference between the two would be the scale of the head. However, if one would enlarge the wide-angle image to the same scale as that of the picture made with the telephoto lens, as far as perspective is concerned, the two portraits would be identical. Because it is the camera position which controls the perspective of a photograph.

The typical wide-angle perspective is characterized by a high rate of diminution, *i.e.,* in the photograph, objects of actually identical size located at different distances from the camera are rendered in markedly different scale, with nearby objects appearing unproportionally large and distant objects appearing unproportionally small. This discrepancy becomes increasingly pronounced, the wider

340

the angle of view of the lens, the shorter the distance between subject and camera, and the greater the subject's depth. Familiar examples of this kind of "distortion" are hands and feet extended toward the camera, which appear in the picture unproportionally large while the head and body appear unproportionally small. To the untrained eye, this kind of perspective appears unnatural and objectionable because it shows familiar things in unfamiliar forms. Actually, however, it is the natural manifestation of "nearness," expressed in the picture with graphic-symbolic means: excessive "distortion." Photographers who dislike this form of perspective can easily avoid it by photographing the subject from a greater distance with a lens of longer focal length.

The typical telephoto perspective is characterized by a low rate of diminution, *i.e.*, in the photograph, objects of actually identical size located at different distances from the camera are rendered with relatively small differences in scale. The rate of diminution decreases proportionally, the longer the focal length of the lens and the greater the distance between subject and camera. Familiar examples of this kind of perspective are, among others, photographs taken during an automobile race in which the competing cars appear to sit on top of one another and go crabwise; television-screen images taken in convention halls in which people in the second and third rows appear bigger than those in the front row; and city scenes in which space appears "compressed" and the buildings seem to have unproportionally little "depth." Personally, I find this form of perspective particularly beautiful because it preserves, as far as this is possible in a photograph, the natural size-relationships between the depicted objects. In a waterfront scene taken with a standard lens from a relatively short distance, for example, the ships in the foreground dwarf the actually much larger buildings in the background, whereas in a telephotograph taken from farther away, the ships appear relatively small and the buildings huge and dominating. The natural proportions of the subject or scene are preserved in the picture, and the effect of the photograph reflects the essence of the scene.

Through appropriate choice of subject-to-camera distance in conjunction with a lens of suitable focal length, a photographer can create whatever form of perspective he desires. If he wishes to preserve as much as possible the natural proportions of objects to one another in depth, avoid "distortion," emphasize the background, and prevent things in the foreground from unduly dominating the scene, he must take the picture from a great subject-to-camera distance with a lens of relatively long focal length. If he wishes to emphasize the foreground, create a feeling of nearness, relegate the background to secondary importance, or

produce particularly strong impressions of depth, he must take the picture from nearby with a lens of relatively short focal length. By taking the picture with a standard lens he can approximate the images as seen by the eye; by using wide-angle and telephoto lenses from appropriate subject distances he can create emphasis through exaggeration. He has complete control over the space impression of his picture.

Nonrectilinear perspectives

The fact that we see things in rectilinear perspective must not mislead us to assume that this is the only "correct" way of seeing, that other forms of perspective are "wrong" because they "distort." We know, for example, that certain birds, fishes, and insects have eyes that encompass views of 300 and more degrees and produce visual sensations which must be radically different from anything we are able to experience. As a matter of fact, one might even say that rectilinear perspective too is "wrong" because, strictly speaking, horizontals are not straight but curved and verticals are not parallel but diverge. If you question this statement, the next time you look at a globe, imagine an enormously long building stretching all the way from New York to San Francisco. Its walls, of course, are vertical everywhere, whether in San Francisco or New York. Verticals, by definition, are lines perpendicular to the horizon that, if prolonged, would pass through the center of the earth. Now do you see why a vertical line in San Francisco cannot be parallel to one in New York? Or, for that matter, why even within the same building one wall cannot be *exactly* parallel to another wall if *both* point *precisely* at the center of the earth—a geometrical point through which it is impossible to draw two parallel lines?

And now visualize the floors in this immense building which, at whatever point you may check them, would be level, *i.e.,* horizontal. But can you imagine a "horizontal" line stretching from San Francisco to New York that is "straight"? Obviously not, since it must conform to the curvature of the earth. But if a 3,000-mile-long "horizontal" line is curved, doesn't it follow that each section of it is also curved?

Although these phenomena have nothing to do with color photography, I mention them here because I believe that thinking along these lines can help a photographer to understand the significance of two strange "new" forms of perspective, cylindrical and spherical, which have been made accessible to him in recent years by the introduction of two "revolutionary" pieces of equipment: the panoramic camera, and the fish-eye lens.

A panoramic camera produces pictures in which perspective is *cylindrical, i.e.,* only those actually straight lines that run parallel to the scanning axis of the lens are rendered straight in the picture. All other actually straight lines must appear curved, decreasingly so the closer to parallelity they are with the plane of scanning of the lens.

A fish-eye lens produces pictures in which perspective is *spherical, i.e., all* straight lines are rendered more or less curved *except* those that intersect, or would intersect if prolonged, the optical axis; in the photograph, these lines are rendered straight, diverging radially from the picture's center like the spokes of a wheel.

At first, seeing lines one "knows" to be straight rendered in the form of curves may seem unnatural—a "fault" of the picture that makes "reading" such photographs correctly difficult or impossible. On second thought, however, it will be seen that whenever abnormally large angles of view must be shown within a single rendition, this curving is not only perfectly natural but inevitable. To understand this phenomenon, let's consider the following hypothetical case:

Imagine that you have to photograph in side view an enormously long low building that stretches from horizon to horizon, encompassing an angle of view close to 180 degrees. Not having a 180-degree fish-eye lens, you decide to take the picture in two parts, each including an angle of view of 90 degrees. To photograph the first part, you turn your camera 45 degrees toward the left. Since now the front of the building is no longer parallel to the film, it will be rendered "in perspective," i.e., "distorted" insofar as its roof and base lines will not appear parallel in the picture (as they actually are), but converging toward the left side of the photograph. Subsequently, you turn your camera toward the right and take the other half of your future composite picture; this time, the roof and base lines will, of course, converge toward the right. This convergence of actually parallel lines will seem perfectly normal until you join the two picture-halves together. Then you will find that the roof and base lines of the building, which in reality were straight, form an angle in the center of the composite picture which did not exist in reality.

To avoid this objectionable angle right in the middle of your photograph, you might decide to make another composite picture of the building consisting of *three* separate parts. This would enable you to eliminate the break in the middle by taking the center shot at an angle of 90 degrees, which would have the added advantage of rendering this section distortion-free since then the front of the building would be parallel to the film. But the two other components of your composite

picture—the views toward the right and left—being "angle shots" would be rendered "in perspective" and their roof and base lines converge toward vanishing points. Consequently, when you assemble your triptych, you will now have two angular breaks in the actually straight roof and base lines of the building instead of only one.

Theoretically, of course, such breaks can be avoided by taking an infinite number of pictures, each taken at a different angle. In this way, by subdividing the over-all view into an infinite number of segments, each break in the roof and base lines of the building would be infinitely small and therefore unnoticeable: the "straight" lines of roof and base would be rendered as curves. And this is precisely the form in which a panoramic camera would show this building.

That this curving is inevitable and not merely some form of "optical distortion" becomes clear if you look at it in this way: directly in front of you, the building has a certain height; seen at an angle, either toward the right or the left, this apparent height diminishes more and more until finally, where the immensely long building dips beyond the horizon, its apparent height is reduced to zero. Now, if you were to take sight-measurements of the apparent height of the building at different angles from the camera position and plot them in the form of a graph, you would get a number of points representing the apparent height of the building at different distances from the camera. If you now connect these points by a line you get a curve—which shouldn't surprise you since the only line that can extend from the left horizon across the top of the building in front of you and from there on to the right horizon *without a break* or *angle* is a curve. And this is precisely the form in which a photograph taken with a panoramic camera would show the immensely long building in a right-angle view: its roof and base lines would appear as curves—perspective would be "cylindrical."

Now you may rightfully ask why, in the center-part of your three-section composite picture, the roof and base lines appeared straight and parallel instead of curved although, as we just concluded, the laws of "natural perspective" demand that rendition be curved? The reason is that this is the way we see (or think we see) such lines, and that most photographic lenses are "corrected" to duplicate this view. However, had you made the picture with an "uncorrected" meniscus lens (for example, an ordinary magnifying glass), the straight lines would have been transformed into curves and, strictly speaking, the resulting perspective would have been truer to reality than a rectilinear rendition, although few people might agree to this.

344

Now it seems only logical to ask whether this peculiar curving of actually straight lines should be limited to horizontals or apply to all straight lines regardless of their direction, including verticals. The latter, of course, is correct. With the exception of the artificial "academic" form of rectilinear perspective, the respective laws that govern any particular form of perspective do not distinguish between horizontal and vertical lines or, for that matter, lines running in any other direction. Consequently, in any "natural perspective," vertical lines must also appear as curves. And this is precisely the form in which a photograph taken with a fish-eye lens would show the subject—perspective would be "spherical."

A simple way to visualize how a specific view would look if rendered in spherical perspective by a fish-eye lens is to study its reflection in a mirrored sphere—a Christmas tree ornament or one of those large mirror-plated glass spheres designed for use as lawn or garden ornament. This will clearly show the gradual transition from the virtually distortion-free central portion of the image to the violently curving distortions near the periphery of the circular picture. Photographing such a reflection can sometimes substitute for taking a picture of the view itself with a fish-eye lens, particularly if conditions permit the photographer to hide himself and his camera behind some suitable object; otherwise, both would be featured prominently right in the center of the view.

That we normally don't see the apparent curving of actually straight lines is due to the fact that the angle of our sharp vision is rather narrow, and within this narrow field of view the amount of curvature is too small to be noticed. But there is a way of becoming aware of it: stand across an alley formed by two tall buildings with parallel walls and, with a stick held horizontally at arm's length, measure the apparent width between the two walls first at street level, then at roof level. Obviously, the apparent width will be shorter at roof level than at street level, proving that the walls cannot *appear* parallel. But if we don't see them as parallels they must appear to converge, and the question is only whether this convergence is straight or curved? If the walls appear to rise in the form of straight lines, the angles which they form with the street must, of course, be smaller than 90 degrees. This is obviously not the case—each angle is 90 degrees. Therefore, the only alternative is that we see the walls rise from street level at right angles and then curve inward. And this is precisely the form in which they would be rendered in a photograph made with a panoramic camera with the lens scanning the subject vertically.

Cylindrical and spherical perspectives are relatively new forms of photographic

expression—so new in fact that many photographers still consider them "gimmicks" rather than useful means for symbolizing space. The reason for this is lack of understanding—they haven't yet learned how to "read" such images correctly. They look at fish-eye pictures as if they were ordinary photographs instead of views encompassing the fantastic angle of 180 degrees. They don't consider that such pictures show at one glance what in reality might necessitate a full turn of the head. To learn how to "read" such views I recommend to look at them one section at a time, turning the picture into the appropriate position for each separate section. In this way, each part of the view can be "read" easily and thereafter related to the rest, and after a while, the whole makes sense because it will be seen as a unit. And not before a photographer has reached this point will he be able to utilize successfully the enormous potential of cylindrical and spherical perspectives for showing certain relationships between a subject and its surrounding space with greater clarity and emphasis than was previously possible, and thereby depict more tellingly specific aspects of his world.

Space definition and scale

Creating a feeling of space in a photograph is often not enough to make the rendition effective. Unless the depicted space is also defined in terms of size—how big? how small?—the impression made by the picture may be incomplete. Anyone who ever tried to come to grips with the immensity of certain landscapes—the Grand Canyon, Niagara Falls, the Redwood forests—knows what I mean: his photographs were inadequate because they lacked one of the subject's most important qualities: bigness.

Bigness is another one of those elusive subject qualities which ordinarily cannot be rendered directly in a photograph—how often do we have the chance to make a photomural? And reduced to the size of a snapshot—or even an 11 x 14-inch print—most things which in reality excited us because they were so big appear no larger than the surface on which they are seen. This is one of the reasons why the same kind of landscape that when projected at home looks deadly dull "comes to life" when seen on a Cinerama theater screen.

Obviously, size is a quality which rarely can be rendered directly in a photograph—actually only when the scale of rendition is 1 : 1 (rendition in natural size). In all other instances, if size is an important subject quality, it can only be indicated symbolically: by giving the picture scale.

The essence of scale is comparison. By comparing a subject of unspecified dimensions (a landscape, a tree trunk, a rock formation) with a subject of known dimensions (the human figure, the botanist's foot rule, the geologist's hammer), we relate the unknown to the known and see how big or small it really is. Now, in creative photography, it would obviously be a mistake to indicate, for example, the hugeness of a redwood tree by tacking a foot rule to its trunk, or the size of a rock formation by including in the picture a hammer. These are the accepted methods of the scientist—uncompromising, precise. The creative photographer's methods of imparting scale to his subject are more sophisticated. Scale must be used as if it were an integral part of the picture, unobtrusive, subtle, yet instantly effective. In the case of the redwood, for example, scale can be provided through juxtaposition of the immense redwood trunk and an ordinary spruce; the spruce—a tree familiar to everyone—makes the redwood look huge. And instead of using a hammer, a photographer could give scale to an interesting rock formation by including in his picture some wildflowers that grew naturally from a crack. In both cases, the unit of measure, the provider of scale, the spruce or wildflower, would be actual parts of the scene yet instantly disclose its size.

A large variety of objects of familiar dimensions exist to provide a photograph with scale. Heading the list is, of course, the human figure. For close-ups, a hand is often excellent; for super close-ups, a pair of fingertips. Other units of measure familiar to all are automobiles, telephone poles, cows and horses, farm houses and machinery, windows, ships. . . . For example, seen from afar, the high-rise buildings of a city appear like toys on a hazy day when their windows are obscured by mist, but huge on a clear day when hundreds of windows give them scale. And the distant silhouette of an ocean liner on the horizon will in contrast to its own smallness make the sea appear immense.

This is the whole secret of scale: to make something appear big, contrast it with something small—if not small in reality, then small in the picture. For example, in comparison to a landscape, the human figure is very small; but placed too near the camera in a photograph it will not make a landscape appear big. Only if the figure appears small enough in the picture, *i.e.*, if it is placed far enough from the camera to be *rendered small*—appearing as a solitary speck in the immensity of space—can it fulfill its purpose as a unit of measure and be effective as a graphic device for making the landscape look big.

However, the purpose of scale is not always to make the depicted subject appear big. Occasionally, a photographer may also wish to provide his picture with scale

in order to indicate an unfamiliar subject's actual size, or to make it appear smaller than it actually is. In commercial photography, for example, it might be desirable to make a new product look as small as possible; if this is the case, the unit of measure which gives it scale must, of course, be relatively large. Therefore, in a close-up, instead of choosing the small hand of a girl as a scale indicator, it would be advantageous to use a man's large hand which, in contrast to its own bigness, would make the subject of the photograph appear even smaller than it really is.

By controlling the actual or apparent size of his scale indicator, a photographer can control the space impression of his picture. However, although lack of scale is a common cause of the ineffectiveness of many landscape photographs, *scaleless close-ups* can make some of the most fascinating pictures. In particular, small objects of nature—insects, flowers, crystals, shells—are well suited to scaleless rendition and, if shown in many times natural size on the projection screen, precisely because they lack scale, can surpass all else in structural beauty, ornamental design, and sheer fantasy of form.

Contrast between sharp and unsharp

Human vision is such that we can focus sharply on only one point in space at a time; everything else, although we are still aware of it, appears more or less indistinct. With *both* eyes open, take a look at the opposite wall in your room: you see it clear and distinct. Then, without shifting focus, interpose your index finger by holding it straight up some 8 inches in front of your face: the finger will appear indistinct and "transparent" with the view of the wall shining through. Next, focus on your finger: now it is the wall which will appear indistinct. Finally, try to see simultaneously both finger and background sharply. You cannot do it. No one can, because the depth of field of the human eye is too shallow. As a consequence, whenever we see one thing distinctly and other things in more or less the same line of sight indistinctly, we know subconsciously that actually these objects are located at different distances from us: contrast between distinct and indistinct evokes the sensation of depth.

p. 85

With the aid of a technique known as *selective focus,* photographers can evoke similar depth sensations in their pictures: by using a high-speed lens, focusing carefully upon a preselected plane in depth, and making the shot with a large diaphragm aperture, they can limit sharpness of rendition to one specific depth zone, making everything in front of or behind this zone appear more or less blurred. And by doing this—by juxtaposing something distinct and something indistinct—

348

they create impressions of depth: contrast between sharp and unsharp is a symbol of space.

Contrast between sharp and unsharp will be the greater and therefore the impression of depth the stronger, the larger the relative diaphragm aperture, the longer the focal length of the lens, and the shorter the distance between subject and camera. As a result, through appropriate choice of these factors, a photographer can control in his pictures the extent of sharpness in depth and thus make space appear deeper or shallower in accordance with his ideas and the nature of the subject.

The technique of selective focus is most effective if in the photograph the subject can be rendered sharply in its entirety and the background and foreground blurred, i.e., if the subject itself has relatively little depth and no transitional zones of sharpness to unsharpness exist between it and objects shown blurred in the picture. For example, the photograph of a face or a sculpture, well out in front of the background and separated from it by a relatively large zone of empty space, in which the face or the sculpture are rendered sharply in their entirety and the background appears completely blurred, will produce a stronger feeling of depth than the oblique view of a long building in which the near side is sharp and the far side blurred with a zone of transition existing in the middle.

A photographer may wish to use selective focus for one of three reasons:

To symbolize depth. Juxtaposition of sharp and unsharp is graphic proof of depth —it is impossible to render a two-dimensional subject simultaneously sharp and unsharp unless, of course, it is photographed at an angle; but then, any angle view automatically involves depth.

To draw attention to a specific part of the picture by showing it in sharp focus while the rest is rendered unsharp and hence, by inference, unimportant. For example, by differentially treating subject and background, a photographer can emphasize the first and play down the second. This might become desirable if the background is overly prominent in color or design, in which case its graphic aggressiveness can be toned down by blur.

To achieve graphic separation between objects located at different distances from the camera which otherwise might blend into one. Although this eventuality is more likely to occur in black-and-white than in color photography, there will always be cases in which the colors of different objects are so similar that the simplest way to effect a clean separation between them is through selective focus.

Contrast between light and dark

The earth's atmosphere is never perfectly clear. Depending upon location, altitude, and weather conditions, it contains varying amounts of solid particles, smoke, exhaust gases, water droplets, and vapor which to a higher or lesser degree impair its transparency. These impurities interfere with the passage of light, the result being cumulative: the thicker the air mass which the light must penetrate before it reaches our eyes, the stronger the effect. Consequently, the appearance of objects changes with distance from the observer. The name of this phenomenon is *aerial perspective*.

Since it is directly connected with distance, aerial perspective offers a visual measure of remoteness: the lighter a mountain range appears, the farther away we assume it to be; the darker, the nearer. Consequently, contrast between light and dark becomes a symbol of space.

Altogether, as far as a color photographer is concerned, aerial perspective manifests itself in three different ways. As distance between subject and camera increases

> objects appear lighter in tone,
> subject contrast decreases,
> color is distorted toward blue.

Whereas a black-and-white photographer commands powerful controls with which to counteract as well as emphasize the effects of aerial perspective in the picture, a color photographer is much more limited in this respect. Most serious is his lack of control over the contrast range of distant objects, which is the main reason why telephotography in color can be such a frustrating experience, the results being only too often flat insipid monochromes in blue. In comparison to this inability, the fact that both tone and color of distant views are subject to a limited amount of control is of relatively little value. For what good is a transparency that is acceptable as far as lightness and color are concerned if contrast and therefore subject differentiation are virtually nil? Here are the steps which a color photographer can take to cope with aerial perspective:

Selection and rejection. When photographing distant hazy views, include some graphically strong, dark foreground matter in the picture—trees, branches, rock outcroppings, human figures, telephone poles, powerlines. . . . These will make up for the flatness of the subject itself and introduce the necessary contrast without which such pictures are often wishy-washy. Expose for the distant view, letting the foreground matter go black.

350

If you can, wait until atmospheric conditions are in harmony with the character of the subject and the purpose of the picture. Sometimes, as normally in telephotography, this means waiting for an exceptionally clear day. Such days are most likely to occur in fall after a storm when heavy rains have precipitated atmospheric impurities and clean cold air moves in from the north. This is the time to take the big lens and go out and shoot those distant scenes and skyline views you waited all summer to photograph. At other times, it means waiting for haze or low-lying fog of the kind most often encountered at sunrise. Night photographs in the city are always most effective on damp and foggy nights when aerial perspective becomes an asset to the photographer who takes pictures at medium and short distances. Under such conditions, the air itself seems to become luminous, colorful reflections in wet asphalt enliven the streets, buildings in different planes appear well separated from one another by haze, street lights and advertising signs are surrounded by colorful halos of mist. In contrast, city photographs taken on clear dry nights often appear ink-black with ineffective pinpoint lights, separation between the different planes in depth is lacking, buildings merge, and the overall effect is harsh and crude.

Filters. If desirable, the bluish tone, so typical of distant views, can be "corrected" with the aid of a light-balancing filter (Series 81) or a warm-up color compensating filter (CCY or CCR) in the appropriate density, although no amount of filtering can restore the actual colors of the subject. Personally, instead of completely eliminating the beautiful blue overall tone of hazy views, I prefer either to leave it and even accentuate it by contrasting its remote coldness with some "warm" red or yellow in the foreground (like maple leaves in fall), or to tone it down only slightly by using a filter too weak to eliminate completely the blue. In many cases, an ultraviolet-absorbing filter or a polarizer will produce the most pleasing effects. p. 36 p. 37

Distribution of light and dark. Athough *contrast* of light and dark—or light and shadow—always produces illusions of depth, the effect varies with the *distribution* of light and dark in the picture. If light and dark are more or less evenly distributed over the entire picture area—as is normally the case if sidelight is used —although objects appear three-dimensional, the picture as a whole may not evoke particularly strong impressions of depth. But if light and dark are distributed in such a way that *all* distant objects appear light and *all* near objects dark—in other words, if we imitate the effect of aerial perspective in our picture (which may even have been taken indoors)—compelling impressions of depth result. Precisely the opposite happens if the order of light and dark is reversed, the foreground rendered light and the background dark, as is the case in photo-

graphs taken with single flash at the camera. Such pictures do not only appear to have no "depth," but also make an artificial or unnatural impression because the "natural" order of light and dark is reversed: the distance, instead of being light, is dark, while the foreground, instead of being dark, is light. The validity

pp. 222, 257

of this observation is confirmed by backlighted scenes where the order of light and dark is reversed again: the sides of objects that face the camera, that are close, that comprise the foreground, are dark; those that face the other way, toward the distance, that comprise the background, are light. Hence, the distribution of light and dark in backlighted scenes is the same as that familiar to us from aerial perspective and, true enough, more effectively than light from any other direction, backlight creates illusions of depth.

Consequently, two main rules emerge for the creation of particularly powerful depth impressions with graphic means: keep objects in the foreground darker than objects farther away; arrange your picture so that the subject is illuminated more or less from the back.

MOTION

Mobility is an important quality of many photographic subjects, but motion can obviously not be rendered directly in a still photograph. Realizing this, many photographers give up and render subjects in motion as best they can without considering that, although motion cannot be rendered directly, the feeling of motion can very well be evoked with graphic means. Others try indiscriminately to "freeze" every moving subject and render it as sharply as possible, thereby often negating the very reason for making the picture. Such ignorant and uncritical attitudes are bound to lead to ineffective pictures.

Since motion cannot be rendered directly in a photograph, it must be implied through symbols. This can be done in several ways. Which symbol a photographer should choose depends on the following:

> The purpose of the picture,
> the nature of the subject,
> the kind and degree of motion.

The purpose of the picture

Some time ago, a car magazine ran the photograph of a racing car trying for a new speed record on the Bonneville Salt Flats in Utah. According to the caption,

352

at the moment the picture was shot, the speed of the car exceeded 500 miles an hour, and it was pointed out with pride that, despite this tremendous speed, the photographer had succeeded in stopping the car's motion in his picture. And indeed he had—both the car and the background were rendered perfectly sharp— with the regrettable result that the picture seemed to show the car standing still. Incredible as it may seem, there the photographer was, privileged to witness a spectacular event, a drama of life and death, but all this was lost on him because he was so insensitive and engrossed in his photo-technicalities that his only interest was in getting a sharp picture. The fact that he could get all the sharply detailed technical-information pictures of the world's-record car either before or after the run apparently never occurred to him; nor did it occur to him that the reason for making his shot was to give the reader of the magazine an impression of the almost inconceivable speed of this car. To him, blur, a symbol of motion, apparently was the mark of the amateur, the poor duffer toting a box whereas he, the great professional, works with a camera which enables him to "stop" the fastest motion. That, in this particular case, the duffer with his box would probably have come up with a more significant picture than he did with his five-hundred-dollar outfit is something which obviously was beyond his comprehension.

I mention this as an example to demonstrate that it is the underlying purpose of the picture which decides the form in which motion should be indicated. In this particular case, the purpose of the picture was to illustrate "speed"—an intangible subject quality that can be rendered only symbolically. In other instances, the purpose may be to furnish a precise record of the behavior of the subject in motion; if this is the case, motion must obviously be "stopped" in the photograph and rendition be clear and sharp. Therefore, mapping his approach to a subject in motion, a photographer must be clear as to aims: What exactly does he want his picture to say? He has the choice of three different possibilities:

To show the moving subject itself as clearly as possible. A typical case would be a motion study of an athlete with the aim of analyzing his performance and form. This would require that every detail is clearly visible, necessitating that motion in the picture is "stopped" and the subject rendered sharply.

To show that the subject is in motion. This requires graphic "proof of motion." Such proof can be furnished in two ways—either through symbols, or through the action or position of the subject itself, as will be shown later. An important requirement is that the subject remains recognizable in the picture, i.e., not, for example, rendered so blurred that it becomes unrecognizable.

pp. 355-363

To create the impression of motion. If this is the case, the subject proper of the picture is an intangible: speed. The actual subject is merely the medium by which intangible concepts like motion and speed can be expressed in picture form. In such a case, only a symbolic treatment can express the essence of the subject and the intentions of the photographer.

The nature of the subject

As far as the influence of motion upon the physical appearance of the moving subject is concerned, a photographer must distinguish between two types of subjects:

Subjects which appear different in motion than when at rest. Examples are people (a person with one foot off the ground is obviously walking or running, is in motion), animals, breaking waves, wind-bent trees, etc. Since motion becomes apparent through changes in the physical appearance of the subject, it does not necessarily need to be expressed in graphic-symbolic form unless, of course, the photographer wishes to *emphasize* the fact that the subject moves: the slightly *blurred* picture of a running horse creates a *stronger* impression of motion than a perfectly sharp rendition, although, in the case of a horse, the latter would also show that the subject was moving when the shot was made.

Subjects which appear unchanged whether they are in motion or at rest. Examples are automobiles, airplanes, ships, many kinds of machinery, etc. Since the motion of such subjects is not evident through changes in their appearance, it can in the picture be indicated only through a symbolic treatment. Frequently, however, "proof of motion" is furnished indirectly: although the sharp photograph of an automobile in motion is in no way different from one at rest as far as the subject itself is concerned, proof of motion may be evident in the form of a dust cloud raised by a car traveling over a dirt road; likewise, the bow and stern waves of a speeding motorboat as well as its position in the water would be convincing proof of motion although the hull itself appears the same whether in motion or at rest. And a flying airplane is obviously moving although, when shown in the form of a sharp photograph, the picture will not evoke the feeling of "speed."

The kind and degree of motion

"Proof of motion" is not the same as "impression of speed." The sharp picture of an aircraft in flight, by the very fact that the plane is airborne, contains *proof* of

motion, but it cannot evoke the *feeling* of motion. If this is important, the motion of the plane must be indicated in symbolic form—through blur either of the image of the plane or the landscape below it. Without such blur, the plane will *appear* to stand still although we *know* that it moves. Likewise, a horse photographed above a hurdle is obviously in motion, but if the picture is sharp, the animal *appears* to be suspended in midair; to evoke the *feeling* of motion, the rendition must contain a degree of blur. This is the difference between a sharp and a blurred picture: the first may or may not contain proof of motion; but only the second can convey the sensation of speed.

To be able to create convincing impressions of speed, a photographer must consider the *degree* of motion: how fast? how slow? In this respect, it is useful to distinguish between three different degrees of motion:

Slow motion. Motion is so slow that the moving subject can be seen clearly and in full detail. Examples are people walking, moving sailboats and motorboats, trees swaying in the wind, clouds drifting in the sky. In such cases, a sharp rendition is usually called for since a symbolic treatment of motion might easily evoke impressions of speed incompatible with the concept of *slow* motion. Proof of motion is either furnished by the appearance of the subject (the bow wave of a motorboat) or, as in the case of drifting coluds, motion is so unimportant that it can be ignored.

Fast motion. Motion is so rapid that the subject cannot be seen clearly in every detail. Examples are fast-moving athletes, running and flying animals, speeding automobiles seen at relatively close range, rapidly moving machine parts, etc. In such cases, effective characterization of the subject usually requires that the photograph evokes the sensation of motion: motion must be indicated in symbolic form.

Ultrarapid motion. Motion is so fast that the subject becomes nearly or entirely invisible. Examples are whirling propeller blades, the wing beats of a hovering hummingbird, projectiles in flight, etc. To convey the feeling of ultrarapid motion is impossible. To photograph such subjects, special equipment and techniques are usually required, and the resulting pictures can obviously never appear "natural."

The symbols of motion

The sensation of motion is a relative experience. Seen from the ground, an aircraft flying at an altitude of five miles and a speed of 600 miles an hour appears

to move more slowly than an automobile passing us at only one-tenth that speed. This difference in impression is due to differences in *relative* speed, the so-called *angular velocity*, which plays an important role in the photography of anything that moves: the closer we are to the moving subject, the faster it appears to move; and vice versa. Angular velocity also explains why, for example, an approaching automobile seems to move more slowly than the same car passing at the same speed at right angles to our line of vision. This phenomenon, of course, is the reason why most tables of minimum shutter speeds required to stop the motion of specific kinds of subjects in a photograph give three different sets of data for each subject applying, respectively, to motion toward or away from the camera, motion at approximately 45 degrees to the optical axis, and motion more or less at right angles to the optical axis. Motion in the first direction requires the slowest, and motion in the last direction the highest, shutter speed to "stop" a subject moving at a uniform rate of speed. Consequently, consideration of the angular velocity—speed relative to the distance from the camera and the direction in which the subject moves relative to the camera—is the first prerequisite for effective motion symbolization.

The second prerequisite is answering the question whether subject motion should be "stopped" or indicated symbolically. In the first case, a sharp rendition is required; in the second, it is necessary to consider the subject's "speed" as it should appear in the picture. For the graphic symbols of motion can be varied to evoke different impressions of speed—from slow to fast—enabling a knowledgeable photographer to create precisely the feeling he wishes to express. He has the choice of the following:

"Stopping" motion. The photographer times his shot so that he captures the most significant moment out of the flow of motion and "freezes" it on the film by one of two techniques:

High shutter speed. The picture is made with a shutter speed high enough to "stop" the subject's motion in the photograph. Actual shutter speed is determined by three factors: the speed at which the subject moves, the distance between subject and camera at the moment of exposure, and the direction of the motion relaive to the camera. The higher the subject's speed, the shorter the distance between subject and camera, and the more nearly at right angles to the optical axis the direction of motion, the higher the shutter speed necessary to "stop motion" in the picture. The following table contains approximate data to give the reader an idea of what's involved:

Speed of subject	Subject distance	Direction of subject motion		
		toward or away from camera	at 45-degree angle to optical axis	at 90-degree angle to optical axis
5–10 mph (people, children, sailboats, pets, etc.)	25 ft	1/125 sec.	1/250 sec.	1/500 sec.
	50 ft	1/60 sec.	1/125 sec.	1/250 sec.
	100 ft	1/30 sec.	1/60 sec.	1/125 sec.
20–30 mph (athletes, motorboats, city traffic, etc.)	25 ft	1/250 sec.	1/500 sec.	1/1000 sec.
	50 ft	1/125 sec.	1/250 sec.	1/500 sec.
	100 ft	1/60 sec.	1/125 sec.	1/250 sec.
Over 50 mph (racing cars, trains, air- planes, etc.	25 ft	1/500 sec.	1/1000 sec.	pan*
	50 ft	1/250 sec.	1/500 sec.	1/1000 sec.
	100 ft	1/125 sec.	1/250 sec.	1/500 sec.
	200 ft	1/60 sec.	1/125 sec.	1/250 sec.

* "Pan" means: use the technique known as *panning*; it is discussed later. Generally, panning at the here-indicated shutter speeds will produce still sharper pictures of the moving subject (although the stationary background will appear blurred) than holding the camera motionless while making the shot. If a camera doesn't have the here-recommended shutter speeds, the one that is closest to it should be used; any difference in sharpness will be negligible.

Electronic flash. The moving subject is "stopped" in the picture by momentarily illuminating it with a high-intensity flash of extremely short duration. In this case, p. 45 it is the flash that "freezes" the motion, not the shutter which usually is set for a relatively low speed, particularly if the camera has a focal-plane shutter p. 57 which, unlike a leaf-type (between-the-lens) shutter, can be synchronized for electronic flash only at speeds that, depending on the respective design, range from 1/30 to 1/125 sec. This may create a problem: if the existing light is relatively bright, the permissible shutter speed may not be high enough to assure that the image produced by the existing light will also be sharp. In that event, a secondary, blurred "ghost image" will be superimposed upon the sharp, speedlight-produced image of the subject. The only way to avoid this is either to take the shot with a camera equipped with a leaf-type shutter in conjunction with a sufficiently high shutter speed, or to use electronic flash for stopping fast motion only in relatively dim surroundings, such as indoor sports arenas, or outdoors after sunset.

Directional blur. By fixing one's eyes upon a moving object and following its

motion, unless such motion is excessively fast, one can see the object sharply although the stationary background will appear blurred. Conversely, by fixing one's eyes upon the background in front of which an object moves, one can see the background sharp and the object blurred. But it is impossible to see simultaneously a moving and a stationary object sharply—if one appears sharp, the other must appear blurred, and vice versa: blur is both proof and symbol of motion. Consequently, in a photograph contrast between sharpness and blur evokes the impression of movement.

Speaking as a photographer, I feel it is necessary to distinguish between two types of blur: blur which has nothing to do with motion but is the result of accidental or deliberate out-of-focus rendition, and blur which has nothing to do with out-of-focus rendition but is the result of movement of either the subject or the camera. In this book, I refer to the out-of-focus type of blur as *unsharpness* and to the motion-caused type of blur as *blur*.

Effective motion symbolization through blur depends upon timing: the photographer must choose a shutter speed that is slow enough to produce blur, yet not so slow that excessive blur makes the subject unrecognizable. In other words, shutter speed must relate to the *apparent* speed of the subject—its angular velocity—which in turn is the combined result of actual speed, distance from the camera, and direction of motion relative to the optical axis.

A correctly chosen degree of blur not only provides proof of motion, but is also a clue to the moving subject's speed. The more pronounced the blur is in the picture, the faster the subject seems to have moved in reality. Consequently, a photographer has complete control over the desired speed-effect: motion can be made to appear either fast or slow simply through choosing the appropriate shutter speed.

The contrast between sharpness and blur and therefore the illusion of motion in the picture will be most effective, if the sharp picture areas are *perfectly* sharp. Accordingly, if shutter speeds that are too slow to be safely hand-held must be used to produce the required degree of blur, to avoid confusing blur caused by inadvertent camera movement, the camera must be steadied by being pressed against a solid object or mounted on a tripod.

Panning. Since it does not matter for the "speed-effect" whether the moving subject or the stationary background is rendered sharp—as long as one is sharp and the other blurred—the feeling of motion can effectively be evoked also by reversing the normal conditions and rendering subject matter in motion sharp and subject

matter at rest blurred. The obvious advantage is, of course, that the subject proper of the picture, even though it moves, can be shown in sharp detail; that the less important background is made to appear even less significant by being rendered blurred; and that despite this reversal in the form of rendition the feeling of motion is preserved in the picture. The necessary technique, which is called *panning*, requires that the photographer uses his camera the way a hunter uses a shotgun on a flying bird: center the image of the approaching subject in the viewfinder, hold it there by following through with the camera and, at the moment the subject passes you, release the shutter while swinging. Some of the most striking effects are obtained with relatively slow shutter speeds of 1/8 to 1/15 sec. Since panning holds the image of the moving subject more or less stationary on the film during the exposure while the background moves, the outcome will be a picture in which the subject appears sharp in front of a background streaked in the direction of motion. This technique is particularly recommended in cases in which a subject moves at a uniform rate of speed in a straight line across the field of view of the observer.

A related technique, limited in application but of great expressiveness, is to take pictures from a moving automobile at relatively slow shutter speeds. I have been particularly successful using a 90- or 100-degree wide-angle lens in conjunction with a shutter speed of 1/5 sec. I made pictures of the highway and oncoming automobile traffic by shooting through the windshield of my car moving at a fairly high speed along a tree-lined road, with the camera pointed straight ahead and including the front end of my car (while another person was driving). Because of differences in angular velocity, which ranged from virtually zero to very high, objects at and near the center of the picture were rendered sharp and objects near the periphery blurred, increasingly so, the closer they were to the edges of the film. The general effect was that of an explosion—streaks of blur radiating in all directions from the center of the picture, with oncoming traffic and the front end of my own car rendered sharp.

Motion graphs. If we expose a bright moving dot very briefly, it will appear on the film in the form of a dot; if we prolong the exposure, it will be rendered as a line in the width of the dot, its length depending on the duration of the exposure and the speed with which the image of the dot moved across the film. This is the principle of all motion graphs: mount your camera on a tripod, open the shutter, leave it open for a certain length of time depending on how long you wish the resulting line to be, then close the shutter and develop the film.

A prerequisite for the successful completion of a motion graph is that the moving subject is relatively bright—either in its entirety or in part—and the background dark; if conditions were reversed, the light background would "burn out" the dark image of the subject. Familiar to all are time exposures of automobile traffic at night in which the headlights and tail lights of the moving cars trace traffic patterns that look like linear designs. Other applications of this technique are photographs of fireworks, pictures of lightning strokes, and time exposures of the clear night sky showing the circular tracks of wheeling stars.

This type of photograph fulfills its purpose through association. The moving subject itself is normally invisible in the picture, only its motion is revealed in the form of a graph. But because we know that the graph was made by, for example, automobile lights, we experience the feeling of traffic flowing although no automobiles are shown.

Combination time and flash exposure. If the fact that a motion graph does not show the moving subject itself makes this technique unsuitable for a specific task, the following method can perhaps be used which enables a photographer to superimpose a sharp picture of a moving subject on a graph of its motion: in darkness or very dim light, a motion graph of the moving subject is made against a very dark background. At a significant moment, perhaps when the subject crosses the center of the picture, an electronic flash is fired at the subject, momentarily "freezing" its motion and superimposing a sharp image of the subject on its track. The shutter, of course, must be open before, during, and after firing the flash and not be closed until the subject is outside the field of view of the lens.

To be successful, this technique requires that several conditions be fulfilled. For example, the moving subject must be bright and its image small relative to the size of the film; otherwise, instead of leaving a clean-cut track, it will only leave a smear. Since the number of subjects fulfilling these requirements is small (good examples are distant automobile headlights and the stars), many otherwise unsuitable subjects can be made suitable by equipping them with battery-fed flashlight bulbs. To my knowledge, the inventor of this technique is Gjon Mili who fastened battery-operated flashlight bulbs to the hands and feet of a skater to trace her graceful movements on the ice, then, at the height of a leap, superimposed her picture upon this light-track by illuminating her with action-stopping electronic flash. Another prerequisite is, of course, that the background is sufficiently dark to enable the luminous tracks to stand out clearly. And finally, the light emitted by the flash must only illuminate the subject but not the back-

ground because, in that event, the light-track might be "burned out" and the flash-illuminated image of the subject merge with the background.

Picture sequence. Instead of trying to express the essence of a subject in motion through a single photograph, a photographer can subdivide motion into a number of phases and show each in a separate picture. This technique is particularly suitable in cases in which it is difficult to choose a single phase out of the flow of motion as the one "most typical." For example, during an automobile race, a car has an accident, takes to the air, flips over, hits the ground, and bounces several times before it comes to rest. In such a case, a sequence of pictures taken in rapid succession would give a more effective impression of the event than a single photograph showing the car "frozen" in midair. For this kind of photography, the use of a motorized camera is advisable and may even be necessary. Several 35-mm cameras and at least one 2¼ x 2¼-inch SLR can be equipped with spring-driven or battery-operated electric auxiliary motors which automatically advance the film and cock the shutter at a rate of up to five exposures per second. For higher rates, special cameras are available.

Picture sequences are particularly suitable to depict effectively subjects that move slowly or change gradually. Examples are sailboats tacking, the berthing of a great ocean liner, the gestures and expressions of a speaker, children at play, or the emergence of a piece of pottery from a lump of clay in the hands of the potter. And the only way in which extremely slow changes can be depicted is by means of a picture series. Examples are the "growth" of a building under construction for progress documentation, the unfolding of a flower, the emergence of a butterfly from the pupa, or the seasonal changing of a landscape. For best results, the camera position must be the same for all pictures of the sequence, so that the subject's changes can be evaluated in reference to the unchanging background.

Multiple exposure. Occasionally it is possible to record a subject's progress in space and time in the form of a single picture by exposing the same piece of film a number of times in succession. In most cases, prerequisite for success is a controllable environment in which the subject can be shown light against a dark background. The camera must always be tripod-mounted and its position remain unchanged until the entire series is complete. If subject motion is slow, the individual exposures can be timed with the shutter (for example, the motions of a growing plant, or the movements of the sun or moon during an eclipse). More often, however, an electronically controlled light-source will be required—repetitive (stroboscopic) flash—which automatically times and spaces the individual exposures. Since the shutter remains open during the entire sequence, to avoid ghost-

like streaks and smudges on the film caused by the moving subject, such pictures must be taken either at night or in a darkened room, and care must be taken that the light which illuminates the subject does not strike the background, or the image of the subject might "burn out." Masters of this technique are its inventors, Dr. Harold Edgerton and Gjon Mili, whose stroboscopic motion studies should be familiar to most readers.

Multiple printing. Virtually the same effect as that of multiple exposure can be obtained by multiple printing, *i.e.,* photographing individual phases of a motion on separate sheets of film and subsequently combining them in a single picture. Drawbacks are that only relatively slow motion can be depicted in this way, and that the number of phases shown together is limited normally to four or five. Advantages are considerably greater freedom in the compilation of the series: if one phase of the motion is rendered unsatisfactorily, it does not necessarily spoil the entire sequence; the sequence can be arranged *visually* to form the most effective pattern; and pictures shot at different occasions as well as pictures of different subjects or backgrounds can be combined. The result can be either a color print on paper or a transparency suitable for projection. If the originals are shot on positive (reversal) color film, internegatives have to be made on special color film; if negative color film was used, the color negatives are, of course, used like ordinary black-and-white negatives during projection printing in the enlarger. That considerable changes and corrections in regard to color, lightness or darkness, and scale can be made during printing goes without saying. However, the techniques involved are complex and beyond the scope of this text.

Composition. Unless motion is random and chaotic in character, like that of choppy water, it has direction. By graphically emphasizing this direction through a dynamic arrangement of the picture components a photographer can create the illusion of motion through composition.

Unlike a static composition which is characterized by a framework of horizontal and vertical picture elements within which the subject is more or less centered, a dynamic composition consists of tilting lines and off-center arrangements. Frequently, merely tilting the image of the moving subject is sufficient to evoke a feeling of motion, whereas the same subject, rendered level, would appear at rest. Other times, placing the subject along one of the picture's diagonals, or near one edge or corner, will evoke illusions of motion. For example, take the photograph of an approaching sportscar shot during a race: placed at the center of the picture the car is "neither here nor there" and no feeling of motion results. Placed in one

of the upper corners of the picture with plenty of empty track ahead of it, the car will seem to approach—to be in motion. And if it is placed in one of the lower corners with the empty track behind it—the distance already covered—the photograph will suggest arrival, which likewise implies motion. Even if motion is already symbolized by controlled blur, such placement would intensify the impression that the subject has moved.

TIMING

The most decisive step in the making of a photograph is pressing the shutter-release button. NOT because this is the operation that "makes the picture"—it isn't, because, as I pointed out earlier, the picture existed already in conceptual form in the photographer's mind *before* he made the exposure—but because it is irrevocable. Until he presses that fateful button, the photographer is free to choose and change, select and reject, improve and correct—he can do anything he wants, whatever he feels is necessary to give his pictures purpose, meaning, and power of conviction. But once he has taken that decisive step and pressed the shutter-release button, the die is cast, for better or worse, and there is very little he can do afterward to change the appearance of his picture. This is the reason why *timing*—choosing the moment when to release the shutter—is the most consequential step in the making of a photograph.

pp. 23-25

No matter how well chosen his equipment or flawless his "technique," unless his timing is also right, a photographer is in danger of producing pictures that are technically unassailable yet ineffective. For experience has shown that, no matter how much criticism a photograph may deserve on the score of inadequate technique, if the subject matter is interesting, the presentation imaginative, and the timing right, the picture will not fail in its purpose, because most people know very little about photo-technique and care even less, but they care a great deal about whether a photograph means something to them.

Admiring an especially dramatic or exciting picture, people often exclaim, "What a lucky shot!" Perhaps they are right that the photographer got the picture by luck alone; more likely, it was a well-deserved reward for hard work. But no matter whether a good photograph was produced accidentally or according to a plan, a large part of its success is usually due to correct timing.

The purpose of timing is to capture what Cartier-Bresson, the master of the well-timed picture, aptly calls "the decisive moment"—the peak of action, the highlight

of an event, the most significant gesture or expression; but also the moment when all the picture components fall into place to form the perfect graphic design.

As far as a photographer is concerned, this requires the ability to observe, to concentrate, and to anticipate. Power of observation is necessary in order not to overlook some seemingly insignificant detail which, in the end, may make or break the picture. Concentration is necessary to be ready when the significant moment arrives. Anticipation is necessary because action is often so fast that by the time the photographer realizes "this is it" it is already too late to shoot. In sports photography, for example, the photographer must start pressing the shutter-release button a fraction of a second *before* the climax is reached to allow for the unavoidable time-lag between the action and the exposure, which is caused by the photographer's own reaction time and the mechanical inertia inherent in his equipment.

The best insurance against missing the "decisive moment" is to take a large number of pictures. Amateurs often misunderstand this, complaining that if they took as many pictures as most professionals they too would have occasional "hits." This is not the point. Such large-scale shooting is not done indiscriminately. Each of these shots was carefully timed and made as possibly the final climactic picture. But then another more significant moment occurred, invalidating the previous photograph; and another, and another. Most professional photographers realize this and act accordingly. It is precisely because they are *professionals* that they cannot afford to miss, due to faulty timing, the one climactic shot they were assigned to get.

In regard to timing, a photographer must consider the following factors:

> The psychological moment,
> motion relative to composition,
> light, weather, and season.

The psychological moment

Every drama, every action, every event, has its climax—the moment when tension reaches the breaking point, when nervous strain is released, when the inevitable happens, tempers explode, or collapse sets in—the moment of victory or defeat; Ruby shooting Oswald; Khrushchev at the UN pounding the desk with his shoe. . . . Because they are obvious, to recognize and capture such dramatic moments is usually not difficult. However, many poignant moments are *not* obvious—the abandoned Chinese baby sitting forlorn at the railroad station; the Frenchman crying

364

at the defeat of France. . . . To capture moments like these also requires timing, but impelled by a special kind of awareness.

One of the most difficult things to time correctly is a smile. And by "smile" I don't mean the dental displays shot by commercial photographers at the command "Say cheese"—the smiles without joy or pleasure, as meaningless as the spurious claims and "testimonials" they promote. No—a genuine smile is an emotional response to a tender or humorous situation that reflects in the eyes and transforms the entire face—a precious moment in time gone almost as soon as it began which can be captured on film only by perfect timing.

Motion relative to composition

We live in a world of motion: people and pets, cars and planes, breaking waves and drifting clouds. And even when things are static, the photographer himself moves, and with every step he takes he sees his subjects from different angles, in different apparent sizes, and in different relationships to their surroundings. No wonder the difference between a successful and an unsuccessful photograph is often a difference in timing.

For instance, earlier I discussed the importance of positioning correctly a subject pp. 362-363 in motion within the frame of the picture: as far as the impression of motion is concerned, we learned that it makes a great difference whether the image of a racing car is placed near an upper corner of the picture, at the center, or near a lower corner. Placing this image correctly in a photograph is a function of timing.

Another connection between timing and motion stems from the fact that many subjects change in appearance as they move. As an example, take a picture sequence of a person walking. Doubtless, in some of the pictures the subject will look as if he is stumbling over his own feet whereas in others he will appear to move along with a free-and-easy stride. In other words, depending on their timing, some of the pictures may look clumsy while others convey the essence of flowing motion. Or consider the movements of a flag in a light breeze: at one moment limp, scarcely moving; at another, ponderously flapping or briskly rippling—constantly changing form. Whether a photograph conveys the feeling of a limply hanging rag or the proud symbol of a nation depends again on timing.

Let's take another example: a photographer wanting to photograph an approaching group of people. As the people come closer, their apparent size increases—at which moment should the shutter be released? The larger the image of the people, the more detail can be seen and the more important the figures become in com-

365

parison to the surroundings—the street, the buildings, other people, cars, the sky.
. . . But only up to a point: if the people are very close, they can be rendered only
in part—a head-and-shoulder shot, a close-up of a face, eyes and nose. In other
words, the character of the picture changes with relative subject size—from overall
shot to street scene to people to portrait to close-up to unsuccessful shot to missed
opportunity. Which of these a photographer gets depends again on his timing.

Some time ago I stalked a fascinating young couple in New York's Greenwich
Village trying to get a good shot. Up and down the streets they went, past houses
and fences and trees, now standing out clearly against a wall, now merging with
the pattern of doors and windows, now obscured by passing people. Color and
design of the background changed all the time—mostly unsuitable, too busy, wrong
color—automobiles interposed themselves between subject and camera just when
things began to look good, sunlight alternated with shade, frontlight with side-
and backlight according to the direction of the walk. Although my subject, the
couple, remained the same, the pictures which I got were as different as night and
day because of the differences in timing.

Although this example covers a very simple situation it contains the main picture
aspects determined by timing: apparent subject size, subject-to-background rela-
tionship, phase of motion depicted, character of illumination, juxtaposition of colors
and forms, overlapping of subject matter, and position of the subject within the
frame of the picture. Accordingly, *before* he finalizes his picture by releasing the
shutter, a photographer must consider the following questions: What is the mo-
mentary relationship between the subject and the rest of the picture elements?
How do the various picture components affect one another in respect to clarity of
rendition? Does one component cover, impair, or blend with another in some
undesirable way? How do they affect one another in regard to composition? Do
the main masses in the picture balance one another? Do the colors harmonize?
What are the proportions of light and dark? And what about subject distance and
image size, and subject position within the frame of the picture?

To recognize the moment when all conditions are right, when the picture com-
ponents combine to form a good design, and to capture this moment, that is timing.

Light, weather, and season

Changes as consequential in regard to the appearance of the subject—and the
picture—as those brought about by motion are caused by differences in light,
atmospheric conditions, and the seasons. Choosing the precise moment when these

external factors are in harmony with the character of the subject and the purpose of the picture is also a form of timing.

The effects of some of these factors are obvious, those of others subtle. For example, seasonal effects, like differences in the appearance of the same landscape or tree in summer and winter, are obvious; less obvious to the untrained eye are differences in the character and direction of light. For example, a textured wall may look dull all day long except for fifteen minutes when sunlight strikes it at just the right angle. The shadow of a mountain, a house, or a tree may fall in a pictorially unfortunate direction in the morning but in a favorable direction in the afternoon. For outdoor portraits, light from a hazy or overcast sky is preferable to direct sunlight, and the experienced photographer will time his outdoor portraits accordingly. Photographed in sunshine, a slummy neighborhood can appear positively "quaint" instead of squalid as it actually is and would look in pictures taken on a gray and rainy day.

As a rule, the moment the average photographer sees a subject that appeals to him, he shoots it, rarely considering the possibility that it might be more effective at a different time of day, in a different light, or under different weather conditions. Often, of course, the reason for such a snap-decision is lack of time—it's either now or never. This, incidentally, is one of the most frustrating experiences of many photo-journalists—the fact that deadlines and limited expense budgets compel them only too often to finish their work in a hurry and do the best they can although conditions are not at their best. Unfortunately, unless he is given sufficient time, no photographer can "time" his shots effectively. For to achieve their full potential, outdoor photographs in particular must be timed in accordance with requirements which may entail a long wait: if sunshine is needed for best results but the sky is gray; if a soft and misty mood is required but the air is clear; if storm clouds are necessary to dramatize a scene but the sky is serene—then a photographer has the choice of only two possibilities: either he compromises, perhaps finds a new solution, and does the best he can with available means. Or, if he is a perfectionist who is aware of the importance of proper timing, he waits, returns at a more opportune moment, or saves his film for a worthier project.

Even such unlikely factors as air temperature and relative humidity can on occasion change the effect of a picture, and influence timing. For example, photographed on a warm day, steam locomotives in a switchyard and geysers in Yellowstone National Park yield pictures that appear lifeless and dull; but when temperatures are low and frost is in the air, these same subjects appear impressive and "alive,"

belching forth immense clouds of steam which could not condense in warmer air. To realize the importance of such factors, to have the patience to wait until conditions are right, to reject the unsuitable moment rather than compromise and settle for second-rate pictures—that too is timing.

COMPOSITION AND STYLE

There is little doubt that the majority of photographers consider "composition" one of the most intriguing, mysterious, and most difficult to understand aspects of photography. There is good reason for this interest: "good composition" is universally and rightly regarded as one of the essential requirements of any "good" photograph. But although a lot has been written about this subject, most of it is a rehash of obsolete academic rules and the rest, with few exceptions, either too esoteric or too personal to be of real help to the student photographer. However, the importance of the subject seems to me to justify one more attempt at clarification, although I realize that whatever contribution I may be able to make has to be personal.

Composing means giving form by putting together. Giving form to what? The intentions and conceptions of the photographer. Putting together what? All the elements that constitute the picture: sharpness and blur, color arrangement, perspective, subject position, picture proportions—in short, all the *graphic* components of the photograph that play such an important role in creating the impression which the picture is going to make upon the beholder. This should make it clear that composition is NOT something that can be taken care of at the last moment or, like "cropping," introduced as an afterthought, but something which must be considered from the instant the picture is conceived.

What is this elusive "something" that must be considered? Unfortunately, the answer depends in large degree on whom you ask. This is what makes "composition" such a difficult and esoteric subject. You see, there are no "rules"—or rather, most of the existing rules are not universally accepted. And even the few "accepted" rules are subject to numerous exceptions and furthermore likely to change with the changing standards of the times—they evolve, and are ultimately replaced by others. The young photographers of today have totally different concepts about composition than the previous generation at the photo-club whose ideas in turn are different from those in vogue fifty years ago. And even among groups of photographers of relatively similar outlook individuals often disagree on specific

points, and defend their personal viewpoints heatedly. So it should not come as a surprise that what I have to say in the following can only be a personal interpretation of the meaning and essence of "composition" as I see it. My consolation is the thought that no one can please everybody, that different people react differently to one and the same photograph, and that, in the end, the only lasting satisfaction lies in making pictures that please oneself. Because no matter how much the critics may praise your work, if you know that it is not the outgrowth of your own convictions, ideas, and creativity, but the result of opportunity or imitation—in other words, if you simply had "luck" or are a copycat—you cannot truly enjoy your triumphs because in your heart you will always feel guilty and ashamed. Only a photographer of integrity and conviction can make pictures with pleasure and show his work with pride.

Clarification and organization

I start "composing" the moment I conceive the idea for a photograph. It was Edward Weston who said that "good composition is merely the strongest way of seeing things," to which I fervently add: amen. Consequently, my first concern is with organization: how can I create order out of the natural chaos of my surroundings where everything acts upon and interferes with everything else, where things blend and overlap and compete with one another for attention, where a riot of forms and colors vie for the interest of the beholder—how can I separate the wheat from the chaff, isolate my subject, simplify my picture, and present what I feel and see in the graphically most effective form?

Again, as so often in photography, it is impossible to give orderly step-by-step instructions on how to proceed. Too many aspects must be considered simultaneously, and an improvement in one respect is only too likely to create new problems in another. To give an example: I wish to photograph a large outdoor sculpture. I don't like the background, so I walk around my subject to get it against a different and more suitable background. But from the new angle the sculpture looks quite different, and the angle of the incident light is different too—perhaps better, perhaps worse. Let's say the new angle of view and background are satisfactory but the light is not. In that case, I can either wait until the light is right (for which I may not have the time), or go back to my first camera position, where everything was fine except for the background. I can perhaps tone it down by throwing it out of focus—shooting the picture with a larger diaphragm aperture than originally planned. This, of course, would effect the exposure. Alternatively, I may be able to shoot from a lower angle, or from much closer with a wide-angle lens; the first possibility might eliminate most of the undesirable background by

showing the sculpture against the sky; the second possibility would render the background in much smaller scale relative to the sculpture; but both would involve considerable changes in "perspective" which might or might not be acceptable. And so on.

However, no matter how numerous and complicated the steps involved, my first objective is always clarification. Usually, this means simplification—exclusion of extraneous picture elements by going sufficiently close to the subject, using a lens with a relatively long focal length, subordinating the background through appropriate selection and treatment, and generally presenting the subject with straightforward photographic means. In this approach, I often find myself in disagreement with photographers who prefer a more emotional or "expressionistic" approach characterized externally by conspicuous use of unsharpness, blur, graininess, and halation. I have no quarrel with this type of approach as such, as long as it is in agreement with the nature of the subject or event, expresses the intentions of the photographer, and is compatible with the purpose of the picture; and although it does not suit my own nature, I greatly admire some of its results. But it also seems to me that this *avant-garde* approach is often used merely as a disguise for photo-technical incompetence and editorially fuzzy thinking, and I suspect that many pictures of this kind are palmed off as "art" with the implication that if a person doesn't "understand" them, such a reaction is an unflattering reflection of that person's sensitivity and education rather than a sign of lack of competence on the part of the photographer. But, as I said before, each must follow his own conscience and abide by his own nature and, to me, simplicity and clarity are the prime elements of good composition—perhaps to an inordinately high degree.

Picture proportions. My next consideration is usually to decide whether to make a horizontal, a vertical, or a square picture. This, of course, depends entirely on the nature of the subject and, if applicable, its motion, actual or implied. For the soaring rise of a tree or a building can well be experienced as motion in latent form which can be liberated by graphic means: a narrow vertical format, slim and tall, and composition along diagonal lines. Actually, the proportions of the picture play an important role in establishing its effect, even in color photography, where transparencies can be masked to get away from the monotony of the camera format. Particularly photographers working with square film formats should keep this in mind; but even if you work with a standard 35-mm camera your slide show will gain in interest if you vary the proportions of your transparencies imaginatively. As far as possible, these proportions should be established, in concept if not in fact, already at the moment of conception of the picture.

Whereas an amateur has only to please himself, a professional photographer, and particularly a photo-journalist, must always consider the future use of his pictures. Art directors and layout-men may not always agree with his way of seeing things. To make his photographs as useful as possible (and of what use is a photograph without an audience?), he must compose his pictures with a certain amount of leeway for cropping. If he works with a rectangular film format, if possible, it is advisable to take two photographs instead of only one and compose the subject for both horizontal and vertical use. And if the camera format is square, sufficient space should be left surrounding the subject to permit cropping for use as either a horizontal or a vertical picture. Without these precautions, even otherwise excellent shots may be rejected because "they did not fit."

Static or dynamic. As a photographer essentially has the choice between a horizontal and a vertical picture, so he has the choice between a static and a dynamic composition. And as there are innumerable intermediate proportions between extreme horizontal and extreme vertical formats, so innumerable intermediate degrees exist between outspokenly static and dynamic compositions. Which of these a photographer should choose depends, like so many decisions in photography, on the nature of the subject, the way it affects the photographer, and the feeling he intends to evoke with his picture.

A static composition is one that is graphically in equilibrium. Equilibrium implies stability, and the most stable line is the horizontal, the most stable form the horizontal rectangle or the square. Vertical lines are also lines of stability because they are "in equilibrium," although they are somewhat less stable than horizontal lines; one always has the feeling that a tall vertical line or form might topple and fall—motion is, if not implied, at least hinted at.

A static composition suggests rest, quietness, security, solidity, latent power. It goes with pictures taken on a calm day, the immensity of the sea, the serene beauty of a lovely face, or the presence of controlled power. Any head-on view, any "distortion-free" rendition, and most shots made with extreme telephoto lenses, are almost automatically more "static" than pictures taken "at an angle," "distorted" views, and most photographs made with wide-angle lenses. Likewise, photographs in which a specific subject is more or less centrally located are more static than pictures in which the subject proper is placed more or less off-center, i.e., more toward one of the edges or corners.

If a photographer wishes to evoke feelings of restfulness, calmness, stability, reliability, security, firmness, or strength, his composition must be essentially static.

A dynamic composition is one that is graphically unstable, one in which lines and forms seem to slide, topple, or move. The most dynamic of all lines is the diagonal, the line of action, the longest possible line in any photograph. Forms become dynamic when they are tilted, placed at a slant, or jagged and irregular; subjects make a dynamic impression when they are "seen in perspective" instead of "head-on," or when they are rendered "distorted," *i.e.*, with their proportions exaggerated or changed from what is accepted as "normal." For example, photographed on a *horizontal* plane, a skier appears *static* and seems to stand still; photographed on a *tilting* plane—a slope—he appears to slide down the incline and through implication of motion becomes *"dynamic."* All angle shots are dynamic because they involve tilting forms, diagonal lines, and "distortions" in the sense discussed earlier in this book.

pp. 192-194

A dynamic composition suggests motion, action, passion, excitement, violence, and active power. If the nature of the subject or event includes these qualities, or if a photographer wishes to evoke them through his pictures, his compositions must be essentially dynamic.

Subject position. Distinguish between two basically different types of subjects: those which, like a landscape or a view along a street, fill the entire picture; and those which, like a portrait or a group shot of people, constitute only part of the picture while the remainder is filled by "background." In the latter case, positioning of the subject proper is an important part of composing. Depending on whether the subject mass is placed more centrally, or more toward one of the edges or corners of the picture, the composition will be essentially static or dynamic, respectively.

Subject placement also affects the graphic balance of a photograph. A high placement of the subject-mass within the frame of the picture can become an effective means for creating tension—the composition appears top-heavy, it seems precariously balanced, the subject is lifted off the ground—and the resulting feeling of lightness and excitement effectively amplifies with graphic means the excitement generated by the subject itself. Quite the opposite happens if matters are reversed and the subject is placed low. Then it seems to rest firmly on solid ground, a feeling of security and stability replace the previously encountered mood of elation, and the impression of the picture is one of heaviness, dullness, or complacency.

Even the depth-effect of a photograph is affected by subject-placement. For example, the small-scale image of a human figure placed high within a landscape photograph will seem farther away from the camera, and therefore create a

372

stronger impression of depth, than the same figure in the same scale placed closer to the bottom edge of the picture.

Framing. Compositionally, the purpose of framing is twofold: by contrasting the relatively close object which acts as the "frame" with subject matter farther away, a photographer, through contrast between near and far, creates illusions of depth. And using the "framing" subject matter as an organic boundary for his picture provides him with an effective means for condensing interest and presenting the subject in the form of a self-contained unit.

Subject matter suitable to serve as a frame can be found almost anywhere: arches and doorways; tree trunks and branches; wrought-iron grillwork; traffic and advertising signs; structures and constructions; abstract sculpture; openings formed by objects of any kind and description. However, a word of caution is in order: precisely because "framing" is such an effective compositional device, it has been overdone and the "framed view" has become a cliché. The Vermont church framed by birches, the rodeo shot through the paddock fence with a pair of booted and spurred cowboy legs dangling from the top rail, the backlighted country road seen framed by the tunnel of a covered bridge—these and other stereotypes have given "framing" a bad name. To avoid the stigma of imitation and triteness, photographers must find new ways of using "the frame."

Contrast and shock. One of the most powerful means for commanding attention is contrast based on shock—the unexpected among the commonplace. A single white flower in a bunch of blue ones; a small patch of brilliant color in a sea of grays and white; a tiny child in a crowd of grownups. But stronger still than these more familiar examples are the incongruous juxtapositions and superimpositions so effectively employed in certain types of "experimental" photographs: the lovely nude in the decaying shack; soft skin overlaid by cracked and peeling paint—a memento of the transience of all flesh. Or the striking way in which Bill Brandt contrasts human and natural forms, making the female body appear as monumental as the rocks, and the rocks as rounded as woman—showing us new perspectives of reality as well as of thought, opening new vistas of awareness. To use such powerful tools, sensitivity must be guided by understanding, and daring cautioned by restraint. For in this area of composition, only a hairline separates the sublime from the absurd.

The horizon. If present at all, the horizon is one of the most consequential picture elements. Compositionally, it divides a photograph into two parts—ground and sky—the proportions of which greatly influence the effect of the picture.

Evaluated in symbolic terms, the ground represents nearness, intimacy, and earthy qualities, the sky remoteness and spiritual qualities. Consequently, by composing his picture to include either more ground, or more sky, a photographer can at will make his photograph appear heavy or light, more earthly or more spiritual in accordance with the nature of the subject and the feelings he wishes to express.

If the horizon divides the picture into two equal parts, a feeling of conflict may ensue since neither one clearly dominates the other. However, depending on circumstances, such a state of equilibrium may also evoke impressions of tranquillity or monotony and, in cases in which these qualities must be implied, become a legitimate and valuable means of composition, notwithstanding obsolete academic rules to the contrary.

As far as the dividing line itself is concerned, a *straight and horizontal horizon* suggests equilibrium, serenity, and permanence—typically static qualities. A *tilted horizon*, by introducing the element of instability into the composition, makes the picture dynamic and suggests motion and change. A *wavy* or *jagged horizon* evokes feelings of dynamic fluidity, action, and drama.

Symmetry and asymmetry. Symmetry is one of the highest forms of order, exemplified by the design of classic temples, the equality of the two sides of a butterfly, and the patterns of many flowers. But precisely because of this perfection, symmetry can also evoke feelings of monotony and boredom, as is generally the case when the horizon divides a photograph into two equal parts.

However, in addition to this static type, other forms of symmetry exist, comparable, perhaps, to the state of balance between the two pans of a scale loaded identically but with weights of different forms: in the left pan, say, a one-pound weight; in the right pan, a half-pound and two quarter-pound weights. The graphic equivalent to such an arrangement, which might be called "dynamic symmetry," also exists in composition where different picture elements can "balance" one another if arranged on the two sides of an imaginary axis without being mirror images of each other. For example, imagine the photograph of a farm depicting, on one side, the farm house overshadowed by a group of large old trees, on the other side the cluster of barn and silos. Such a photograph can be said to be in dynamic balance and therefore will evoke feelings of stability, permanence, and peace although, strictly speaking, the composition is asymmetrical.

On the other hand, true asymmetry is always dynamic, tension-filled, dramatic. The vast majority of photographs are asymmetrically composed, a fact which

374

doubtlessly contributes to the often chaotic impression of many pictures. Particularly if asymmetry is combined with complexity, the effect is almost invariably disorganized, confused, and unattractive. However, asymmetry in conjunction with simplicity in regard to subject matter and composition can produce outstandingly beautiful and compelling effects.

Pattern and repetition. A favorite pastime of most pictorialists is making pattern-shots—photographs in which the same kind of subject or picture element repeats itself in an orderly way to form a geometric overall design. Although this kind of photograph contains a very high degree of order, it is usually exceedingly boring—order amounting to mechanical perfection can be very dull. Typical examples of this kind of photograph are pictures showing large numbers of identical machine parts stacked in even rows in a warehouse. However, the moment this monotony is broken, pattern shots can "come to life." For example, an aerial shot of a modern subdivision in which identical houses are arranged in straight rows is deadly dull; but if some of the streets curve irregularly and the houses differ slightly in design, although the pattern-effect is maintained, the impression is considerably more interesting and can even have a certain kind of abstract beauty. Similarly, the parking lot of an automobile-manufacturing plant filled with rows of identical cars waiting for shipment is subjectwise dull whereas the parking lot of a supermarket, partly filled with cars that differ in shape and color, can make a "pattern" which, if shot from afar with a telephoto lens to minimize perspective distortion, combines beauty with interest.

An analogy between photographic and mechanical perfection comes to mind: many objects of daily life such as textiles, wooden salad bowls, ceramic vases, blankets, rugs, etc., are available in either machinemade or handmade versions. But when he has a choice, a discriminating buyer usually prefers the handmade article and willingly pays the often considerably higher price—precisely because small irregularities and imperfections "break the monotony" and make the object more interesting, give it character and individuality, make it *unique* and therewith desirable—a one-of-a-kind item that is different from the rest. Photographers who use patterns as elements of composition should think of this.

Faults and fallacies

As should be clear from the foregoing, it is virtually impossible to list specific pitfalls and "faults" which a photographer must avoid when "composing." Likewise, it is impossible to formulate a set of "rules" for "good" composition except, perhaps, in the most general terms. The reason for this vagueness is that excep-

tions can be found for every "rule." Subjects, situations, and techniques that would spell unmitigated disaster to duffers may turn into stimulating photographs when handled by experts.

However, since nobody is helped by generalities, I'll list in the following some "faults" of composition which, in my experience, are likely to lead to unsatisfactory pictures: disorder; overcrowding of the picture with subject matter that should have been treated separately; lack of separation in regard to tone, color, and form; unfortunate overlapping and juxtaposition of different picture elements; compositional imbalance (which is not the same as asymmetry); color dissonances; garish, loud, and overdiversified color; distracting picture elements of no particular purpose; insipidity, triteness, dullness; "artiness"—novelty for novelty's sake; a "gimmicky" approach to composition.

On the other hand, the vaunted academic "rules" of composition are of no real help either. All that talk about "leading lines" which are supposed to "lead the eye of the viewer to the center of interest" has long since been disproved by qualified investigators: the eye roams in a totally unpredictable way all over the photograph, going straight to what is of momentary interest to the viewer, then jumping to some other point of attraction, completely disregarding all the so carefully prepared "leading lines." The famous "S-curve"—the main justification of innumerabe academic compositions—has through overuse become almost a symbol of triteness and epitomizes the photographic cliché. And "triangular compositions" exist usually only in the minds of academic photographers but are rarely appreciated by the average viewer of the picture, who normally doesn't even recognize the triangular arrangement unless it is pointed out to him—and then he couldn't care less. In my opinion, all those pretty line-diagrams "explaining" the compositional structure of accompanying textbook illustrations are nothing but window dressing or padding to attract a buyer and confuse rather than aid the student photographer. This is not what is needed. The purpose of a textbook is not to encourage childish exercises to please teacher. If only one looks long enough, or crops a little bit here and there, any photograph can be made to fit some preconceived idea of "composition." But this is attacking the problem from the wrong end. Composition is a means, not an end—the most perfect composition does not justify a meaningless picture. Composition is a tool designed to sharpen the impact of photographs. Equality of subject interest and phototechnical treatment provided, a well-composed photograph makes a stronger impression than one in which composition is weak. It is as simple as that.

376

Self-criticism and analysis

Self-criticism is a vital part of learning. It enables a photographer to see his work in perspective, to draw conclusions, and to ask the right questions: Where do I stand? Am I making progress? How can I further improve myself?

The basis of any constructive self-criticism is honesty. Anybody can fool other people, but no one can fool himself, at least not for long. On the other hand, indulging in maudlin self-accusations of the "I'm no good, I'll never make it" kind is pointless too. Only a dispassionate, computerlike approach is likely to be fruitful. It should start with taking stock of one's merits and faults.

Merits and faults of a photographer. In my opinion, the greatest asset a student photographer can have is enthusiasm. Unless he truly loves what he is doing, he may just as well do something else, preferably something more remunerative. Next in importance seems to me a sense of wonder and an almost childlike desire to explore things—people, feelings, objects, images. It is this precious sense of awareness unspoiled by preconceived ideas, prejudicial learning, and premeditated approach which is the secret of youth and explains why it is usually the young photographers who come up with new ideas and produce images that astound us by their freshness and poignancy. Having been neither confused nor dulled by too much learning and living, they are still free to go about their work with a childlike unconcern for "how things ought to be done." Having no "reputation" to lose, they can only gain by being unconventional, disregarding photographic taboos and attempting the unattainable. As long as a photographer keeps on working in this spirit he is on the right track, no matter how much he still may have to learn in regard to photo-technique. Anyone who makes the effort can acquire technical proficiency; but a sense of wonder and exploration is a precious gift which, once it has been dulled, is spoiled forever.

In my opinion, the greatest fault a student photographer can have is lack of self-confidence. A man without confidence in himself and his abilities invariably looks elsewhere for guidance. Just as inevitably, this passive form of searching leads to imitation, the meaningless cliché, the frustrating life of a hack. And the greatest fault a photographer who has "arrived" can have is to repeat himself.

To a certain extent, imitation is an unavoidable part of the learning process. Every young animal and every growing child learns by imitating his elders, and photographic beginners are no exceptions. But eventually there must come a moment where the paths of teacher and student part. Unless he is satisfied to play the life-

long role of a second-rater, the young photographer must grow up spiritually and develop in harmony with his own personality. He must discover his interests and form his own opinions in accordance with his convictions. He will continue to look at the work of others and may be influenced by it, but in a more mature way. No longer will he slavishly imitate what attracted him; instead he will analyze this attraction, discover the underlying cause, and use it creatively in his own manner—imitation is sublimated and transformed into constructive stimulation. When he has reached this point, the former student has grown up to become a photographer in his own right.

The personality of a photographer. Personality is the sum total of one's traits. These traits determine not only a photographer's growth potential, but also his limitations. Self-analysis is therefore an important step in the development of any photographer: What kind of person am I? What am I interested in? What do I wish to do?

But almost more important than discovering one's good qualities is, at least in my experience, the need to discover one's weaknesses and limitations. Because it is these qualities that can effectively thwart a photographer's career: unless he is adventurous, he should not travel, no matter how romantic the life of a photojournalist working for a national picture magazine may seem to him; unless he feels compassion for humanity, he should not photograph people, because he would never be able to do it well; unless he is methodical and precise, he should not attempt to work in the fields of industrial, architectural, or scientific photography; if he is deliberate and slow by nature, sports photography is not for him; and so on—I think you see what I mean.

Having ruled out what he should NOT do, a photographer can then give his attention to the problem of deciding what he SHOULD do. In the ideal case, *i.e.*, unless economical or other considerations rule otherwise, the choice should be made in accordance with his interests: which field of photography, what kind of photographic subject matter, is most attractive to him? The importance of interest as the decisive factor in choosing a career lies in the fact that any good photograph is *more* than a mere reproduction of the subject—it is an interpretation by the photographer in the light of his own experience: what he felt and thought about the subject, what it meant to him, how he intended others to see it. This presupposes knowledge and understanding, which are natural outgrowths of interest but hard to come by if the respective subject leaves one cold. Knowledge and understanding in turn furnish the basis for a personal opinion expressed in the form of photographs which, besides showing what the subject looks like, through the way in

which it is shown, gives the viewer the benefit of the special knowledge and insight of the photographer who thereby enriches the beholder's experience.

Analysis of a photograph. Self-criticism should not be restricted to one's personality but must extend to one's work. Here are some of the most important questions that must be answered:

Motivation: Why did you make this photograph? Did the subject interest you? move you? excite you? Did you make the picture because somebody else had made a similar photograph which you admired? gave you the idea? had been published? had received a prize? Or did you make it simply because the subject was there and you felt it might make an "interesting picture"? Interesting to whom? Yourself? your family? friends? members at the photo-club? the public at large? Was it a planned picture? a grab-shot? a lucky accident?

Value: Do you still think the subject was worth photographing? Why was it worth photographing? Or do you feel now that this picture is neither particularly beautiful, interesting, informative, moving, and actually in no way superior to countless other pictures of similar subjects taken by other photographers? Are you glad you made the picture? or do you wish now that you had saved your film?

Purpose: What did you expect to accomplish when you made this photograph? (The answer to this question is particularly important in order to find out how well you did—meaningful criticism of any photograph is possible only in relation to its purpose.) Did you wish to produce a record as an aid to memory—a snapshot, a photographic sketch? Is this picture a form of self-expression—a graphic statement communicating what you felt in the presence of the subject . . . a move of protest . . . a call to action . . . reform . . . revolt? Did you wish to express the beauty of the subject . . . its sex-appeal . . . perhaps a special quality, such as monumentality, nonconformity, desolation, squalor, cold . . . or love, hate, trust, disgust or despair? Did you wish the photograph to be informative, funny, educational, shocking? Is your picture a straightforward or a symbolic rendition—should it be taken at face value or is there a hidden meaning? Does it have a purpose at all, or did you make it without thinking anything beyond the fact that there was the subject, and how could you best get it on the film?

Execution: Are you satisfied with your picture in regard to photo-technique—sharpness, blur, exposure, color, contrast, light? How well do you think it succeeds in fulfilling its purpose (by the way, what *was* its purpose?). Is its execution personal and original, or hackneyed, trite, a photographic cliché? And if the execution is different from the run-of-the-mill kind of photographs of similar subjects,

in what respect does it differ? Is it better (why?), more artistic, or perhaps only arty? Does this difference contribute to making the photograph more beautiful, informative, emotionally stirring, graphically interesting, or is it merely a gimmick to attract attention?

Reaction: Honestly—what is your own reaction to this picture? Does it make you feel happy, curious, excited, angry, disappointed, bored? Frustrated—because it does not "give enough" and should have been much better? Ashamed—because you know it is only an imitation of somebody else's work? Proud—because you really succeeded in depicting what you felt in the presence of your subject? How do other people react to it—your family, friends, other photographers, strangers? Were their reactions more or less unanimous, divided, flattering, disapproving? Did they understand what you wanted your photograph to say? Did they care?

Personality and style

No two photographers are exactly alike in regard to personality, background, education, interests, taste, and degree of sophistication. Consequently, we might assume that, if we were to compare representative bodies of photographic work by several photographers, their personal differences should reflect in their pictures in the form of differences in regard to subject selection and treatment, composition, style, and so on. Unfortunately, such distinctions are extremely rare, mainly because stronger than differences of personality are similarities in thinking—the effect of what amounts almost to a "brainwashing" brought on by the corrosive influence of group activity combined with lack of courage to "buck the trend." To resist these negative forces must be the first consideration of any photographer who hopes to produce original work.

Anybody who ever accomplished anything of lasting value was an individualist—one not afraid to break new ground, buck the trend and go his own way willing, if necessary, to fight for his convictions. This is exactly the opposite from the current tendency for "togetherness" as exemplified by the photo club, the "school," the "group," or some "movement." Photographers who identify with any specific body of people united by a common cause—people who agree among themselves on most major points and "think alike"—don't get the stimulating exchange of ideas which any human being needs for his intellectual and artistic development. Having "an idea" is not the same as having to defend this idea against a clever opponent or putting it down on film. The first is vague and dreamy—everybody has "ideas"; but only the second can prove the feasibility and value of the idea—or disprove it. Photographers who are not willing to assert themselves lose their

freedom as artists and atrophy—stop "acting alive." Living is almost synonymous with fighting—against outside influences as much as against one's inner self. This fight is much more than merely a struggle for physical existence in a competitive field. It is a fight for survival on a higher plane, a fight for one's integrity and pride, the silent fight of the mind against one's own inertia (Why try so hard? No one will notice the difference!); against one's feeling of inferiority (I wish I were like such and such a person!); against the corroding influence of public opinion (What will other photographers say? What will my editor think?); against the temptation to get quick recognition by imitating the successful style of others (After all, they all steal ideas from one another!). Only by winning this fight can anyone ever become a photographer in his own right. And only by becoming a photographer in his own right can he ever develop a distinctive style of his own.

A personal style—the coveted mark of individuality—distinguishes a photographer's work from that of other photographers. And just as an art expert can recognize a painting by Picasso or a sculpture by Henry Moore without looking at the signature, so any experienced photo editor, without having to look at the stamp on the back, can recognize a typical photograph by, say, Edward Weston, W. Eugene Smith, Richard Avedon, Yousuf Karsh, Erwin Blumenfeld, Ernst Haas, or Art Kane, to name only a few that have their own distinctive style. I deliberately say "typical" because only when a photographer is free to express himself can he make pictures that carry the seal of personality; photographs made to specifications set by clients or editors may, of course, be partly diluted by such outside influences.

A prerequisite for the development of a personal style is knowledge of one's self and self-criticism—style evolves from an individual's personality. A photographer who is highly organized in his habits and thoughts will, of course, express this orderliness in the form of pictures that are sharp and precise in execution as well as in meaning. If these traits are combined with an unassuming nature, profound respect for all living things, and a deep love of outdoor life, it becomes clear why Edward Weston worked in the way he did. The man, his character, his interest, his feeling and thinking, his way of seeing and expressing himself, are all interconnected and fused into one, manifesting themselves in his personal style.

Take a look at the work of W. Eugene Smith, whose brooding character, preoccupation with human problems, and utter integrity allowing for no compromises are clearly reflected in his dark and moving photographs. His is a style that evolved through suffering, insight, and compassion for humanity.

Consider the work by Richard Avedon, the modern romanticist, glorifier of everything that is elegant and feminine. His suave sophistication, his sense of color and motion, his unconventionality, daring, and taste combine to produce a style that, no matter how many dfferent facets it may have, expresses his individuality unmistakably.

In contrast to Avedon who, after many years at the top, still can surprise us with his inventiveness, Karsh seems to have settled into a groove. His mastery of light and texture are still admirable, his compositions as well worked out as ever. But his habit of repeating himself has caused him to stand still with the result that his style, although as unmistakable as ever, begins to seem dated while other photographers move on.

Where color is the main criterion, Erwin Blumenfeld, Ernest Haas, and Art Kane are first among those who have won fame by their pioneer work in this still relatively new medium. And yet—how different their individual styles: Blumenfeld—inventive, capricious yet sensitive, immensely daring smashing old taboos with his sophisticated use of color. Haas—fascinated by motion symbolization, whipping up a storm in a "still" through superbly controlled use of blur brought to the highest pitch by the addition of color. Kane—the "designer photographer," using color with unrestrained abandon, creating poster effects of such striking boldness that they have won him wealth and fame.

To emulate these examples, a photographer must keep in mind three things: Only complete *honesty* with himself can get him ahead. The moment he gives way to temptation, takes the easy way, and tries to work with forms of expression alien to his nature—the moment he starts to imitate—he warps his personality and puts a crippling crimp in his artistic growth that may take him a long time to straighten out, provided the damage is not permanent.

To a certain degree, *specialization* can become an aid in the development of a permanent style. Each of the photographers mentioned above is a specialist in a more or less sharply defined field. Specialization is the result of interest—the creative mind is always interested in specific subjects while more or less disregarding those that are of lesser interest. Interest, of course, leads to proficiency—knowledge, improvements, inventions, and discoveries—the ingredients of a personal style.

The pitfall of trying to be *original for originality's sake*—the bane of the over-ambitious—must be avoided. In our age of the "gimmick" it is only too easy to

become known as, for instance, "the photographer who makes those funny distortions," or "the man whose work can be recognized by the way he photographs hands." In my opinion, such peculiarities are trademarks rather than evidence of creativeness—ruts in the road to success in which a photographer can get stuck before he reaches his goal.

Not every photographer will, of course, be able to develop a personal style. Unless one is fired by conviction, sparked by interest, gifted with sensitivity, and powered by drive he will not be able to rise above mediocrity. And even gifted photographers may be held back by imitating the work of those they admire. Instead of looking within themselves, they look toward others in a misguided form of hero-worship. Admiring their accomplishments, they fail to give themselves a chance. And acclaimed photographers often fail to develop their full potential through endlessly repeating the style that brought them fame. Only one thing is certain: a personal style cannot be forced. It must grow from within. It is the inevitable reflection of oneself.

6

How To Enjoy Your Color Shots

Everything we have been talking about so far has been in preparation for the payoff, the moment when your color transparencies are ready for your inspection and enjoyment. To see them to best advantage, or to show them to an audience, you have the choice of three methods:

Viewing,
projecting,
printing.

VIEWING

Color transparencies larger than 2.1/4 x 2.1/4-inch are rarely projected; instead, they are shown and enjoyed by looking at them on a table viewer or a light-box. Likewise, a viewing box or a slide sorter is an essential piece of equipment for editing small-sized color slides in preparation for projection and organizing the show.

The worst possible way of viewing color transparencies is the common practice of holding them up to an ordinary lamp or the sky. The color temperature of these illuminants is usually completely wrong and bound to produce severe overall color distortion. Furthermore, light around the edges of the transparency causes the eye to adjust to a level of illumination that is higher than that of the light passing through the color film. As a result, the transparency appears less colorful and brilliant than it actually is.

p. 224 To bring out the full inherent beauty of a color transparency, three conditions must be fulfilled: the room illumination must be as low as possible; the transparency must be properly masked; and the color temperature of the source of illumination should fall between 3200 and 5000 K.

For satisfactory viewing conditions, the brightness of the viewing surface should

measure at least 100 and better 150 candles per square foot and be 20 or more times as high as the brightness of the room illumination measured at the viewing surface. The brightness value of the light-box can be established with the aid of an exposure meter for measuring reflected light by multiplying the reading by the factor which the meter manufacturer recommends for converting the reading into foot-candles. For simple demands, a 60-watt blue tungsten bulb placed behind a sheet of flash-opal glass makes a satisfactory illuminator.

If transparencies are viewed in a near-dark room, the color temperature of the source of illumination may be as low as 3200 K. The eye quickly adapts to the slightly yellowish tint of such light and accepts it as white. As a matter of fact, so great is the visual-compensation power of the eye that it is often impossible to tell which of two transparencies showing the same subject—one with perfect color balance and the other with a slight overall color cast—is the correct one. Having looked for a while at the correctly balanced transparency, an observer will im-mediately pronounce a subsequently shown, say, bluish, transparency too cold. However, after looking at the bluish transparency for a while (with no other to compare it with), his eye will become adjusted to its color balance and eventually accept the rendition as correct. Then, if the correct color transparency is shown once more, it will by contrast appear decidedly too warm—as if it had a yellow color cast. Actually, the inability of the eye to judge color correctly is so pro-nounced that if two transparencies are shown side by side—one with a slight and the other with a strong overall cast of the same color—even a trained ob-server is often unable to tell how a correctly balanced rendition of the subject in question should look, and will decide that proper color balance lies halfway between the two versions shown, despite the fact that actually both are "off" in the *same* direction.

p. 224

While editing color transparencies on a light-box, I always keep a number of strips of black cardboard in different widths handy. I use these to quickly mask larger transparencies as I shuffle them around on the viewer, and also to prevent stray-light from escaping between the cardboard frames of mounted 35-mm slides. This practice not only facilitates color and density evaluation, but also makes the job easier on the eyes by preventing strain and fatigue.

PROJECTING

The most effective way to present color transparencies is by projection. Watching a parade of large, luminous screen images—color glowing out of darkness, sub-

jects enlarged to dramatic dimensions—not only represents the nearest approach to reality that can be achieved in color photography but, particularly when close-ups are shown, may even surpass the original experience by its dramatic intensification of seeing. However, to make the presentation as memorable and rewarding as possible, careful attention must first be given to each of the following steps:

Editing,
captioning,
masking,
organizing,
performing.

Editing. Few things are more tiresome than to have to watch politely a seemingly endless succession of dull and repetitious color slides. To save his captive audience from this harassing experience, a photographer should rigorously edit his slides before he puts on a show. Not only will this help him to keep his friends and even make them come back for another show but, by presenting only technically perfect and subjectwise interesting slides, will also make him appear a better photographer than he really is.

No matter how painful it may be to go through a whole vacation "take" of several hundred color transparencies—each one shot with love, care, and high expectations—select 30 or 40 of the best. This self-disciplinary action is only another one of those often painful but necessary steps that are part of the process of growing up as a photographer.

Editing a slide show is a two-step process. First, one eliminates all technically unsatisfactory shots—everything that is out of focus (unless, of course, unsharpness is deliberate), under- or overexposed, light-struck, obviously off-color, scratched, spotted, or otherwise likely to provoke a raising of eyebrows; then one cuts down the rest to manageable proportions. Since by that time the material consists only of "good" slides, making the final choice can be painful. What has to go this time is everything that is not strictly needed to put together a coherent show: all duplicates and near-duplicates; everything incidental that does not belong to the theme; variations of the same subject which, although different in regard to camera position, lighting, color, atmospheric conditions, etc., are nevertheless redundant subjectwise (studying an interesting subject exhaustively with the camera is sound practice; letting the audience decide which one of the resulting shots is the best, is a sign of insecurity). When editing their slides, beginners in particular are likely to make the mistake of trying to hold on to transparencies that were difficult to

386

make although the subject is uninteresting or the treament unsatisfactory; understandably, they feel that so much effort should not be wasted. But this is only another hurdle in the development of a photographer that must be overcome—the tendency to assume that a difficult or troublesome shot, or one that involved expenditure or danger, must *ipso facto* be an interesting picture. A good way to avoid such pitfalls is to get a second person interested in the job of putting a slide show together; his comments, untroubled by photo-technical knowledge and personal involvement, although doubtlessly painful at times, if taken in a constructive spirit, can be invaluable in assembling a show that will hold the attention of any audience.

Captioning. Any slide show gains enormously in interest if the pictures are accompanied by an appropriate narration: what each photograph represents, where, when, and why it was shot, what else happened, and so on. To be able to live up to this, and to avoid confusion of places and dates, a photographer should always carry a little notebook and make notes on the subject at the time he makes the picture. Such notes, which are keyed to the photographs by numbers identifying the respective film roll and frame, don't have to be elaborate and are merely intended as aids to memory: the place, the name, the date. Occasionally, it may also be advisable to include technical data, for example in conjunction with shots taken under unusual or difficult circumstances like indoors, against strong light, at night, and so on. Later, such data can become valuable aids in similar situations.

After the slides have been returned to you by the processor, write down important information (place, name, date) directly on the cardboard mount. This should be done not only with vacation, travel, or professional photographs, but also with family pictures where in later years you may be glad to recall with certainty who looked how when and was photographed where.

Masking and mounting. As I said before, adjusting the proportions of a picture in accordance with the requirements of the subject can considerably enhance the effect of a photograph. As far as color slides are concerned, the time to make such adjustments by *masking* is when you mount your slides between glasses. Although not strictly necessary, this is good practice because it protects color transparencies from scratches, dust, and fingermarks and also keeps them flat during projection, *i.e.*, prevents them from "popping" suddenly out of focus as a result of warming up in the projector. Glass-mounting of transparencies is particularly recommended in cases in which slides are frequently handled, shown, or sent out to competitions. Or protect your slides with plastic *Kimac* sleeves.

The first requisite for successful glass-mounting of color transparencies is cleanliness. Since projection involves enormous degrees of magnification, even minute specks of dust and lint would appear prominent and disfiguring on the screen—a single hair of fuzz curling across an otherwise clean surface can ruin the effect of the most beautiful slide. To avoid this calamity, clean new cover glasses with soap and water, dry them with an alcohol-dampened chamois, and protect them from airborne dust by stacking them beneath an upturned glass bowl until you are ready to mount your slides. With a fine camel's-hair brush, remove particles of lint and dust from the transparency, insert it in its mask (having, of course, removed the cardboard mount first), and place it immediately between the previously cleaned cover glasses. Check once more for specks of overlooked or newly deposited dust by examining the "sandwich" with a reading glass magnifier against a well-illuminated white surface before you place it into the metal or plastic frame or, if you prefer tape, into one of the handy mounting vises and bind it together.

Finding the right kind of binding tape can be a problem because many of the commercially available types have the annoying habit of oozing, as a result of which glass-mounted slides sooner or later stick together. A commendable exception is 3 M's No. 850 Polyester silver tape, which neither oozes nor sticks.

p. 271 Another nuisance which can make life miserable for photographers who glass-mount their transparencies are Newton's rings—interference patterns in the form of concentric bands of colored light that appear around areas where slightly buckling film touches the glass. They can be avoided either by using special so-called anti-Newton's Rings glass, or by a minute application of the antioffset powder used by commercial printing houses. Place a small amount of this powder in a plastic squeeze bottle equipped with a spout, knock the bottle against the table to raise a small powder cloud inside the bottle, then gently squeeze it and quickly pass the cover glass through the emerging cloud. Only so little powder should adhere to the glass that, if you can see it, it is already too much.

If transparencies are to be cropped by masking, make sure that the masking material is thin enough to fit, doubled over, between the two cover glasses without making the sandwich too thick to go easily through the projector, and that it is sufficiently opaque to prevent light from shining through. Best for this purpose is a special kind of paper which has been given a metallic surface for perfect opacity.

A common error of the beginner is to project a slide accidentally sideways or upside-down. Experienced photographers avoid this embarrassment by identifying the lower left-hand corner of every slide (when the slide is correctly oriented

388

for viewing) with a spot or other mark. When the slide is properly positioned for projection, this mark appears in the upper right-hand corner where it can easily be seen or felt when the slide is loaded into the magazine or fed into a top-loading projector.

Organizing. To be enjoyable, a slide show must be a well-organized performance that has a unifying theme, a beginning, a middle, and an end. Unfortunately, only too many have neither.

The theme can be anything a photographer cares to choose, just as long as it makes for a coherent show: your children, your home, your town, a fishing trip, flowers and gardens, antique automobiles, people in the street, the market in Acapulco. . . .

For those who find it difficult to organize their shows, I recommend studying the layouts of picture stories on subjects similar to their own in picture magazines like *Life, Look, Holiday,* etc. There they can learn how the subject is generally intro-duced in the form of a symbolizing shot that sums up the theme; how overall views are amplified by medium-long shots and these in turn by close-ups; how change of pace is achieved by means of contrast and variety: horizontal and vertical pic-tures alternate, light ones are interspersed with dark ones, a red one follows a green one, yellow is contrasted with blue. Architectural scenes alternate with people shots, group pictures with close-ups of faces. A wide-angle view prepares the way for a telephoto shot that discloses a detail which the preceding picture showed in the context of its surrounding. Pictures taken in sunshine alternate with pictures taken on gray days, at sunset, or at night. Exterior shots and interior shots complement one another.

Equally important as to what to show is what to exclude: the personal kind of pic-ture that interests only you but bores everybody else, like snapshots of your baby or your relatives; the shots that show the great traveler standing proudly in front of the Eiffel Tower, the Taj Mahal, the Colosseum, the Pyramids . . . you name it; the photo-calendar type of picture; the photographic cliché that everybody has seen *ad nauseam:* the New England church in the valley framed by the trunks and branches of birches . . . the partly frozen brook winding its S-curve between snowbanks . . . empty lobster pots stacked on a wharf in Maine. . . .

For bringing order into the chaos of a slide show in the process of emergence, a slide sorter—a table viewer on which slides can be arranged in rows—is an almost indispensable piece of equipment. In its absence, a sheet of flash-opal glass ap-

proximately 12 x 20 inches large and illuminated from below will also do the trick. The great advantage of such a device is not only that it enables a photographer to lay out his pictures in their proper sequence but that he can see the entire show at one glance, study it as a whole, and see where changes are needed, perhaps because pictures that follow one another are too similar, an additional picture would improve continuity, a picture placed in one spot would fit better in another, and so on.

Experience has shown that 30 to 50 slides are sufficient to make up a good show which should run anywhere from 30 minutes to one hour, but not longer. Better to have your audience clamor for more than to see it get up stifling yawns.

Performing. To be a success, a slide show must not only be well put together, but also be run professionally, smoothly, and without a hitch. Good showmanship demands that the screen be up, the projector in place, the focus adjusted, and the slides in proper sequence in their stacks or magazines, before the audience is asked to sit down and enjoy the show. That the room must be blacked out properly goes without saying. Needless to say, the optical system of the projector must be spotless because dust adhering to the condenser or the heat-absorbing glass can show up in giant size on the screen—occasional cleaning of the interior is therefore required. Having a spare bulb handy in case the one in use burns out unexpectedly is an elementary precaution. If you can persuade your audience to refrain from smoking during the show, your slides will look so much better.

Slide projectors are available in a large variety of different models that range all the way from simple, relatively inexpensive, manually operated, single-loading types to completey automated, magazine-loaded, sound-synchronized machines. Less well known is the fact that some projectors spill more light than others, and that a few are even likely to dazzle the operator to a degree that it interferes with proper operation. Accessory lenses of different focal lengths often make it possible to adjust the size of the projected image to the size of the room—if the room is small but you like to see your slides in an impressive size, select a wide-angle projection lens. Variable focus or zoom lenses are also available although their focal length ratio is somewhat restricted.

A sometimes overlooked important consideration when shopping for a new projector is the fact that, although all slide projectors, magazines, and trays accept standard cardboard-mounted slides, only certain makes and models accept glass-mounted slides or slides mounted in plastic or metal frames.

Photographers who only occasionally expect to project slides may be best off

with a projector equipped with a shuttle-type changer which accepts any kind of mount and is designed to project one slide at a time. Advantages are simplicity, versatility, relatively light weight, small size, and reasonable price.

Next in order are semiautomatic projectors equipped with a stack-loading slide changer which permits you to project batches of 20 or more slides in preestablished sequence with the aid of a manually operated push-pull mechanism.

Still more sophisticated are the tray-loading or magazine projectors which come in two types: those designed to accept rectangular trays of varying lengths with capacities that, depending on type and make, range from 30 to 60 and more slides; and projectors designed to accept circular trays holding 80 or 100 slides each. Advantages are that the slides, once they are loaded into the magazine, can stay there forever, remain always in proper sequence, and are protected from dust and accidental fingermarks. The main disadvantage of rectangular trays and circular magazines is that they are not standardized; that those made by one manufacturer may not fit a projector made by another; and that some magazines accept only cardboard-mounted slides whereas others accommodate also slides mounted between glasses provided they don't exceed a certain thickness. A few rectangular magazines designed to work in conjunction with magnetic slide changers require that slides are mounted in metal frames or equipped with a metal clip attached to one edge.

Finally, for those who want the best and can afford it, there are fully automated projection systems, some of them synchronized to tape recorders and stereophonic speakers. These enable a photographer to do all the necessary work in advance and then sit back, relax, and enjoy the show without ever having to go near the projector. Slides are focused automatically from preloaded magazines and changed either at predetermined intervals, or at the discretion of the operator who can change slides from any place in the room by remote control with the aid of a small, hand-held, cordless, ultrasonic device.

PRINTING

Like color-film development, color-film printing involves processes which I consider outside the scope of this text because the overwhelming majority of color photographers work with positive color films which don't require printing; because manufacturers of color-printing materials are likely to change their products and processes at any time, as they have done in the past, and information given here might be obsolete before this book is off the press; because authoritative instruc-

tions are already included with all materials needed for printing color films; because the techniques involved in color printing are complex and critical as a result of which photographers who work with negative color films largely let commercial color labs make their prints; because excellent instructions for making color prints on Kodak materials are already available in the form of the inexpensive, authoritative Kodak Color Data Book *Printing Color Negatives,* which is available at most camera stores—a "must" for anyone intending to make his own color prints. It is for these reasons that I present in the following only basic information—sufficient to give the reader who is interested in color printing an idea of what is involved. Should he later decide to make his own color prints, he will find all the necessary instructions in always up to date form in the sources listed above.

Photographers used to seeing positive color transparencies on a light-box or projected on a screen are often disappointed to find that, by comparison, even the finest color print seems dull and flat. The explanation of this difference lies in the fact that color in a transparency is experienced in transmitted light, in a print in reflected light. In the first case the effect is comparable to that of, say, a traffic light—disks of colored glass seen in transmitted light. In the second case, the effect is comparable to that of a painted warning sign—what we see is reflected light. Obviously, the traffic-light signal must appear brighter and more luminous than the opaque warning sign that is merely painted.

The difference between a transparency and a print is basically the difference between transmitted and reflected light—the same difference that exists between "light" and "white." When a color transparency is viewed on a light-box in transmitted light, only the light which has passed through the transparency reaches the eye of the observer. This means that even in the deepest shadows where the light may be transmitted only to the extent of perhaps one-tenth of one percent, the light is still controlled by the dyes of the transparency. As a result, the full range of tones of the transparency is seen by the observer.

However, although a color print is similar in structure to a color transparency insofar as it consists of three layers of dye images, light which reaches the eye of an observer derives from two sources: the first, as in the transparency, is that which passes through the dye layers and is reflected back to the observer's eye by the underlying white print base. The second (and note that this does not occur when one contemplates a color transparency on a light-box) consists of the light which is reflected directly from the surface of the print without ever having passed through the dye images. Since this second component of the light amounts to approximately 2½ percent of the total light reflected from the print, the maximum ratio between

the brightest highlights and deepest shadows in a color print can never amount to more than about 40 to 1. For no matter how much one increases the intensity of the light by which one views a print, its lightest and darkest parts always receive the same amount of illumination, and its contrast range must consequently always remain the same. For this reason, a color print on an opaque base can never appear as vivid and natural as a color transparency viewed in transmitted light.

Another problem in direct color printing is created by the imperfect absorption characteristics of the dyes which must be used. Although there are inevitable losses in any color reproduction because the dyes are not perfect, in positive color transparencies made directly from the original subject these losses are minor and generally pass unnoticed except when the transparency is compared critically with the original. But when a color print is made from a transparency, no matter whether positive or negative, the result becomes a reproduction of a reproduction. Losses in faithfulness of color rendition become cumulative, distortion is multiplied by distortion, and color degradation can assume proportions which make the subject appear decidedly unnatural as far as its colors are concerned.

How to select color negatives for printing

Although it is possible, within reasonable limits, to correct certain faults of color negatives during printing, the fact remains that color negatives which are already as nearly perfect as possible invariably yield the most beautiful prints. To be specific, the following points require attention:

Contrast. As explained above, the tone scale of a paper print is relatively short. If a color negative contains simultaneously very dense and very thin areas, either one or the other can be rendered satisfactorily with ordinary printing techniques, but not both together in the same print. Consequently, color negatives in which contrast is relatively low, always yield the most pleasant prints.

If excessively contrasty color negatives are expected to yield good prints, masking is required. A "mask" is a positive contact print made from the color negative, usually on low-contrast panchromatic black-and-white film, which is "dense" where the color negative is "thin," and "thin" where the color negative is "dense." During printing, the mask is bound in register with the color negative the contrast of which is thereby reduced to a printable level.

Color. The production of a color print always involves a certain loss of color saturation. In addition, as explained above, some color degradation is unavoidable. Therefore, color negatives of subjects in clean and highly saturated colors

usually yield better prints than negatives of subjects in dull colors or pastel shades which not only will appear even drabber in the print, but also reveal inaccuracies in color rendition more prominently than vivid colors in which even relatively large departures from the actual color shade may pass unnoticed.

pp. 397-398 Overall inaccuracy of color rendition in the negative due to, for example, excessively bluish or yellowish light, fluorescent illumination, tinted window glass through which a photograph was taken, etc., can usually be corrected without much difficulty during printing by an appropriate adjustment in filtration, as will be explained later.

Exposure. Since printing inevitably involves some loss of color saturation, under-exposed color negatives, in which color is already desaturated to a higher or lesser degree, invariably yield disappointing prints. On the other hand, color negatives which are somewhat denser than normal owing to a slight degree of overexposure, generally make excellent prints. Contrary to good practice when working with positive color films, when shooting negative color film, erring on the side of overexposure is therefore preferable to exposing too little.

Definition. If the print is to be substantially larger than the color negative, the negative, of course, must be sharp enough to stand the necessary magnification. The best way to find out how sharp a color negative is, is to place it in an enlarger and project it upon the easel in the size of the intended print. If it still appears sharp, it is sharp enough for printing.

How to make a color print

In essence, making a print from a color negative is identical with making a print from a black-and-white negative *except* that, in color printing, the enlarger light must be color-balanced in accordance with the color characteristics of the negative and the desired overall color of the print. For this purpose, special color filters are used which come in two types: Kodak CP (acetate Color-Printing) filters for use in enlargers which accommodate filters between the lamp and the negative (this is the best filter location; filters so placed cannot interfere with the sharpness of the print); and Kodak CC (gelatin Color-Compensating) filters for use between the enlarger lens and the sensitized paper. Minimum requirements: a red, a magenta, and a yellow set of filters, each set having four filters in different densities if acetate, and six filters in different densities if gelatin. In addition, no matter what type of filter is used, the enlarger must be equipped with a constantly used ultraviolet-absorbing filter (Kodak Wratten Filter No. 2B or Color Printing Filter CP2B) and a heat-absorbing glass (Pittsburgh No. 2043).

p. 36

394

The first step in color printing is determining the correct *basic filter pack, i.e.,* that combination of filters which, used with a "normal" color negative, will produce a print of satisfactory color balance. Unfortunately, the combination of color filters will vary with the voltage applied to the enlarger lamp, the color of the enlarger's condensor and heat-absorbing glass, the specific color paper emulsion (which usually varies from batch to batch) and, of course, what the photographer prefers. Consequently, it is not possible to predict in advance which combination of color filters will give the best result, and the only way to establish the basic filter pack is by trial and error.

Photographers who work with Kodak negative color films (Kodacolor or Ektacolor) should begin by making an exposure determination test using a basic filter pack consisting of a 2B and a 50R filter and the combination of diaphragm aperture and image magnification with which the final color print will be made. The test paper should be exposed in strips as follows: cut a sheet of Ektacolor paper into strips approximately 2 inches wide. Place a strip on the easel. Cover four-fifths of it with a piece of cardboard, and expose the exposed part for 32 seconds. Uncover one-fifth more, and expose for 16 seconds. Repeat this operation, exposing the remaining three-fifths of the strip for 8, 4, and 4 seconds, respectively. Thus the five sections of the strip receive exposures of 64, 32, 16, 8 and 4 seconds, respectively. Develop and dry the strip. In bright light (but *not* in fluorescent illumination), examine the print for exposure and color balance. If the darkest section of the strip is still too light, the longest exposure was still not long enough and a new test with longer exposures must be made. If the lightest section of the strip is still not light enough, the shortest exposure was still not short enough and a new test with shorter exposures must be made. If one of the sections of the strip contains the correct exposure, judge its color; if you like what you see, you are all set to make the final color print.

However, it is much more likely that your first test will be unsatisfactory and its overall color not correct. If this is the case, determine the exact shade of the excess color. This is most easily done by analyzing the neutral shades, particularly gray and white if present, otherwise skin tones and pastel shades. If they are too red, too yellow, too blue, etc., add to your basic filter pack a filter in the same color as the color cast of your test print and make a second test. The density of this additional filter depends on the degree of the color cast: if the cast is very mild, use your palest filter (CC05); if the cast is moderate, use a moderately dense filter (CC10, CC20); if the cast is very pronounced, use a still denser filter (CC40, CC50). And if the color cast seems to be a combination of two colors, for example red

and yellow (*i.e.*, orange), add one red and one yellow filter to your basic filter pack.

But what should one do if the print happens to turn out with, for example, a blue-green (cyan) color cast? Then, instead of *adding* a cyan filter in the proper density (which, of course, would correct the color cast), it is more practical (because it requires the use of a smaller number of filters) to *take away excess red filtration* (which achieves the same result because red is the complementary color of cyan as was explained before) and, instead of the originally used 50R filter, use a weaker red filter, perhaps 30R, 20R, 10R, 05R or, if this is not sufficient, omit the red filter alltogether.

As this example shows, the overall color cast of a color print can be corrected in two different ways:

> by *adding* a filter in the *same color* as the color cast;
> by *taking away* a filter in the *complementary color* of the cast.

In practice, such corrections can usually be accomplished by combining color filters in different ways, and the best way is always that which requires the smallest number of filters.

Additive primary colors Subtractive primary colors

red	is complementary to	cyan
green	is complementary to	magenta
blue	is complementary to	yellow
red	is equivalent to	yellow + magenta
green	is equivalent to	cyan + yellow
blue	is equivalent to	magenta + cyan

To be able to select the best possible filter combination, a photographer must put into practice what he has learned previously when we discussed the nature of color, and particularly the principles of additive and subtractive color mixture which here, for our present purpose, can be summed up as follows:

p. 262
pp. 278, 280

The relationships between these colors should make it clear why any desired color correction can be made with filters in only three different colors: cyan, magenta, and yellow. For example, if the overall tone of the test print is too blue, you can remove the excess blue either by adding blue to your basic filter pack (which means increasing the number of filters which, as we have heard, is always dis-

396

advantageous); or you can get the same effect by subtracting yellow (since blue and yellow are complementary colors).

Now, if you started your test series with a 50R filter as recommended, you can NOT, of course, take away a yellow filter because there is no yellow filter in your filter pack. However, as is evident from the above table, in effect, a 50R filter is the equivalent of a 50Y (yellow) plus a 50M (magenta) filter. Hence, if you substitute these two filters for your 50R filter, you would get the same effect. But now you have a yellow filter in your basic filter pack, and if you chose instead to combine a 30Y (instead of a 50Y) and a 50M filter, you would in effect have subtracted yellow in the amount of a 20Y filter. The following table, which shows the inter-relationship between color cast and color correction filters, should make it easy to select the appropriate correction filters.

If your test print contains too much	Either subtract filters in these colors	Or add filters in these colors
red	cyan	red (or yellow + magenta)
green	magenta	green (or cyan + yellow)
blue	yellow	blue (or magenta + cyan)
yellow	magenta + cyan (or blue)	yellow
cyan	yellow + magenta (or red)	cyan
magenta	cyan + yellow (or green)	magenta

Changes in the basic filter pack influence, of course, the exposure which must be corrected accordingly. The new exposure can be determined either by making a new test strip with the changed filter pack, or by using the Kodak Color-Printing Computer. It is included in the Kodak Color Dataguide which, in my opinion, is indispensable to any photographer who wishes to develop and print his own Kodak color films.

Once the principle of corrective color filtration is understood, the mechanics are simple and can be summed up as follows:

To correct a color cast (*i.e.*, to eliminate excess overall color), subtract a filter in the complementary color from your filter pack. This method usually gives the best results because it normally involves the smallest number of filters. Alternatively, you can add to your filter pack a filter in the same color as that of the color cast.

To give the print a specific overall color shade (for example, yellow to make

397

it "warmer," or blue to "cool it off"), subtract a filter in the same color from your filter pack. Alternatively, you can add to your filter pack a filter in the complementary color.

The greater the amount of color you wish to remove or add, the greater the density (and the higher the number) of your CP or CC filter. If a filter with the highest number is not dense enough to produce the desired effect, two or more filters of the same color can be combined. For example, a combination of a CC40R and a CC50R filter is equivalent to a CC90R filter (which does not exist in the form of a single filter).

The color relationship between Kodak color correction filters is such that the additive filters red, green, and blue each contain approximately the same amount of the same dye as the two corresponding subtractive filters yellow + magenta, cyan + yellow, and magenta + cyan. For example, a 10R (red) filter produces the same effect as a 10Y (yellow) + a 10M (magenta) filter, and a filter pack consisting of a 10R + 20Y + 10M filter is equivalent to one consisting of a 30Y + 20M filter (because 10R is equivalent to 10Y + 10M). Accordingly, a specific color can usually be produced by different combinations of filters, and the best combination is always that which requires the smallest number of filters and which also has the least density and requires the shortest exposure.

Local contrast control. Areas which in a "straight" or uncontrolled color print would appear either too light or too dark, can be darkened or lightened, respectively, through "dodging." Dodging involves giving the dense areas of a color negative proportionally more exposure than the thin areas. This is achieved by techniques known as "burning in" and "holding back." Burning in is done by allowing the light from the enlarger to penetrate for an additional period the dense areas of the negative which otherwise would appear too light in the print, while the rest of the sensitized paper is shielded from overexposure by interposing either an appropriately shaped piece of cardboard, or the hands of the printer, between the paper and the enlarger lens. Conversely, thin negative areas that normally would appear too dark in the print can be kept lighter by "holding back." This is done by shading the area of the print which otherwise would turn out too dark, after it has received the required amount of exposure, from excessive light either with an appropriately shaped piece of cardboard, or the hands of the printer, while the rest of the print continues to be exposed. In both techniques, to avoid unsightly "halos" surrounding the treated areas, the dodging device (or the hands) must be kept in constant motion to blend the tone of the treated and untreated areas of the picture.

7
Random Thoughts And Observations

I can't remember where I heard or read that "a color photograph can be as loud and vulgar as a singing beer commercial . . . or as harmonious as a passage from a Mozart quartet." But wherever it was, this seems to me a very valid observation.

It is the mark of the novice to think of color in terms of quantity; experts see color in terms of quality.

It seems to me most unfortunate that color photographs are constantly compared to paintings, and that so many people believe that the highest compliment they can pay a color photographer is the assertion that a particular shot is "like a painting." In my opinion, notwithstanding certain superficial similarities, the two have nothing to do with each other—there is a world of difference between color photography and painting: In his work, a painter shows reality as it appears to *him,* as he sees or feels it, emphasizing what he believes important, disregarding what he considers superfluous, and generally revealing more about himself than about the subject of his painting. Any painting is therefore a subjectively "edited," "digested," and "distorted" representation of reality *seen through the eyes of a person,* no two of which are alike.

On the other hand, no matter how important the contribution by the mind and imagination of the photographer, a color photograph is *seen through the "eye" of a machine*—an objectively registering recording device identical to thousands of others—in strict adherence to optical laws. As a result, its product, the color photograph, is essentially objective, true, and therefore "undistorted" in the sense that whatever it shows and no matter how incredible it may appear, the subject which it depicts was "real" and actually present at the moment the picture was made in the form in which it is shown.

Taking advantage of these facts, a color photographer can therefore improve his work in three ways:

1. Through expert utilization of the *technical* aspects of photography, by exploiting the qualities in regard to which the photographic medium is superior to the eye —sharpness; virtually unlimited angle of view; instantaneous "freezing" of motion, etc.—a photographer can use his camera as a tool for making discoveries in the realm of vision, showing his public aspects of reality which, because of inherent limitations of the human eye, could not have been seen directly in this form, and thus contribute to man's knowledge.

2. Through imaginative utilization of the *creative* aspects of photography—by exploiting the potentialities of the superrealistic close-up; the carefully chosen moment or view; the subject skillfully isolated and lifted out of the context of its surroundings for greater emphasis; perspective control; symbolization of intangibles through color and "mood," and in a multitude of other ways—a photographer can make people aware of heretofore unnoticed beauty and significance and thus contribute to the esthetic enrichment of life.

3. By *combining* the technical and creative potentialities of the photographic medium, a photographer can document reality in the form of moving and meaningful photographs which, no matter what their scale of influence, can help people to better understand themselves and their neighbors, people of other nations, and thus aid man in his eternal quest for mutual understanding and peace.

This lofty goal, of course, is a far cry from the simple snapshot with which we began; from the slogan that contributed so much to making photography the universal hobby which it is today: you press the button—we do the rest; from the concept that color photography is "easy."

Yes—color photography can be easy; nothing is easier than snapping a simple subject and, a few days later, picking up at the corner store where you left your film, a set of pretty pictures. On the other hand, few things demand more patience and skill, more sensitivity and devotion, than the making of great color photographs. It all depends on the demands you make upon yourself and your pictures, on your values.

One of the curses of our time seems to be that most people are interested only in what is "easy"—the most important line in ads addressed to do-it-yourselfers is "It's easy!" "You too can paint, write, make great color photographs, and earn lots of money. . . . All you have to do is to subscribe to this home-study course, buy this inexpensive kit, follow these simple instructions. . . . IT'S EASY!"

If all you want is a formula for easy results, then you wasted your money when

you bought this book; or, for that matter, any book on color photography. Because all you need is already neatly summed up in the simple instructions packed with your new camera, exposure meter, and film—and it's free.

But if you belong to that breed of photographers who still believe in quality, honest work, and meaningful results, then you will find all the necessary guidance in the pages and pictures of this book. To give more is impossible—the rest is up to you. That final ingredient for success—creativity—cannot be taught.

From the substance of his surroundings, a photographer gathers impressions which he evaluates in the light of his own experience, interest, and personality. Discrimination, selection, and rejection precede the making of his picture. Organization, clarification, and technical skill transform his raw material into a form which in intensity of seeing, symbolic suggestiveness, and dramatic impact can surpass by far the experience of the actual moment. If this is achieved, the photograph is good —reality has been transformed into art.

Index

402